FROM
PURE VISIBILITY
TO VIRTUAL REALITY
IN AN AGE OF
ESTRANGEMENT

John Adkins Richardson

Critical Perspectives on Culture and Society
Ralph A. Smith and Matthew Kieran, Series Advisors

Westport, Connecticut
London

Library of Congress Cataloging-in-Publication Data

Richardson, John Adkins.
 From pure visibility to virtual reality in an age of estrangement
/ John Adkins Richardson.
 p. cm.—(Critical perspectives on culture and society, ISSN
1097–5020)
 Includes bibliographical references and index.
 ISBN 0–275–96088–9 (alk. paper)
 1. Art, Modern. 2. Modernism (Art) 3. Art and society.
 4. Alienation (Social psychology) I. Title. II. Series.
 N6350.R53 1998
 701′.1′03—DC21 98–10918

British Library Cataloguing in Publication Data is available.

Library of Congress Catalog Card Number: 98–10918
ISBN: 0–275–96088–9
ISSN: 1097–5020

First published in 1998

Praeger Publishers, 88 Post Road West, Westport, CT 06881
An imprint of Greenwood Publishing Group, Inc.

Printed in the United States of America

The paper used in this book complies with the
Permanent Paper Standard issued by the National
Information Standards Organization (Z39.48–1984).

10 9 8 7 6 5 4 3 2 1

Copyright Acknowledgments

The author and publisher gratefully acknowledge permission for use of the following material:

Excerpts from *Doctor Faustus* by Thomas Mann, translated by H. T. Lowe-Porter (New York: Alfred
A. Knopf; London: Martin Secker & Warburg). Copyright © 1948 by Alfred A. Knopf Inc. Reprinted
by permission of Alfred A. Knopf and Martin Secker & Warburg.

Excerpts from *The Theory of the Avant-Garde* by Renatto Poggioli, translated by Gerald Fitzgerald.
Copyright © 1968 by the President and Fellows of Harvard College, translated from *Teoria dell'arte
d'avanguardia* (Societe editrice il Mulino, 1962). Reprinted by permission of Harvard University
Press.

For
Glenda Marie,
Robin,
Christopher,
Christopher,
and
Lisa Christine

CONTENTS

ILLUSTRATIONS

PLATES

FIGURES

ACKNOWLEDGMENTS

Some of the material in this book has previously appeared in slightly different versions and other contexts in the following scholarly journals as here designated:

The British Journal of Aesthetics: "Illustration and Art: Thematic Content and Aesthetic Standards," (Autumn 1971) Vol. 11, No. 4, pp. 354-86. "Estrangement as a Motif in Modern Painting," (Summer 1982) Vol. 22, No. 3, pp. 195-210.

The Journal of Aesthetics and Art Criticism: "On the 'Multiple Viewpoint' Theory of Early Modern Art," (Spring 1995) Vol. 53, No. 2, pp. 129-37. "Discussion: a Rejoinder to Nan Stalnaker," (Summer 1996) Vol. 54, No. 3, pp. 291-93.

The Journal of Aesthetic Education: "Compliant Rebellion: the Vanguard in American Art," (July-October 1976) Vol. 10, Nos. 3-4, pp. 225-36. "The Assault of the Petulant: Postmodernism and Other Fancies," (Spring 1984) Vol. 18, No. 1, pp. 93-107. "Art, Science, Modernity," (Fall 1985) Vol. 19, No. 3, pp. 89-99. "The American Grain, Crosscut," (Winter 1987) Vol. 21, No. 4, pp. 145-48.

Many thanks and much gratitude to my friend and former colleague, Howell K. Wilson, for help on matters mathematical as well as for saving me from mysterious computer disasters. I wish also to acknowledge the assistance of the following: Cultural Perspectives series directors Ralph A. Smith and Jane Garry; editorial staff members of Greenwood Publishing Group, Gillian von Nieda Beebe, Leanne Jisonna, and Dolores Abbott; and reference librarians at the University of Maine, Orono's Raymond H. Fogler Library.

INTRODUCTION

The web of truths is no less tangled than Sir Walter Scott's tissue of deceit. And, when we set out to separate the threads that lead from fact to event and event to result, we tend always to find our ways through the maze according to our own, prior inclinations. In the pages following this brief prelude I have been guided by four long held convictions: First, whatever significance can be found in the fine arts must first and foremost exist as the physical effect of a palpable structure upon the viewer. Secondly, from the beginning of the fifteenth century in Italy Western imagery has been dominated by a particular kind of formal structure that is so powerful as to permeate nearly any culture it touches and is typically misinterpreted as being primarily concerned with illusion. Third, the past century and a quarter has been characterized in the West by what amounts to an epidemic of loneliness that is partly revealed in a taste for fragmentation of artistic form and content. Fourth, an interlinked set of fallacious myths about "simultaneity" as a feature of modernity is as mystifying as it is ubiquitous but in some measure associated with humanists' generally infirm grasp of contemporary science and technology.

That a book in a series called "Cultural Perspectives" begins with a discussion of perspective drawing is largely coincidental. Yet the interpretation of Renaissance perspective as *a formal system of order* rather than a technique for producing illusions is highly relevant to the overall thrust of the series. For a central theme of this book is the decisive effect upon cultural history of an increasing fascination with the physical reality of fine arts objects as visible phenomena, and one of the most interesting and neglected features of this development is the tenacious hold that a taste for abstract formality has had on the imaginations of both artists and their critics from, say, 1400 to the present, even among those most strenuously opposed to formalism as an aesthetic theory.

Do not leap to the conclusion that I am here to deny the patent fact of representationalism or the significance of subject content. Nor am I about to argue that the aims of the Quattrocento were similar to those of avant-gardists at the beginning of this century. For one thing, the period of what is called modernism coincides with a profound sense of estrangement that lies sunken

beneath the iron veil of progress, infecting every thought we feel and chilling all our aspirations. Indeed, one of the few things shared by great masses of people in Europe and North America is alienation from other individuals. Not only the disaffected intelligentsia but also vast numbers of "ordinary" people have come to feel that participation in society is ultimately impossible and that transgression of traditional values is the only conceivable way of expressing individual will in the modern world. Thus, the solemnization of what used to be called "deviant behavior" as a form of higher insolence by icons of popular culture who celebrate drug use, male and female homosexuality, promiscuity, sado-masochism, racial segregation, theft, and even murder. This kind of thing, promulgated to the masses by way of concerts, recorded music, and video tapes, challenges the fiction of normalcy in ways no merely artistic gesture possibly could. The phenomenon itself is widely acknowledged and, in many quarters, looked upon as an alarming social pathology about which something ought to be done. Most likely, nothing can be.

Such movements in society attain their force from a contagion that is immune to interference. If any doubt this, let them consider how we are ruled by so seemingly slight a thing as fashion which holds millions of us in its spell. Obeyed with an unhesitating compliance to which law but vainly aspires, fashion subjects people to discomforts, dangers, and absurdities no government would dare impose—not even during time of war. Conformity to specific styles in dress and grooming may appear to result from clever promotion by special cliques of entrepreneurs, but the fact is that many episodes prove the futility of *any* group attempting to rescind a popular mode before its time is run. When it comes to regulating the length of hair and skirts, amounts of rouge, or drug preferences, the cosmetics, clothing, and liquor industries have had no greater success than the schools and armed services. In the community develop the underlying social attitudes which neither advertisers nor the law can ever supersede. The government cannot retract them, the huckster cannot for long defy or deeply invade them. And nearly everything that is true of fashion is likewise true of art. Its styles also reflect underlying social attitudes, in reflections that are sometimes advanced and sometimes are belated.

Almost always new influences in art first appear in works rather than in innovative commissions or literary injunctions to artists. But, in any case, influence (even if posthumous) originates in realms far larger than an artist's studio. For without a community of like-minded to receive it, a unique vision would remain forever a novel eccentricity. Yet, writers on art have been so overpowered by the deceiving myth of the lonely geniuses who walk down paths no predecessor has made for them that they continue to argue in support of the autonomous priority of artistic will. Periodically, however, challenges are raised to this entire line of thought—most recently by the so-called postmodernist Left. One of the few refreshingly positive things about their criticism is that it tends to reject the idea that isolation is creatively progressive and acknowledges the predominance of social forces in producing works of

genius. Thus postmodernists and their philosophical sidekicks, the deconstructionists, have embraced the psychoanalytic theories of Jacques Lacan, precisely because he supplanted Freud's biological interpretation of the self with a theory of unconscious social forces.

From Lacan's viewpoint alienation is not an affliction of the self that can be overcome through analysis or any other therapy; rather, it results from what he considered the initiating "mirror stage" of infantile development when a child of six months or so identifies the image of itself in a mirror as "another." "It is this moment that . . . turns the I into that apparatus for which every instinctual thrust constitutes a danger, even though it should correspond to a natural maturation—the very normalization of this maturation being henceforth dependent, in man, on a cultural mediation as exemplified, in the case of the sexual object, by the Oedipus complex."[1] I cannot forego remarking that this is one of the more lucid statements in the book—and made the moreso by virtue of my ellipsis. But despite Lacan's maddeningly obscure style and very questionable, perhaps ridiculous, notions about human development, he is important for having attempted to resolve an inherent conflict between Freud's rather mystical conception of psychical reality and the external world of social relations. His acknowledgement of universal isolation as a necessary condition of human existence was by no means revolutionary—for any number of poets had waxed poignant over that—but he provided the awareness with a philosophical structure. It is surely no accident that Lacan was early in his life associated with a group of modernists whose particular interest is individual isolation, the Surrealists. And, like him, they had at times attempted to connect Freudianism with the social theories of Karl Marx. After all, Marx's ideology is not unlike Freud's unconscious in emphasizing that we see the world from a false angle.[2]

Standing entirely apart from all of this contention are conservative humanists who complain that contemporary art, with its fragmentation, formalism, and angst, results from nothing more nor less than domination of artistic common sense by critical theory. Ironically, they have accused even postmodernism of creating a climate congenial to the spread of uncultivated weeds in the soil where, before, finer arts had blossomed. That's nonsense. For good or ill, the cultural environment is a whole, even when what seems most evident about it is the fracturing of images, forms, and social relationships in the art of the period stretching from French Realism to contemporary postmodernism. Breaking up visual wholes into fragments is coincident with the disruption of traditional class hierarchies and conventional social demeanor in society at large. Clearly, the emergence of a view of each person's mental life as being ultimately insulated from all others—being, as the American Thomas Wolfe put it, "forever prison-pent . . . forever a stranger and alone"[3]—is directly associated with the crumbling away of familial and communal structures that once provided an extended identity for all but the clinically alienated. Novels and memoirs by second and third generation Asian-Americans invariably reveal just what a powerful solvent to such old fashioned ties the relativism of the West can be.

Sociologically, the inevitable consequences of the breakdown of older forms of social organization are easy to see, at least in hindsight, but the significance for art of the shattering of conventional modes of order is hard to deal with. Recently, I saw two letters to the editor of a national newsmagazine concerning a piece published on the death of the Abstract Expressionist, Willem Dekooning. The first said the works of the school were "completely devoid of any real meaning, not to mention skill." The second complained that the writer had met "many artists whose work has its roots in the tradition of the old masters . . . and are producing art that is both personal and universal." She complains, of course, that the galleries will not accept their work because of a preference for "paint-splattered shower curtains or pieces so esoteric you can't even see them."[4] I can appreciate the feelings of the second person. As someone who has been a portrait painter, engraver, advertising illustrator, fashion artist, delineator, technical illustrator, and adventure cartoonist I'm in a position to attest that transmuting reality into something quite different called "art" is an incomparable delight. But the fact remains that, while there is a solid market for skillful traditional art, the preferences of the serious art buying public have been set in an entirely different direction by forces far more powerful than gallery owners' biases. As for the first commentator, her comment shows how blind to certain kinds of skills most people are. Dekooning is no favorite of my own, but anyone who has seriously experimented with undertaking work in the manner he chose is not likely to characterize such expression as meaningless or devoid of technical skill. As a professionally trained artist it has been my experience that conclusive judgments about technical skill usually show no feeling for the variety of modes that may comprise what is meant by skill. In my role as an academic in art history such thinking takes me aback with its retrograde provincialism. A contemporary worldview must be amenable to a far greater range of expression than what held sway a century or two ago.

The spontaneous, seemingly unstructured character of Abstract Expressionism embodies a sort of principle that, while never made explicit, has nonetheless been part of the evolution of art since at least the end of World War I and the emergence of Dada. The existence of this principle is inarguable but its results produce bafflement and just the kind of quarrelsomeness vented in the letters column of the newsmagazine. It is this: *Any unquestionably inept treatment which would utterly damn an academic painting (in any of its styles) in the eyes of any informed observer is capable of being practiced by someone in a manner so fastidiously coherent that it will resist imitation by either academics or amateurs.* Dekooning's brushstrokes, Chagall's drawing, Jackson Pollock's drips, David Salle's syncretic compositions, Jean-Michel Basquiat's scrawls, all fall into this category. When dealing with someone like Basquiat we might describe the principle as honoring the originality of incompetence were it not for the fact that his particular brutishness is not easy to imitate. In point of fact, Basquiat's whole lifestyle and death is actually concinnuous with the transgressive morbidities of postmodern rebellion. That the artistic style is so expressive of a

lifestyle the majority probably find repugnant is what makes it so difficult for them to tolerate. We've an instinctive understanding that sloppiness, even elegant sloppiness, suggests moral slovenliness. People recognized from the very outset that the japes of the Dadaists, the hallucinatory imagery of Surrealism, and the deformations of Expressionism are implicitly critical of middle class morality as well as commonplace sensibilities. But not all avant-gardisms provoke the same reaction from the public. The artistic progeny of Cézanne and the Cubists present another sort of problem.

Because of its emphasis on pure form and artistry for the sake of art Cubism, especially, seemed to require from its opponents highly intellectual challenges to its sheer appearance. When Theodore Roosevelt said he preferred his Navajo rug to the works of Duchamp and the other "Knights of the isosceles" his sarcasm caught the formal purposes and even the asymmetry of the style but missed the significance of a movement that was non-representational without being decorative. The importance of this early abstract art was hard for most people to see, and its champions were hard put to come up with explanations. When, finally, they came up with something winning—specifically the idea that Cubism revealed different aspects of objects by combining multiple views into unified compositions—they were misrepresenting the works of the greater artists with a rationale invented by second rate imitators. And, as if that were not misleading enough, the multiple viewpoint explanation of Cubism was extended to many other kinds of modern art, usually with disastrous results for understanding. Be that as it may, these misapplications of what critics usually call "simultaneity" have remained popular and much of Chapter 3 is devoted to discrediting them. As it happens the conception of Cubism that sponsored that speculation has also enticed quite a few artists and critics into connecting the movement with pseudo-science and occult fatuities. We should not, then, be surprised that contemporary artists and aestheticians have found it more difficult to deal with the actualities of a technological world than with the mythic past. It is striking how few airplanes occur in modern paintings while appearances of Icarus, winged Victories, and angels are ever with us. There's nothing in-explicable about this, but it is remarkable. Phenomenal, too, is the failure of the more gifted contemporary artists to incorporate into their creative work the amazing technology of the late twentieth century. Quite probably that is due to the dependency, even of visionaries, upon conventions inherited from the Renaissance and preserved as fundamental properties of modernism and postmodernism despite their non-representational disguises.

In the latter connection, it is worth remarking how little the formal character of modern art has changed over the last four decades. Virtually everything pronounced as "new" has really been just another change rung on older styles, sometimes as pastiche, sometimes in emulation. And what is true of the art is true, as well, of the criticism—which is most certainly not to imply that my own commentary is in any way a radical departure from what has been said before, even by me. I do, however, hope to direct certain attention to matters that are

frequently glossed over, view things from a perhaps perversely irreverent angle, and contend against the soft-mindedness of the artistic left and the corollary dementia of the philistine right.[5]

The foregoing matters and related features of the evolution of taste to the end of the millenium are the subjects the book treats. Given the breadth of the overview and the brevity of the volume it should occasion no surprise that many of the footnotes are discursive, perhaps even digressive, and references to artists, authors, and works frequent. To have included as many reproductions as we'd have liked would have made the book prohibitively expensive, so I have attempted to use works that are presumably well-known to the kind of reader likely to peruse this book. Generally, a reproduction occurs only when the point being made is too explicit for memory to serve most readers unaided. I should mention, too, that it is generally my practice to capitalize the names of movements, such as Impressionism, Cubism, Abstract-Expressionism, in order to distinguish them from general stylistic traits (impressionistic, cubistic, etc.); this sometimes leads to a inconsistency when an author quoted follows the more conservative convention of using the lower case for the same nouns.

1

Pure Visibility and the Emergence of Formalism

A work of art must carry within itself its complete significance and impose that upon the beholder even before he recognizes the subject matter. When I see the Giotto frescoes at Padua I do not trouble myself to recognize which scene of the life of Christ I have before me, but I immediately understand the sentiment which emerges from it, for it is in the lines, the composition, the colour. The title will only serve to confirm my impression.

Henri Matisse[1]

This briefly eloquent statement is, perhaps, the most comprehensive description of the precedence of form in the fine arts ever put to paper. In these few words Henri Matisse surpasses what Roger Fry accomplished in his own search for harmony of form and content among traditional works in the long essay, *Transformations*. [2] It is one of the small curiosities of art history that Matisse's defense of formalism should have appeared in an essay published in 1908 that was generally antagonistic to contemporary Cubism and is typically cited as evidence of the painter's alliance with expressionism. As I, myself, have written, Matisse's *Notes of a Painter* represents "a general tendency towards atavistic thought" reflected in André Gide's *Les Nourritures Terrestres*, the novels of D.H. Lawrence, and the philosophy of Henri Bergson.[3] Of course, emphasis on expression does not preclude the priority of formal organization; as Matisse implies, it is the essential vehicle of artistic content. And, in the instance cited, the relationship is verifiable.

Let us take, for our example, a work by Giotto from the Arena Chapel in Padua to which Matisse referred—not, in this case, from the life of Christ, but from the history of His mother's family. Completed about 1306, the murals depicting the lives of Mary and her parents are ranged along the upper reaches of the chapel wall. Plate 1 represents the father and mother of the Virgin embracing before Jerusalem's "Golden Gate." For anyone at all familiar with the story it will be true, as Matisse wrote, that the sentiment is embodied in the lines and

8

forms. Indeed, it is difficult to imagine a more convincing image of marital intimacy than this representation of the childless couple, Joachim and Anna. The image is all the more touching in view of what has gone before. For Joachim had been driven from the temple in Jerusalem as one who gave no increase to the people of God. Shamed, he had gone to dwell among his shepherds, but the angel Gabriel appeared to him, saying that the Lord does not punish nature but only sin, and that he is return to Jerusalem where his formerly barren wife will bear a daughter to be called Mary. "And this will be a sign to thee: when you shalt come to the Golden Gate of Jerusalem, Anna thy wife will meet thee there, who now grieves at thy tarrying, and will rejoice to see thee." Of course, this comes to pass and, indeed, the divine issue of Anna's womb is Mary, the virgin mother of Jesus.[4]

We observe the meeting in Giotto's painting. The couple embrace before the gate just as a quartet of young women emerge through the portal, passing before an older woman dressed in black. While youth is amused by this show of affection between a mature man and woman, age is embarrassed by intimacy made public. The former smirk, the elder looks askance from behind a cowl that shields her from unseemly behavior. The workman on the left is bemused. These reactions are, of course, customary in virtually every society; it is the young who are amorous, the mature prudent. That is ordinary, expected, mundane. Giotto, however, has posed against these commonplaces what amounts to a massif of marital devotion. The couple merge together in a curve enclosed that echoes the hollow of the adjacent archway and drives home the fullness of the commitment of wife and husband in contrast to the emptiness of material space and customary behavior. Joachim and Anna are one; not only are the folds of their robes virtually continuous, their haloes, too, are joined together in an ensign of spiritual oneness.

Granted, as a purely formal exercise Giotto's mural would not be capable of conveying to Matisse the sentiment of the story. One must know something of what to expect in order to understand what is being shown. This feature of artistic interpretation was given an exhaustive analysis by E. H. Gombrich in his classic, *Art and Illusion*, the entire point of which is the utter dependency of illusion upon conventions that are learned rather than instinctive.[5] While it is perfectly obvious that viewers unfamiliar with the story would miss the specifics of the theme we may nonetheless suppose that nearly anyone will understand the significance of the embrace as a symbol of tenderness and devotion. In that, however, we would be mistakened. For the formal effectiveness of this wonderful symbol depends upon knowing, first of all, that we are observing human beings in a setting. And, even if we comprehend what is being represented on so fundamental a level, we must also understand the meaning of an embrace, the significance of such conventions as the shielding oneself from what offends one's eyes, and the fact that a halo is a symbol of spiritual radiance and not some sort of visible headdress.

Of course, many who formed the audience for Giotto's frescoes in the Arena Chapel were in fact well equipped to appreciate the meaning of the image. See how the Sienese painter of the following century, Sassetta, adapted the embrace of robed figures against a hollow opening in his panel painting of *The Meeting of St. Anthony and St. Paul* (Plate 2).[6] It does not, of course, have the formal power of a Giotto. Rather, it is being reprised as a sign, indicating pious devotion. It is an effective device and has been remarked for its grandeur of feeling in a picture that is under nineteen inches tall.[7] Still, it is a grand effect entirely derivative of the greater artist. In fact, Sassetta's manner is intentionally archaic. His homage to the fourteenth-century master is a celebration of what had become archaic charm by 1440. What Giotto began laid at least the cornerstone in the foundation for a revolutionary conception of representation.

Let us, for a bit, return to the painting of Joachim and Anna before the Golden Gate. The architecture itself is rendered with a primitive simplicity that fits the circumstance but seems retrograde in contrast to the figures. Drawing buildings on a scale far smaller than that of human beings was a Trecento convention that did not trouble observers of the time; similarly, they accepted flat, diagramatic backdrops in somewhat the way you and I tolerate cinematic conventions such as background music and bird's eye views. Yet, the merely acceptable did not set a limit for Giotto. For he has introduced a gratuitous hint of empirical realism in the angularities of architectural elements such as moldings and stonework divisions that are not parallel to the picture plane. Note that the roof line farthest to the right is more steeply declined than the string course below and the water table is angled upwards; these variations are not consistent in the way optical perspective requires, but they are an anticipation of the unified space it furnishes pictures beginning only in the third decade of the coming century.

A more striking instance of Giotto's strides towards the future can be observed in his *Maesta* (Plate 3). This painting is frequently used to show the way Trecento vision gives way to the Quattrocento; it is full of innovations that are immediately obvious when one stands in the Uffizi gallery where it is set up in a magnificent grouping with two other Madonnas in majesty—one done by Duccio in 1285, the other by Cimabue around 1280.[8] I wish to stress one point only, namely *the point of view* the artist has provided for the viewer as his own. It is entirely different from what his teacher, Cimabue, affords us and it is hugely important in the history of artistic mimesis. It is, indeed, beyond what we might think of as "renaissance," in the sense of rebirth, since there is no known prototype for this degree of specificity in any imagery from classical antiquity.[9] Consider where you would have to be standing to see the Madonna and Christ child, the throne, and the adoring angels from this angle. In contrast with any previous treatment of the theme, this one is very much like something one might actually see, despite the retention of many medieval characteristics (such as larger scale for the more important personages). It is possible to verify that the observer is just slightly left of center and is approximately as tall as the

two angels standing toward the front on either side of Mary's throne. The tops of the throne arms are visible, which means our eyes must be elevated above them, and we can see the underside of the canopy, which leads to the conclusion that our eyes are below that. All in all, the details suggest a relative position lower than Jesus' head but higher than His feet. The lateral position is very certain because you can see a bit more of the left end of the trapezoidal step at the base of the throne than you can of the right. This subtle explicitness has an importance that is impossible to exaggerate. Without a sense of exactness of viewpoint, perspective rendering is impossible to conceive. And, without perspective, not just Western painting, but Western thought would be very different from what we know.

RENAISSANCE PERSPECTIVE AS VISIBLE ONTOLOGY

Few people, even those actively involved in the fine arts, really understand what a remarkable thing scientific perspective is or the kind of effect it had upon those first exposed to the mathematics behind its illusions. Fillippo Brunelleschi, its inventor or discoverer—depending upon your predisposition—surely divined the sense of the thing from empirical observation. For instance, if you pin threads to the corners of a square and lead them back toward your eye you can see (albeit with some difficulty in focusing) that the threads also appear to coincide with orthoganals of the square—that is, the edges converging to the distance. Indeed, Brunelleschi's disciple, Alberti, depends on precisely this relationship for the procedure he describes in *Della Pittura* (1436), the first record of perspective drawing. But central projection—a more accurate term for scientific perspective—is a form of projective geometry. In fact, even Alberti's system, to which he referred as "the best method," has the preordained character of a purely theoretical system. Also called a *velos* or "reticulated net," it entails drawing a rectangle with lines converging from equidistant points on the base to a "vanishing point" somewhere within—typically rather high, on center. The resultant triangle is intersected by horizontal lines called "transversals" that are progressively closer together as they approach the apex.

Figure 1 shows the result of the procedure just described, including the estalishment of a "point of distance" to space the transversals correctly. Obviously, this kind of array can be applied to any group of geometric solids with unfailing effect so long as they are seen from straight on. Two point perspective (Plate 4) is simply an extension of one-point. In my drawing there are actually more than two vanishing points but the principal elements are caught in two and no single object has required more than two to draw. Like Alberti's approach, however, this rendering grew not from observation but from a rigidly applied system. The illusion of the third dimension is evoked for those of us familiar with the conventions of European art, but that is not, in and of itself, what made perspective so impressive to the fifteenth century. To comprehend its impact,

you have to understand just how abstract the geometry of central projection really is.

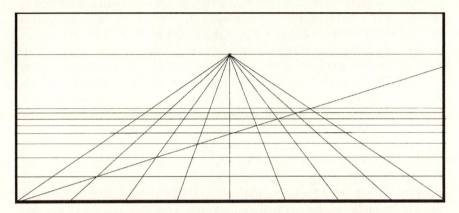

Figure 1: Alberti's "best method" for beginning a perspective drawing

Most often we encounter perspective delineations in the field of architectural drafting. Typically these are not drawings of existing structures but, like Plate 4, "artists' conceptions" of what a building will look like when and if it is actually constructed. Working from elevations and a plan, I produced, mechanically, by application of the techniques of projective geometry a drawing of a non-existent edifice. The procedure for doing this is tedious, but highly accurate and *entirely* mathematical. What struck perspective's first converts as being almost miraculous was its ability to generate from applied geometry the appearance of things when they were actually built. Even today many people regard it as nearly magical that a photograph of a building constructed according the plans and elevations that produced Plate 4 will match the drawing of the building line for line. Of course, the like illusions of central projection and camera imagery also depend *primarily* upon conventions learned rather than naive truths revealed, but more of that later. From the time of Masaccio (1401-c. 1428), in whose Brancaci Chapel murals perspective first appears in painting, painters and their audiences were powerfully affected by scientific perspective because it seemed to them the ultimate example of an abstract, theoretical system that revealed visual truth. Out of mathematical propositions, illusion is produced. Could anything be a better illustration of the Neo-Platonist doctrine of the decreasing mundanity of images? The order Divine that lies concealed from most of humanity beneath the muddle of prosaic reality is revealed to the geometer as a latticework of light rays that can be charted as straight lines. Moreover, the little universe of the eye, with its parallax cone of vision, is matched by a mental image of the world in which the analogue for the point of focus within the lens of the eye becomes the vanishing point at infinite distance. God's orderliness writ

small, writ large. This way of thinking about perspective is virtually an ontology of linear perspective! And so it was read.

When this representation of historic enthusiasm for perspective is offered up before fashionably sophisticated critics today their objection is the quite sensible one that pictures are not reality in any sense of the word and illlusionistic projections—even those of photography and motion pictures—are very different from our visual experience of the world. Only the naive believe that art can be "realistic."[10] After all, if it could be, birds really would pick at painted grapes and dogs would pay close attention to photographs of cats. Imagine a straightforward photograph of a landscape, and let us take for granted a certain resemblance between the picture and the locale it represents. Even so, looking at the picture is an entirely different visual experience from looking at the scene itself. First of all, within what is known as the "depth of field"—that is the range within the photograph that is clearly focused—everything is in focus, from the farthest left edge to the right and from top to bottom. You don't perceive a natural landscape this way. Rather, your eyes flick about, picking up a tiny fragment here, another there. In terms of the whole these bits and pieces are quite small. Just take note of how little of this page you can see with even some degree of clarity; the same thing is true of the room you are in or of the world seen through the window.

Now, obviously, someone is bound to argue that you cannot see more than a bit of the photograph at once either. True, but irrelevant. The camera "sees" the whole instantaneously. It is not like a single eye, let alone two eyes working in concert. On the other hand, the eye is capable of constantly varying focus; it is not limited by the range of a depth of field in the way even highly advanced mechanical lenses are. This is a feature of vision that seemed to stand in the way of emerging naturalism in art from the first. In early fifteenth-century Flanders Jan van Eyck tried to project the visible truth in wonderfully detailed oil paintings that show such things as a string refracted through amber beads of a rosary on a wall at least fifteen feet from the viewer. Every detail in his work is as meticulously rendered as if it were being observed with relentless patience from about three inches away. He must have supposed that variations in scale would balance out the uncanny sharpness of his minutely textured surfaces. They do not. The works have the charm of a magical realism that is not at all in accord with vision. Painters seeking to convey visible reality gradually moved towards a sort of generalized focus in which nothing is as sharply defined as everything is in van Eyck. Pieter Bruegel, the Elder working in Flanders during the sixteenth century makes things clear, but not as clear as van Eyck. John Constable shows us the landscape of nineteenth-century England as if filtered through a slightly coarse haze that gives substance while not obscuring essentials; his is the model for most realistic scenes to this day. What something like *The Haywain* (Plate 5) does is assimilate the multiple views of the world into a gestalt that resembles the world as we *think* we have seen it. Such representations are, in every sense, conceptions of vision rather than copies of it.

Surely, it is true beyond doubt that pictures on canvas, paper, or film never reproduce real vision but only give us constructions and convincing fictions of what we believe is natural. That said, it seems to me quite muddle-headed to assume the divorce between imagery and reality is absolute. And why? Because some kinds of imagery have an isomorphic relationship to what is first apprehended by the eye. Silhouettes, for example, are the most primitive replications of reality. That is, the outline of one's hand is no different, in its essential shape, than the shadow it casts when held up to the sun. Similarly, a photograph of the hand, taken from the same angle, reveals identical contours. Likewise, a conscientious tracing of the hand will preserve the same configuration, and a meticulously freehand drawing must result in something very like the hand itself. It is by no means surprising that the earliest drawings found in Pleistocene caves are tracings of human hands. This kind of realism is so basic that one does not have to learn any artistic conventions to recognize the imagery. In a related, though even more basic fashion, fundamental space cues like overlapping of distant things by nearer ones are not merely conventional, for even lower animals learn them in their infancy. That a given object will appear smaller as it is more distant is not quite the same sort of thing since dimunition depends upon concepts of constant size and spatial magnitudes. And, yet, it is obvious that the highly accurate depth perception of feline hunters must depend upon the optical effect of apparent scale, at least in some fashion. And if a tabby's instinct gauges the wee rodent's distance by its size cast on the retina, why should we scoff at the success of the effect in graphic art as being somehow delusive? The role of outlining, overlapping, and even scale relating to distance are evident even in Paleolithic drawings from Alta Mira, Lascaux, and particularly from the recent finds at Chauvet and Cosquer.[11]

Every student of art history knows that prehistoric peoples moved from what seems a virtually instinctive sort of naturalism towards something quite different—highly stylized representational forms of art that are nearly as dependent upon convention as are written languages. In point of fact, the imagery from Neolithic cultures and early civilizations is invariably more pictographic or ideogrammatic than mimetic. That is true not only of works from Mesopotamia, Egypt, Mycenea, and Crete, but even of Greek classical art where the desire to achieve ideal perfection of form leads to such things as a preference for highly inorganic treatments of the male physique. Figure 2 contrasts the Greek Classical torso with that of an extremely well-developed human being. The latter possesses the organic unity of an organic whole; the former has a Polyclitan harmony that is nothing short of architectonic.

The idealizations of classical antiquity are but tenuous reflections of the world itself. In the next century, though, after the establishment of the Alexandrian Empire and the emergence of a cosmopolitan Mediterranean culture, glamorous examples of illusion appear. The astonishing verisimilitude of Roman portrait sculpture (Plate 6) is the most striking exception to the ancients' characteristic

Figure 2: Comparison of a Greek classical
torso with that of a highly developed male athlete

preference for abstract formality over the merely authentic. Although this degree of realism probably found its origins in folk religion and veneration of ancestral death masks, by the end of the Republican era the culture of Rome was thoroughly secular. One of the truisms of history is that the more secular a people, the more worldly they are likely to be. Further, the more worldly they are, the more apt are they to celebrate the natural world with copies of its contents. Since the real religion of Rome was patriotism of mythic proportions, even the creation of a pantheon parallel to that of Olympus was an official political device more than a spiritual manifestation. In such a context not only portraiture, but also the iconography of genuinely mystical sects was infused with all sorts of mundane representationalism. Therefore, wall paintings, instead of being esoteric symbols, feature realistic treatments of the revels of the faithful (as in Pompeii's famous "Villa of the Mysteries"), or humanistic gods and goddesses in misty, "impressionistic" settings, or vignetted against a void. Some of what we respond to today as straightforward landscapes and still lifes may in fact have been some fertility cult's celebrations of idyllic nature. A Roman citizen during the Republic might have been a worshipper of Cybelle, Mithras, Dionysus, Osiris, or some other salvation figure, but his eyes and art were focused on the world. It should not, therefore, occasion surprise to find hundreds of stone effigies of ancient Romans that are like the general, Lucius Cornelias Sulla, in their impression of absolute fidelity. One knows the leader must have looked just this way. His sculptor seems not to have flattered the man, but to have given us a completely accurate rendition of his physiognomy, necessarily exaggerating the defining crevices to compensate for the difference between dead marble and living flesh. Nowhere else in the ancient world do we encounter such marked versimilitude as in Rome; such relentless imitation of surface appearances is unique. It was, however, an isolated deviation that could not

survive the decline of pagan Rome even through the reign of the first Christian emperor, Constantine I, between 324 and 337. Almost at once the situation was completely reversed, and what had been an art of the literal was transformed into an inventory of ideographic symbols.

Any society whose first concern is with sanctification of authority through compliance with the decrees of a deity will turn away from wordly things and devise special symbolism to commemorate and communicate with the *super-*natural. And representations of the spirits and their intercourse with humanity will surely be unnatural-looking; after all, what lies beyond nature and controls her destiny cannot be equivalent to her. Sometimes the material world is thought of as itself profane. Then, all efforts to mimic divine creations are self-evidently delusional, idolatrous, and sullied by *hubris*. Gregory I averred that whatever could be said of God was unworthy, simply because it was capable of being said. For Thomas à Kempis the source of sin was physical existence itself. Given such a worldview, it was foreordained that when Christianity became the dominant belief system of antiquity, realism would descend into oblivion's abyss. It would not reappear for a millenium. Eventually, the Church's sanctified modes of representation became ritualistic, taking on a host of associations that gave the conventions sonorous, even mystic qualities. Like other forms associated with divine ordinance, the very existence of the mannerisms came to bestow a kind of benediction upon the faithful. Thus, when late medieval artists, like Cimabue or Duccio, began to depart from conventional means of representing the saints and the Madonna, their revisions tended to appear in marginalia and on the backs rather than fronts of altarpieces. Moreover, when the art work finally took on an illusion of physicality as substantial as it is in the frescoes of Masaccio, it was within a highly formal matrix that has a special religious and psychological meaning not altogether removed from the pieties of the Middle Ages

Perspective's geometry was, for the Renaissance, not only a simulacrum of the divine substructure of existence, it had as well special properties that intensified the believer's relationship to the biblical past. For example, the position of the vanishing point in many paintings directs attention to the face of Jesus, but it also brings the observer into direct association with the privileged viewpoint of the artist who is, in turn, the ideal witness of the sacred event he has portrayed. The role of the individual is immeasurably enhanced by the requirements of the system. Convention, here, has the somewhat paradoxical duality of liberating the spirit of the individual through extremely confining restraints that simultaneously bind naive mimesis in formal refinements that are anything but natural. The relationships are complex. They seem also to be virtually irresistible.

The conventions of Euro-realism have tended to overwhelm indigenous vision wherever they have been introduced. The way in which age-old traditions of drawing have been usurped in Communist China's propaganda posters by the techniques of illustrators like N. C. Wyeth, Howard Pyle, and Maxfield Parrish

is startling. Japanese, Indian, and African societies show the same effects. And it's no good accounting for the change as many have, by saying it is all the result of photography's convenience. Photography, after all, is only a mechanical application of the optics of central projection married to the chemistry of the nineteenth century. Besides, the illustrators mentioned above didn't work in photorealistic styles; every one of them was a romantic who had mastered a standard set of academic procedures. There is something peculiarly compelling about the Western view of the physical world. Certainly, explanations of this appeal lie ready to hand. The fact that this kind of vision arose coincident with the rise of capitalism and a middle class, materialistic conception of human destiny may signify that it is identified with social norms of the kind; when Asian or African societies accommodate themselves to technological, consumption-oriented economies, the European way of seeing things may be the obvious alternative to traditional, conventionally prescriptive techniques of representation. It is clear that the influence of Western values in many things is epidemic over the world, even in places where secular freedom and civil liberty is considered nothing short of satanic doctrine. And what is artistic currency, even in those despotisms, arose during the Quattrocento.

CLASSICISM, FORMALISM, AND THE RISE OF "PURE VISIBILITY"

Inevitably, images as dynamic as those of Italian Renaissance paintings inspired a good deal of speculation among thinkers whose central concerns are distinguishing between truths and illusions. But one of the striking things about philosophic speculation on the matter is the ease with which the realistic aspects of rendering were tolerated nearly without mention while the role of subject matter and spatial formalities were given primary and secondary emphases in an interpretation which came to be the "classical" mode. In part, if not the main, this was surely traceable to the enormous prestige of Platonism—a system of thought that had been a major influence in early Christianity and had survived in an active, albeit adulterated form as Neo-Platonic theology throughout the Romanesque and Gothic periods. Since Plato conceives of the concrete universe as a sort of animated picture that is the physical and temporal embodiment of eternal, changeless truths or ideas, it follows that everything we experience directly is as shadows are to objects and, in a sense, the entire natural world is an illusion. But a corollary of this view is that all efforts to render convincing depictions of natural appearances are a hopeless perpetuation of falsehoods. Even were the world "real," a trompe l'oeil rendition of it would be a dangerous lie for it would delude the viewer into mistaking false relations for real ones. Plato's stated dislike of naturalistic painting was reflected in a hierarchy of images in which a drawn diagram of a triangle is an image of the mental figure that describes the ideal, the physical construction of a triangular bridge truss a lesser image, and a drawing of the bridge the most inferior image of all. In *The Republic*, for instance, Plato has Socrates use the example of a bed to instruct

Glaucon: first, there is the essence of the bed—which is made by God—then, the physical bed made by a carpenter and, finally, a portrayal of the bed by a painter. Using his well-known technique of leading queries, Socrates causes his pupil to agree that the painter is an imitator who is "thrice removed from the truth."

Because the Greeks seem to have been incapable of considering art from any angle other than mimesis their philosophical speculations on it were severely limited. Plato found beauty not in imitation but in geometry; Aristotle confirmed the mathematical basis of the beautiful but conceded to artistic skill the capacity to make ugliness in art acceptable. Just how skillful the painters Aristotle knew actually were is something we know little about. Not a single work has survived and literary descriptions of pictures are notoriously unreliable. Certain kinds of pottery decoration—notably on Attic White *lekythos*— shows mastery of foreshortening and anatomy, but most of our confidence in Greek art rests on sculptural evidence, and there is no persuasive evidence that the Greeks understood the mathematics of central projection. That the Renaissance knew not only perspective but also Platonic metaphysics led to a conception of artistic truth melding geometric spatial illusions to idealized, unnatural depictions of the natural world. In a twist of meanings that would almost certainly have distressed Plato, this manner assumed the identity of the philosopher's ideality.

Of course, associating a certain sort of drawing style with the greater Truth or Ideal was not a direct result of rationalizing Renaissance artistry with philosophical texts from ancient Greece; rather, it was a matter of accounting for the remarkable appearance of the new art with ideas lying ready to hand. The works of a Masaccio or Raphael could by no stretch of the imagination be considered naturalistic; they are far too stylized and formal for that. Yet, the environments Renaissance gods and saints inhabit have in common an uncanny kind of naturalness. That is, although altogether unlike any human beings we have encountered, they've an easy grace that seems innocent of artifice. The *putti*, for example, are infants with none of the uncoordinated impulsiveness of real children. Like the trees in the forests and the clouds in these skies the masters' tots are incredibly suave, adorned in nothing more than softly golden light. This is the classical ideal summoned forth by a combination of mathematics, humanist literary content, and the desire to simplify and improve upon a natural world full of syncretisms and chaotic proliferation of diverse forms.

During the early Renaissance, Alberti quoted Cicero to the effect that nothing newborn is ever perfect so it is the duty of the artist to select only the most beautiful parts from nature in order to avoid the imperfections that always occur in natural things.[12] This, clearly, was already implicit in Platonic and Neo-Platonic doctrines, and it should not surprise us to find Leonardo da Vinci enthralled by the mathematical orchestration of empirical experience. As Jan Bialostocki said, "Now nature is meant not so much as the reality of visual experience and not so much as a divine or irrational power holding sway over human life; now it is meant first of all as a cosmic system . . ."[13] Bialostocki

also cites Lodovico Dolce from his *Dialogo della pittura* of 1557: "If then the artist, correcting [nature's] imperfections would 'surpass nature,' would render her fairer than she is, he must be guided by a study of the faultless antique. For the antique is already that ideal nature for which the painter strives and 'the ancient statues contain all the perfection of art.'" In effect, then, nature imitates art—at least to the extent that art of a classical kind embodies the ideal principles of a perfect nature.

Variations of the doctrine that artists (guided by reason and the laws of mathematics while under the sway of classical ideas of perfection) produce images that are nearer the ideal than are physical objects themselves held a firm grip on the critical imagination of the West. Mannerist art theory, in some of its more mystical undulations, conceived of the artist's concepts of nature as divine, inspirited directly from the deity. During the Baroque period the supreme example of art work based squarely upon the doctrine that classical antiquity is the model for surpassing nature can be found in the paintings of Nicolas Poussin during the seventeenth century. This model hangs on—particularly in the official academies and art institutes—well into the twentieth century. Indeed, it could be argued that some forms of conceptual art constitute a sort of resurrection of the same presumption.[14]

Absolute confidence in classical prescriptions begins to crumble during the end of the eighteenth century. That might at first seem odd. After all, the Classicists and Neo-Classicists were firmly in control of the principal institutions of professional art instruction throughout Europe and, although hindsight tells us these worthies were soon to become victims of social change and accompanying vicissitudes of taste, they took it as given that the ideals of the past would prove irresistible to fashion. They were wrong; classical theory could not endure while Europe was convulsed by changes that would undermine all absolutisms. Like aristocratic power and medieval privilege, classicism was doomed. As it happened, however, the most thorough exposition of the prevailing aesthetic occurred among a select *cénacle* when the aesthetic itself was waning. As the power of capital gradually eroded the foundations of traditional social structures, corroding the sanctity of hallowed custom, we find what is arguably the most comprehensive defense of classical theory in Sir Joshua Reynolds' fifteen *Discourses*, delivered during the final decades of the eighteenth century. The determination of people like Reynolds and, later, Matthew Arnold in Britain and Delécluze in France, to defend aristocratic punctiliousness against what they correctly perceived as the linked tyrannies of bourgeois liberalism and popular taste was futile. Yet, though doomed, it nonetheless produced penetrating commentary on not only the shallowness of philistine pragmatism but also on the pomposity of classical pretensions.[15] Their defense of traditional practice was, besides being an unwitting party to its demise, also adjunct to more powerful intellectual forces in the realm of philosophic speculation.

Platonism and its idealist progeny were inherently supportive of the status quo, in politics as well as aesthetics. Even the comparatively dynamic idealism

of Georg W. F. Hegel, where nature was cast in the role of an Absolute Idea whose ultimate goal is human consciousness, conceived of the State as the larger, more perfect expression of the individual. In Hegel's philosophy, human beings enjoy freedom only when they submit their private wills to the laws of the state which maintain the various social orders of society and govern civilized existence. Hegel, too, felt nature was inferior to classical art than which "nothing more beautiful could be." True, Christian art had for him an emotional appeal the classical did not, even though it comprises the grotesque and unpleasant at the expense of sensible perfection. You will note, however, that what is ideally aesthetic remains the antique. Interestingly enough, the underpinning of Hegel's idealistic conception of nature had already been severely weakened by another German philosopher, Immanuel Kant.

Kant, unlike his younger colleague or ancient predecessors, was able to conceive of beauty that was not derived from a beautiful model, whether physical or purely abstract. In his *Kritik der Urtheilskraft* of 1790 he contrives to distinguish between "dependent" and "free" kinds of beauty. Dependent beauty is beauty evoked in association with the extrinsic character of a thing, thus making it possible to establish an ideal of perfection. He specifies such objects as a woman, a horse, a building. Free beauty has, for us, an attractiveness independent of other things, for instance, ornamental frets, spirals, rosettes, and the like. This is somewhat more radical a departure from the past than it may at first seem, because Idealist philosophy, from Plato to Hegel, had reckoned that all beauty is dependent and interpreted artistic form as a sort of packaging that conveyed the ideal—as thrice removed in the case of Plato, as its refined concretion in post-Renaissance thought. Kant himself did not deal with the issue directly so much as he systematically justified the subjectivity of judgment. He "rejected all rules in art; fused the concept of beauty with that of art; distinguished art and science, art and nature, sense and imagination; and accentuated the spontaneous and original character of genius productive of art."[16] This permitted him to emphasize that the arts belong to a tradition that must be followed but not imitated.

Drawing from Kant's body of work, particularly the enormously influential *Kritik der reinen Vernunft* (*Critique of Pure Reason*), Johann Friedrich Herbart took the first step towards the establishment of what are called theories of "pure visibility" in art criticism. As every undergraduate student of philosophy will know, one of Kant's most influential distinctions was the one between *phenomena* and *noumena*, the former being sensations prompted by things external to the perceptor, the latter being the things-in-themselves that provoke the sensations. A thing-in-itself (*Das Ding an Sich*) can be apprehended by us only through the senses; the true, nonsensational nature of an object lies beyond human experience. This is a major epistemological insight, but it is only an element in Kant's attempt to demonstrate the existence of a priori *synthetic* judgments—that is, to show that an a priori statement is not necessarily tautological (that is, *analytic*) but can, like a posteriori statements, have an empirical reference. This contention need not detain us further, except to note that Kant's

identification of the laws of reality with human thought opened up a universe of transcendent possibilities for imaginative successors like Hegel and August Comte, the one an absolutist the other an empiricist.

Herbart realized that, if the thing-in-itself is unknowable, knowledge is reduced to form "and all beauty to form free from sentiment. He thus established an abstract formalism that is in opposition to the doctrine of content in idealistic aesthetics."[17] To clarify these dependencies we may refer back to the dialogue between Socrates and Glaucon in Plato's *Republic*. From Herbart's perspective the carpenter's bed is, as a physical object, as far removed from direct apprehension as would be God's ideal original. The painter's recording of the phenomenal effect of the bed upon vision is, then, merely an exercise in manipulating formal elements of art. In principle, there is really nothing else, no removal from the real by stages, no elevated truth to be found in classic columns as opposed to rustic fenceposts. This is not to say that Herbart and his followers deny the value of classical models. Like most other intellectuals of their day, they are enamored of Wincklemann's reinterpretation of the past in light of the excavations of Pompeii and Herculaneum. With his *Geschichte der Kunst des Alterhums* (*History of Ancient Art Among the Greeks*) of 1764 Johanne Wincklemann made the art of Greece the unchallenged model of nobility, tranquility, and grandeur in the fine arts for the century to come. Even Konrad Fiedler, the first to consciously devise a theory of pure visibility, relied upon Greek and Italian Renaissance art for his measure of fineness in art.

Fiedler's theories about art are influenced by two of the major synchronisms of the nineteenth-century thought. The first, and most obvious in the present context, is formalism, that is, the attempt to reduce various spheres of thought to primarily formal relationships. Preoccupation with form over content is characteristic of a vast number of tendencies in philosophy, the physical sciences, and the arts between the end of the Franco-Prussian War and the start of World War I. The emergence of logical positivism in philosophy, of logicism, formalism, and intuitionism in foundations of mathematics, of the non-Euclidean geometries in pure mathematics and physics (in connection with Relativity Theory), are coeval with the appearance of highly formalistic emphases in painting (Cézanne, Seurat, Picasso, for example.), music (Schönberg, Bartok), and art criticism (Fry, Richards).[18]

The other synchronism pertinent to the emergence of a theory of pure visibility is preoccupation with the subjective character of human thought. Surprisingly, perhaps, the most obvious influence in the arts shows itself less in such phenomena as expressionist painting than in the rise of naturalism in literature. The avant-garde on the continent and in the British Isles had progressively discarded the formal prescriptions of traditional poetry and fiction, aiming instead at more personal, introspective measures of reality. One discerns this readily enough in Symbolist writing, but it is also a characteristic of the tradition threading through Balzac and Flaubert to Virginia Woolf and James Joyce. In his celebrated analysis of portrayals of reality in literature, *Mi-*

mesis (1946) Erich Auerbach emphasized that objective descriptions of the world are never as convincing to the reader as the partial, purely subjective image of the world given by some first-person observer like the speaker, Encolpius, in Petronius's *Satyricon* (First cent. A.D.) The mimetic ideal pursued by the French Realists and Naturalists led, by insensible gradations to the "streams of consciousness" we associate with Woolf and Joyce, among others. Long before, Russia's Turgenev, Chekhov, and Dostoevsky had plunged into the baffling complexities of the human soul that Sigmund Freud and philosopher Henri Bergson were concerned with at the century's turn. Dostoevsky's works had appeared in English during the 1880s, but English novelists were unready to make use of his revelations. Then, after 1912, translations by Constance Garnett, coming upon the heels of Bergson and Freud, found the British ready and willing to absorb the aberrant realism of something like *Notes from the Underground* (1864). It is not far from the internal narrative of Dostoevsky's alienated grumbler to the "streams of consciousness" in *Ulysses* (1922) or *The Waves* (1931). We need not presume a direct influence here; rather, interest in the unconscious becomes almost pandemic among European intellectuals at the end of the nineteenth century and continues unabated into the twentieth. The enthusiasm for reproducing the whole, complex texture of human sentiment that led James Joyce to write something as generally incomprehensible and superficially "unrealistic" as *Finnegan's Wake* (1939), was anticipated in the fine arts where the rather simple-minded Realism of Gustave Courbet gave rise to a search for exquisite sensations culminating in Claude Monet's paintings of water lilies. Monet and other Impressionists reveal to us the subjectivity of the glance, of their private *visions* of nature. That provided a foothold for painters like Vincent van Gogh, Edvard Munch, and James Ensor to disclose their subjective *feelings* about the world. In a very real way, the deformations of the mundane in later Expressionism and the hallucinatory imagery from the Surrealists is in direct line with the mimetic tradition in art. It would be surprising indeed if this irresistible trend in the arts had not also made itself felt in theories of art history and criticism.

One very obvious and important example of such influence is Giovani Morelli's rationalization of the techniques of connoisseurship. A physician with a profound interest in Renaissance painting, Morelli held that identification of the author of a given work depends upon "small idiosyncracies which seem inessential, subordinate features which look so irrelevant that they would not engage the attention of any imitator, restorer, or forger: the shape of a finger-nail or the lobe of an ear."[19] In other words, the unconscious tendencies of the painter become of overriding importance to those making attributions. As it turned out, this was a highly successful procedure and the reattributions achieved by Morelli and his principal follower, Bernard Berenson, were spectacular. The method, albeit updated with new knowledge and technology, is now a standard part of the curriculum in the fields of art history and museology.

The work of Konrad Fiedler is allied with the formalizing of intuition we observe in Morelli. In his articles (collected as *Schriften über Kunst* in 1896 under the editorship of Marbach) Fiedler combined a theory of pure form with a psychological concept advanced by Robert Vischer in 1873. *Einfühlung* (empathy) as an artistic element had been discussed by the theologian Johann Gottfried Herder, but its reference to form in the fine arts first comes from Vischer for whom it was clear, says Venturi, "that the content of a work of art is not its material theme but the artist himself and his spiritual life."[20] The emotions, according to this interpretation, are conveyed through symbolic treatments of shapes and colors. For example, vertical lines cause the spirit to soar, horizontal ones to calm and expand it, and broken, sinuous, or jagged lines are more emotionally charged than straight ones. Taking this idea as fundamental, Fiedler (and a colleague, Adolph von Hildebrandt) developed a "science of art" based on purely visual formal laws which purported to analyze the elements of art as symbols of artist's feelings and intentions, excluding sentiment from any role in judgment and reducing the study of art to knowledge of what is visible as pure form. Hence arose the late nineteenth-century and early twentieth-century propensity for approaching art and its emotional contents in purely formal terms—much as we have observed Henri Matisse do with respect to the Giotto frescoes at Padua.

Surely, it is obvious that the list of philosophers, psychologists, artists and art historians I have given cursory mention here do not constitute the whole of the story. The sweep of influence in the direction of a theory of pure visibility has many more components. For instance, the great English critic, John Ruskin, was the first important voice to distinguish the basis of beauty in art from that of beauty in nature. In his *Lectures on Art* (1870) he rejected the ancient Greek model of selection of beautiful elements from nature, finding this classical belief merely insolent in the face of nature's universal and unexceptional worth. Rather, he says, in words that would delight a Picasso or Matisse, the artist must choose from among the elements of art. And Lionello Venturi comments at length on an obscure predecessor of Ruskin in William Henry Wakenroder, author at age twenty-four of a brief essay, *Herzensergiessungen eines kunstliebeden Klosterbruder*s (1797), and dead at twenty-five.[21] This paper begins from the then highly radical assumption that each artist has a unique vision and uses the elements of his craft to make it concrete. A poetical commentator whose "effusions from the heart" can be exasperatingly pious, this sickly young friar also stressed the visible contents of the fine arts as a way to assess the characteristic individuality of artists. It seems as though the rise of theories of pure visibility, with their emphasis on purely formal attributes, was fated. That the Vienna school of thought in art historiography adhered to Fiedler's conception of art from the time of Franz Wickhoff, who held the chair of art history at the University of Vienna during the late nineteenth and early twentieth century, seems to confirm its foreordained eminence. Alois Riegl, a follower of Fiedler, carried on his formal tradition, applying it as a history of problems faced by

artists. His is a major battle against prejudicial judgments founded in the ancient, invidious distinction between the fine arts and so-called minor arts and the cultural elitism that assigns some cultures (such as Greek or Renaissance) an inherently superior place in a hierarchy which, in Riegl's time, relegated Imperial Roman and Baroque art to second or third rate status. Possibly the best and most easily grasped example of pure visibility is a systemic history of style devised by Heinrich Wölfflin.

Wölfflin's theory is fully developed in three major works: *Renaissance und Barock* (1888), *Die klassische Kunst* (1899), and *Kunstgeschichtliche Grundebegriffe* (1915). (The latter book is available in English as *Principles of Art History*[22] and is probably the clearest, and certainly the best known expression of his thought.) In a brilliant analysis of the art of the sixteenth and seventeenth centuries Wölfflin contends that art during this period tended to move from one set of characteristics to another, specifically from: (1) the linear to the painterly, (2) the parallel surface form to the diagonal depth form, (3) closed to open compositional form, (4) multiplicity to unity, and (5) the clear to the unclear. In a purely formal way, he attempted to map out a sort of topography of historical developments. He was not arguing that all artists in every nation modified their styles in a synchronic way, nor did he intend his designation by centuries to be taken literally; his favorite example of sixteenth-century art is Leonardo's *Last Supper*, painted before 1500, and he often uses Tintoretto as an example of seventeenth-century form, even though Tintoretto died in 1594. Probably, it would be better to use the terms *High Renaissance* and *Baroque* in place of sixteenth and seventeenth centuries. Whatever the case, we are dealing here with broad generalities. Moreover, they are generalities subject to dispute of the sort that would cause a scientific theory to be discarded straight away. Yet, given the inexact nature of humanist scholarship, these are postulates with a good deal of substance, and they show how a theory of pure visibility can reveal commonalities by overcoming the more obvious individual differences among artists of the same period.

To clarify the meaning of Wölfflin's polarities, let us contrast a print of 1504 by Albrecht Dürer with one done by Rembrandt van Rijn in 1638. In each case, the subject is the same, Adam and Eve in the presence of the serpent as they contemplate the forbidden fruit. Since Wölfflin's system is meant to apply to all fine art, including architecture, it is useful to use intaglio prints to indicate, for example, the way he applies the idea of "painterliness" to something apart from painting. By "linear" he means that outlines are relatively clear and stress has been laid upon the limits of things. By "painterly" he means depreciating the emphasis on outline and emphasizing the larger zones of dark and light. Thus, in Dürer's engraving (Plate 7) the limits of things are very clear whereas, in the Rembrandt etching (Plate 8), which is made up of drawn lines, the effect is quite different. There are places in the Rembrandt where the edges of things are not indicated at all; notice the lighted side of Eve's right leg or the way shade merges with shadow under the serpent's foot. What strikes one in looking at the

etching is not the outline of forms but the dark/light masses in the work. Parallel surface form need not be as severe as it is the Dürer to satisfy Wölfflin's requirements, but this kind of thing is its model. Everything has been arranged in levels parallel to the picture plane. In Rembrandt things are much looser and the spatial container is correspondingly more three-dimensional than the limited, shallow setting in the Dürer. With respect to the rather more difficult notion of "closed and open compositional form" you will remark the very symmetrical, fixed, and deliberated look of the sixteenth-century engraving as opposed to the more open, casual quality of the etching from the seventeenth century. In a related way, the Dürer is constituted of a collection of disinctly separate forms; we can separate out the male figure or the female and comprehend them as individual items quite easily. Indeed, the figures themselves are made up of separable muscle groups. This is what Wölfflin meant by "multiplicity." The Rembrandt is, in his terms, more "unified" because everything flows together and each part has, therefore, greater dependency upon other parts so that the etching as a whole is a unit in a way the engraving is not. Clarity as opposed to its absence is, like the other polarities, closely associated with the difference between linearity and painterliness, but is a kind of "catch all" category to tie up loose ends in the theory, and the effect is intuitively obvious, surely—at least in the examples given.

Wölfflin's favorite example of absolute clarity is Leonardo's *Last Supper* (1498) in which the human beings have been reduced to geometric forms, in which the perspective scheme focuses on Christ's face, in which all twenty six of the diners' hands are shown. It is a perfect example, not least because when the theorist was writing the Leonardo was a mere ghost of the original work and was always full of the artist's smoky *sfumatto* which still today, after restoration, obscures outlines. In other words, the conception of clarity is so dominating that it overcomes haziness. This sounds far-fetched, perhaps, but when Leonardo's *Last Supper* is contrasted with the one by Tintoretto in San Giorgio Maggiore, Venice, completed in 1594 the difference is striking. Tintoretto's drama takes place in a dark, smoke filled inn and is viewed from a remote angle of the room, far over on the right. Nothing is clear and the overall effect is fantastical and powerfully moving. Clarity is not an objective; thrilling inspiration is.

If you look at a random group of masterworks done in Europe during the sixteenth and seventeenth centuries, it is easy to believe that Wöfflin's principles are well-founded. Just contrast Piero della Francesca with Rubens, Raphael with Poussin, Giorgione with Steen, Holbein with Vermeer and it will become obvious that *most* Renaissance painting is distinguished from *most* Baroque painting in the ways the theory stipulates. Of course, it is obvious that individual works may have attributes of both stages of development since, inevitably, some artists are caught between the first and second style of vision. Therefore, Wölfflin assigns the work of Pieter Bruegel the Elder to a transitional phase of development, writing that "he is not yet Vermeer, but paved the way for Ver-

meer."[23] Such adjustments do not mean the theory is sound, only that it has the plausibility of a "rule of thumb." Wölfflin, himself, initially supposed it applied to most historical epochs. Later, he admitted that modern art was not accessible to it and also realized that various factors might influence artistic developments so markedly that they would not correspond to the theory. He was, however, unable to modify the system to take account of such variables.

In 1938 Paul Frankl published an immense work, *Das System der Kunstwissenschaft*, which attempted to retain what seemed valid in Wölfflin's theory while overcoming its difficulties. Frankl's theory depends on the assumption that art, at its extremes, represents things as either in a state of Being—having a firmly fixed existence (Raphael)—or in a state of Becoming (Rembrandt). Within each of the two categories are subordinate phases: preclassic, classic, and postclassic. The preclassic and postclassic have within themselves alternative directions which enable him to take into account such things as Mannerism or Neo-Classicism that do not find a comfortable position in Wölfflin. Meyer Schapiro said of Frankl's scheme that it was "not designed to describe the actual historical development—a very irregular affair—but to provide a model or ideal plan of the inherent or normal tendencies of development, based on the nature of forms." At the same time Schapiro noted that such historiographic theories as those of Frankl and his predecessors have had relatively little influence on actual scholarship since "the principles by which are explained the broad similarities in development are of a different order from those by which the singular facts are explained."[24] Given that every specialist knows a thousand facts the ingenious, all-encompassing scheme fails to take into account, it should occasion no surprise that most art historians hold developmental theories up to ridicule. That is true, also, of an approach which sees the whole matter from a slightly different angle.

Formalism, whether as the historiography of pure visibility or an aesthetic of art criticism, conceives of subject-matter as a pretext for form. Some devotees of pure visibility never left the sphere of purely formal relationships; for most, however, form meant expression of artistic feeling by individuals who share features of their culture with others. Max Dvořák, Wickhoff's successor in the chair of art history at the University of Vienna, accented the social implications of form, merging the history of art with that of the culture as an expression of the spirit (*Geistesgeschichte*). To put it most directly, Dvořák conceived of the history of art as a history of ideas. From this grew a branch of study often thought of as the antithesis of formalism, that is, the sociological approach to art pursued by such scholars as Frederick Antal, Wylie Sypher, Gustav Hocke, Joseph Paul Hodin, and Pierre Francastel. Arnold Hauser, a neo-Marxist who had studied with Dvořák, published in 1951 a two-volume *Social History of Art* that is really quite amazing in its scope and erudition, despite having the flaw from which surveys of world history are never immune: there is a direct correlation between a reader's skepticism and his or her knowledge of the period being discussed. Despite the many cavils that can be raised against Hauser's project, it

remains a provocative and sometimes impressive synopsis of art and literature from pre-history to the early twentieth century. Still, it is an achievement more or less unheralded in professional circles. That sociology of art was cultivated in eastern Europe during the time of Soviet hegemony probably made any social history of art more unpopular among professional art historians than were doctrines of pure visibility. In recent decades, however, the rise of still another school of thought, *semiology*, has moderated such feelings, at least in academic circles.

SEMIOLOGY, STRUCTURALISM, AND THE DECONSTRUCTION OF THE ARTS

Semiology is the study of communication in every mode that involves signs or symbols. First devised by Ferdinand de Saussure in an analysis of language as a system of relations among signifiers, his principles are among those underlying the contemporary field called *structural linguistics*. His posthumous *Cours de linguistique générale* (1916)[25] described any language as being made up of entities called signs, each in turn constituted of (1) the *signified* (for example, concept) and (2) the *signifier* (for example, word). My example is oversimple and Sassurean thought complicated (though not very complex), but one thing should be apparent in connection with what has been presented herein thus far: once pure visibility had reduced the fine arts to form—even form expressing content and feeling—a painting could be examined as a system of signs. Further, it is also evident that society itself is subject to just such analyses since *every* convention in a culture is expressive of its context in precisely the same way a sign would be in the language. Gestures, too, are signs. And so are tastes.

The development of the idea that *everything* in a civilization is, in one form or another, a kind of language is not restricted to linguists. Ernst Cassirer, a Neo-Kantian philosopher with deep interests in the history of modern science, felt that symbolic representation is the principal function of the human mind; science, myth, religion, art, history, language all are nothing more. Society is, itself a symbolic representation. In a parallel connection, the French sociologist Émile Durkheim, to whom the intelligentsia owes such catch-words as *anomie* and "collective consciousness," believed in basic epistemological "molds" that give human beings their ability to conceive the totality of experience. Most prominent are: me/other, life/death, culture/nature. A semiological version of anthropology called *structuralism* amounts to a contemporary embodiment of this idea.

Claude Lévi-Strauss's first major statement involving his theory of structuralism was in *Les Structure élémentaires de la parenté* (1949), published in English twenty years later as *Elementary Structures of Kinship*. In this book he attempted to show that the wide variations in kinship behavior and institutions found in human societies ultimately rest in Durkheim-like "molds" as models

for communication. Marriage, for instance, is a ritual intended to mediate the conflicts with society of me/other, us/them among *males*. A system of exchange, it applies to all social systems. Woman is a gift men bestow upon other men who reciprocate. Lévi-Strauss took for granted male supremacy as a universal given and believed symbolic thought required that women, like words, be exchanged.26 This, he said, was the only way to ameliorate the incompatibility between male inclinations toward promiscuity and male proprietary feelings towards a mate and children. In a later work, *Le Cru et le cuit,* that is, *The Raw and the Cooked* (1964) he asserts that meals consist of certain foods rather than others in a culture not because they are good to eat but, rather, because they are "good to think." This is because, for Lévi-Strauss everything is either a thing signified or a signifier and, as in Durkheim, signifiers (such as words) can be treated also as what is signified. In looking at social behavior he takes the view that anything is, first and foremost, a signifier of the binary concept of *nature* or *culture*. I should note that within this structure there are subsystems referring back to the entire structure in what structuralists call "examination." Unless one is thoroughly familiar with the specialized jargon of the theory, reading commentary from structuralists can be tedious indeed. Too, texts can be mindbogglingly presumptuous, as the following analysis seems to me. Lévi-Strauss tells us that roasted food is "natural" because it is cooked in direct contact with flame. But food that has been boiled is "cultural" on account of the barrier of water that comes between the food and the fire. Why is it that French families traditionally boil chicken for family meals but roast meat for banquets? Is it a matter of cost, quality of the raw material, relative convenience? None of that. It is because one's kin are the center of cultural life and, therefore, receive cultural food. Guests are outsiders and, so, part of what is external—nature. They are given roasted food. Lévi-Strauss goes so far as to predict that cannibals will roast enemies but boil kinsmen killed for ritual purposes. This assumption seems nothing short of ridiculous on the face of it. Human flesh, despite Swift's *A Modest Proposal*, is dangerous stuff to eat. It is so laden with deadly pathogens that the safest way to prepare it for eating would be by boiling. Paul Shankman of Harvard discovered, in 1969, that the cartoonists had it right all along—boiling enemies was in fact preferred. Actually, what was most striking about Shankman's study was that most cannibals varied the approach and, of those who used only one method of cooking human beings, *baking* was preferred.27 Of course, I am focusing on the more ridiculous features of Lévi-Strauss's presentations. A lot of what we run across in his work sounds like a huge joke, but the essential idea of structuralism isn't so foolish as its perpetrator. When applied to the arts a parallel mode of thought has led to what is known as "deconstruction," the close examination of a work with the objective of stripping away its supposedly self-evident aspects to reveal the signification of social biases to which we are generally blind. (To take a perhaps too obvious instance, the thousands of Italian Renaissance images of an uncircumcised Jesus, being

contrary to Luke 2:21, are affirming that God is not only a white male but also a gentile.)

Lévi-Strauss holds a lofty position among certain contemporaries (known collectively as "deconstructionist postmoderns") because of the relevance of the binary models of Durkheim to such artifacts as churinga stones, totems, ancestor figures, and—by extension and personal interest—to contemporary art. Lévi-Strauss, himself, has been concerned with the ways art and myth connect. They are alike in being creative and coherent in structure, though music is more akin to myth than is painting. Why? Myths are cultural. So are the tonal variations in music, but the colors of the painter exist in nature. Among semiologists concerned with the fine arts are Roland Barthes, who was not only a deconstructionist theorist of literature and society, but also a creative writer and critic of art, and Jacques Derrida, known as a *poststructuralist*—largely because his "grammatology" theory discards the structuralist "sign" (that is, signified and signifier) for what he calls the *"gram* or *différance"* (*la différence* is standard variation, *la différance* is eternal ambiguity). This substitution recognizes the boringly obvious fact that signs are objects referring to other objects that are not present. In literature things are never simply present or absent, and nothing exists except traces of traces. "The gram, then, is the most general concept of semiology—which thus becomes grammatology."[28] This seems to me to gain nothing in clarity and less in logical process. But that is part of Derrida's objective; he's fascinated by things like collage, in which the fundamental character of material elements is altered by putting them in a context different from the one of origin, and by discussions like those of the psychoanalyst Jacques Lacan or Michel Foucault who emphasize the ways signifiers and the signified are always changing their meanings and combining in new ways. (Need I point out that this constant "alterity" leads to the elimination of discriminatory value judgments about madness, immorality, and ethical judgment?)

Even when one has a grasp of Derrida's intentions, his writing remains a strangely overdone bouillabaisse. Here, he is commenting on the way collage (especially in writing) appropriates intellectual property protected by copyright:

> In the code of set theories, if I may use it at least figuratively, I would speak of a sort of participation without belonging—a taking part without being part of, without having membership in a set. The trait that marks membership inevitably divides, the boundary of the set comes to form, by invagination, an internal pocket larger than the whole; and the outcome of this division and of this abounding remains as singular as it is limitless.[29]

I am particularly taken by the term "invagination," which here means nothing more than placement of a collage element in a new context. How curious that this somewhat sexist metaphor should be linked with boundlessness. The idea itself is by no means profound. In a graphic arts context it is perfectly clear that insinuation of a fragment of a photograph into a montage affects both the fragment and its surroundings. For instance, when one positions a 40 dpi halftone

against a magnified element from a steel engraving the peculiar characteristics of what communications experts call the *channels* of visual communication (in the case of Figure 3, tiny black dots and sharp black lines that fatten and taper) are given exaggerated identities in somewhat the way simultaneous contrast makes a black look blacker against a white than it does against a gray. Granted, it is not easy to put in words what is obvious in fact, but *invagination*? Derrida seems forever to be thrashing straw men before cheering audiences whose grip on reality is very infirm indeed.

Figure 3: Magnified halftone dot image contrasted with enlarged line engraving

By contrast, Barthes was a comparatively impressive fellow. In a 1953 book, *Writing Degree Zero*, he dealt with modern art in an essay, "The Disintegration of Bourgeois Consciousness," saying that the formalism of modern painting forces art towards "blatant assertions of its own objecthood." Unlike nearly every other liberal commentator of the day he recognized that art after Cubism is really no different from traditional art so far as being a signifier of exclusiveness and luxury. Postmodernists and poststructuralists have, expectedly, seized upon this observation in order to rationalize the exceptionalism of things like conceptual art and performance art. But it is in two later books, *Elements of Semiology* (1964) and *System de la mode* (1969) that Barthes presented the world with what is probably the first really comprehensive assertion that organized social relationships are actually nothing more than complete language forms. This idea has reverberated through the intellectual community and resonated with particular force among groups that feel more or less alienated from contemporary society. Among these, of course, are many people aligned with the poststructuralist left, about whom I shall have something to say presently. One of the interesting things about the development of semiology in this direction,

though, is that it is itself an extremely formalistic interpretation of the entire world, but one that rejects the standard categories as invariably exclusive and dehumanizing.

Barthes' treatment of the signifier and signified is in line with Durkheim's comparatively simple outline. The dichotomies he uses break down this way:

SIGNIFIER:	speech	image	form
SIGNIFIED:	language	concept	content
NATURAL:	individual	selection	usage
CULTURAL:	society	values	system

Barthes then further separates the relationship of the signifier to the signified into *Connotative* and *Metalanguage* levels. The system is truly complex and not easy to comprehend. Non-objective art turns out to constitute a sort of metalanguage while ready-mades (*objet-trouvé*) and some forms of conceptualism are connotative. One can see the general sense of this construction, but one might suppose that traditional representationalism would be connotative, too, in view of the form/content distinction most of us are accustomed to emphasizing. In Barthes' theory this may not be the case, however, because the top level is always a language object capable of analyzing the lower levels. Thus, a trompe-l'oeil work like William Harnett's *Faithful Colt* (c.1855) is in metalanguage because it is, ultimately, not a pistol but an elaborate set of conventions creating a false illusion. That is one of the reasons René Magritte's *Vise of Words* (1929)—a sign-painterly representation of a pipe captioned by the phrase, *Ceci n'est pas une pipe*—is such a favorite of the deconstructionists. For them it is not a paradox or a witty revelation of the self-evident; it's a comment on the very nature of signs.[30] And, despite my impatience with Lévi-Strauss and Derrida, I do believe we owe to the semiologists (and also to structural linguists, notably Noam Chomsky) a good deal. For they have provided us with far greater consciousness of the degree to which nearly everything in the society is, indeed, part of a symbol system. Studies of proxemics, of non-verbal communication, of the ways in which gestures and postures connote social caste the way dialects do, and the implications for social intercourse of such things—all these have been immeasurably enhanced by the implications of semiological theories. I fear the supposed contributions of such theories to the history and criticism of the fine arts, however, are seriously overrated.

Quite often, in dealing with structuralist criticism, one spends what seems endless hours slogging back and forth through mucilaginous prose and tortuous reasoning (of the sort Derrida exudes) in anticipation of wonderful things to be disclosed about actual artworks once the system is applied. How dismaying, then, to discover that the transformational shifts depend, finally, not upon a reliable tautology or even a preclusive dialectic, but upon the same kinds of intuitions we rely on in traditionally opinionated criticism. Sometimes, as in Ronald Barthes' stuff, the intuition produces rather illuminating perceptions. More typically, it results in superficial banalities of the worst kind. Almost

always—presumably because of the origins of structuralism in social anthropology—poststructuralist criticism, especially, finds it difficult to distinguish between such diverse forms of art as serious painting, graphic design, salon kitsch, academic modernism, and hack illustration. There are those, and as it happens I am among them, who welcome these confusions as part of a general erosion of distinctions between high and low culture that have more or less corresponded to the difference between illustration and art in painting and the elite and the masses in society. Social reform abominates hierarchy. But, all too often, confronted with the criticism of the last two decades, I have found myself in the position of Dr. Johnson upon reading Edward Young's *Conjectures*—surprised to find some author taking as novelties what I had thought very common maxims. And what is more disconcerting still, the publication of these commonplaces is sometimes received with shock and controversy. Also, there is the matter of the ideological bias for which structuralism has an affinity.

Claude Lévi-Strauss always affirmed his commitment to Marxism and liberal-leaning Marxists have tended to support the sort of postmodern structuralism with which Derrida and Foucault are identified.[31] With respect to understanding this matter one needs to know of the long-running controversy between schools of Marxian aesthetics known, on the one hand, as "naïve" (that is, strictly doctrinaire) and, on the other, as "critical" (revisionist, Trotskyite, liberal). In the West those considered strictly doctrinaire are few, while the number of revisionists is legion. The reason is clear. Every change in the circumstances of the art world seeks to reflect itself in the institutions of critical thought and only where goverment is rigidly constrained will such cultural changes be less inhibited in their development. Presently, of course, naive Marxians scarcely exist, so far as public presence is concerned, even in Russia.

Many of the poststructuralists who participate in conferences and colloquia express the kinds of convictions that inform the Frankfurt School of social thought, a movement initiated in 1923 and affiliated with the Institute for Social Research at the University of Frankfurt, except for an interlude during the Third Reich when it was exiled in New York. It is from the attempts of this group to develop a critical theory of Marxism that much New Left thinking flows. Typically, its spokesmen have been opposed to positivism, naive materialism, and all technocracies, whether capitalist or socialist. They have been highly attentive to aesthetics in mass society, to the role of consciousness in social change, and to the probable necessity for revolution. Leading figures of the Frankfurt School have been Walter Benjamin, Theodor Adorno, Herbert Marcuse, and Jürgen Habermas. Generally, people connected with this mode of thinking believe modernism is either anti-progressive or defunct and Habermas, for instance, does not believe postmodernism is an alternative. Hal Foster distinguished between two kinds of postmodernism—that which "seeks to deconstruct modernism and resist the status quo and a postmodernism which repudiates the former to celebrate the latter."[32] Needless to say, it is the deconstructive variety that informs the New Left and its contemporary hangers-on.

One of the major appeals poststructuralism has for critics from the left is its promise of the direct application to normative matters of a system that is essentially "dialectical." Usually, these critics do not claim that such a system will be "value free" but maintain, instead, that it is less ideologically tainted than traditional analyses. This contention had, for me, a certain plausibility ten or twelve years ago. By now I have been fully disabused of confidence in the intellectual integrity of poststructuralists, given such inanities as characterizing the *tyranny* of the signifier in art as comparable to patriarchy's dominance of women about which something, by God, will have to be done. Alongside such galloping nitwittedness, sentimental anarchism reminiscent of the disastrous 1960s is common among these people. Ralph Smith has characterized the mind set rather well:

> Deconstructionist criticism is inherently negative in that it consists not of revealing a work's plentitude of literary values and meaning but of the unmasking of what are called the logocentric tendencies of language. A logocentric tendency is any tendency that manifests a bias toward such concerns as truth, reason, rationality, logic, etc., and toward the spoken rather than written word.[33]

Frederick Crews, a prominent critic of deconstructionism, is cited by Smith in connection with his concern over what he calls the "theoreticism" of the movement—that is, indulgence in speculation without substantiation, an emancipation from fact.

> Theoreticism denies the possibility of objective understanding and indulges a range of strategies that, on the one hand, reject interpretation itself if it is taken to imply the construal of a text's meaning, and, on the other, regards works of art as mere pretexts for the creation of additional texts. . . . Not only that; since deconstructionists hold that texts are inherently incoherent and contradictory, the next step follows inexorably—a critique of a text becomes just as important as the text itself, or more so. Thus to radical scepticism and dogmatism is added what can only be called arrogance. . . .
>
> To reiterate, behind much of the discrediting of the concepts of logic, rationality, objectivity, communication, meaning, authority, and reality is a Marxist revolutionary agenda that understands such notions as the means by which the elites of a capitalistic middle-class society maintain their power and control its members. According to this doctrine, whoever strikes a blow against logocentric concepts therefore strikes a blow for freedom and against bourgeois hegemony.[34]

If you have been following this with some attention, it should be obvious that, despite all of the references to texts and linguistics what deconstructionism does is formalize criticism as criticism. In its final analysis conventional "content" no longer exists; it is merely a trace of the signifiers which are, after all, sounds

or marks. It is kind of amusing to find that a degree of formalism even the most extreme Trotskyite could never have imagined should now present itself as the means of subverting bourgeois taste. Of course, not every deconstructionist is a Marxist; I know two followers of Derrida who are, in fact, laissez-faire Libertarians—a political position that seems far better suited to the essential anarchism of the doctrines of the master. So far as art criticism is concerned, what deconstructionism does is turn the plastic elements into motivating forms for language divorced from meaning other than itself. No wonder performing artists like John Cage are fond of it and the poststructuralists fond of him. But, if this is formalism, it is also a paradoxically formless kind. That would be expected from an approach to the arts that repudiates the value of technique and discipline, that rejects any hierarchy of aesthetic value, indeed, denies the existence of a capacity for judgment and takes it as principle that discrimination is never fine but always biased. It is, I think, of supreme interest that the academic departments where the deconstructionists have had the most influence are typically the fields in which specialists don't really have to know how to *do* anything. Oh, it's assumed they write. Yes, but that is a specialty of nearly every faculty member in any university with a graduate school. Where do you find deconstructionists? Not in the sciences, mathematics, or even in philosophy, generally. No, it is almost always in something like literature or art history. And when you turn up a practicing artist with a proclaimed penchant for poststructuralism, it's almost invariably—in my own experience, *has* been invariably—someone who couldn't draw a foreshortened hand if life required it, someone whose own artistry involves something like toting around crudely lettered posters proclaiming, *"Everything Within these Quotation Marks is False"*. Hmmmm. I just made that up and you are welcome to it. Pretty lame, perhaps, but it's a perfect postmodernism, even providing a basis for Derrida-like allusions to set theory. Is it worth pondering? Not a bit.

Ralph Smith, in *The Sense of Art*, was primarily concerned with the deleterious effects deconstructionists may have upon education, particularly liberal education, partly because of their nihilistic view of knowledge and partly because of the politically "correct" atmosphere in areas dominated by them. "[Peter Shaw] remarks the commonplace that in many academic departments today nothing less than an avowal of radical political beliefs is tolerated. Indeed."[35] While this may be less the case today than it was in the middle 1980s—largely because of the aging of the faculties and an unfortunate decline of public interest in social reform, even as the need for change grows at an alarming rate—it remains the case that deconstructionist conceptions of truth underpin much of what has become the intellectual substructure of fashionable transactions today. And one of the most pernicious of its effects has been to disallow the *possibility* of truth in history.

History, it is true, must always be a kind of explanation and, to that extent, historians invariably express the biases of their culture—even if in a way antagonistic to it. This is by no means something only recently understood; Fritz

Stern, in his Introduction to *The Varieties of History* (1956) said: "The very nature of truth in history is an unresolved problem of epistemology and involves profound questions about the nature of historical judgment."[36] But there is, in point of fact, an irrefragable difference between history as explanation and history as chronicle. At least in principle it is possible to determine such things as the time when Aristotle died (322 B.C.) and the years the great library at Alexandria was constructed (323-285 B.C.) by Ptolemy Soter. We know that things do happen in time and that objects can be dated, records unearthed, facts revealed. How to interpret those facts, is another matter. When someone says Artistotle lifted his ideas from the Alexandrian collection, however, it will not do to assert that the dates may be in error and the overlap much greater than "history" tells us. Is some error possible? Of course. That much error? Hardly.

Before continuing, I want to make something clear, particularly to any Afrocentrists who happen to be reading this book. A few of them may know that there is no question in my mind that the white European view of ancient history is highly distorted and that these distortions are defended with dogmatic and unrelenting prejudice by the scholarly elite of the Western world.[37] But to argue that is not to say everything in the record is a lie, and still less to hold that all histories are equivalent. As Mary Lefkowitz asserted in *Not Out of Africa* (1996), a book inspired by a confrontation over the claim that Aristotle got his ideas from black Egyptians:

> If it is true (and I think it almost always is) that no historical work can be written without bias of some sort, it follows that no historian can be trusted to give an entirely accurate picture of what the writer is seeking to describe. Of course, historians (and their readers) have always been aware that they can and do write with an evident bias— the Roman historian Tacitus tells us at the beginning of his *Annals* that he proposes to write the history of the emperors from Augustus to Nero *sine ira et studio*, "without anger or intensity," but his narrative shows he did not mean what he said. But recently, many historians have been concentrating on another type of bias, this time unconscious: the blinkers put on everyone's vision by the values of their particular societies. These scholars insist that history is always composed in conformity or response to the values of society in which it is produced, and for that reason can be regarded as a cultural projection of the values of that society, whether individual writers are aware of it or not. Such beliefs, if carried to their logical extreme, make it possible to say that all history is by definition fiction. If history is fiction, it is natural to deny or to minimize the importance of all historical data (since it can be manipulated). Instead, these writers concentrate on cultural motives.[38]

While I do not support Professor Lefkowitz's book *in toto*, her position as stated above seems unassailable. And it is obviously the case, as she says elsewhere in *Not Out of Africa*, "Despite its anachronism, history based on acceptable (as

opposed to warranted) proof has considerable appeal among American academics today."[39] I hasten to note, though, that not all historians claimed by the postmodernists and poststructuralists are of the same stripe; postmodernists have a tendency to grab up every innovator who is not an acknowledged neo-conservative and tag them with a postmodernist label. Among these is Svetlana Alpers, whose *The Art of Describing* (1983) is, in effect, a tour de force demonstration of the justice of Arnold Hauser's description of the painting of the Protestant Baroque as a naturalism that attempted to make "all visible things a spiritual experience."[40]

Poststructuralist criticism is not inevitably identified with a particular set of beliefs about social and interpersonal relationships, but it has an affinity for historical revisionism as antidote to traditional practices that are, without question, biased in favor of a Eurocentric, paternalistic conception of cultural destiny. It is hardly surprising, then, to find that many sub-specialties of academic scholarship have felt the impress of deconstructionist theory, either directly or indirectly. Afrocentrism and women's studies are two of the most obvious areas of influence, but other newly emergent fields are striking examples of well-intentioned advocacy for special minority interests. A good example is what its own proponents call "Queer Theory," that is, analysis of cultural events with an emphasis on homosexuality. Since even traditional scholarship has never seriously denied the influence of this particular preference in the works of some artists and periods—for example, in the work of Caravaggio or Leonardo, in the Classic Age of Greece and Imperial Rome—the tendency in Queer Theory is not so much to "out" homosexuals pretending to be "normal," as it is to reveal homosexual desire that has been repressed and disguised. Often enough these revelations are examples of *post hoc ergo propter hoc* reasoning carried to levels of transcendent dubiety. Queer theory is forever in pursuit of geniuses who can be shown to be somehow, however slightly, "gay." Not only the obvious candidates but even people like Raphael, Renoir, and Picasso have been studied with such intentions.[41] As a matter of fact, the sexist bragadoccio of Renoir does seem to bear upon the way he portrays nude women as cute pets, made to be fondled. But I am personally annoyed to see elaborate scholarly apparatus applied merely to suggest that a given cultural phenomenon entails acceptance of androgeny or that an individual artist was consumed by passionate affection for another person of the same sex. It is patent that much traditional art presupposes an ability to draw upon the ambivalent sexuality of individuals of whichever sex. And who among us has not felt deeply in love with someone of the same sex, even felt a thrill in watching the undulations of that person's physicality? This is normal in the sense of being commonplace, ordinary, and taken for granted by all but the most severely repressed. But when an experienced adult prefers intimate genital contact with people of the same sex it is safe to say the preference is exceptional, not to say queer, and is statistically abnormal. If Picasso had sex with Georges Braque or even Jean Cocteau I might be at least bemused; to discover that he might have

some secret insecurities about his own sexuality is, perhaps, of critical interest but is otherwise no more than evidence of a certain normality.

If one takes a cynical but sympathetic view of the unhappy situation faced by young humanists in colleges and universities today, the proliferation of special subject categories is perfectly understandable. A topic of some kind—say, Sexual Proxemics in Literature and Art—occurs first as an experimental or "honors" course, then as colloquia, seminars, and ultimately comes to occupy full scale undergraduate and graduate programs of study supported by associations and journals devoted to the field. Any day now I expect to see an academic fashion emerge to explore the ramifications of transsexualism. In fact, a friend of mine will probably be its creator and, if so, she (nee he) will do an intellectually respectable job. But nearly anything is grist for the mill if the purveyors are clever enough. Thirty years ago J. B. Priestly wrote a book called *The Image Men* which is as pertinent to building a curriculum from nothing very much as Mary McCarthy's *Groves of Academe* (1952) had been to exploiting academic freedom as an alternative to academic competence. The "image men" are a couple of erudite con artists who take advantage of one of the new "red brick" universities to establish a center for the study of "Imagistics," a specialty invented out of the whole cloth that eventually becomes an actual sociological discipline. Priestly's send up of the entire field of sociology, which the protagonists master in a few days simply by memorizing the jargon, is hilarious. But the way this confidence game proceeds from swindle to institutional celebrity is a study in the irresistible thrust of pretension in the world of humanities and the so-called "soft sciences." (The novel is inspiring in its way. I tried to talk the woman who brought it to my attention into collaborating on a grant for a Center for the Study of "Analectics," hoping we could gain access to the soft money abundantly available to universities in the United States at that time. All things considered, it is probably fortunate that she was too honorable to cooperate. Or perhaps not; I cannot imagine what we'd have done would have been less worthy than the fuzzy-minded experiments in learning pursued by educationists attempting to apply the theories of Abraham Maslow and Carl Rogers to pedagogy.)

There is, at last, a supreme paradox in the poststructuralist/ deconstructionist/semiological believers' presupposition that they are sole exceptions to widespread delusion. As has been pointed out in many attacks on the movement, even by some within it, every speech or essay by a deconstructionist is an excerise in futility. After all, it too is "just one more text grafted onto a giant intertext that consists of nothing but traces of traces, etc."[42]

I believe Hilton Kramer's premier editorial for his neoconservative *The New Criterion* described the whole postmodernist situation rather well. Essentially, it comes down to the recognition that bourgeois appetites for novelty are so rapacious that the most pungent items are eventually consumed as if they were delicacies created solely for the delectation of the leisured class. Postmodernism, born out of the facetious attitudes associated with Pop and Camp Art, is the

ultimate result. The revenge of the philistines has been at last secured by their ostensible enemies.[43] Smith says that postmodernism results, in part, from "millennial anxiety." That is, surely, an appropriate way of saying it, given the tendency of the movement to speak of itself in apocalyptic terms. One of the frequently stated objectives of the radical wing of postmodernism is the obliteration of the distinction between life and art. Accomplishing that end would be truly radical because it would disrupt the reliable course of daily existence in a sacrifice to the achievement of something that a tiny minority feels would be more worthwhile than public tranquility. What the postmodernists actually do, however, is sometimes annoying but never dangerous since their actions are a form of attitudinizing that is labeled as such. Whether going under the rubric of postmodernism, poststructuralism, or deconstructionism, the latest protestations against liberal academicism and bourgeois taste are just another version of domesticated modernism, but now out of sorts due to a hyperactive disposition and a diet too rich in success. It is a form of dissent, surely, but one that expresses boredom, moroseness, fatigue. So far as social conscience is concerned, most of it falls just this side of apathy; the version that actively repudiates the status quo is scarcely anything more than a tantrum mounted by a petulant mob. With respect to one, overriding feature of contemporary life, this new wave called postmodernism is no different from the modernism preceding it. Estrangement is its primary feature, and that feature the soul of its being.

Estrangement and the
Nature of Modernity

*The bonds that unite another person to ourself exist only in our mind.
Memory as it grows fainter relaxes them, and notwithstanding the
illusion by which we would fain be cheated and with which, out of
love, friendship, politeness, deference, duty, we cheat other people,
we exist alone. Man is the creature that cannot emerge from himself,
that knows his fellows only in himself; when he asserts the contrary,
he is lying.*

Marcel Proust[1]

"Irony is the daughter of time," said Febvre,[2] and so it would appear when we
examine the last one hundred years in Europe and the Americas. For people
seem never to have felt more abandoned, forlorn, and vulnerable than during
this period when the expansion of advantage for the ordinary person moved
irresistibly forward in all industrialized countries and gained impetus from every
technological advance and population increase. Why this should have been has
so many speculative aspects, not excluding the possible invalidity of the
premise, that the consideration we venture to give it here will be incidental and
inadequate. But when we turn to the far simpler question of what writers and
artists during the time thought, then the answer seems perfectly clear. We
observe on every hand what at first sight resembles utter self-absorption on the
parts of writers and artists. Moreover, their audience is conceived of by them as
being itself fragmented and pathetic, a mere simulacrum of the social group,
with each individual forever insulated from all others. Poets and patrons alike
see themselves as the self-centered recipients of feelings and sensations that
cannot be shared. Yet, ironically, this very sense of estrangement is not only
shared, it is epidemic.

Estrangement has never formed part of the canon of any theory of criticism—
not even that of postmodernism. And, yet, it is a subject that has exerted
enormous influence upon critical judgments that are, ostensibly, concerned with
form and style. Consider the treatment Roger Fry gave a group of pictures in his

celebrated book *Transformations* (1926). The objective of the opening essay was to examine an assertion made by I. A. Richards in his *Principles of Criticism* (1924) that there "is no reason why representative and formal factors in an experience should conflict but much reason why they should cooperate." Fry sets out to find an example in which subject and form *do* co-operate. The first pictures he takes up are Bruegel's *Carrying of the Cross* (which, he says, subordinates plastic to psychological interest in creating a great work more akin to literary than fine art); Daumier's *Gare St. Lazare* (which seizes our attention by virtue of form but soon plunges us, again, into the spaceless, moral world of the novel); and a work attributed to Poussin, the *Achilles Discovered Among the Daughters of Lycomedon* (which has form that can be dwelled on with delight but whose content is of the meagerest, least satisfactory kind). Rembrandt's *Christ Before Pilate* combines the psychological insight of the great dramatist or novelist with the supreme formal ingenuity of the great painter but the form and content operate *separately,* they do not co-operate. Only Rembrandt's hasty little calligraphic ink drawing, *The Hidden Talent,* meets Fry's criterion for co-operation of form with content.

What is most fascinating about the ranking of the works in *Transformations*— apart from the critical acuity Fry brings to all such enterprises—is that there is a direct correlation between the standing assigned to a work and the number of people prominently featured in the work. The Bruegel has hordes of them, the Daumier is of a crowd, the painting of Achilles holds but a number. The Rembrandt picture of Christ and Pilate depicts a mob, but only a handful of principals grips our whole attention. The little drawing by Rembrandt contains two people and they are at odds.

In undertaking studies of social phenomena as they appear in the arts there is always, of course, a certain risk in finding the object of one's interest in everything surveyed. But in the case of the estrangement motif in modern art the difficulty lies in the opposite direction. The most exaggerated claims take on genuine plausibility owing to the diffusion of the theme throughout our culture. Indeed, it would be easy to multiply instances and thus convey the impression that modern painting represents, entirely, a dominion of silence and privacy. I do not believe that it does, but a feeling for estrangement *has* been the unacknowledged legislator of every advanced sensibility from the middle of the nineteenth century to the present day.

So puissant is the assumption that modernity and estrangement are in some way tied together that a sufficiently strong impression of the latter will cause critics to embrace as "modern" a literary or artistic style that has otherwise fallen into desuetude. Thus, Andrew Wyeth is made to seem somehow more representative of the times than is his brother-in-law, Peter Hurd, whose pictures of the American Southwest evoke something less relevant. Similarly, Edward Hopper's depictions of a world that is either devoid of life or is populated by spiritually vacant people ally his paintings with the early work of Giorgio de Chirico in the minds of some critics[3] although it is by no means clear in just

what way Hopper's lonely Americans fit into the empty piazzas of Italian Metaphysical art.

To claim that modern painting is wholly characterized by evidence of personal estrangement or social isolation would certainly exaggerate the case absurdly. But, absurd or no, it would amount to far less of a distortion than one might at first suppose.

The term customarily used to denote the isolation and loneliness that seem to pervade so much of modern art and literature is "alienation." *Entfremdung,* its precise equivalent in meaning, first appears in German in Goethe's translation of *Le Neveu de Rameau* by Diderot and was intended to connote just the sense of personal isolation from society that modern painting reveals. Karl Marx received the term from Hegel, but Marx gave it a somewhat narrower focus.[4] Unfortunately, the retranslation of the word as "alienation" in English has caused it to be applied in an obscure and varying way to everything from genuine anomie through sentimental *Weltschmerz* to what is merely a willful preference for the esoteric. And we really have little need to resort to this term, with its vaguely significant connotations and general lack of explicitness. As it happens, the appearance of estrangement as a motif in painting can be treated in a purely descriptive way.

With rare exceptions, the early moderns signal their uniqueness with portrayals of human beings isolated within a context of sociability and free communication. Consider the people chatting beneath the trees in Edouard Manet's famous *Dejeuner sur L'herbe* of 1863, one of the premier works in the history of modernism.[5] The nearer man turns his head away as he makes a tentative, seemingly irrelevant gesture towards the nude girl. Although he seems, on first impression, to be addressing the other man, a little study will show that he is looking off into the middle distance over the left shoulder of his comrade who, in turn, stares somewhat vacantly into the space just to the viewer's right. The nude model, Victorine Meurend, looks into one's left ear, with a certain damning skepticism, and her chemise-clad friend remains entirely self-concerned as she dips a hand into the surface of the pool. No one in the picture makes eye contact with anyone else, not even with the viewer. Isolated in their intimacy, these people seem curiously alone, disengaged, and unaware of one another. Such aversion can, of course, be interpreted as a revelation of self-consciousness, a feature of human relations which tends to produce embarrassment in onlookers. That, perhaps, intensified the uneasiness with which people confronted the scene. In contrast to the officially acceptable rutting satyrs and hot-blooded, pliant nymphs of Bougereau, Chantron, or Alfred-Phillipe Roll, Manet's disclose a chillingly aloof familiarity that is neither illicit enough to be romantic nor cordial enough to make them members of that special genre concerning artists and their models.[6]

Examples of Manet's detachment and the isolation of his subjects are easily turned up. In Manet's last painting, *Bar at the Folies-Bergères,* an attractive barmaid, surrounded by succulent candied fruit and wine bottles, stares directly

at the viewer. An immense mirror at her back operates in an impossibly perverse fashion, casting her reflection off to the right where it becomes obvious that she is engaged in conversation with a man who can be standing in only one place, just where the viewer would be standing if in fact the picture were real. Manet's looking-glass world is a disconcerting place in which the viewer's identity is as obscure as everyone else's position in space, and in which genuine communication seems quite impossible. There could hardly be a better example of the devaluation of ostensible subject matter by means of its pictorial treatment .[7]

It is easy to anticipate at least one reaction to the foregoing remarks. For even if it is granted that these two examples indicate a tendency in Manet's paintings to stress the separateness of individuals within the social group, the tendency itself may be nothing more than an idiosyncrasy of this particular artist. After all, Jan Vermeer van Delft, painting in seventeenth-century Holland, suggests something equivocal about the people who meet in his pictures. "Eyes never meet in Vermeer, action is stilled. There is no speech, these almost unmoving figures communicate by letter or on the keyboards of virginals."[8] But Vermeer is unique, himself isolated from the main trends of Dutch art which, especially among those of his school, are characterized by an almost cloying congeniality. Manet is by no means so unusual for his time. Compare Edgar Degas, the waspish aristocrat of the painters who met at the *Café de la Nouvelle Athènes.*

Some of Degas' paintings are positively dumbfounding in their revelations of social groups disintegrating into isolated particulars. The girls Degas shows us in the Opera's *foyer de danse* are, like his businessmen at the cotton market, or audience at the theatre highly self-contained, introverted people; frequently, they too have been set apart in a personally tailored group of intervals, each girl wearing a different attitude of gaze.[9]

In Degas' pictures people, typically, are prevented from attaining what might pass for intimacy. They do not touch one another nor do they make eye contact. And in the well-known *L'absinthe* we have the painter's most famous representation of isolation and emptiness in close proximity to another human being who is equally lonely. The title, though, is a misnomer; Degas called this work simply *Au Café*; when exhibited in London it was retitled by the Victorians in order to make it a morality lesson. Degas had intended nothing so banal. This quite respectable couple—the engraver Marcellin Desboutin and actress Ellen André—were made to seem joylessly dissolute by being shown in glum repose as they sit close together in an environment associated with effulgent gaiety. They are parted, too, by the colors of their costumes, his being black and hers pale beige.

Again, as in Manet, the frequency of isolated individuals in the oeuvre of Degas is related to the artist's personal attitudes. But the most unlikely styles reveal elements of anomie. Take any of Renoir's large groups—his *Moulin de la Galette* or *Luncheon of the Boating Party,* for instance. Given the festive nature of the events depicted, it is remarkable how many of the participants have their

eyes averted, as if they are daydreaming or momentarily distracted. This behavior would seem very strange to us, I think, were it not for the fact that we are now thoroughly accustomed to social fragmentation in painted groups and also to the progressive diminution of the human presence in all avant-garde art.

Impressionism itself made everything attractive, easygoing, and unproblematical. But there is a darker element behind the kaleidoscope of pale hues enriching the canvases. The principle of visual subjectivity, which recognizes that things may vary in their objective appearances depending upon conditions of light and atmosphere and the situation of the viewer, conceives of the human receptor as fundamentally singular, enclosed, and solitary. Each version of a Monet haystack is Monet's private vision; no other could have experienced those particular color sensations in precisely the way he did at that moment in time and only Monet would have selected Just the pigments he did to interpret what he called his "naive impression" of the scene. The very theory of Impressionism entailed at least this mild avowal of the priority of solitude. That is consistent with Arthur Schopenhauer's contention that "to have original, extraordinary, and perhaps even immortal ideas one has but to isolate oneself from the world for a few moments so completely that the most commonplace happenings appear to be new and different, thus revealing their true essences."[10] The world from which Monet and his followers had withdrawn was, of course, the world of conventional vision. And after 1880 they have not only excluded the commonplaces of ordinary vision from their works, they have also begun to exclude other viewers from the landscapes themselves.

Monet's haystacks stand in deserted fields. Even his Cathedral of Rouen, in all of its many variations, has been abandoned by passers by. The lily ponds at Giverny reflect everything upon their surfaces. They burst with sunlight and are speckled with blossoms' hues broken apart by delicate ripples; the willows and wisteria drape soft, violescent shade over the water and mute the tones of things hovering in a vegetative, floating world. What they do not reflect is a human face. No boatman dips an oar here, no woman twirls a parasol. Monet's entire personality is diffused in finely discriminated points of color he alone could sense.

The vision of the so-called Post-Impressionists was subjective in a somewhat more conventional way; not only do the landscapes of Vincent van Gogh and Paul Cézanne tend to be unpopulated, they are utterly unique in appearance. That, of course, is the most notable thing about them. Nowhere will one find trees that twist like those in van Gogh; in no country do hillocks spill over the horizon so tortuously, nor are there anywhere cloud formations of the curiously bondaged kind found in the Dutchman's art.

Van Gogh's portraits are a special case. Many of them have a good deal to tell us about the sitters, through distortions of feature and form and by means of the postures and the still life objects included in the pictures. But all of them are, first and foremost, self-portraits of the artist. And his own self-representations are peculiarly unflattering. In fact, John Russell the Australian's portrait of van

44

Gogh and one by that master catcher of likenesses, Henri de Toulouse-Lautrec, show us a man quite different from van Gogh's picture of himself as grim visaged, coarse of feature, and rigid enough to be some Romanesque prophet, glaring, transfixed against a background aflame with long brushstrokes that seem sometimes to emanate from the figure itself.[11] But, again, it is common to most of the important painters known as Post-Impressionists that they subsume their painted image within a stylistic manner and treat physical appearance as a kind of self-revealing mask. That is, the true self is never exposed except through some kind of painted subterfuge.

Paul Cézanne treated himself with extraordinary severity in his famous *Self-Portrait with Palette*. The forms of the picture, which are architectonic in character, constitute a set of walls and barriers to physical contact; moreover, the painter is hard at work and, so, does not look at us. Too, I seem to be the first person to note in writing that he has given us an uncorrected mirror image of himself; the palette is shown in his right hand though there's plenty of evidence he was not left-handed. In Figure 4 I have diagrammed the work, using two broken lines to emphasize the barriers and the arch-like shoulders the painter has given himself in this portrayal. Cézanne's landscapes are as empty of life as those of the aged Monet. They do not even contain the iconic notations

Figure 4: Diagram of Cézanne's
Self-Portrait with Palette (1885-1887)

of people van Gogh sometimes incorporated into his scenes. More frequently than not the view is of a subject not easily accessible from the site. We are looking at a rock quarry beyond a chasm, staring over l'Estaque from some incredibly lofty vantage point, or viewing the Mont St. Victoire from the edge of a high cliff. Moreover, what we can see is not nature, it is pure Cézanne. It has been reduced to a special geometry of planes that proclaims the superior force of the painter's will at every point and in every region of space.[12] The partialisms of Cézanne, van Gogh, and the other Post-Impressionists were intentional stylizations established for a purpose; they are intended to heighten

or intensify the uniqueness of the artist in a way that sets him apart as a solitary adventurer who explores a world that only he could have made. Similarly, Seurat's desire to rationalize painting and turn it into an art of systematic, scientific construction took on special overtones when it required human beings to be made up of dots and caused them to be reduced to isolated mannequins who do not communicate with one another.[13] In Gauguin's seasonless idyll of the South Pacific, within an easygoing Polynesian tribal culture, we discover the self-conscious aversions of Manet and Degas. These were, of course, Gauguin's importations to Tahiti. He takes it as the most normal thing in the world for people to be forever turning their backs on one another. Face to face confrontations are unbelievably rare in his works, when one considers that most of them contain two or more figures.

If we wish to find an artist of appropriately impressive standing whose depictions of human society deviate from the path herein surveyed, we might turn to Toulouse-Lautrec. Not withstanding all that has been written about his own deformity and unconscious aggression the fact that the girls of a brothel actually speak to one another is enough to make their lives seem part of common humanity. Of course, *in toto,* Toulouse-Lautrec's work seems a bit claustrophobic, like the numberless interiors with mothers and daughters by another great artist among the unalienated, stylish Mary Cassatt. Her family vignettes are as wholesomely immune to despair as Toulouse-Lautrec's milieu is infected by the promise of false gaiety. Whatever else these subjects may imply, estrangement is not a significant part of it. That is true, too, of course, of many lesser moderns. In fact, it may even be that they are sometimes considered less significant by the umpires of taste precisely *because* their subjects are more communicative. None the less, we can dismiss them as unimportant for our purposes because they did not carry their present forward into the future. The artists who did are more often to be counted alongside van Gogh, Cézanne, Seurat, and Gauguin.

Proto-Expressionists Edvard Munch and James Ensor were both specialists in the proclamation of universal estrangement. Their examples were strongly moving to young artists in Germany just before World War I. Ernst Ludwig Kirchner did paintings around 1907 that are particularly reminiscent of certain Munchs.[14] Other members of *Die Brücke,* the group of Dresden artists led by Kirchner, were concerned with similar things, though not many of them emphasized solitude in an urban setting to the degree Kirchner did.

In contrast to the rather pessimistic view of the human condition instinct to much German Expressionism, the Fauves of Paris were optimistic. The appellation of "wild beasts" they received from a journalist in 1905 conveys the ferocity but misses the joyous, pagan self-affirmation characteristic of the group. Their leader, Henri Matisse, specialized in pictures so decorative in spirit and luscious in color that any human beings appearing in them take on the character of purely aesthetic objects. This way of looking at things in painting was left free to Matisse and the Fauves by their predecessors, the Post-

Impressionists; by 1913 the Cubists and the Russian-born German Expressionist, Kandinsky, had arrived at purifications of that viewpoint none before could have known or even wished to see.

Authoritative statements to support the idea that Cubism was "the most important art experiment of our time" are easy to find.[15] And it is not much more difficult to turn up claims that Cubism's rejection of visible reality was the ultimate step in what Ortéga y Gasset called the "dehumanization of art." In his famous essay *On Point of View in the Arts* Ortéga connects retraction of the forms of living things from modern art with the "progressive dis-realization of the world" in modern philosophy.[16] As usual, there is a good deal in what Ortéga writes, even when his prejudices are so apparent. After all, substituting for seen reality a structure built from clustered planes, lines, and strokes, as did Picasso and Braque was to do hardly more than exaggerate the procedures of the Post-Impressionists. Cézanne and van Gogh had distinguished their private visions from objective realism by emphatically reforming the shapes of nature according to their own wills. Beginning in 1907, Picasso and Braque took that emphasis as a point of departure and, by 1911, the true subject-matter of their paintings was explicitly as well as implicitly, artistic form as harmony and composure. A constant theme in statements from the two painters was that their intention was to constitute pictorial facts rather than reconstitute aspects of other realities. In 1917 Braque wrote, "The subject is not the object; it is the new unity, the lyricism which stems entirely from the means employed."[17]

MODERNISM AND PUBLIC ALIENATION

Establishing a style militantly devoted to the exploration of the range of possibilities of the elements of the painter's craft removed the work from the realm of ordinary understanding. Most people—even those who purchase art on a regular basis—haven't the faintest notion of relationships an artist takes for granted: of, for example, the dependency of drawing upon design or the derivation of illusion from convention. To the extent that Cubism emphasized artifice and diminished its relationship to illusions of material substance it was dedicated to the dis-realization of the world, just as those prejudiced against its effects say that it was. So far as it avoided recognizable depictions of human beings or ordinary human vision it was dehumanized, at least in common-sense terms. But the degree to which Cubism exemplifies the estrangement of artists from their fellow beings has been obscured by the sheer success of the style among those of us with a special interest in fine art.

The importance of the hostility of the general population to modernity in art really cannot be overemphasized. And public uneasiness is perfectly justified, for there can be little doubt that an egregiously supercilious elitism pervades modern art and most writing about it. Daniel Bell, among others, has noted that what in the late nineteenth century was the avant-garde life style of a small *cénacle* has, through the succeeding decades, been diffused through the West so

that many middle-class intellectuals and hangers-on now pattern their lives along lines first established by a bohemian élite.[18] Even today such people constitute a small minority within the society at large, but they are large in number and influence compared with their *fin de siècle* prototypes. This extended *cénacle,* which contains as members the author and most readers of this book, promotes modernity in art and has domesticated each of the avant-gardes it has not chosen to destroy with the most terrible weapon in its arsenal—indifference. That its most deeply held preferences in art are for things the general public finds obnoxious is witnessed by the inevitable controversy that arises over the commission of any public monument in a contemporary style. Thus, the modernist phalanx finds itself estranged from the very tax payers who support its whims unwittingly when they are hidden away in university cloisters and intimidating art museums. Can there be much doubt that the esoteric nature of modernism already designates an enormous degree of insulation from the community? The fact that we who defend modern painting are as quick to accuse its adversaries of incompetence as they are to demean its artists is clear evidence of just how alienated are modernists from the populace at large. For nearly a century the former have answered with supercilious scorn the rancor and hatred of the latter. As it happens, the auspices of our limited *camaraderie* sometimes blind us to the isolation permeating the art itself. But it has been there from the outset. In the incipient beginnings of Cubism there was already the seed of loneliness.

Picasso's "blue period" (c. 1901-1904) remains his most popular style. Full of hauntingly melodious pictures of gypsies, outcasts, acrobats, and clowns, this phase of the artist's development is appealing in its melancholy sentimentality; the bittersweet longings of our youth come to us disguised as figures from *commedia dell'arte* isolated in some Spanish *desierto.* There are some extraordinary things to note of them. To begin with, they are performers but they are never performing for an audience; they are alone or they are practicing. Once in awhile they are shown as members of a family. But it is a family set off from the other families in human society. The costumes alone would, of course, establish the singularity of a harlequin's family. They also make for irony since the characters of Harlequin and Columbine in traditional pantomime are frivolous, gay, vain, and irresponsible; to cast them in the roles of sober lovers and concerned parents quickens our awareness of the differences between the fancifully artistic roles they play on stage and the backstage life the performers lead.[19] Picasso had been anticipated in this irony by poet Charles Baudelaire in a vignette entitled "*Le Vieux Saltimbanque*" included in the posthumous collection *Le Spleen de Paris* (1869). It describes how Baudelaire, finding himself in the middle of a holiday carnival, caught sight of an old clown, "stooped tottering, decrepit, a ruin of a man, leaning against the jamb of his hovel; a shanty more miserable than that of the most brutish savage."[20] The poet was overwhelmed by the sight of a clown who had "abdicated," whose "fate was sealed." Then, suddenly, the crowd surged and swept Baudelaire away.

> But I looked back, obsessed by the sight, trying to analyze my sudden
> depression, and I said to myself: "I have just looked upon the
> archetype of an aged man of letters who has been the brilliant
> entertainer of the generation he has survived, the old poet without
> friends, without family, without children, degraded by poverty and
> the ingratitude of the public, and whose booth the indifferent world
> no longer cares to enter."[21]

How fitting that the one to feel such disconsolation at a fair should be he who had written of feeling a "sense of *solitude,* since my childhood. In spite of my family, above all when surrounded by my comrades—the sense of a destiny eternally solitary."[22]

Of painters the only one to capture the full sentiment of Baudelaire's feelings, identifying the serious artist with acrobats and clowns, was Pablo Picasso in his blue period. In many of the paintings done around 1904 the artist used a line of a curiously inorganic and constraining kind. His *Blind Guitarist,* for example, was conceived in terms of a system of fixed relations which imprison the old man by the very line that defines him. Similarly locked within themselves are the man and the woman in the famous etching *The Frugal Repast.* While the fixity of this couple joins them together in a way that has caused some critics to use them as an illustration of the love that survives against adversity,[23] it remains the case that they turn away from one another and are enclosed within themselves even as the woman is held, lightly, by the man.

Following the blue period, Picasso moved gradually (though swiftly) through the rose and Negro periods (1905-1908) into his mature Cubist manner. All of these developments were dependent upon a progressive detachment from living imagery, just as the enemies of modern art have insisted. What is not widely recognized, however, is the detachment and poignant isolation that had been present all along in the blue period representations of circus performers, laundresses, emaciated diners, and needy children conceived as prototypes of the artist who is victimized by an indifferent, philistine society.

The painters themselves did not realize the extent to which their designs stood for solitariness. What they proclaimed—and proclaimed correctly—as unique in the new art was its emphasis on purely visual truths of painting as painting. Ultimately, the Cubists came to recognize—as did others only peripherally connected with the movement—that their way of looking at art could be applied to virtually any kind of painting or sculpture. They discovered, in other words, "that almost all the great masters of the past could be considered Cubists from one point of view—to the extent that they had perceived and expressed the lasting structural values of reality."[24] They had, in still other words, discovered the "pure visibility" that scholars of Renaissance art had been developing at the same time artists like Cézanne had been intensifying the formal autonomy of their art. Formalist critics, of whom Roger Fry is the outstanding example, applied just such judgments to the art of the past, or at least attempted to do so.

It is surely not altogether without significance that, of all painters, it is the conscientiously impersonal Cézanne with whose works Fry's reputation as a critic was most closely connected and through whose apotheosis as a modern master Fry attained his greatest influence.

Fry's predilections were, of course, nothing more than reflections of historical tendencies being worked out around the same time by continental art theorists and major painters working in non-objective styles. It is, therefore, to be expected that many of the critics who followed Fry's lead shared his taste for the isolated as an inexplicitly constant theme in modern painting. Estrangement is a feature of contemporary taste that has touched every movement, every theory, and all styles, remaining influential even today. No conspiracy raised the solitary, the alienated, the estranged to frequent significance. Rather, it was a burgeoning preference that had come to form a central part of the domain of modern individualism.

The objectives of any movement in art or criticism are usually too diffuse to remain confined by a single category. One aspect of an avant-garde easily passes over into a second and that into a third; consequently, there is overlapping throughout the connected series of styles that have come to be referred to as "modern art." One of these avant-gardes, which appeared in 1916 in conservative Zurich, was completely dedicated to alienation as a way of life. I refer, of course, to Dada. Dadaism was contemptuous of every notion of intellectual respectability; it was a cultural demolition operation which contended that all things are meaningless and every activity futile.

Surrealism, the child of Dada, was specifically committed to dealing with the matter under discussion—human estrangement and social alienation. The Surrealists were inspired to try overcoming barriers to communication by means of a universal symbolism grounded in the irrationality of the art many of them had practiced as Dadaists. Freud had stressed that in psychoanalysis fantasy and reality are to be treated alike and that, moreover, the structure of fantasy is dictated by deepest human nature which makes the symbols of dreams and delusions universal, constantly recurrent in fairy tales, myths, literature, and popular sayings. Freud found in this an explanation of the poet's ability "to carry us with him . . . and to arouse emotions in us of which we thought ourselves perhaps not even capable."[25] Consequently, his papers are studded with references to the fine arts and contain several famous studies of artists and writers. It is this connection between the fantasy worlds of psychoanalysis and traditional art forms that gave the Surrealists the hope that, through the elimination of the subterfuges of culture and reason, they would be able to achieve a universal language of human emotion.

That attempt contained a fatal inconsistency. For the world of Max Ernst, Salvador Dali, Michel Leiris, Louis Aragon, or any of the others is the world of introspection; if it has a meaning for the observer it is a meaning for him or her alone, inevitably bound up with his or her particular psychic history. And, should it be true, as Freud and Jung held, that the myths people have made are

psychic necessities reinvented by each of us in the fantasies of our days and nights, they are still, so far as each of us is concerned, our myths alone, just as one's mouthings are never really shared with another. The Surrealist movement proclaimed what everyone already knew: all of us are in this together—by ourselves. Too, there is something in Meyer Schapiro's idea that "we recognize the authenticity of certain paintings in their *strangeness*—precisely because the symbols cannot be readily communicated. . . . We are suspicious of the paintings of Dali, for example, because we recognize the symbols."[26] Salvador Dali was the popular Surrealist, a good deal of whose appeal lay in the familiarity of what he himself referred to as the "discredited academicism" he applied to incongruous combinations. Dali, like René Magritte, the Belgian, and Yves Tanguy, a French merchant seaman, had been inspired by Giorgio de Chirico's lonely piazzas and empty ruins. Their works are also full of loneliness. In point of fact, Dali had absorbed into his monster playground Tanguy's weird stage where delicately fragile enormities cast iron shadows onto a landscape that has never known the human presence. Max Ernst's world was not entirely bereft of humanity, but the rare appearances of ordinary creatures in his realm of excoriated nightscapes made them seem somehow uncanny—their calm regard of the bizarre divorces us from them as much as their world is removed from our own. Magritte treated people like mannequins and other elements of reality as banalities whose only interest resided in their symbolic conjunctions. He can be very amusing, but intimacy with him is impossible. And the beings who populate his pictures are as cut off from one another as he is from us; his *Lovers* kiss, but their faces are covered by the hoods they wear. His nudes turn, above the waist, to stone or dead fish. A woman's naked body contains, as well, the fragment of a clothed male who encircles her waist with his arm and strokes her thigh as she fights to push him away. In Magritte's dreams, when intimacy is not forbidden, it is full of hazard; it is made still more lonely than solitude.

Surreal influences can be seen in the works of any number of socially conscious artists working in Britain and America. Surrealist incongruities and Dali's machine-slick finish pop up in the works of Stanley Spencer, Paul Nash, and George Tooker. *Subway* from the Whitney Museum of American Art is typical of Tooker's depressing commentary on the loneliness and anonymity of contemporary urban existence. His people are often the same person, repeated with variations in color. There is never any communication between them. The harsh geometry of the underground's passageways imprisons them, yet, troubled by the situation, they are powerless to talk about it. What makes such a picture effective is, surely, the fact that it is very, very close to being matter of fact. It is what literary people are apt to call "Kafkaesque." And if to so describe it employs a cliché, that is because the cliché fits circumstance so well. The world Franz Kafka described in his short stories and novels was inspired by an earlier, less bureaucratic time than ours. But what he extracted from Austro-Hungarian society at the century's turn brought into existence an atmosphere "reality had somehow neglected to bring into full focus."[27] For he understood how

officialdom will "justify" any evil at all by asserting that it is the unfortunate but unavoidable consequence of some higher law or purpose. The actions of Kafka's protagonists, comprised in a series of fruitless undertakings, are the only meaningful acts in a world otherwise devoid of sense; they are the undertakings of the prototypical Existentialist anti-hero. That is, their situation is consistent with the ethic of Jean-Paul Sartre for whom there is no reality except in action undertaken according to the formula that "one need not hope in order to undertake one's work."

During the 1940s and early 1950s artists absorbed the Existentialist ethic as an aesthetic attitude and, in so doing, drew from Surrealism new inspiration. The Surrealists had adapted Dadaism's "craziness" to their purposes by structuring it in terms of psychoanalysis. Jean Dubuffet, the French artist, replaced such pretensions with the direct imitation of what psychotics actually *do*, except carried forth on a scale more grand and with incomparably greater richness of surface. The artist committed himself to a "divine quest," standing apart from the world of normality, then worked out the commitment according to its own internal logic. But perhaps the most notable instance of producing paintings by means of Existentialist-like commitment is to be found in the work of the American Jackson Pollock who became notorious for his technique of dripping paint directly from cans onto a horizontal canvas instead of applying it to a surface held upright on an easel, depending upon fortune and intuition and self-reliance to win a final order from what threatened always to become aimless and chaotic.

We need not imagine that Jean Dubuffet or Jackson Pollock had read Sartre or Camus to see that their procedures could very well be taken for an aesthetic programme based on moral Existentialism. The feeling that the individual is isolated in a universe that, like Kafka's, is increasingly organized but fundamentally meaningless seems ubiquitous in the art and literature of the fifties. And the conviction that the solitary individual must create his or her own structure, tailored to the absolute uniqueness of the self and the situation, is pervasive even when it appears without the philosophical machinery and intellection of the Existentialist intelligentsia. Look at a third painter, the British artist, Francis Bacon. Bacon's paintings are full of sick animals, slaughtered beasts, hideous personages, screaming faces, and, finally, fragments of murdered, mutilated bodies. Of this, Bacon has said that his art is not about anything, really, except his own psyche, that he wishes "to remake the violence of reality itself."[28] Dubuffet remarked, "'Reality' is basically a question of habit. Most people are afraid of breaking it because they sense they might lose contact with other people and find out how alone they are"[29] What makes artists different from others, according to Dubuffet, is that they are solitary people to begin with. As Pollock had noted, in a similar connection, "Most modern painters . . . work from within."[30]

But, of course, some modern painters in the last three decades have begun working from the outside. Photo-Realists, for instance, take as their model of reality the image given to them by a camera. This has a moral as well as aesthetic significance, for photographic images are not the same as those presented to us by the human eye, and the interposition of mechanically derived proportions and tonal values between the thing seen and the picture fabricated by an artist insinuates a note of irony into the works. That effect is intensified when the scale of the pictures is—as it is in, say, the work of Chuck Close or Richard Estes—enormous.

The so-called Neo-Realists constitute a far less definable group. Painters such as Philip Pearlstein, Alfred Leslie and Stephen Posen mimic the actual in a very careful fashion but their techniques are more allied with conventional trompe l'oeil art than with photography. In this regard their works resemble the academic attack on the still life since, in conventional still-life painting, the play of shadows and forms, the contest of lighting effects and solid objects, and the pure formalism of realistically painted objects are all taken for granted. When applied to portraiture or figure studies, the effect of approaching human beings in so detached a manner is to delete any suggestion of the spirit from the representations of people. Today the element of social contact in figurative painting operates largely on the implicitly inferior level of applied art, in popular illustration and cartooning which have, in effect, become the art of the proletariat and uncultivated middle classes.

We have, in the course of this brief survey, observed no movement openly antagonistic to human interchange. Yet, the one thing modern art work has consistently revealed is the isolation prevailing when every overt hindrance is eliminated. The extent to which fine artists are alienated from every public except the most elite and specialized followers of serious art is evidenced in the history of the various avant-garde efforts which have perpetually oscillated among various forms of estrangement. What, after all, can be more clearly an instance of this tendency than the emergence of conceptual art, a movement devoted to the disavowal of art as a privileged category of activity ? Without the special status conferred upon art by the elite, the conceptualists would have no station from which to mount any appeal whatever. Consider how disastrous it would be for the people who support conceptualism as a direction were proposals to eliminate distinctions between art and life ever to be taken as seriously in Western Europe and America as they have been in Southeast Asia. Today's avant-garde depend absolutely upon the existence of museums, collections, and commerce in art because conceptual art is really a radical variety of art criticism which, like Dada, raises aloft defiant banners in the form of rather routine philosophic queries. Its proponents can afford to be smug in their discontent, for they are well aware of the likely longevity of their supposed foe, bourgeois art. Irony is the daughter of time, time the mother of despair. The siblings have met in modernism and evoked the face of loneliness. Still, it is a face of real character, yet capable of a wry, self-abusing grin. One of the

amusements for the observer of the current art scene is the willingness of the postmodernists to tolerate what was once considered the nadir of capitalist culture: kitsch.

THE ANATHEMATIZATION OF ILLUSTRATION

Until recently it would have been difficult to find a reputable art critic willing to defend the idea that illustration and Art have anything in common. Although the question whether illustration can ever be considered art was constantly propounded by those who teach others to be artists, it played an instructional role somewhat like that of the host's young children at a cocktail party— brought out only to be dismissed. In studios of fine arts schools, in the lecture halls of state universities, and even in seminars concerned with teacher education, art instructors concluded that illustration cannot be Art. Illustration, they conceded, may be admitted as art in the sense of a human skill, but it does not seem to carry the special kind of imaginative truth we represent by the capitalized term "Art." A pious and overwhelming consensus prevailed and, except among the poststructuralists and (ironically) the "commercial artists," prevails still today.

Any separation of Art from illustration would seem absurd were one to come upon it unawares. What, after all, are Albrecht Dürer's woodcuts, depicting elements from *The Revelation,* if not Art? And what else are we to call the bold conceptions of Olympus that hallmark Classicism, or the hundreds upon hundreds of portrayals of Christ's Passion? Practically no one would ask that these things be considered anything but Art. And the present critical view is that they *are* Art, not illustration. The two conditions are seen as mutually exclusive; Art cannot be illustration any more than illustration Art. Moreover the matter is so conceived as to make even the purported intentions of the artist quite beside the point. Dürer, for instance, may have intended merely to illustrate St. John's poetry; his genius, though, produced true Art. Thus treating the two categories as invariably dichotomous resolves an apparent dilemma. And while the solution may seem forced and unconvincing, it is none the less consistent with the actual practices of living artists and their patrons.

Not only abstractionists but, among serious painters, extreme realists too disdain the "merely illustrative" and are quick to avow the precedence in their works of formal considerations. Andrew Wyeth and Walter Murch, for example, could scarcely be distinguished from non-representationalists were one to judge them from their words alone.[31] Even those whose paintings derive from commercially improvised designs do not contradict the reigning attitude. In the early 1960s Andy Warhol puzzled conservative critics with what seemed to them a challenge to the whole modern frame of mind. He showed huge pictures of Campbell Soup cans done in a very straightforward and unpainterly manner. Since the paintings resembled, in the most precise way, the vignetted renderings that appear in advertisements, many people saw in them the equivalent of

commercial illustration. (Of course any number of art historians, ever on the lookout for the new realism, were quick to herald its arrival in Warhol's cans.) That was a mistake. In actual fact Warhol's ingenuity manifested itself not in any challenge to established fashion but rather in his revitalization of that very fashion. He maintained the dichotomy, he did not destroy it. Consider that his soup cans are not renderings of soup cans as such; they are copies of *pictures* of soup cans. This distinction between a first and second order of representation is a very real one, at least among the *cognoscenti* of so-called "Pop Art." Warhol, Rosenquist, Fahlstrom, and Lichtenstein took as their subject matter the most hackneyed kinds of illustration and cartooning. By formalizing the properties of low-brow art and magnifying them so that they dominate our attention they produced the grotesque as a style, as a delightful manifestation of the debased. Theirs is a pictorial language of stereotypes and, inevitably, individual works have been compared with icons[32] and with totems.[33] Not everyone concedes that such works are Art, but no one any longer supposes them to be the same as illustration.

The anathematization of illustration by serious intellectuals is one of a group of associated phenomena of modern history. The emergence of the intellectual class itself is another. And so is the appearance of *Art* as distinct from craft or skill. Raymond Williams, in *Culture and Society,* shows that this use of the term comes into common English during the last decades of the eighteenth century in company with the use of "culture" to designate a norm opposed to that of the despised masses.[34] Only as capital and industry make possible the total democratization of life is there any serious demand from the highly literate for prescriptions of eliteness to distinguish their values from those of common folk. It can be argued to considerable effect that the very notion of absolute standards of decorum in life was already a response to the incursions of a "patent nobility" (drawn from the wealthy middle class) upon the ancient privileges of the nobility of gentle birth.[35] But all that needs remarking here is that for the greater part of history painters had no notion that they were creating anything but good, mediocre or poor pictures. Apart from its commonsense connection with specific narrative *illustrate* would have been distinct from *picture* for Leonardo only by reason of its greater generality. For him the suggestion that a panel painting by a routinely competent artisan might not be Art would have been meaningless. Such transcendent, exclusive concepts of value did not exist for the Quattrocento. Men of the Italian Renaissance, having arrived at the idea of intellectual property, worshipped genius in the arts. But Art was invented by a later, industrial age.

Historically, antagonism to the illustrative began in a reaction against traditional notions of what constitutes seriousness in art. Until the middle of the nineteenth century all major paintings in the West—with the exception of some by Vermeer and Chardin—ensigned their importance with an imposing subject matter. Even those provocations of the flesh by Boucher and Fragonard purport to be pictures of gods and goddesses, despite the obvious triviality of their

themes. Pieter Bruegel's peasants give moral instruction but were looked upon in their time as conversation pieces of modest significance. One of the reasons the classical style was so long associated with ideal perfection of form is that there was in fact a hierarchy of appropriate subjects for the fine arts. At the pinnacle stood the content of philosophy and religion, next below came the majesty of events from classical antiquity or the biblical past, then history, then portraiture, and so on all the way down to the lowly still life, which could make small claim to any but the most prosaic kind of "truth."

A supreme example of greatness in painting would be something of the order of Raphael's misnomered *School of Athens* in the Camera Della Segnatura of the Vatican. Its theme is philosophy and the explicit subject matter an encyclopedic grouping of great thinkers, whose arrangement is determined by their importance, their chronologies, and the schools of thought they represent. Yet the work is on a higher level than a pictorial outline of the history of philosophy would be. The intellectual clique to which Raphael belonged subscribed to a doctrine maintaining that any proposition from Plato could be translated into a corresponding principle in Aristotle. The picture, really, is an illustration, of this bizarrely intricate theory. As Edgar Wind has said,

> Raphael placed the two philosophers, who "agree in substance while they disagree in words," in a hall dominated by the statues of Apollo and Minerva: the god of poetry and the goddess of reason preside over the thoughts which, concentrated in Plato and Aristotle, are spread out and specified in a succession of sciences: these answer each other in the same discords and concords in which Plato and Aristotle converse. The theory is abstruse, perhaps even absurd, and I may say, from personal acquaintance, that it is a rarefied form of mental torture to study it in Renaissance texts, but in Raphael's figures it acquires a luminosity which overwhelms the spectator . . .[36]

Form and content are married here in "remarkable combinations of intellectual precision and pictorial fantasy."[37] The painting not only deals with Truth as the sixteenth century comprehended it, but is quite literally an illustration of a specific theory of philosophical exegesis. At the closing of the Renaissance the aims of painting were extremely elevated. And, as we have noted in chapter 1, such grandiose conceptions of the theme obtained throughout the Baroque, persisting even into the nineteenth century.

On the other hand, one can observe a general decline in loftiness of themes whenever the middle class comes into an ascendancy. In a few instances that class—like some of its members—aspires to nobility, but its art cannot long sustain such aspirations. Thus paintings from the burgher-dominated Dutch Republic are far less pretentious than those done elsewhere during the Baroque. Rembrandt is "the most spiritual emanation" of his age only in so far as his uncanny vision probes human subjectivity. Except for him great Dutch art is pretty much a family album. The Calvinist religion of Holland tended to

reinforce middle-class preoccupations with worldly competence, wholesome comfort and domestic security, thereby directing Dutch attention towards the mundane rather than the eternal. Catholic Flanders next door had a larger middle class earlier than Holland, yet the Flemish were possessed by a veritable Cult of Majesty. But Flanders was a monarchy; while the wealthy middle class was influential, "ascendant" does not describe its situation. Even so, of all the masters of the age the Flemish painter Rubens was to the forefront in trivializing the classical style—largely through his use of it to ennoble the vacuities of Marie de Medici, but also by way of the natural liveliness of his own manner. Contrast Rubens' work with that of his peers in the less bourgeois lands of France or Spain or Italy. The restraint and gravity in Poussin and Velasquez and the compression of intensity in Caravaggio all conspire to show up the mundane worldliness that informs so much of later Flemish painting. It is not without significance that landscape first flourished in the Netherlands. For it is in depictions of the immediate environment that the middle class finds subjects most congenial to its matter-of-fact interpretation of existence.

A similar psychology directed French Impressionism, the movement which represents in fact the private values of a bourgeoisie ascendant. Where Impressionism differed radically from all older art was in its themes. The history of modern art depends to a far greater extent than is generally supposed upon the introduction into painting of new thematic content. And of all themes those of the Impressionists have proved most influential. To say so sounds odd, certainly. The world that they depict is largely made up of boulevards, cafés, theatre parties, horse races, picnics, and domestic ease. Monet and his colleagues created, for those lonely people they portrayed, an otherwise ideal realm of generalized attractiveness, happiness and enjoyment; with rare exceptions they portrayed French life as a vast, unending vacation. Theirs is an art of pretty colors which shows us lovely things. Impressionist landscapes, for example, were purely scenic phenomena. A sunset had no room for cattle homeward bound with udders full; it had nothing to do with the rural concept of the end of the day. Instead the sunset afforded an overt opportunity for aesthetic contemplation of nature as a spectacle; it was an interstice between a vacation outing and the *café* activity of the night. Meyer Schapiro has articulated the importance of these Impressionist themes for succeeding generations:

> If the concept of abstract design were stated in terms of an antithesis to Impressionism, the leap from the apparent Impressionist realism to a theory of abstract design was easy precisely because the subject-matter of Impressionism was already aesthetic. . . . Hence it was a simple step to the statement that the art of painting resides in the coherent combination of shapes and colors without respect to their meanings. The meanings were all the less important since Impressionism had destroyed the clarity and integrity of single objects [through its technique of breaking the world up into myriad

color sensations.] Already for the Impressionists the meaning of a picture pertained to its whole and was primarily aesthetic.[38]

This statement may appear at first to exaggerate the central character of one particular tendency and do injustice to other more important factors. It may seem to neglect the eminence of someone like Vincent van Gogh, whose proto-Expressionism prefigured so much of twentieth-century art. But one must understand that for van Gogh too the meaning of a picture grew from its appearance. He recognized an emotive content resident within the visual forms themselves: "I am always in hope of making a discovery [in the study of color] to express the love of two lovers by a marriage of two complementary colors, their mingling and their opposition, the mysterious vibrations of kindred tones; to express the thought of a brow by the radiance of some star, the eagerness of a soul by a sunset radiance."[39] That is precisely what an abstractionist like Kandinsky hoped to achieve. He envied the ease with which music, the least material of the arts, expressed feeling and said of his own work, "The observer must learn to look at the picture as a graphic representation of a mood and not as the representation of objects."[40]

Precursors such as van Gogh are by no means isolated phenomena. Such interlinks between Impressionist realism and twentieth-century abstraction turn up on every hand during the *fin de siècle*. Ordinarily the connections are not obscure at all. For example, one whole face of modern painting is typified by the art of Cézanne, who made the role of structure and coherence more evident and thereby led younger men to extend the range of its applications to new elements.

MODERNISM AND THE CLASSICAL HIERARCHY OF SUBJECT MATTER

Cubism is the first non-ornamental painting to portray nothing but itself, to assume that a painting is only a painting, just as a building is a building, and that a picture ought to look no more like a segment of real space than a house ought to resemble a baker's roll. In breaking with the manufacture of illusion and thereby freeing the painter from boundaries that, even to Cézanne, had seemed self-evident, the Cubists established an altogether novel convention, making their art a creative expression of pure visibility. In an important sense Cubism *is* contemporary art, since without the example of its autonomy the movements that succeeded it would have been impossible. It does not stand apart from history, of course, but it is the peak moment in that voyage to the present begun with Impressionist aestheticism.

Among the things that make Cubism so very prominent is that its appearance necessarily coincided with the emergence of a new interpretation of "seriousness" in art. As a style it rejects the previous hierarchy of subjects by completely breaking with all things contained therein. It begins and ends with

the assumption that nature and art are utterly dissimilar: the one absolutely accidental, the other rigorously formal and self-sufficient. That position may seem quite close to the view of classical humanism, which also distinguishes between noble art and mundane reality. But classical art, as we have noted earlier, depended upon an explicit hierarchy of subjects; Cubism relied instead upon the abandonment of content. Which is not to say that Cubism is without a class of themes. Its most frequent subjects are still-life objects drawn, like Cézanne's, from casual bohemian life. But in principle, at least, it did not matter what was painted. Picasso had actually separated the mode of representation from the things represented. As he once said, in a statement alluded to previously: "Art has always been art and not nature. And from the point of view of art there are no concrete or abstract forms, but only forms which are more or less convincing lies. . . . Cubism is no different from any other school of painting." [41]

Looking back, one can see the thing was in the air. Whistler and Wilde had talked like that during the 1880's and the champions of a theory of pure visibility in art history were arguing exactly the same way, even though most of them had no interest at all in modern painting or sculpture. It was only a question of time before someone—if not Picasso or Braque, then Matisse—attempted to turn painting into an art of pure construction like musical composition. It was one of those ideas whose time had come and its inevitability gave Cubism a sway unprecedented in the history of artistic innovation and an appeal that went far beyond the quality of individual pictures. Moreover the style ensigned the emergence of an utterly new critical attitude towards all art.

When Henri Matisse made his statement about the Giotto frescoes at Padua, he was putting into a painter's language what Formalist critics Roger Fry and Clive Bell were calling "Significant Form." In 1914 Bell had written, "The representative element in a work of art may or may not be harmful; always it is irrelevant." [42] By 1928, in a new edition of the same book, he was arguing that realistic forms in an otherwise good composition tended, because of their extra-aesthetic references, to distract one from the relationships of lines and colors that constitute the picture. Formalism viewed every subject as a mere pretext. Where classical critics saw form as a condition of the contents and most art historians of the purely visible believed form was the basis of content, Formalist art critics saw the contents as at best merely the raw material of form, at worst as disruptive, and never as a constitutive element of artistic value.

But despite everything that can be said in support of Formalist detachment the fact remains that we cannot dismiss altogether the fact of representation. Some critics behave as though behind every seen work lies a "true" work of art, buried beneath a subterfuge of imagery. Thus in Ingres the "real" work is a skeleton, a ghost abstraction. This view is altogether foreign to common sense, which tells us that the simplified schematic is not the picture. Certainly it is true that Raphael's *School of Athens* can be appreciated as a formal exercise, but that is no reason to blind ourselves to what else it is. Not that it is possible to ignore

the representational element. We could not bring ourselves to that no matter how cogent we find the truth that forms are forms after all, and not reality.

E. H. Gombrich, among others, has shown that Picasso's statement denying the existence of any distinction between "real" and "abstract" forms is quite correct; even photographs give us plans of visual reality rather than copies of it. But these "Gestaltist" critics have also proved that representations of things inevitably influence our conception of the form, and "pure" forms have meaning for us only in connection with our somatic orientation to the world.[43] Contrary to Bell's opinion we *must* bring something from life to appreciation of a work of art. Not because we ought to do so, but because we cannot do otherwise. Conceptual habits necessary to life require it. The postulate of a critical approach to art unbiased by subject content demands the impossible. It is obvious that no one, least of all the painter, can look upon the *School of Athens* as nothing more than a schematic diagram and color pattern. It is possible that someone from an alien culture might see no more than arbitrary spots upon a wall. But he who comprehends the pattern as a design will also understand that it is figurative. And he will understand something more besides: what Raphael portrayed is higher on the scale of human values than is the portrayal itself.

Even if all kinds of themes have been admitted in principle to be equal, and after one has conceded that value is located in the quality of the painter's handiwork, it is still necessary to grant the existence of an influential hierarchy in the arts for this reason: Some things, such as deities, are more important than any depiction of them can ever be and some, like apples, are of less value than even mediocre pictures. Too, there is a kind of equivalency between a painted landscape and the scene itself, since both can be looked upon as similar occasions of visual delight. There can be no doubt that Roger Fry was right; the apples of Paul Cézanne have a profundity that Lawrence Alma-Tadema's Romans do not. But that is not the end of the matter. Alma-Tadema was at his best with marble, Cézanne at his worst when he portrayed heroic antiquity. One can readily enough entertain the idea that each man's reach for themes of grandeur exceeded his grasp. But the fact is that except for a certain literary pretentiousness Alma-Tadema's skills would have passed without remark. Cézanne, on the other hand, invested prosaic still-life objects with a dramatic precariousness that leaves upon one "the impression of grave events," of having witnessed "dramas deprived of all dramatic content."[44]

It is unnecessary here to get into a discussion of Form and Content. Consideration of their relationship leads to very little except high-flown speculation. Questions concerned with specific styles and certain themes, however, are historical questions whose answers can be verified. We have seen that it was typical of innovators during the late Middle Ages to focus their attentions first on subjects of relatively little iconic significance. Thus thirteenth-century revisions of medieval iconography in the direction of Renaissance realism occur not in pictures of Mary or Christ but in marginal figures, obscure saints, anonymous angels, and on the backs rather than the fronts of altarpieces.

Following somewhat the same pattern, the Cubists emphasized the insignificant still life.

In principle, it is true, the Cubists could have painted pictures of anything at all, or of nothing whatever, but in practice they tended to restrict themselves to the commonplace. The unpretentious still life was for them, as it had been for Cézanne, a model domain of objectivity. Apples, cloths, bottles, and cards, being in and of themselves without importance, permitted the artists to revise configurations radically—sometimes to the point where any connection to reality was deleted. When the techniques were employed in landscape and portraiture—as infrequently they were from the very outset—the landscapes are of no very special moment and the sitters are just friends who have been treated as facades, as pretexts for design. A *nature morte* view of things having no preordained hierarchy of value permeated the whole school of painting.

Modern art criticism and education have been influenced by many other movements, particularly Expressionism, but they have maintained throughout our century a preference for subjects whose status is equivalent to or less than any given work. And this is especially true where it might seem less apt to be. Rouault's portrayals of the Christian past were sponsored by a devout Roman Catholicism. Sophisticated contemporary critics, however, look upon his works as technical enterprises up-dating ancient iconography—an iconography which for them has to do with artifacts rather than religious beliefs. Chagall's Judaic fantasies receive from all but a few special critics a similar sort of treatment. Paul Klee, one of the few modern artists whose paintings are genuinely intel-lectual, has escaped opprobrium for precisely the reasons that the Formalists *say* the old masters have; he created visual symbols with the power to convey unique ideas.

Is it really the case that the masters we revere were formalists in the way suggested by modern apologists? It is certainly true that some were amazing geometers. And we owe to the experience of Cubism both Piero della Francesca's present reputation and Aldous Huxley's revelation that Caravaggio was more a composer than a realist.[45] But the fact is that academicians with reputations as low as those of Jean-Paul Laurens and Henry Lerolle exhibited a discernment of structural proprieties going beyond that of Eakins or Constable and matching, say, Fra Filippo Lippi's. So far as historical importance is concerned theirs is nil, whereas Eakins and Constable are of the second or third water and Lippi a major prominence in the evolution of the classical style. But none of that has anything to do, really, with the formal perfection of a given work or set of works. The conviction that it has, although a belief firmly held by many erudite men and women, seems to me quite muddle headed. Confidence in the inevitable superiority of work that is, for any number of reasons, significant to history has led some critics to argue that such works represent ideal or archetypal relationships of form. It seems unlikely that anyone really believes in such an aesthetic ontology, but many writers on art sound as though they might. The perpetual re-ranking of bygone artists that moves apace from one decade to

the next should by itself give any expert pause. Already, in the winter of 1909, Marinetti was saying on the front page of *Le Figaro*: "But we will hear no more about the past, we young, strong Futurists!" Today the young and strong wish to hear no more about the Futurists.

One might suppose that constant revision of the past would crush old reputations while bringing forth from history to replace them obscure creators whose true worth is suddenly manifested in new doctrines. And, of course, some of that does go on. But the greatest effect of accelerated change is further to standardize and shorten the list of reputable old masters. For only the very greatest genius possesses the range and power to serve as an eternal reservoir of inspiration and delight. Michelangelo's Sistine frescoes would be hard to imagine without the precedent of Signorelli's Orvieto Cycle, but Signorelli's *terribilità* influenced only his era while Michelangelo's passion infects us yet. The rich get richer, the poor poorer, the great grow larger and the less great shrink. In this connection it should be underscored that the very greatest masters have already survived centuries of largely "literary" analyses in which art criticism was non-formalistic and practiced as a kind of literary exercise in the dilettante essay.

One of the most interesting features of contemporary criticism is the informal method whereby we today distinguish the illustrative from the symbolic or artistic. It is a reflection of the deep seriousness with which modern art takes itself that contemporary criticism venerates the same things Neo-Classicism did, that is the imposing, the stately, the dignified, the universal. From the end of the Rococo on there had been resistance to the overt expression of emotion through violent or suggestive themes. Romanticism and, later, Expressionism were resisted on just such grounds. Lessing's famous argument in *Laocoön* (1766), contrasting the necessary repose of painting and sculpture with the violent expression of emotion through poetry, pioneered the modern argument for the sovereignty of formal beauty and virtually established reservedness as a condition for serious art. The aesthetic views of Lessing and Jacques Louis David, the premier Neo-Classicist, were linked phenomena despite the fact that the former resisted Winckelmann whereas the latter was his disciple. Indeed, we have already traced the lineage of contemporary Formalism back to the beginnings of pure visibility in Neo-Classical times. Neo-Classicism and Formalism share the same tastes for what is sober, detached, and pristine. And nothing confirms the closeness of the relationship so much as the employment of a subject-matter hierarchy by the very critics who pretend that themes are unimportant.

If we turn our attention away from what modern formalistic criticism claims for itself and look instead to the actual practices of its purveyors, we shall discover that—with some obvious exceptions—Formalist and classical criticism employ the same thematic criteria. Generally speaking, the things we moderns most value from the past depict historical moments of tremendous gravity or deal with subjects that are clearly significant. This is as obvious in our reaction

to genre painting as it is with respect to religious art; Vermeer's compositions are not only more obviously formal and self-contained than those of Pieter de Hooch or Terborch, his figures are more sedate. It is the frivolity of the people described by a man like Jan Steen that reduces his stature in our eyes. Regardless of a painter's standing, we prefer that work by him which we can call "restrained." The more somber the situation in Chardin the better we like him.

Of course there is an obvious exception. The Chardins most often reproduced monumentalize French domesticity in terms of the still life. The prestige of modern still lifes has lent grandeur to those of the past. And landscape too has been exempted from the classical rule because of the Impressionists and Cézanne. Still, despite the importance of these extremely bourgeois themes[46] to the development of contemporary attitudes, it is the idealized and noble subjects that win the immediate and unqualified approval of the present. In this connection one should remark the attitudes of artists themselves. Although many of the more significant paintings of the nineteenth and twentieth centuries are modest in subject matter, when artists today set out deliberately to do an "important" work they will usually select an exalted theme rather than a still life or landscape. Rarely do they depend upon the nude or upon portraiture unless these carry some larger theme. Instead they deal with mythological and biblical subjects, or disasters of war, or the contents of the culture. Sometimes, as in Ensor's *Entry of Christ into Brussels in 1889,* the theme is mocked by the representation. Thus Claes Oldenburg's soft vinyl versions of things that are normally hard and firm have definite sexual overtones related to an implied impotence of industrial society. Often the purported subject is a disguise for the painter's vanity—as are the luminaries who visit Courbet in his *Studio.* Nevertheless the ostensible subjects are consequential. Artists too capitulate to the antique rule. In fact they do so to the extent that when a picture has been inspired by some specific contemporary happening its artist will try to surmount specificity by treating the image itself as a generalized reference to all occurrences of the type. Picasso's *Guernica,* then, is an indictment of the oppression of living creatures by inhuman superstructures although the title refers to an event that occurred in a little Basque village on 26th April 1937. To have treated it realistically rather than in the emblematic way he did would have reduced its universality, diminished its theme, and quite possibly have turned it into an illustration of a single event.[47]

Today a picture is almost invariably considered "mere illustration" when it represents a situation with such explicitness that it can be understood only through external means such as a text or an explanation. Any dependency whatever will bring modern works into question. Curiously, the rule is not applied to ancient paintings no matter *how* abstruse their sources. Indeed, the relation of the narrative to the art work in such a case, far from being made secondary, is often enhanced by having become the object of scholarly attention. In fact our expectations are confounded when, as sometimes happens,

the painting is the sole record of the writing. To base one's art upon some author's work is parasitic in one's own time; to later ages it is evidence that artists too are learned.

POPULAR CULTURE AND LONELY CROWDS

There is another side to all of this. For in our age what de Tocqueville wrote of the art in his time has come to be entirely true.

> The painters of the Renaissance generally sought far above themselves, and far away from their own time for mighty subjects, which left to their imagination an unbounded range. Our painters often employ their talents in the exact imitation of the details of private life, which they have always before their eyes; and they are forever copying trivial objects the originals of which are only too abundant in nature.[48]

When one considers that the vast majority of paintings we see have been created by commercial illustrators with a view to selling products, one will understand just how well the quotation fits our day. Whereas a few great pictures were produced for the aristocracies, modernity produces for the masses a vast number of insignificant ones.[49] Still the fact is not quite that it produces them but that it reproduces them by photomechanical means.

Once this situation has been admitted it remains to be decided in what way the vernacular of commercial art relates to the esoteric languages of serious art. It is universally accepted that the relationship is a parasitic one because commercial art feeds off the fine. Advertising art directors haunt avant-garde galleries, searching for new "twists" to catch the attention of passersby, casual readers, and speeding motorists. But to insist that commercial art is parasitic is only partly true. It is true, certainly, but it is not the only truth, since in some cases— and so-called "Pop Art" is only the most blatantly obvious one—the relationship is symbiotic; the two kinds of art feed from each other. For commercial artists are not only the virtuosi of a visual commonality, they are its main custodians as well. One observes this in the class-crossing popularity of their comic strips, posters, illustrations, bookjackets, and animated cartoons. The observation suggests already a far greater cohesiveness of the different levels of culture than one usually supposes.

The truth is that one cannot speak of the comprehensive aspects of our society without touching on popular art. Interactions between such things as commercial illustration and serious painting are no longer of mere historical or comparative interest. They correspond to reciprocities that may have great significance for an age of increased social mobility and endless leisure. Inchoate prototypes of future taste patterns are evident now in the pseudo-cultures devoted to jazz, rock music, comics, and film. In these unexclusive fraternities, made up of per- formers and their fans, one observes aesthetic *continua* that afford almost

unhampered exercise of free expression and discernment. They comprise avant-garde seriousness as well as rear-guard trash. Devotees are not always tolerant of the diversity free association sponsors, for barbarisms abound and there is plenty of fraudulence in the "experimental" underground. On the other hand they are not alienated from the extremities they dislike in the way that outsiders are. Their world is far more pluralistic, far more open to variation. Thus it is entirely possible for an Acid Rock fan to experience without indignation John Cage's electronic sound while also treating without condescension both folk singing and Baroque chamber music. That kind of range is not accessible to the conventional lover of serious music because his or her sensorium is adjusted in terms of a distinction between "high" and "low" culture that more or less corresponds to the difference between Art and illustration in painting. That is not the case for jazz buffs. Not that they have renounced all standards of judgment; on the contrary, the nature of their taste presupposes a very discriminating selection, but the distinction between high and low forms of music is not so meaningful for them. Their sensibilities will accommodate, within a scheme of relative values, anything at a given level of intensity. Among young people especially, the high and the low merge together by insensible gradations.

I should not wish to suggest that such broadminded tolerance is characteristic of the majority of our youth. Obviously, most of them are conventionally insensitive members of the herd, paying homage but not much attention to whatever is topping the charts at a given time. Surveys of public opinion suggest that young people at the end of the millennium are as narrow minded as their elders—though in somewhat different ways. On the other hand a substantial minority of the college educated appear to be more tolerant of individual differences and less rigid in their worldviews than their predecessors. Their scheme of values has as its corollary a rather permissive social attitude that rejects as an illusion the objective existence of "the masses" and hopes for a more active conception of human beings and relationships.[50] At the present time everything suggests that this view of society will either eventually prevail over all others or the whole of European and American society will be riven by ethnic and class conflict. That is one of the reasons it has become important to attend to the qualities of pictures from a perspective that discards the distinction between Art and non-Art in favor of a *tertium quid* embodying non-art, good art, and bad art.

In a book now seldom read, *Man and Society in an Age of Reconstruction*, Karl Mannheim anticipated the auspices of today's postmodernist anti-aesthetic when he spoke of the tendency of democracies to produce many elites but to deny these the exclusiveness they require for maturation. Mannheim felt this led to aesthetic styles being apprehended by the masses as mere entertainments that could be consumed like any other commodity. If so, it is axiomatic that the absorption of modernism into mass culture in the form of a mere stimulus was foreordained by the existence of an audience for whom novelty is the last appealing "hook" in merchandising leisure. One has only to watch a few hours

of cable television aimed at young people to get some feeling for the way former avant-gardes have not only penetrated but have, in fact, conquered bourgeois culture and, in turn, been consumed by the gigantic amoeba of the popular will. It seems a confirmation of the existence of an unexclusive aesthetic continuum and surely reflects the postmodern renunciation of the meaningfulness of "great literature" or "fine art."

POPULAR WILL AND POSTMODERN LONGINGS

That adaptation of the cultivated minorities of the present to the new situation will not be easy is evident, I think, in the difficulty most of us have in accommodating our sensibilities to postmodernist works of the kind celebrated by poststructuralists of the Frankfurt School stripe. You will recall that these people are not just antimodernist in a conventional sense; they are actually anti-aesthetes—at least to the degree they oppose the bourgeois composure that lies beneath modernism's very thin veneer of radicalism. In point of fact, these postmodernists are the heirs of the upper-middle-class rebels who created modern art in the first place. There is nothing much new in their postmodernist manifestoes apart from the fact that the sheer, overwhelming success of modernism has made it unacceptably commonplace. The other kind of postmodernists are revisionists who hope to revive academicism or are (according to the left) really neoconservatives who want to reinstate modernism's vigor and exclusiveness. Of course, no one agrees on who fits where in all instances—least of all the artists themselves—but I estimate that such painters as Komar and Melamid, the Wyeths, Robert Longo, Eric Fischl, and James Butler would be at one end of this latter scale and Julian Schnabel, Anselm Kiefer, David Salle, and Gerhard Richter on the other. All of these men are either highly skilled technicians or are at least pretenders to experimentation with media. Since one of the things that more or less typifies the postmodernists of the radical left is antagonism to, or at least impatience with "standards" as being inherently oppressive logocentric measures imposed by the reigning culture, the art of people like Fischl and Richter may represent unwelcome evidences of social bias despite subject content that implies criticism of the society. But this kind of evaluation is blind guesswork, since the actual preferences of the people we are dealing with are not as predictable as the tastes of those they oppose. That very fact will be held up by them as evidence of the solid wholeness of postmodernist inclinations in contradistinction to the equally arbitrary judgments of a conservative elite that stakes the continuance of civilization and civilized behavior on the perpetuity of its literary and artistic canon. The only mystifying thing about this debate is the conviction of the antagonists that their views have any merit so far as bearing on human activity is concerned. Academics who represent the two positions rarely exhibit personally any of the merits they claim others will be likely to induct from exposure to the readings they prescribe; rather, they share with their supporters certain traits

which are reflections of the inclinations that brought them to one side or the other in the first place.

It is to be expected that people of my age, who were force fed on paragons of literary greatness from preadolescence through college, pay honor (if no attention) to Homer, Shakespeare, and Austen, while people who grew up watching television whilst observing the relentlessly self-serving hypocrisy of their educated elders have no qualms about rejecting the Great Books. It is now to the point where a majority of colleges and universities require scarcely a sampling of once deified literary works—at least in the United States. As I write, *The New York Times* has just (January 18, 1997) released a story by William H. Honan noting that a study by the National Alumni Forum finds that two thirds of 67 colleges and universities responding to a Forum survey indicated "that required courses on the great writers are falling by the wayside. In their place, courses proliferate on popular culture topics, such as 'The Gangster Film' (Georgetown), 'Melodrama and Soap Opera' (Duke University), and '20th-Century American Boxing Fiction and Film' (Dartmouth College)." The Forum president says this is happening because English professors do not want to teach what the students dislike. Roger Shattuck of Boston University is quoted as saying the study "documents nationally what many of us have observed: that shoddy propaganda is replacing the study of great literature," and Robert Brustein as follows, "Most English departments are now held so completely hostage to fashionable political and theoretical agendas that it is unlikely Shakespeare can qualify as an appropriate author." The article is, granted, a journalist's report and the quoted material selected to "punch up" the story, but I believe it would be hard to scare up much disagreement on the facts of the case. What you'll find in the way of contention are complaints that the so-called "canon" is not even a century old, that one man's propaganda is a feminist's statement of the facts, or that the printed word is part of a dead technology. Overarching any controversy of this kind in America is the confidence of the postmodernist left that all standards of literary or artistic merit are based on self-referential systems that perpetuate the values of certain social classes.

Probably every reader of these words will have run into the notion that the United States, far from being a "classless society," is actually a nation riven by so many distinctions of rank that only those on contiguous levels are aware of the finality of the divisions. As every deconstructionist will know, particularities of status are revealed in styles of clothing, house decor, language, leisure time pursuits, habitual postures, dining, and so on. European social life is still more hierarchical and the various steps on the social ladder greater in number, farther apart, and more difficult to negotiate without taking a fall. Any American who has spent even a little time studying the cultural history of France, Germany, or Britain cannot help but have been struck by the decisive effect had upon one's life by schools attended, degrees secured, sports played, music liked, entertainments preferred, things despised. In America the lines between high

and low culture are not so sharply drawn—indeed, Europeans have often enough asserted that none exist on these barbarous shores.

The haziness among cultural levels in the U.S. does not derive from some generalized philistinism. In part, at least, it results from the historically peculiar character of American education. In Britain and also on the continent traditional establishment values have been contained and transmitted through extremely selective educational systems of the pseudo-literary "classical" variety—through the "public" schools and gymnasia, through Oxbridge, the University of Paris, and Germany's *Universitäten*. Those who seek to oppose the élite there inevitably find themselves thrown into battle against all standards of decorum at once. In America the establishment has some strong affiliations with the prestige schools of the East, certainly, but the dependencies are vague and continuous associations between higher education and real power are far more tenuous in the "New World" than in Europe. In America the literary iconoclast has always had big business and its exclusively pragmatic world view to resist in the name of art. Men and women of letters have attacked philistinism, illiteracy, and shallowness of values. The more critical among them have raised their voices against racism (which amounts to the *most* distinctive class division of any in history) and the pious form of imperialism that used to go by the name of "Manifest Destiny,"[51] but they have rarely held literary tradition itself up to scorn. Until quite recently they had never done what European radicals began to just after World War I—that is, express revulsion for the entire aesthetic tradition of Western literature. For most of the twentieth century American intellectuals saw their enemy not in the bastions of privileged taste but in the babbitry of the business community and the puritanism of the public. The experience of the 1960s changed much of that. Young white liberals who joined with black civil rights activists in opposing racial segregation in the southern states of America were quickly disabused of the idea that legality had much to do with justice or that justice was itself anything more than "the interest of the stronger," in the words of Protagoras. The perception of these few was reinforced for thousands upon thousands by conflict with authorities over Vietnam and marijauna. Skepticism of officialdom combined with the morbidities of the Youth Movement (which was notoriously tolerant of everything "our parents warned us against") led to questioning all social conventions and every code established for the maintenance of public tranquility in the interests of the stronger.

That the prescriptives of higher education should be reviled by those exposed to harder truths of recent history is not at all surprising. When I entered college in the late 1940s things were mindlessly stuffy and professors still farther over on the left than they are today. Today there is no truly viable left—only a bunch of disaffected intellectuals promoting the kind of soppy open-mindedness which suggests folk tunes are on a par with Bach's *Brandenberg Concerti*, African folk tales with *Paradise Lost*, and comic strips with Caravaggio. That these comparisons may have genuine merit from a purely critical angle is one thing; to

believe they have much efficacy in the college curriculum is another matter altogether. Bear in mind that the author has been an advertising illustrator and graphic story artist and has, in fact, taught upper division college courses, studio courses in cartooning and once, in fact, wrote an instructional text, *The Complete Book of Cartooning,* which was in print for twenty years. Moreover, in another book of somewhat greater longevity, *Art: The Way It Is,* I have made use of cartoons and other kinds of popular art as springboards for understanding loftier works by the Michelangelos and Picassos of our world. But recognizing the commonalities of all varieties within an art form should not blind us to the great differences in quality and complexity that exist among individual works and artists. Most of us who teach others how to draw and paint are also very much aware of just how great those differences are.

In over thirty years of university teaching I could hardly have missed the tendency for academic fashions in curriculum tinkering to oscillate between classical pertinacity and romantic abandon. Either an overly scrupulous narrowness constrains imagination and the students are spoon-fed by a reigning elite from certified packets of knowledge or, conversely, every specialty provides freedom of choice in the cafeteria of course offerings, requiring only that the mishmash ultimately consumed have some arguable connection with with the three intellectual food groups (arts, sciences, social theory). The more conservative former tendency has the greater appeal for me insofar as its rationale at least intends to achieve a common basis of communication and understanding, but it is easy to see how severely restrictive and narrowly biased such a curriculum is. Still, so long as scientific technology and the resulting political culture prevail, the system will require for its social dynamic a culturally literate group to operate it in a decently just and responsible way. I grant that a wider sense of place in the world is to be desired and that place should, perhaps, include great works from below the equator and the east of the Aegean. But to imagine that every interest of the mighty is false on its own account is quite foolish; indeed, many if not most of the moral imperatives of Western culture are of positive rather than negative value. One of these—the sanctity of intellectual property—is a fundamental of modern life that genius has relied upon since the Renaissance. The basis of patent law and copyright, the right to possession of one's imaginative creations has now come under attack from postmodern activists and their apologists.

Be assured that there is nothing self-evidently justified even about the fundamental concept of ownership, let alone the notion of private property. There can be little or no question that the very idea of private property is itself a cultural fiction rather than part of any "natural" order. In aboriginal societies the only property of real significance is land which, typically, is communally assigned to family groups on a more or less equal basis. American Indians were forever baffled by the European view of boundaries and property rights; reason told them that no person possessed nature, that at most the use of some region might be controlled by a nation or tribe. After all, who possessed the dell when

only wild ruminents roamed it? In such connections power really is the end all be all. And the early modern history of England provides a perfect example of the way the strong gain their ends through such mystifications of reality as property "rights." The Whig Revolution and the rise of Parliament and the rule of civil law can be seen as devices well suited to the ruthless seizure of power by the upper classes who managed to give legal sanction to the identification of liberty with property.[52] Thus, John Locke made it a primary maxim of government that it "cannot take from any man any part of his property without his own consent."

When examined from a purely detached and rationalistic viewpoint, the extension of the concept of a right of possession to ideas rather than realty and material objects is surely a rather unlikely stretch from what is arguably arbitrary to the completely ridiculous. On the other hand, all sorts of social relations are subject to this kind of analysis, and civilizations could not stand were every convention subject to such relentless skepticism. For instance, in the biosphere the males of nearly every species attempt to disseminate their seed as widely as possible while females guard their eggs with a jealous fury. Promiscuous aggression versus circumspect belligerance in aid of sustenance of the gene pool. What could be more obvious than the ways in which our histories, myths, legends, and religions obscure and mystify this truth or human institutions strive to moderate inconstancy? Being "civilized" is the same as being unnatural. And some kinds of unnaturalness are more honorable than others.

Derrida's fascination with collage derives in part from the way the form encourages appropriation of others' works and skirts theft by situating what has been pilfered in a new context. Normally, it is easy to see where the line between outright thievery and propitious adaptation falls. Sometimes a startling difference between the meanness of the inspiration and the gloriousness of the presentation make for a kind of masterpiece. In the fine arts, the collages of Surrealist Max Ernst fall into such a category. But in the world of cinema we have a stunning example in one of the most influential films ever made— George Lucas' 1977 picture, *Star Wars*.

Star Wars is legendary for many reasons apart from its success. To begin with, no one was really interested in making it; in fact the Hollywood big wigs couldn't even make sense of what Lucas wanted to do. Most of those men— even the few interested in science-fantasy—were not postmodern enough to appreciate how powerful were the collage elements of Lucas' intentions. That is understandable; when I saw the opening, I was conceited enough to think I'd be the only one who appreciated the show, because I could read the sources well. The mythos from the schlock theorizing of Joseph Campbell serves as a loose outline for stuff plucked from such diverse sources as Fritz Lang's *Metropolis*, Riefenstahl's *Triumph of the Will*, Alex Raymond's *Flash Gordon* (and the Buster Crabbe serials based on it), the Volta men from an obscure 1940s *Planet Comics* strip, "Lost World," and so on and on. Even the subtitle—"Episode IV:

A New Hope"—and the long crawl of words pretending to be a synopsis of what had gone before rolling back into the infinity of a starfield, suggested a very classy Republic Pictures serial. So what actually thrilled this viewer about the film was that my childhood hopes had been fulfilled. For *Star Wars* was the way all of those Depression era Saturday matinee serials from Republic and Universal *should* have been. Indeed, it surpassed even the magnificently false memories that make nostalgia so much finer than past reality. Only a few enthusiasts of the epic trilogy by Lucas could have been old enough to be moved in this way, of course, even given the fact that for decades the old serials had been used as "filler" in the wasteland of children's television programming. Clearly, there is a good deal more to the popularity of *Star Wars* and its sequels than nostalgia. More, too, than merely the way it grafted the individualistic ethic of the Western onto a science fiction tale that has a pseudo-religious subtext running through the whole thing. One of the things that has made it an icon for some of both kinds of postmodernists is the absence of many of the more obviously offensive logocentrisms. Westerns, for instance, are generally full of sexism, implied racism, and ethnic or class prejudices.[53] In *Star Wars* a young woman, Princess Leia, and her Alliance are dedicated to achieving independence from an imperial enemy that is as exclusively Aryan as a Nazi's dream while the rebel band itself is not only multi-racial, it's species mixed. (The television series *Star Trek* also included non-humans as part of the starship Enterprise crew, but they were humanoids and, in any event, the galactic federation Capt. Kirk and Spock work for is just as imperialistic and materialistic as Darth Vader's Empire—or, from the New Left angle, the United States.)

That the superficial character of *Star Wars* is steeped in liberal sentiment, doesn't mean it is anything other than a paean to the social system that spawned it. Like most wildly popular creative undertakings, the film is anything but alienated. On the contrary, the Force itself is a sentimental antidote to estrangement; the Alec Guinness father figure character, Obi-Wan Kenobi, describes it as "an energy field created by all living things." That only sounds as if it means something, but it is exactly like the slogans of New Wave revivalism and fits nicely with the peculiar tradition of evangelical "boosterism" and restored innocence that is deeply linked to the very roots of American culture. It is like some kind of optimistically ingenuous variety of the kind of collage fiction written by E. L. Doctorow, Kurt Vonnegut, or Ishmael Reed.

This excursus seems, perhaps, to have taken us far from the subject of estrangement, but the distinction between derivation and appropriation is made very clear when works by Lucas or Doctorow are contrasted with, say, photographs made by Sherrie Levine during the early 1980s. These are rather poor copies of halftone reproductions of photographs taken by Edward Weston. Levine simply framed them for exhibition in New York's Metro Picture Gallery with labels describing them as being "after" Weston. When this led to a lawsuit threat from the Edward Weston estate which holds copyright to Weston's

pictures, Levine began using work from the public domain in the same way. While that generally freed her from legal action, her work of this kind remained nothing more than theft—albeit thievery undertaken as a deliberate challenge to the concept of private ownership and in advocacy of the collective ownership of everything, including images and, most especially, ideas.

When one looks at Levine's appropriations alongside those of others of her ilk in comparison with somewhat analogous "lifts" by the Dadaists and Pop Artists or the reliance on prefabricated motifs by Lucas, the obvious question to pose is "just where does one draw the line" between the permissible and the unacceptable borrowings. Usually, the implication is that no line can be drawn at all for fear of excluding something one ought not. The inference, however, should be that failing to draw lines leads to exactly the kind of thinking poststructuralist social theorists and postmodernists of Levine's stripe promulgate. It should be clear that Doctorow is at one end of the scale, Lucas somewhere near him, commercial hacks well down the range towards mimicry as routine production, and Levine the moral equivalent of an embezzler. Open-mindedness, carried beyond a certain point, constitutes a public menace. As the promulgators of these notions consider the role of ownership in social relations, particularly in America, they might pay heed to the fact that John Locke's triadic ideal for government was life, liberty, and property while Thomas Jefferson's was life, liberty, and the pursuit of happiness. The difference is not merely rhetorical. Surely, Jefferson had in mind as the recipients of these things, white men of property and education but, as it turned out, the shift of language opened the gate to all including women and those of color. Even though the democratic ideal venerated by him could not be fully put into practice because of concessions he and later statesmen were obliged to make to racism and privilege, it has remained a guiding beacon and has, in fact, been the basis of the dreams of champions of liberty from Thomas Paine through Susan B. Anthony and Martin Luther King, Jr., to the present moment. But this kind of apologia will not impress the poststructuralist left very much. Their thinking is very much within the modernist tradition of disenchantment following in the wake of World War I.

In terms of the history of ideas, that war was unique, for it was conducted as a systematic, rationalized slaughter in which the thousands of dead who participated in desperate acts of horror were merely carrying out routine transactions subordinate to the tremendous effluences of the warring economies. The stalemated nature of the conflict on the Western Front, the ghastliness of trench warfare, and the total absence of a decisive strategy on either side emphasized the purely mechanical aspect of the hostilities. It was far easier to think of one self as a cipher at Verdun than it would have been at Austerlitz, Shiloh, or Sebastapol—even easier than later in patrol actions on Gaudalcanal or during the fitful firefights for the hedgerows of the Bulge. The reduction of men to mere instrumentalities was supposed to have ended with the hostilities, but for many the experience revealed the governing forces of modernity and thereby

rendered the experience interminable and modern life intolerable. It fostered a view of industrial capitalism as an inherently deceptive scheme and the civilization it sponsored an enormous lie.

The New Left absorbed that view of things and, in the wake of World War II, Korea, Vietnam, and the Civil Rights struggle, strove to reveal the unintermittent deviousness of the controlling classes throughout the twentieth century. To them, whatever might impress the uninitiated as social progress that can be obtained by "working within the system" is, in fact, just a sop to make oppression more tolerable. Suffice it to say that many of these theorists hold an unduly Machiavellian view of ideology as a form of higher cunning. Herbert Marcuse, one of the leaders of the Frankfurt School, took account of the seductive elements of our advanced industrial society.

> In this society, the productive apparatus tends to become totalitarian to the extent to which it determines not only the socially needed occupations, skills, and attitudes, but also individual needs and aspirations. It thus obliterates the opposition between the private and public existence, between individual and social needs. Technology serves to institute new, more effective, and more pleasant forms of social control and social cohesion. The totalitarian tendency of these controls seems to assert itself in still another sense—by spreading to the less developed and even to the pre-industrial areas of the world, and by creating similarities in the development of capitalism and communism.[54]

The "oppressed" are indoctrinated by the commodities, entertainment, and information provided to them by a society that militates in this way against what Marcuse called "qualitative change." He has in mind the totality of organized industrial society today, but a taste of what postmodernists can make of certain components of the whole was beautifully cooked up in a display by conceptualist artist Hans Haacke in *Tiffany Cares* (1978).

Haacke's send up is in the form of an elegantly trim display case that contains a public relations advertisement from Tiffany & Co., purveyors of baubles for an extremely wealthy clientele. Their message, titled "ARE THE RICH A MENACE?" is a curiously wheedling defense of the "trickle down" theory of economic progress, beginning: "Some people think they are, so let's look at the record. Suppose you . . . acquire a million dollars net after taxes. That would make you rich, wouldn't it?" Presuming you invest the money, you have provided income to put about thirty people to work. "How is that? National statistics show that for every person graduating from school or college at least thirty thousand dollars of capital must be found for bricks, fixtures, machinery, inventory, etc. to put each one to work." From this somewhat weird segue, the ad goes on to say that you will earn an annual income of over sixty thousand dollars on your investment which you will spend on various necessities and, thereby, "help support policemen, firemen, store clerks, factory workers,

doctors, teachers, and others. Even Congressmen." The piece closes: "Are you a menace? No, you are not." Haacke responded to this message with an equally sappy retort, laid out in highly formal script:

*The 9,240,000 Unemployed in
The United States of America
Demand The Immediate Creation
of More Millionaires*

It is rather amusing that the Tiffany pitch relies first of all on the existence of those graduating from schools and colleges as motive for investment, but rather scary to think anything as mindless as the Tiffany ad might actually have been composed by people with college degrees. Worse to suppose they thought they were being sly in suppressing what is obvious: The economy depends upon investment and circulation of money, but not upon millionaires; it's Tiffany & Co. that depends upon the existence of "rich people." Still, even this criticism may be too optimistic. For the educated wealthy can be extraordinarily obtuse about their insularity. Consider a letter to the editor of the *St. Louis Post Dispatch* from a couple whose address puts them square in a neighborhood full of millionaires.

The Nov. 29 *Post-Dispatch* carried stories on the front page describing the drying up of medical aid and the 100 neediest cases setting a new record. In the same issue the Style section featured debutante party dresses, which were priced into the thousands of dollars.

This is an excellent example of the cultural and economic anomalies that exist, and your reporting only exacerbates the chasm between the affluent and those less fortunate.

No one, least of all the writers of this letter, suggests a restriction on the sale and wearing of expensive clothing. We are well aware that this benefits the retail stores and brings dollars to the charity balls to which the finery is worn. It is, however, tasteless reporting that flaunts the prices of these gowns and that's what we object to. *Certainly, the neediest cases can read. So can those who need and cannot afford expensive medical aid. With simple arithmetic, they can calculate how far the $2,610 spent for a ball gown would go in supplementing their meager resources.*

The activities of those who can afford such gowns are indeed their own business and their *undeniable right*. But, in news articles, let the *Post-Dispatch* describe the color, style and decoration, not the price. [Emphasis mine] December 4, 1987

Are the rich a menace? Perhaps not, but those who can combine this kind of insouciant liberalism with blind deference to the supposed inevitability of vast disparities in an economy surely lend substance to the left's contention that their duty is to strip away the self-delusions of the educated, and tend to substantiate the views of those who are skeptical of the lasting effects of the traditional liberal education commonly completed by middle-aged couples who live in Ladue, Missouri. Yes, that is an isolated example, but just how atypical is the attitude? How uncharacteristic, even now, is that of Tiffany & Co.? Not very unusual, if you compare it with the pronouncements of the Republican Party majority in Congress or the enunciations of Conservatives continuing their support of Mrs.Thatcher's economical ethic. On the other hand, the New Left and postmodernist left are equally impatient with the timidity of the liberals and social democrats when it comes to dealing with the fundamental underpinnings of modern society and what they see as the effective disenfranchisement of the majority by means of technological misdirection and an education for those in the loci of decision that equates complacency with maturation. But, then again, whereas the postmodernist left believes people have been alienated from the reality of their circumstances by the machinations of the system, these leftists are themselves alienated from the realities of the internal life of people in society. It is as if—for all of their concern with the commonplaces of the popular will—they have no understanding whatever of the huge incompatibility of opinion, belief, and enthusiasms for the realization of life among human beings in every culture.

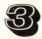

Estrangement and the
Taste for Fragmentation

The art of our century has been characterized by shattered surfaces, broken color, segmented compositions, dissolving forms and shredded images. Curiously insistent is this consistent emphasis on break-up. However, dissolution today does not necessarily mean lack of discipline. It can also mean a new kind of discipline, for disintegration is often followed by reconstruction, the artist deliberately smashing his material only to reassemble it in new and unexpected relationships. Moreover, the process of breaking up is quite different from the process of breaking down. And during the last hundred years every aspect of art has been broken up—color, light, pigment, form, line, content, space, surface and design.

<div align="right">Katherine Kuh[1]</div>

In 1965 Katherine Kuh published *Break Up: the Core of Modern Art* which demonstrates that the urgency "with which modern writers, composers, sculptors and painters have smashed orthodox form is so universal as to have become the trademark of our period."[2] The book is brief but thorough in its coverage, and is generally a thoughtful and well-considered treatment of a description that would be hard to contend against. Kuh's is, however, a very literal-minded interpretation of events beginning with Monet's Impressionism and it is almost exclusively concerned with purely formal aspects of art. But the fragmentations associated with modernism begin before that and are, I think, reverberations of the social alienation dealt with in Chapter 2. It is easy to discern the beginnings of the "break up" in the content of Realism—specifically in the work of Manet and Degas where, as we have noted, people are shown in social groups broken up into isolated spectators who do not communicate with one another.

Not only are social groups fragmented but the paintings containing them become piecemeal "snapshots" of reality which challenge the fundamental notion of what pictures ought to contain. This goes beyond the inclusion of vernacular mannerisms, such as men with their hands in their trousers pockets

and women lounging about in states of dishevelment. The paintings of Manet and Degas are full of partial forms and arbitrary segmentations. In the painting *Nana* of 1877, a portrait of the *cocotte*, Henriette Hauser, the young woman is shown standing in her underclothes before a stanchioned mirror, a powder puff in her right hand.[3] But her head is turned towards the viewer, conveying the impression that we are present in the dressing room. What is more intriguing, though, is the other person depicted—a man in evening clothes, presumably a client, sitting on the settee far over to our right. Indeed, he is so far to the right that he is cut right through by the edge of the canvas. Such segmentation of a principal figure is never encountered in compositions before the nineteenth century but they occur with some frequency thereafter. For example, we see the same kind of thing in Degas's *Place de la Concorde*, a remarkable family portrait of the Vicomte Lepic and his two daughters diverging away from one another. The family wolfhound of this curiously disrupted family stares at a man on the curb, yet another fellow severed by a picture frame. It has been pointed out repeatedly that things of this kind are particularly characteristic of photography. Brutal interruptions of figures by picture edges, objects and parts of objects and people looming in foreground positions, and startlingly abrupt foreshortening "might have arisen from purely pictorial considerations. But photography acted as a catalyst. It brought justification to the painter's bold innovations."[4] It should be noted, however, that in photography the "snapshot" characteristics matching the mannerisms of Manet and Degas were not so prevalent during the 1870s as they came to be in later decades. The random, arbitrary appearance of Impressionist paintings has a kinship with photography but is not derived from it. Given an Eastman Kodak—the device that really brought accidental vision into prominence around 1900—Bronzino still would not have composed pictures the way Degas did during the age of tintypes and collodion plates.

Ponder for a moment just how radical a departure from convention it is to permit a major portion of a significant figure to pass out of the picture plane into the abyss. From the Middle Ages through the Baroque everything of importance is given whole within a finished work. Of course, not every portrait is a full figure. Some are only heads. But, except for fragmentary studies, you will not see figures sans heads or observe huge portions of a landscape blocked out by a carriage jutting up in the foreground. Things become untidy only later on. And a preference for wholes is not merely a matter of classical propriety. It is also a normal way of thinking. Look through any family photo album compiled by ordinary people. Fragmentation is rare and, when it does appear, it will be an error preserved for the humorous effect. So far as composition is concerned, you'll rarely find anything other than unimaginative centering of Uncle Fred or Aunt Millie who are seen in their entirety, head to toe. "Here we are at the Louvre." "That's our tour guide in front of the Pyramid of Khufu at Gizeh."

"Here's Millie ready to go aboard at Patras." And what do we see? Same composition. Figure on center about eight feet away, smack dab in front of something big, like a pyramid, museum, or ship. Even those of us with artistic pretensions rarely cut a sitter off at the far edge the way Manet and Degas do. Human vision doesn't have a frame; things merely blur away into a haze at the periphery of vision. It is the most natural thing in the world to do what the artists of Paleolithic times did on cave walls, that is, treat the surface as interminable and draw each creature whole. But the camera interpolates into reality a rectangular boundary so most people try to get as much as possible in the picture. Why all of these images focused on the self instead of the scenery? If you question a tourist about this he or she will say: "Oh, we have postcards of the place." (Video camcordings are different in that they permit panning, which contains an implied promise of unbounded visibility. Still, even these tend to come back to the self or a companion at the close of the sweep.) More sophisticated yet unimaginative photographers, like myself, either leave the friends out of the picture or relegate them to incidental status. There's my wife sitting alone, a tiny figure in bright red pumps, before the H. H. Richardson courthouse in Pittsburgh. She is far over on the left in a shot of Fisherman's Wharf and in the right corner of the picture of Parliament seen from across the Thames. Degas or Manet might have left only a piece of her nose in sight. Well, perhaps not were the person an intimate; there is an element of social status as-sociated with this business of cutting people out of the picture or obliterating them with overlaps.

Among the works of Degas, a man of snobbish inclination, there is a portrait of Mary Cassatt at the milliner's. Degas says somewhere that he liked "the little red hands of the modistes," already a dehumanizing way of describing the makers of bonnets. In the painting Cassatt is posed to our left, studying her reflection in a full length, free-standing mirror of which we see only the back. This mirror blocks out most of the milliner herself, except for her *petites mains* which hold out alternatives for the customer to try on. The wealthy lady of fashion is shown as a complete entity, in an attitude quite like a painter before an easel, while the personality of the mere tradeswoman is expunged and only her wares left to represent her. This sort of disruption is more frequently seen in Degas than in any other Impressionist, but similar things occur in the works of some others as well, most notably in Manet and Toulouse-Lautrec.[5] Usually, the disruptions of human beings in other Impressionists result from the shattering of chiaroscuro into splinters of colored light. Thus, in Claude Monet's *Madame Monet Under the Willows* his wife has been diffused into brushstrokes like the field of grass she is resting upon, differing from her surroundings only in color and relative density of stroke. This is typical of Pissarro, too. And there is a sense in which Cézanne's treatment of humanity as architectonic and Seurat's reduction of human beings to stylized cutouts can also be seen as breaking what are normal irregularities down into unnaturally ordered structures. Of Cézanne's later work, Katherine Kuh said, in reference to a

landscape: "Planes are simplified, broken up and reduced to transparent cubes, revealing the geometric structure of mountains, trees, and houses."[6] He was, she continues, the forerunner of Cubism which "was the beginning of a new idea, an idea which was to transform the twentieth century visually. . . . In its simplest, most orthodox form, Cubism was an attempt to show all sides of an object at once."[7]

As it happens, when *Break Up* came out I was serving on an architectural arts committee with Ms. Kuh and took friendly issue with this treatment of Cubism as the product of multiple viewpoints—a commonplace that I think is utterly mistaken, although so widespread as to be taken for granted by most people who write on Cubism as a cultural phenomenon. Katherine's reaction was very typical; it could be summed up in the assertion: "But everyone knows that." But everyone doesn't know it. Yet a lot of well-educated people believe it, despite the numbers of specialists who deny the multiple viewpoint theory of modern art. Believe me, few authorities on the history of Cubism accept this popular interpretation of the movement. That many others promote it is just another example of the way the mass media have made it easy to perpetuate falsehoods as wisdom.

We need not vex ourselves over the reasons why certain misunderstandings persist in print despite tireless efforts of the expert to prevent their recurrence. Examples are unending. Consider that whenever a journalist uses the term "schizophrenic" to mean someone afflicted with a dual personality disorder, editors are inundated with letters from psychologists explaining that the personality of the schizophrenic is "split," not in twain but away from reality. These corrections have the same effect as sprinklings of water upon Gibraltar. A less familiar error, perhaps, is one that has been made for over sixty years by detective story writers whose only experience of the criminal world is through books. In Dashiell Hammett's *Maltese Falcon* (1929), when Sam Spade refers to young, pistol-packing Wilmer as a "gunsel," he is using prison argot accurately, if esoterically, to describe the homosexual lover of an older inmate; the readers got it wrong, of course, and so many generations of "hard-boiled" novelists have used it to mean a gunman that usage has made it so for lexicographers. It is an archaic term and, so, a harmless misinterpretation. But most of us will understand how much mischief has been done by taking evolutionary theory in vain with "survival of the fittest" misinterpretations of Darwin's theory of natural selection. There is no end to this kind of thing. And, of course, aesthetic theory and art criticism are by no means immune.

A prominent example of such an error is the peculiarly tenacious conviction that Cubist art from Paul Cézanne through Picasso and Braque derived from a hermetic geometry that modifies the visible world in somewhat the same way scientific perspective had given unity to Renaissance vision. It is a rather queer notion, for the supposed analogy lies in the contradictions; thus, where

Brunelleschi's space was monocular, his observer fixed in space, and objects projected as measurements among points in a forest of orthogonals, cubistic space is said to have been dependent upon ideally geometric solids which are then fragmented by the shifting viewpoint of a moving observer. If this sounds plausible, it can only be because of its familiarity. It is a perennial cliché of critical writing, yet those who have some special knowledge of Cubism reject the description the cliché depends upon, as will be shown in the course of this book. An endnote will give just a few of some more recent uses of Cubism as a literary analogy.[8] Please understand, however, that I am not implying the writers are wanting in judgment except to the extent that they have employed a false description of a phase of modern art.

ON GEOMETRIC SOLIDS AND THE ART OF PAUL CÉZANNE

Consider for the moment just the idea that some consummate geometry is the basis of Cubist form. Until recently, virtually everyone who talked about Cézanne remarked, as did John Canaday, upon his "idea that all forms could be reduced to geometrical ones such as cylinders, cubes, spheres, and cones."[9] This is an idea that is not only wrong, but *demonstrably wrong*. That is, it is not just a matter of opinion but can, in fact, be proven false. After all, this theory of Cézanne's art cannot be applied to actual works without doing violence to common sense. Anyone comparing a still life by, say, Jean Baptiste Chardin with nearly any by the mature Cézanne would surely have to confess that the objects in the former more nearly express the fundamental geometry of solids than does the irregular choppiness typifying the latter. This should be perfectly obvious to anyone. It is to art historian Theodore Reff.[10] It is to the foremost authority on French Impressionism, John Rewald.[11] It is to me.[12] And yet, for many years writers on modern art have claimed that a statement from the artist himself, in a letter to Émile Bernard dated April 15, 1904, proves their case. It is a statement often misquoted, rarely quoted, and when quoted, almost never given in its entire context. Here is what it says: "May I repeat what I told you here: treat nature by the cylinder, the sphere, the cone, everything in proper perspective so that each side of an object or a plane is directed towards a central point."[13]

Readers of this book will not, I think, have missed the absence of the cube mentioned by Canaday and most others, nor will you have overlooked the prominent mention of "proper perspective." As we noted in Chapter 1, perspective in the fine arts is not some generalized vagary as it is in common speech, as when one speaks of "taking a different perspective" of a subject; it is a form of applied mathematics and is derived from orthographically projected planes and elevations. If there is any thing obvious about Cézanne's paintings, it is that they *never* contain proper perspective. Just why he wrote what he did, then, appears altogether perverse, but it can be accounted for in a straightforward manner. Really, there is nothing mysterious about it.

A bit of study suggests that Cézanne's words were never intended to describe what he himself had been doing for over thirty years, although that's the way everyone, beginning with Bernard, seems to have interpreted it. In this connection consider a letter Cézanne wrote to his son Paul *fils* two years after sending the more famous one to Bernard. In the second letter he mentions "the unfortunate Émile Bernard . . . an intellectual constipated by recollections of museums, but who does not look enough at nature." The master was not giving Bernard the "secret" of how to paint a Cézanne; he was instructing him on how to look at nature—in terms of basic geometric forms. This was standard academic advice to students of the time and is, indeed, standard advice to beginners still today. But Émile Bernard was too full of himself even to begin to imagine that he was being told how to observe a landscape merely because of Cézanne's hope of "instilling into him the idea . . . of a development of art through contact with nature."

Others who knew Cézanne have lent false substance to Bernard's supposition by including his insight in their own memoirs, often without reference to Bernard himself. Invariably, these are people like Edmond Jaloux or Joachim Gasquet, who came late into the master's circle of friends. When they were not just taking Bernard's lead, they were sometimes reporting remarks made by Cézanne concerning his preoccupation with the relations of planes to volumes— remarks that have sometimes been taken out of context by later critics to support the theory of geometrical reduction. At other times these men were reporting from their youthful days something that paralleled in conversation what Cézanne wrote in the letter to Bernard. For instance, when asked by a young artist what was most necessary for a beginner to study, he said, "Copy your stovepipe." Such offhand remarks can seem to support the geometrical reduction theory of Cézanne if you do not understand beforehand that the drawing masters of the Academy were apt to tender similar advice.[14]

My principal point here is that anyone with eyes can see the paintings do not answer to the description. That has not prevented Maurice Raynal from characterizing a Cézanne self-portrait as possessed of a monumental, plastic quality derived from "the presence of elements of cones and cylinders, of dihedral and even tetrahedral angles."[15] Does this tell us anything whatever? Consider for a moment: when one describes a physiognomic structure as being constituted of *elements of cones, cylinders, dihedral, and tetrahedral angles,* one has not made a comment on a particular painter's version of an individual; one has merely characterized, in somewhat pretentiously mathematical terminology, the topography of *any* face. Even Hans Holbein—whose verisimilitude in portraiture gives an impression of sovereign objectivity surpassing even that of photography—could be said to have derived his realistic effects through meticulous delineation of what are, ultimately, tetrahedral complexities. This is all quite obvious. Those of us who instruct neophytes in

how to draw a human head nearly always make some reference to the geometry of the skull. The cranium can he conceptualized as an imperfect sphere, the face and jaw as a tapered rhomboid, the features characterized as being planar, conical, cubic, and semispherical. Just such formulations make up the various matrices trained artists use to cast the specific features of portrait subjects and the character of figures. The jargon may sound impressive, but the applications are straightforward, for which see Figure 5.

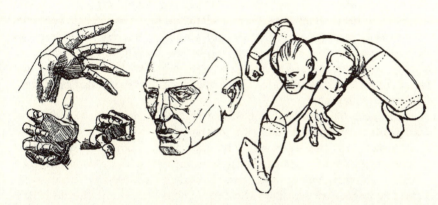

Figure 5: The author's reduction of hands, a head, and a figure to geometric elements

On the other hand, Cézanne's representations of the object world are certainly not straightforward. Devoid of geometric regularity, they are never in correct perspective. Also, these paintings contain bizarre distortions that cannot be attributed to the customary "imperfections" associated with freehand drawing. We observe lopsided compotes and tilted bottles, weirdly constructed tables whose edges are discontinuous, and cylindrical objects whose cross sections not only appear to be lozenge-shaped rather than elliptical but also defy the conventional expectation that whichever is farther from the eye level will be wider rather than more narrow (see Plate 9). Such effects are not only contrary to "central projection" but also to the empirical facts of common sense experience.[16] Obviously, such radical deviations from the norm require justification by anyone attempting a rational analysis of Cézanne's style. Incompetence is a possible explanation, but the fact that the master's early drawings and preparatory sketches throughout his life are far more conventional puts the lie to that sort of criticism. He must surely have intended to distort things as he did—or, more precisely, he must have departed from convention deliberately.

One way to account for the strangeness of Paul Cézanne's drawing style is simply to accept the notion that his primary goal is to establish a harmony of forms that is based on the sensed relationships of shapes instead of being grounded in mathematical projections that remain the same for all draftspersons

and have preordained rules that mere sensation cannot countermand. In this connection, it is important to understand that Cézanne, like his Impressionist colleagues, was resisting the Cartesian rationalism that had been equated with high seriousness in art since the time of Poussin. In a sense, the frivolity of the rococo was a minor divergence from the principled march of reason from baroque classicism through the Neo-Classical manner of Jacques Louis David and his disciples in the Academy. There is, for example, a real analogy between René Descartes' attempt to derive an entire philosophy from what seemed to him one unassailable premise, isolated and pristine, *Cogito ergo sum,* and the procedures of his contemporary, Nicholas Poussin, who was imbued with what Anthony Blunt has called "Stoic ideas of virtue."[17] But Poussin's desire to achieve a measured geometry as rational as the modes of Greek music in antiquity could never have produced as abstemious a diet of reason as the *Discourse on Method* of Descartes. That remained for the more rabid rationalists of the succeeding century.

As it happens, the relentlessly logistical aspect of Jacques Louis David's Neo-Classicism has been obscured by the prominence of its thematic content and didactic intentions. But when his works are studied from the purely formal viewpoint of an artist at work composing a picture, it becomes obvious that each elaborate structure has grown, like Descartes' philosophy, from some irreducibly simple first principle. Thus, the famous *Oath of the Horatii* (1795) uses a complex matrix of simple triads to create a composition supporting the sonorous theme of individual sacrifice for the good of the whole. The figures are confined by triangularities, by a rhythm that establishes patterns of threes, even to the extent that swords, legs, arms, figure groups, and the heads of individuals are arranged with two together, one apart, over and over.

Surprisingly, perhaps, the great composers coeval with David—that is, the Romantics and their immediate predecessors—were as rationalistic in their approach to music as were the Neoclassicists in painting. Consider the way in which the opening of Haydn's Symphony in G, known as the "Surprise" Symphony, establishes a premise for all that is built upon it and how this differs from the complexities of the rococo. Or think of Beethoven's still more famous opening chords for his Fifth Symphony, which has a similarly "Cartesian" progression. His Piano Sonata in F Minor, op. 57, the "Appassionata," is like the *Oath of the Horatii* in that the initial statement of the theme consists of three-note patterns in a rhythm slightly separating the first note from the two that follow. It is characteristic of the eighteenth century to pattern great works upon discrete steps moving from simple premise to complex results. The lines from the American *Declaration of Independence* exemplify the Enlightenment's approach to political manifestoes: "We hold these truths to be self-evident, that all men are created equal, that they are endowed by their Creator with certain inalienable rights, that among these are Life, Liberty, and the pursuit of

Happiness. That to secure these rights, Governments are instituted among Men, deriving their just powers from the consent of the governed." Jefferson's rhetoric advances with inexorable purpose from the foothold of a winning premise to an impudent conclusion. That is entirely typical of the times.[18]

David's notions of aesthetic purity required that a canon of rationality obtain in every aspect of an artwork, that clarity be paramount and, thus, that the rule of measured certainty rule over all. But in neither politics nor art can such puritanical abstemiousness be sustained for very long; indeed, David himself departed from it in his later works. Soon, his successors within and without the Academy—whether ostensible disciples like Jean Auguste Dominique Ingres or antagonists like Eugene Delacroix and Gustave Courbet—turned away from the verities of antiquity to embrace the unfulfilled possibilities of other times and exotic places or alternative truths ranging from the fancies of delirium to the irremediable facts of ordinary existence. They did not, however, defy the stylistic conventions of representational art. On the contrary, most of them preserved the fundamentals of perspective drawing and chiaroscuro, though sometimes employing them in exaggerated ways. It remained for Monet and his followers to challenge the traditional premises of representationalism.

French Impressionism is typically thought of as being a prettified version of realism, revealing the private spectacle of nature in an array of optically dazzling hues instead of the embrowned chiaroscuro of traditional art. True, Impressionism's change of emphasis in color from dark-light values to contrasts of hues and intensities is one of its most notable characteristics. But that is only one of a number of radical modifications of tradition that characterize Impressionism. Thus, Impressionist perspective is *always* "wrong" in terms of the geometrics of central projection. Even in the works of a comparatively traditional modernist, such as Degas, the perspective is never "scientific," which is to say it is arbitrary, irregular, and sensed instead of being measured and predictable.

But perspective *is* a premeditated arrangement; that is why I can project from blueprints a perspective drawing of a building not yet standing that will match a photograph of the finished structure line for line, and from any point of view or distance. All that needs be done is modify the relative measurements on the diagrams from which the drawing grows. On the other hand, when I make a freehand sketch (even a very careful one) of a dwelling in a landscape, I make use of a sort of empirical perspective that is "sensed," like that of Degas, in which orthogonals have a generally correct angle and the scale seems intuitively right to the ordinary observer. There is nothing "wrong" in doing this. On the contrary, it is the usual approach to drawing. Still, if all parallel orthogonals do not have a common vanishing point, as they rarely do in Impressionism, then the scheme is arbitrary and irregular.

So far as the forward-looking painters of nineteenth-century France were concerned, the whole idea was to escape the impersonally "objective," the preordained, the externally imposed, the purely intellectual reductionism of

academic art. Of the entire avant-garde only the Neo-Impressionists led by Georges Seurat attempted to generate an art form from rigorous application of what seemed to them an invincibly rational method. Seurat was enthralled by the auspices, if not the genuine methodology, of modern science,[19] and it is, perhaps, the same desire to seek vindication for the aesthetics of modernism that has led so many critics to explain the works of Cézanne and the cubists in terms of theoretical geometries instead of painterly intuition. Their urge is understandable but mistaken.

What Cézanne's seemingly eccentric mannerisms do is elevate the neglectful attitudes of Monet, Degas, and Pissarro to a plane of higher purpose. We have only Émile Bernard's word for the master's announced intention to "vivify Poussin after nature,"[20] but Cézanne's style is, in fact, consistent with an attempt to achieve a level of order and completeness similar to French classicism while disdaining seventeenth-century methods of composition. His attainment of a property of genuine essentiality was recognized by Renoir when he spoke to Pissarro of Cézanne's paintings having "I do not know what quality like the things of Pompeii, so crude and so admirable."[21] inevitably, the paradox of harmonious grandeur being evoked by seemingly inconsistent, not to say haphazard drawing has led critics to postulate all sorts of reasons and excuses for it.

THE "MULTIPLE VIEWPOINT" THEORY OF EARLY MODERN ART

Probably the most common explanation of the many deformations of still life and landscape elements in Cézanne has been that they result from a frequent shifting of the artist's viewpoint while he was studying the objects. For instance, Erle Loran's little book *Cézanne's Composition* contains many diagrams in support of this theory.[22] I cannot demonstrate with absolute finality that it is false, for obviously the painter might possibly have peered at still life objects from all sorts of different angles and then composed the separate views into a single image. But why should he have? In order to attain the kind of composure Cézanne did in his paintings a photographer would have had to combine separate shots into a unified whole (as David Hockney has done in some remarkable photomontages, for example), but the painter is not so dependent upon what is set out before him. Nor was his mind a passive receptacle. There is really no reason for a painter to shift viewpoints, even subjectively, to achieve Cézanne's adjustments. Still, might not multiple viewpoints account for at least *some* of the distortions? Surely. But you can account for any error of drawing in *any* picture, even one by a rank amateur, by attributing it to some variation in the angle of view; as a matter of fact, most mistakes in elementary perspective done freehand are due to exactly this cause. With respect to Cézanne, Meyer Schapiro pointed out that it makes sense to "ask why he shifted his eye or

accepted the result of such shifting, if that is indeed the cause."[23] It is, of course, *conceivable* that Cézanne peered at still life objects from different angles and then combined them into a single image. But it seems ridiculous to account for drawn distortions in this way. Perhaps it would be helpful to clarify my feelings on this point by use of an art form whose whole objective is ridicule.

Caricature is a popular art dependent upon deviations from the norm and, when a caricaturist exaggerates the scale of a subject's nose, it *could* be said that he or she has employed a radical close-up of the nose while presenting the rest of the face as if seen at arm's length. But it is not so. Cartoonists merely change the scale and relationships to achieve a grotesque, yet recognizable effect. Photographers have to select various positions and combine exposures to attain such effects; cartoonists and painters do not. In a related connection, suppose I say to you: "In beginning a caricature you must bear in mind that when seen from the front, straight on, the subject's eyes will fall on a horizontal line approximately half way between the crown of the head and bottom of the chin." I am not telling you what the relationships in a caricature ought to be; I am specifying the normal proportions from which you may diverge. This is, I think, not far from what Cézanne was probably doing, too, albeit it on a far more elevated level of conception.[24]

Cézanne accepted what appear to be distortions because these deformations, discontinuities, and asymmetries were not incidental byproducts of his method; they *were* the method. As Schapiro himself emphasized, the painter's objective was quite probably the establishment of a stable harmony that had been generated from out of inconstant components. It is in the very nature of his art that it can never be accounted for, even in part, by some pat formula that might be learned and then applied. It is the result of a wager placed against chaos. After all, it is precisely this kind of gamble, which pits composure against disorder, that is the moving and dramatic content of the kind of abstract art which Paul Cézanne, more than any other, anticipated and arguably opened the way for—that is, Cubism and its non-objective offspring.

From the myth that palpable solidity is concealed within Cézanne's apparently fractured forms, we turn to its virtual opposite, the notion that Cézanne's successors, the Cubists, disrupted stable substances by fragmenting individual objects and then reconstituting them as aggregations of separate views. Yes, this is essentially the same thing Loran and others have said about Cézanne. His works are said to have combined successively different attitudes of gaze and, so, can be taken as clear precedent for paintings done between 1909 and 1912 by Picasso and Braque, both of whom were eager to acknowledge the predominant influence of the nineteenth-century master upon their works.[25] That is the implication but not, perhaps, the proper inference, since it is a conclusion arrived at by retroaction. That is to say, Loran's interpretation of Cézanne seems not to have been inspired by the distortions he observed in Cézanne's work so much as it was derived from critical commentary on Cubism that he applied, by hindsight, to Cézanne. Thus, he makes reference to the

appearance in Cézanne still lifes of a "familiar device" of Picasso's, combining profiles and frontal views, and there are included in *Cézanne's Composition* tracings from Braque still lifes intended to show that Cézanne's discontinuities recur in the work of the Cubist.[26] To characterize a style by means of its ostensible effects takes advantage of hindsight in a way that would seem to insure that one's insight into the past, at least, would be unerring. After all, even though Meyer Schapiro and lesser critics, such as myself, seriously question the plausibility of shifting viewpoints in Cézanne, our reservations are made less cogent when it can be shown that a major movement like Cubism employed the same technique on a grand scale and that its practitioners recognized that it was inchoate in the art of the man they claimed as their foremost predecessor. If Picasso not only saw angular variations in Cézanne's views of objects but also perceived these to be both significant and purposeful, can our objections to the very existence of such variations amount to anything more than pedantic carping? In truth's balance the preponderant weight must be granted the artist and not mere art historians and aestheticians. As it happens, however, the notion that Cubism necessarily incorporates the simultaneous presentation of multiple views is itself an invention of critics rather than artists, and it has no more substance than the ephemeral cones, spheres, and cylinders that are supposed to reign over the forms of Cézanne. Erle Loran's book, which was first published in 1943, merely reiterates in an oblique fashion ideas about Cubism that had been enunciated over thirty years before. That certainly does not make them wrong, nor does it refute whatever merit their application to Cézanne may have. But here again we encounter received wisdom that is without merit despite the fact that it is everywhere to be encountered and is evidently considered irrefragable by the greater seerhood of art criticism.

Making reference to the intransigence of this very questionable idea, Leo Steinberg wrote that "familiar ideas about difficult things tend to hang on; they are economical, and sharing them becomes a kind of companionship." He notes, too, that the theory of Cubist simultaneity no longer occurs in the writings of "thoughtful observers."[27] Obviously, I am eager to concur. But, then, I am quite sure that the multiple viewpoint thesis and the threadbare notion of simultaneity associated with it produce in both Professor Steinberg and myself a reflexive skepticism. We would not be very likely to consider "thoughtful" anyone who maintained these ideas. Those beyond that pale, however, are numbered in legions whose population seems to have grown rather than to have decreased over the decades since Cubism became an art of the past that no one practices any longer.

The astonishing intractability of the multiple viewpoint theory is surely due to the fact that Cubism is not easy to comprehend. It is also because of some nonsense propagated by a rather clever chap who happened to be a minor Cubist of relatively meager artistic ability. In 1911 this man, Jean Metzinger, managed

to inflate his reputation by purveying his speculations about the Cubists in writing: "they have uprooted the prejudice that commanded the painter to remain motionless in front of the object" and "have allowed themselves to move round the object, in order to give ... a concrete representation of it, made up of several successive aspects. Formerly, a picture took possession of space, now it reigns in time."[28] Figure 6 will give you a notion of what is supposed to be going on, except that the result is *more* like Picasso's Cubism than Metzinger's.

The following year Metzinger, along with a slightly greater talent, Albert Gleizes, published a slim book, *Du Cubisme,* that attempted to ally their interpretation of the Cubist method with exotic ventures into the frontiers of mathematics and physics. These artists, like most others who undertake to compare the principles of an art form with those of abstract theory, were standing on a film of ice. The ice may be thick or thin; in this case it was quite insubstantial. What Metzinger and Gleizes attempted was to justify Cubism by showing that, although apparently irrelevant to reality, it actually presented successive aspects

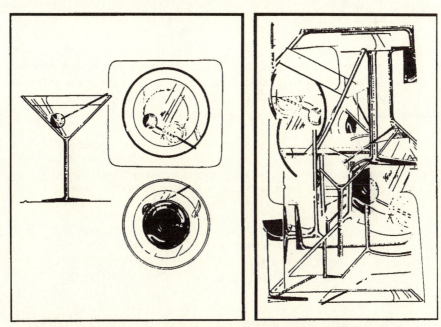

Figure 6: Successive views of a dry martini transformed into a Cubistic cocktail, according to the "multiple viewpoint" theory propagated by Jean Metzinger

of objects simultaneously, thereby incorporating time as the theories of physics did, as a fourth dimension. In their endeavor to rationalize the Cubist method of drawing, the authors—like their cohorts André Salmon, Guillaume Apollinare, Alexandre Mercereau, and Maurice Raynal—use phrases cribbed from scientific writings and from science fiction in what amount to mere incantations. What the words show is that their writers have little or no understanding of the scientific

principles they are referring to. Indeed, the contentions of Metzinger and Gleizes usually misrepresent both Cubism and modern physics.

MODERN ART AND SCIENTIFIC THOUGHT REVISITED

In 1971 I published *Modern Art and Scientific Thought* in which I attempted to fit more or less coeval innovations in modern science and the arts into a dialectical paradigm of my own device. Its purpose was not the discovery of truth so much as the revelation of synoptic commonalities; therefore, it made sense to compare Cézanne's breakdown of traditional space in painting between 1873 and 1906 with the non-Euclidean geometries which came into their first prominence about 1868, though they dated from earlier in the century. I made this comparison despite the fact that there could really be no question of direct influence. Similarly, what the major Cubists were doing between 1907 and 1914 to emphasize pure form in painting seemed to me more akin to ideas simultaneously emergent in the foundations of mathematics than to the new physics and non-Euclidean geometries that minor figures like Jean Metzinger and Albert Gleizes actually cited in an attempt to justify the unconventional appearance of Cubism. A large section of one chapter of *Modern Art and Scientific Thought* was devoted to a consideration of whether or not Cubism did, in fact, have any relationship to simultaneity in modern physics or, in particular to the Theory of Relativity. As the reader will no doubt anticipate, I argued against any connection.

> The fragmentations of Cubist art did not derive from simultaneous presentations of shifting points of view, but even if they had they would be unconnected with the Theory of Relativity. Thus it can be argued that the entire notion of a hermetic connection between Einstein's theory and Cubism is false. And, in fact, Einstein himself voided the connection. Responding to an essay sent him in manuscript which argued [in favor of a connection] Einstein . . . commented: "Now, as to the comparison in your paper, the essence of the Theory of Relativity has been incorrectly understood in it, granted that this error is suggested by the attempts at popularization of the theory."[29]

During the past decade *Modern Art and Scientific Thought* has been succeeded by a number of books and articles treating art and science, written by serious historians specializing in the area. The most sympathetic, informed, and balanced treatment of Cubist group with respect to such matters is Linda Dalrymple Henderson's *The Fourth Dimension and Non-Euclidean Geometry in Modern Art,*[30] which I am forced to count the definitive treatment of a subject I had for some time in the 1960s staked out for my very own. That is not to say I

find whatever she has to say agreeable and still less to pretend that all contention is foreclosed. Yet, no one henceforth will be able to discuss modernity in art and science without taking account of what is contained in Henderson. Her approach to connections between art and science is nothing like so cavalier as mine. She is the traditionally objective historian rather than a synoptic freebooter. You'll not find her embracing generalities merely because of their alluring sheen, nor will you catch her casually consigning to the oblivion of "pretension" some avant-garde claim of a scientific alliance with esoteric truths. She takes these people as seriously as they take themselves. And even when it has become quite obvious that a claim is, indeed, merely pretentious, Henderson does not lose sight of her ultimate objective; she will want to know from what causes this particular affectation springs, and usually she will find out. It is a stunning performance. I had thought it rather clever of me to have inserted H. G. Wells into my own discussion of confused beliefs about the fourth dimension as a temporal mode of spatiality. Henderson not only knows all about *The Time Machine,* she has read a 1912 work by one Gaston de Pawlowski, *Voyage pays de la quatriéme dimension,* which also uses the fourth dimension as a tool of social criticism. Although she has restricted herself pretty much to the first three decades of this century, she is thorough beyond all comprehension, apparently having read everything of genuine relevance and pursued every bibliographical, biographical, and archival lead available. I feel quite safe in saying that *The Fourth Dimension and Non-Euclidean Geometry in Modern Art* is the most well-informed book ever written on the subject of early twentieth-century art and its mathematical and scientific associations.

Despite the above encomiums, I do have what may be thought of as cavils. Henderson seems to me all too ready to accept what some painters claim for themselves, their works, and their ideas. And I have grave reservations about the place of non-Euclidean geometry in modern art. For all of that, she is surely more often right than wrong, and she certainly spikes the notion that the Cubists in their paintings have some reference to Relativity Theory. My own thrusts in the same direction are to hers as a minor skirmish in Dumas is to Tolstoy's descriptions of Napoleon's campaigns. Yet, though sadly overmatched I feel required to mount a small and timorous attack upon a central tenet of this book.

The author deals at considerable length with statements by Marcel Duchamp that sometimes make direct reference to non-Euclidean geometry and sometimes contain phrases that may allude to it. She believes that his notes on *The Bride Stripped Bare by Her Bachelors, Even* "establish conclusively that he did read Jouffret and Poincaré" who dealt with relevant matters in nontechnical papers. Well, Duchamp was a wonderfully intelligent, witty, and erudite fellow, and I certainly do not resist the evidence she submits in support of the idea that he had read Henri Poincaré's comments on Berhard Riemann's geometry. (In the past I had rejected this out of hand because of some statements I overheard him make in St. Louis during 1964, but Henderson effectively refutes the recollections of his later years.) It is only when we come to the matter of what the artworks have

to do with the mathematical ideas that relationships seem to me to have been fetched from very remote distances indeed. To explain why that is the case is probably impossible in the space available, but a few remarks apropos my contentiousness should at least suggest how much deference is due Linda Henderson for undertaking a scholarly challenge as fraught with intellectual hazard as this one is.

A fundamental problem anyone dealing with these matters encounters at once is that the language of mathematics has virtually nothing in common with that of ordinary discourse. The equation

$$ds^2 = \frac{dx_1^2 + dx_2^2 + dx_3^2}{I + \dfrac{K}{4}(x_1^2 + x_2^2 + x_3^2)}$$

may be said to express a quadratic differential form that defines the essential properties of a Riemannean manifold in a coordinate space of three or higher dimensions. (You are following this, aren't you?) What does that statement *mean?* It means what the equation relates as abstract concepts and not what the words attempt to convey. The significance of the description, however, could be given a somewhat visual form by showing how it applies to manifold localities. If the constant K in the formula is zero, the space is the neutral planar space of Euclid in which parallel lines never meet and all triangles have 180°. If K is less than zero, space is negative, parallel lines can lie in a multitude of angles relative to one another, and all triangles have less than 180° or even fewer when they are larger. When K is more than zero, space is positive (that is, spherical), parallel lines do not exist, all triangles have more than 180°, and the sum of the angles grows with the size of a triangle. These three alternatives comprise the geometry of Euclid, the non-Euclidean negative-space geometry of Nicholas Lobatchevsky, Karl Friedrich Gauss, and John Bolyai, as well as the non-Euclidean positive-space geometry of Bernhard Riemann, the mathematician who himself devised the formula that contains them all.

Unlike Euclid and Isaac Newton, Riemann treats mathematical space as amorphous and nonhomogeneous by making the character of any given ndimensional domain dependent upon the particular curvature of its locality. Once again, the meaning of this resides in abstract relationships that resist description in ordinary ways. For instance, Lobatchevsky's negative space geometry can be demonstrated on a surface called a *pseudosphere* which resembles a trumpet bell, but it is not possible to give concrete form to a continuously hyperbolic manifold. Riemannean principles, however, have the

effect of undercutting Euclid's unstated but seemingly commonsensical assumption that it is essential to consistency that geometric figures remain rigid and unchanging when moved about, as exemplified by a material rod of absolute rigidity transported from one spot to another. This appears to be essential to physical operations since we want a board we saw to a given length in the basement to match the space we have for the shelf it is to become in the kitchen. Yet, it should be easy to see that not only would it not matter if everything shrank proportionally whenever it entered the kitchen, we would not even be able to detect the change. In a sense, Riemann devised a geometry in which the "deformations" of the kitchen's field would be recognized and accommodated in the normal continuum. As it turned out, this accommodation was essential to the creation of Einstein's Theory of Relativity.

Now one can surely understand the appeal of anything as exotic as Riemannean alternatives to rigidly unchanging congruency for someone like Marcel Duchamp who was engaged in the wholesale demolition of conventional ideas. It might very well be that he conceived *Three Standard Stoppages* as a sort of symbol for the deformability of geometric rods. This work entailed, in part, the permanent fixing and mounting of three pieces of thread one meter long in the forms they took after having been dropped horizontally from a height of one meter onto a piece of blue canvas. It is possible to discern a vague analogy between ends and points, threads and lines, random curves and deformed arcs. Kind of. Perhaps, I guess. But to say that the movement of a thread "illustrates that geometrical figures do not necessarily retain their shape when moved about, as Euclid and geometers for two thousand years after him had assumed they would"[31] is unjust, even after we grant such license as is required for any discussion of mathematical ideas to occur. Among other things, it not only treats as nitwits Euclid and his fellow geometers but also denigrates René Descartes, Isaac Newton, and Gottfried Leibniz, along with others who dealt with bodies in motion.

I understand Henderson's claim for Duchamp is no more meant to be taken literally than Duchamp's hand-held threads could be equated with ideally straight, rigid rods. For nothing could be more readily evident than that Henderson is extremely intelligent and superlatively knowledgeable about the foundations of geometry and the history of modern art. And yet the significance of Duchamp's *Stoppages* has been of an entirely different sort than her remark suggests; it has been of the kind conveyed by his first note on that work in *Green Box*: "canned chance." His employment of the shapes made by the threads in *Network of Stoppages* and *The Bride Stripped Bare by Her Bachelors, Even* emphasizes the application of randomness in a structured manner rather more than any other mathematical notion. (Need I confess that the very thorough Henderson does take note of the fact that Poincaré and Jouffert would have interested Duchamp because of their interest in probability theory?) So far as the business about deformability is concerned, I am confident that it would be hard to find a professional topologist or geometer who would take Henderson's

side in this dispute, but I am also sure that anyone who took my disagreement to be much more than a mere quibble in contrast to her monumental achievements is slightly dotty. Every writer who undertakes to compare the principles of an art with those of an abstract theory puts himself or herself in the way of brutal second guessing from specialists on either side. I have focused attention on one particular statement because I feel that, recently, it has been rather seriously misapplied by some who have a very infirm grasp of just what is involved here. But that statement is an isolated remark in a lengthy treatment of Duchamp and non-Euclidean geometry. And while I am skeptical of the stress Henderson lays on the conscious mirroring of ideas in Poincaré and, particularly, Jouffret by Duchamp, the truth is that so much of what the mathematician, the artist, and the art historian say is contingent on the interpretation of abstract concepts that have been translated into discursive language that it is hard to know whether differences of opinion are substantive or what used to be called "semantic." Unquestionably, Henderson's exegesis of principal works by Duchamp in terms of non-Euclidean geometry demonstrates the appeal new conceptions of dimensionality and congruence held for the artist. Too, I cannot deny that her attempts to confirm her case have a sort of compelling dramatic fascination all their own.

FURTHER COMMENT ON SIMULTANEOUS REPRESENTATIONS OF SUCCESSIVE MOMENTS OF VISION

Quite apart from whether the Cubist method had anything to do with contemporary mathematics, physical science, or similarly abstruse and prestigious endeavors, there remains the fundamental question: are multiple viewpoints characteristic of Cubism? I believe that they are not and, moreover, feel that any thoughtful critic can verify this as self-evident by taking hardly more than a glance at a few of the more famous works done between 1909 and 1924 by either Picasso or Braque. As Steinberg, I, and heaven knows how many others have pointed out, the two most important Cubists do not portray fragments of single objects; rather, they create pictures from discontinuous fragments and elements of marks. Mark Roskill, in a really excellent study of the movement, wrote

> It is of course true that in Picasso's and Braque's work of 1910-12 different parts of the same object . . . are shown from implied viewpoints that are incompatible with one another; but not in such a fashion as to imply a "free mobile perspective" (in Metzinger's words of 1910), which is that of a spectator in motion around the objects. Rather, the individual "aspects" or "attributes" (as Picasso and Braque later came to call them) are increasingly stressed, in separation or isolation from one another.[32]

There is really no just way of describing what the Cubists do *not* do, but I find it difficult to believe that Picasso's famous portrait of the art dealer, Vollard (Plate 10), could have been derived from shifting viewpoints. It is more plausible to suppose that the artist built the image of his dealer from V-shaped units than to imagine that he broke nature down into bits and pieces. The thoroughgoing organization of the painting overall takes it far beyond mere "stylization," but Picasso's enrichment of the image with ambiguous segmentations of forms and variable spatial containments does not involve multiple viewpoints or composite perspective. There is an unfinished painting of a young woman named Fanny Tellier begun by Picasso in 1910 and known as *Girl with Mandolin* that is now part of New York's Museum of Modern Art collection. Clearly, it is based on a reductive approach to the geometry of the human figure. Its plain, broad contours surely must have been intended to serve as the foundation for an investigation of the properties that diversify and articulate surfaces. From the outset, the emphasis was on formal composition working from the inside out, not upon breaking up a given space into disparate units which were to be recombined in some mysterious fashion. Future developments clearly demonstrate this.

Within a year after the Vollard painting Picasso was doing things like his *Ma Jolie.* The title was derived from the title of a song popular in the cabarets of the day and was also the painter's pet name for his new lover, Eva Gouel (a.k.a. Marcelle Humbert).[33] Now, if the multiple viewpoint theory of Cubism had real validity, one would expect a work inspired by sexual intimacy to give at least some slight hint of an organic form—perhaps an earlobe or eyelash or a lower lip. Instead, the painting contains nothing recognizable, not to the degree that we could agree that "this," for instance, is a piece of a fragment of a section of an eye. When one gets down to the microstructure of *Ma Jolie*, there is nothing left but marks and brushstrokes. These are not even "signs of objects"; they are elements of signs, as it were. For Picasso to have begun such a work by circumnavigating his subject and recording fragmentary glimpses of Mademoiselle Gouel would be equivalent to a farmer setting out to build a barn by first dissecting some of the stock. Neither farmers nor artists go about things in these ways.

Before continuing, I should stress that nothing said here is intended to deny that it is possible to find in works of Cubists what anyone could agree are combinations of separate views of things in a single picture. Obviously, they occur in the work of Metzinger and Gleizes, who are numbered among the painters called "Cubists." But are those the names one summons to mind when the school is mentioned? Of course not; they are minor figures whose works are known largely as reflections of what Picasso, Braque, and Gris had done. Moreover, pictures by the authors of *Du Cubisme* did not much resemble those of their betters at the time the book was being written. And yet it would be wrong to deny that there do exist in the oeuvre of Georges Braque the kinds of combinations that appear in Loran's *Cézanne's Composition.* Obviously,

Picasso's *Girl Before a Mirror (1932)* shows us a profile of the young woman's face superimposed upon a full-face frontal view. That, in fact, is one of the artist's most frequently imitated devices. Still, such combinations of forms are not common in Cubism except among its lesser artists before the late 1920s, and they tend to appear in the works of Picasso and Braque with some frequency only after 1928. Combined views would seem to have been a consequence of the deployment of fragments in so-called "Synthetic Cubism" beginning in 1912 rather than the basis of Cubism itself.[34] This is a matter that warrants a bit of exposition.

There is a powerful tendency among critics to identify the undeniable taste for fragmentation in modern art with something that is, in fact, vastly different, namely, the combining of segmented views into pictorial compositions. That actual cubist segmentations were irrelevant to multiple viewpoints is easily verified by the character of the *papiers colles* first done in 1912. When Braque, Picasso, and Juan Gris began to create these small works of art by pasting bits of paper, cloth, and other substances on grounds, the results were never revelations of different aspects of single objects. Instead, disparate pieces of material have been brought together into a design. All of these collages are similar in this respect, and the Synthetic Cubist works done between 1913 and 1924, immediately after the experimentation with paper and paste, exhibit the same character. A variety of textural fragments, harmoniously coordinated according to shape and color, were employed to produce compositions that may or may not resemble other things, such as musical instruments, chessboards, and caned chairs. One infrequently encounters combinations of objects married in unexpected ways, but rarely if ever do we observe unions of various viewing attitudes towards the same object.

Some movements that closely resemble Cubism in superficial appearance of picture surfaces and that are, in fact, the spawn of the French movement, do contain disruptions of individual entities, breaking them down into momentary views of successive instants of motion—in something like the manner of far later stroboscopic photography. Italian Futurism, prerevolutionary works by Soviet Suprematist Kazimir Malevich, and the notoriously cubistic *Nude Descending a Staircase* (1911) by Marcel Duchamp all make use of sequentially overlapping images of motion arrested. They also seem a good deal more like what Metzinger and Gleizes talked about in *Du Cubisme* than does Cubism itself. Undoubtedly, the existence of such paintings, along with the rare conjunctions of discrete objects in simultaneous space that occur in works by Picasso, Braque, and Gris done in the late 1920s and afterwards, made the multiple viewpoint thesis seem somewhat more plausible than it might otherwise have. But it is not true that *any* of them involve, to use Metzinger's words, moving "round the object." After all, the multiple viewpoint theory of Cubist art between 1910 and 1912 holds that it has as a necessary condition

"free mobile perspective." The mobility of Futurism is of objects external to the viewer and not of the observer. The fragmentations of Synthetic Cubism suggest no movement at all, but only combinations of discrete fragments.

As Katherine Kuh recognized, from its very first appearance in the nineteenth century, modernism in painting has been to a greater or lesser extent concerned with the fragmentation of visible wholes. Edgar Degas' malformed perspectives do, in point of fact, provide us with discrete viewpoints joined into single images. But that is not significant in and of itself, it merely confirms the reluctance of the Impressionist avant-garde to accede to an academic regimen like scientific perspective. In *The Bar at the Folies Bergères* (1881), Eduoard Manet presented the barmaid Suzon, standing face-front before a mirror that is parallel to the picture plane. We noted earlier that the young woman's reflected back has been shifted far to our right where it becomes obvious that she is engaged in conversation with one Henry Duprey, who should, therefore, block our view of her—unless we are meant to identify with him as spectator. It is a disconcerting image, and predictably, the multiple viewpoint argument has been raised in its defense.[35] But modernity is full of shatterings of visual reality.

When Claude Monet split light up into spectral fractions and rendered them with distinctive brushstrokes to effect what is called "broken color," he was already a typical modernist. Surrealism joined incongruous bits of reality into dreamscapes. Expressionists broke human silhouettes into choppy grotesques and divided humanity into isolated individual entities. Hockney's afore-mentioned photomontages imitate pathways the eye takes in its constantly shifting and refocusing survey of the world before it. There is really no question at all that fragmentation of the visible world is everywhere to be encountered in modern art. It can be found in Cubism and in Cézanne as well. But it has nothing to do with the process the standard explanation outlines. Both common sense and subtler sensibilities construe it otherwise, and historical analysis confirms the doubts.

Any discussion of multiple views in art is complicated by the undeniable fact that our conception of reality is derived from the thousands of viewpoints the moving eye selects for the mind to generalize into a momentary image of actuality. Traditional perspective or "central projection" is monocular, fixed, and precisely regulated. It is not surprising to find radical artists of the nineteenth century rebelling against it; for it, still more than *chiaroscuro,* is the perfect analogue for a hierarchical, constraining system of values. Technically, one would be correct in arguing that all Impressionists and so-called Post-Impressionists employ multiple viewpoints. But when the champions of the standard doctrine apply their multiple viewpoint theory to Cézanne and the Cubists, they are not just saying the deviations result from the absence of traditional perspective; they are saying the style is dictated by the disruption of a perspective reality in a highly specific way. My own feeling is that this whole business of multiple viewpoints and buried geometric solids is antithetical to what modernism at the turn of the century was all about. It makes the artists too

passive and too dependent upon nature as given. Ultimately it is a very conservative approach that attempts to explain away the autonomy of the artist's vision by making Cézanne's art, in particular, a slave to visual banalities that have been stylized by an eccentric mode of observation. Certainly, it does not leave room for the dynamic result critics like Fry, Schapiro, Roskill, Steinberg, and others, sense in the finished works.

It is only fair to note that when Erle Loran and others applied the presumed principles of Cubism to their analyses of Cézanne they were not being perverse nor were they acting without plenty of historical precedent. It is, after all, standard behavior to honor great artists by demonstrating emanations of the future in their works. Vasari said of Giotto that those who followed him improved upon his manner, outline, expression, and color without in any way originating new directions.[36] In introductory studies one always stresses the ways in which the frescoes that Masaccio painted for the Brancacci Chapel of Santa Marie del Carmine of Florence in 1428 anticipate the later *Quattrocento*.[37] It was to some extent conventional, then, for the first great champion of Cézanne's art, Roger Fry, to base his interpretations upon what he construed to be the fundamentals of Cubism, which he said sought "to give up all resemblance to natural form and . . . create a purely abstract language of form-a visual music."[38] The only difference between Fry and the proponents of Cubism as a multiplication of views of natural forms was that his construction is distinctive enough to describe what we can agree upon about the development and aesthetic effect of Cubism and is even capacious enough to comprehend their interpretation, whereas theirs is too meager to contain the artists' vision and is, besides, impossible to verify.

COLLAGE AS THE ROOT OF A GENUINELY NEW VISION

George Braque's use of *papiers collés*, that is, creating designs by pasting pieces of cut paper on a ground is part of a more general movement bringing vernacular materials into the realm of the fine arts. After all, many avocational diversions had used essentially the same technique; advertising displays had long been produced by combining printed pictures and type together, the "genteel" hobby of *découpage* that persisted throughout the late eighteenth and nineteenth centuries resulting in those sentimental valentines and horsehair bouquets we see in "antique" stores still today. In Williamsburg, Virginia you can find examples of "quilling"—which involves making tiny scrolls of paper by winding them about a goosequill and gluing them to a backing surface—from the 1700s that rival the complexity of anything a professional artist would undertake. But what the hucksters did for sales and the young ladies of the Tidewater Basin for diversion is quite different from the Cubists' manipulation of bits of paper. I am sure Braque, who had been a sign painter and grainer in

his youth, would have been quick to admit that the first *papier collé*, done in September of 1912, was really just a little painting done with paper instead of pigments. But this kind of experiment brought out the distinctive textural properties of the elements in a way earlier folk art of a similar kind could not. Practitioners of quilling, découpage, and hair sculpting sought smooth compatibility in a search for overall harmony. The Cubists were exploring the ways disjunction could be used to dramatize purely formal relationships. In his *The Story of Modern Art* Norbert Lyton remarked a feature of this effort that seems highly pertinent:

> There is a precedent for a multiplicity of materials in the old practice of enhancing the value and effect of a painting by affixing jewels or by clading it in gold or silver. For the use of common materials such as newspaper there is another kind of precedent: the painter's trick of trying a piece of paper on his canvas as a way of testing the effect of a particular shape or color. Picasso and Braque may well have used paper shapes in plotting the larger forms in their Analytical Cubist paintings. To leave such a piece of paper permanently in place would have seemed only a small step that fitted in well with their playful attitude to representation.[39]

The expressionistic potency of the formal contrasts characteristic of collage was probably best exploited by the German artist, Kurt Schwitters, in his multi-room *Mertzbau* construction, created in Hanover between 1924 and 1937. But it is clear that not every artist exposed to *papiers collés* would overlook the potential use for *découpage* applications in the creation of works in which the principal aim is thematic invention rather than formal play. And so it was that the Berlin Dadaists, who were politically engaged in a way their Zurich predecessors had not been, began to employ collage as social commentary. Georg Grosz, Raoul Hausmann, Hanna Höch, and John Heartfield (nee Helmut Herzfelde) all produced works dependent on photographic materials used first hand or, more frequently, clipped from magazines and newspapers. The invention of this new collage form, the *photomontage*, has been credited to all of the above and each has claimed credit for the innovation. In Cologne a Dadaist with a background in philosophy and psychology, Max Ernst, began doing elaborate satirical commentaries on every aspect of modern society and eventually "invented" the Surrealist collage. His earliest Dadaist collages were made up of things found in a catalogue of objects for use in scientific lectures and demonstrations and nearly always involved painted additions from his own hand. Sometimes the pieces were constructed without glue and sometimes didn't even make use of paper. But in 1922 he moved to Paris and began doing collage novels which relied entirely on cutting out and pasting together in new combinations pictures from old books, magazines, and catalogues. Since most of these clippings are from illustrations printed as woodcuts or wood engravings

done in the highly conventionalized techniques familiar to any reader of nineteenth-century periodicals, Ernst's pictures in *Le femme 100 tétes* (1929), *Rêve d'une petite fille qui voulut entrer au Carmel* (1930), and *Une semaine de bonté ou les sept éléments capitaux* (1933) have a consistency of form uncommon in collage. His contrasts are not of textures but of subject matter. For instance, the first book, "Sunday," in *Une semaine de bonte*, that is, *A Week of Kindness*, takes as its "example," The Lion of Belfort; the works all feature human figures, at least one with an animal head. Usually the head is feline, but the twelfth image shows a couple strolling arm in arm through a dreamscape, the male having what appears to be the head of a dog. Of course, the settings are always weird, full of incongruities and disturbing incidentals. On "Tuesday" in the "Court of the Dragon" the collages are full of conservatively dressed men and women who sometimes sprout wings (either plumed or, more often membranous) from shoulders and even waists.

The reader will recall that collage, in a more general sense of disparate elements brought together into juxtaposition, is celebrated as an ultimate kind of expression by Jacques Derrida and Michel Foucault, among others. In literature "collage," so called, comes down to a matter of contrasting different modes of expression so that, as with color and texture in the fine arts, the peculiar characteristics of the individual modes are set off in stark contrast. Poet Guilliame Apollinaire, a champion of modernism in art, contrasted bits of vernacular speech with poetical form in his poetry—for instance, in "*Aussi bien que les Cigales*," a calligraphic poem written to resemble the cricket of the title. It concludes, "People of the South it is necessary to see to drink to piss as well as the crickets in order to sing like them. THE ADORABLE JOY OF THE SOLAR PEACE." Lynton points out in the same place quoted above that Ezra Pound, T. S. Eliot, and James Joyce also derive their styles in part from collage-like combinations of forms. A still more obvious example is the once celebrated trilogy *U.S.A.* by John Dos Passos which appeared between 1930 and 1936. Dos Passos combined long, rather conventional narratives about a dozen Americans whose lives intersect with extremely well done biographies of people of coeval prominence (such as Wilson, Ford, Edison, Veblen, Burbank), "Newsreels" made up of headlines, bits of popular music, advertising, feature items, and so forth, and stream-of-consciousness passages named "The Camera Eye" that are the author's rather chaotic, unpunctuated impressions of public events the narratives touch upon. One of the things borne out by a re-reading of any the *U.S.A.* volumes (*The 42nd Parallel, 1919,* and *The Big Money*) is that heavy reliance on contemporary vernacular dooms a work to obsolesent self-parody. Other than that, it's still a "swell" piece of applied modernism. Probably, however, Joyce's *Finnegan's Wake* remains the ultimate example of a collage novel as literature.

Actually, "collage" is not the best term for this kind of thing. If we really must use something derived from the visual arts, the term *montage* would seem more suitable. The term is from French for "mounting," and is a good catch-all for techniques that involve clipping (*coupage*), and mucilage (*collage, collé*). The related word, *photomontage,* suggests that the material is exclusively from still cameras, but really signifies only that photographs are the principal element.

Cinema is the field in which *montage* is used as technical jargon most frequently and consistently, where it signifies splicing images together in a discontinuous series—an editing technique pioneered by American D. W. Griffith in 1909 and polished by the Russian avant-garde. The dominion of montage over conventional narrative is evident in such a film as Sergei Eisenstein's 1925 *The Battleship Potemkin* where the editing pulls heterogeneous bits of reality into a cogently focused statement on the failed Revolution of 1905. We see the men of the Potemkin working strenuously in the engine room of the cruiser. In rapid succession we see wheels revolving, a man's arm straining, rods driving pistons, an arm, a sweating chest, wheel, man, throbbing mechanisms seen at precarious angles, a man, a pressure gauge, faces distorted with exertion, machinery pounding, wrenching, churning. Jagged, discontinuous imagery builds into a staccato crescendo of implacable, dehumanizing force. This early masterpiece of filmmaking contains also one of the most moving and terrifying sequences in cinema history, the famous "Odessa Steps Sequence." A great crowd has gathered on the high, broad steps of the port in the city of Odessa to cheer the successful mutineers of the Potemkin. Above them appear ranked Cossacks who begin a relentless march towards the crowd, bayonets mounted. In a series of separate images we see: the massed crowd; the Cossacks from the rear, then in profile as a moving forest with rifles before them like sharpened limbs; gunfire; a mother with her dead child in her arms; the feet of people in flight, trampling over the fallen; the face of a horrified old woman, a Cossack officer with drawn saber, the old woman's face, the grimacing Cossack as he slashes, the bloodied face of the woman. The blow itself is not shown, only the assailant and the victim in the instants before and after. Then the steps littered with the bodies of the dead. These are but a few of the many separate images that make up the sequence. Another heart stopping incident shows a baby carriage, slipped from a parent's grasp, bouncing down the steps. It's empty! A symbol of promise doomed? The contrasts of the individual shots are severe, startling, yet the director's use of diagonals and parallels of similar magnitude in the steps themselves, the rifles, the shadows cast by the soldiers, gives the whole montage a unity like something from a symphony by Tchaikovsky.

The Battleship Potempkin also used montages of quick cuts back and forth from events aboard the vessel to life ashore, revealing both differences and continuities between the mutiny and nascent revolution. The ability of film to convey the simultaneity of separate events in this way is one of the most

gripping things about it. And, predictably, the use of montage to suggest that things seen in sequence are occurring at once has inspired many attempts to associate the cinematic use of montage with such things as Cubism's supposed multiple viewpoints and Surrealism's dream imagery, and any number of twentieth-century phenomena. Thus, Arnold Hauser wrote:

> We meet the Bergsonian conception of time, as used in the film and the modern novel—though not always so mistakably as [in Joyce's *Ulysses*]—in all the genres and trends of contemporary art. The '*simultanéiré des états d'ames*' is, above all, the basic experience connecting the various tendencies of modern painting, the futurism of the Italians with the expressionism of Chagall, and the cubism of Picasso with the surrealism of Giorgio de Chirico or Salvador Dali. . . . With its analysis of time, the film stands in the direct line of this development: it has made it possible to represent visually experiences that have previously been expressed only in musical forms.[40]

Laszlo Moholy-Nagy, the principal spokesman for the avant-garde school of industrial design, the Bauhaus, in both its Dessau and Chicago Institute of Design incarnations, published a book in 1947 that takes the possibilities of film montage as a kind of *sine qua non* for modern expression. *Vision in Motion*, the title, is synonymous, according to Moholy-Nagy, with "simultaneous grasp. Simultaneous grasp is creative performance—seeing, feeling, and thinking in relationship and not as a series of isolated phenomena. It instantaneously integrates and transmutes single elements into a coherent whole. This is valid for physical vision as well as for the abstract."[41] Like most modernists, Moholy-Nagy had a tendency to confound the auspices of the movement with the facts of his case. In this instance, it should be clear that what he says can be applied to any kind of orderly undertaking, no matter how banal, repetitive, or old-fashioned. He did, in fact, recognize that traditional art fulfilled the description but his text and illustrations are almost entirely concerned with what seemed to be the cutting edge of aesthetic "progress" at the very end of World War II. The social philosophy and educational theories expressed in *Vision in Motion* owe a great deal to Karl Mannheim's "Sociology of Knowledge," which in some ways is a kind of liberal anticipation of the postmodernist left insofar as it recognizes that all social thought, no matter how ostensibly "objective," represents a particular viewpoint because every person occupies a specific social habitat and his or her experience brings anyone into contact with only a limited range of experience. Inevitably, every opinion is partial and there is no such thing as an objective, unbiased truth. Mannheim and the Bauhaus, however, are more openly insistent on the need for social control in an unregimented society.[42] Moholy-Nagy, for instance, conceives the

primary purpose of modern design to be overcoming the "barren isolation" of individuals who are "losing the realization of the collective nature of man's existence."[43] One gains the impression from his writing that the example of montage is a simulacrum for the unification of a whole consciousness from fragmentary social elements and isolated souls. His preposterous proposal for a Parliament of Social Design (which would become a cultural center of world government and "translate Utopia into action") draws from an enthusiasm for cooperative creative undertakings such as filmmaking and group poetics that are invariably dependent upon what can easily be described as montage effects.

Somewhere just beyond montage or collage, though employing its principles, are small scale constructions of the sort that used to be called "shadow boxes." Of these, arguably the best made and most ingeniously evocative are the assemblages of Joseph Cornell (1903-1972). Cornell's boxes are filled entirely with second hand material. So far as I can tell the artist never learned to draw but his really exquisite sense of design and his feeling for the poetry of objects as icons is unsurpassed by any of the Surrealists who claimed him for their own. Only Marcel Duchamp was better at creating original art from the detritus of industrial civilization. But Duchamp's creations are few and very grand in their aloof wryness whereas Cornell's boxed reveries are numerous, intimate, and delicately lyrical. Cornell's works were constituted from the huge variety of printed material—a good deal of it having to do with ballet and motion pictures—he kept in his basement on Utopia Parkway in Flushing, Queens.[44] His was an extraordinarily constrained and highly introspective existence, an almost hermitlike separation from the hurly-burly of city life in New York, whereas that of Marcel Duchamp was marked by insular genius operating within the select realm of cosseted sophisticates.

Duchamp either took his *object trouvé* "neat," adding nothing whatever (*Bottle Rack*) or very little, as in his notorious *Fountain*—a urinal set up on end and signed "R. Mutt,"[45] or he contrived to construct objects of vastly greater physical and intellectual complexity than the poetical playthings of Cornell. Duchamp's most famous piece is *The Bride Stripped Bare of Her Bachelors, Even* but his very last work, completed in 1966, and now in the Philadelphia Museum of Art along with most of his other work, is a kind of collage in the form of a diorama. *Étant Donnés: 1. La Chute d'Eau; 2. Le Gaz d'Éclairage (Given: 1. The Waterfall, 2. The Gas for Lighting)* features a startlingly exposed female nude on a bed of leaves and branches. She's sprawled out with legs spread apart and head out of sight, her left hand holding an antique filament gas lamp. The nude is remarkably realistic; it is a plaster casting completely covered in pale pigskin and the hairless pubic mound and parted vulva have a strangely authentic yet somewhat implausible character. The backdrop is a trompe-l'oeil photomontage of an idyllic landscape containing a waterfall. It is a mysterious and provocative piece and, like much of Duchamp's ouevre, the fragmentation is of meanings as well as imagery.

One of the most intriguing things about the introduction into the fine arts of ordinary objects like the apothecary jars, souvenir postcards, and astronomical diagrams of Cornell or Duchamp's urinal, bottle rack, and bicycle wheel is what it implies about our aesthetic valuations. Conservatives would perhaps assert that what it really implies is that we have no sense of value at all, but here is a situation in which the deconstructionist turn of mind is useful. Regard the way most of us accept without hesitation the presence in the great art museums of objects originally intended to be used in connection with rituals of one sort and another. Unless these artifacts are exhibited in collections exclusively devoted to ethnographic study, both viewers and curators conceive of them as art works similar to easel paintings. The cultures of the Far East have long traditions of aesthetic sensibility more refined than those of Europe and, undoubtedly, most Buddhists look upon the life-size bronze of Buddha from A.D. 447 that is in the Metropolitan Museum of Art as an object of art at least as much as an object of veneration. But the same cannot be said of the original owners of, say, a Bakota guardian figure from Gabon in West Central Africa, a ritual war club from the Maori of New Guinea, or the bauxite squash goddess from Cahokia Mounds in Illinois. These things were perceived by their creators and by those who used them as utilitarian objects. Craftsmanship and beauty were entirely incidental to the value of a figure to warn inimical spirits away from a sanctuary, for instance, or insure a good harvest. The war club has much to do with destiny and its elaborate ornamentation pertains to the preciosity of the singular role of the weapon in a rite but not with attractiveness *per se*. When we remove a guardian figure from its intended context and place it on a sculpture stand in an art museum we reify the shapes and turn them into a formal statement reflecting Western values. It becomes Art with a capital A.

This fragmentation of elements of a foreign culture and reconstitution of them into a collective fiction called something like "African Art of the Colonial Period" which comprises all sorts of incompatible ethnic groups under the common vision of the European-educated curator is not really an imperialist atrocity of any magnitude. But it is highly arbitrary and it revises utterly the original meaningfulness of sacred or functional objects by treating them as visual artifacts. Nor is this a matter of ethnic or racial hegemony; we do precisely the same kind of thing with Christian icons and Hebrew toroth. We are at a time in history when it is possible for us to experience all the world's art as formal gestures of the various cultures and different states of mind. It is but a tiny step from appreciating the way the concavities in a Bakota statue contrast and complement its convexities and its angularities to seeing that Duchamp's repositioning of a "Bedfordshire" style urinal emphasizes the surprising harmonies of that vessel. A voluptuously trigonic hollow tower of white porcelain is measured against the drain holes, themselves arranged into the shape of a triangle. And those small holes contrast with the large pipe hole that

is now on the base of a ready-made sculpture, *Fountain*. The least artistic part of the whole thing is what hasn't been manufactured in a factory but was hand made by an artist—that is, the crudely lettered signature with date. Duchamp's simple transformation may not have turned an appliance into a work of art, but it has made an incisive comment on the capriciousness of purely formal judgments in the field of the fine arts. Of course, it also pokes fun at the prudery of those who exhibit paintings of naked goddesses and gods in the Renaissance rooms or phalli and labia in ethnographic shows of "primitive" art without a blush. Marcel Duchamp was a funny man, but his paradoxical hijinks always had a serious aspect. And that he often behaved as if these efforts were some sort of hoax only makes the game the more intriguing.[46]

COMIC STRIPS AND "BREAK DOWN" IN NARRATIVE FORM

The indefinite expansion of the meaning of *montage* or *collage* by Moholy-Nagy and the postmodernists suggests that virtually anything can be made to fall under one of those headings. It is therefore rather odd that the "comic strip"—an art form consisting of separate images in temporal succession—has rarely been dealt with as montage even when discussed by well-informed critics of popular art such as Maurice Horn and Scott McCloud.[47] In his book, *Understanding Comics*, McCloud deals with Max Ernst's collage novel, *Une semaine de bonté*, as a special instance of the comic strip, but he does not look at things the other way around. At least I don't believe he does. *Understanding Comics* is a little difficult to check out for specifics because of its unusual format; the book is itself an obsessively thorough and thoughtful analysis of the comic strip presented in comic book form. McCloud does comment: "You might say that **before** it's projected film is just a very, very, very, very **slow** comic!"

Although the comic strip came into existence simultaneously with motion pictures and has, in fact, a number of features similar to film, it has rarely aspired to anything loftier than merely popular art. Surely, there are the occasional works of genius like George Herriman's *Krazy Kat*, which even in its day was recognized as a comedic innovation on the same plane with the films of Charlie Chaplin and has often been compared with the best works of the Surrealists.[48] It is the most poetic of all comic strips. The dramatis personae are a black cat whose sex is never made clear, a white mouse named Ignatz, a white dog called Offissa Pup, and a brick. The cat is in love with the mouse whose main passion is for hitting the cat in the head with a brick, an act the adoring Krazy considers evidence of Ignatz's affection. The Kop, Offissa Pup, strives to protect "that dear Kat" from Ignatz's sadism and the cat's masochism. Herriman's scratchy drawing style is well suited to the happenings and to the fantasy land in which these characters live—a place where, in successive panels, a distant house will turn into a yet more distant mesa and then be transformed into a tree. Such metamorphoses are taken for granted by the characters and never mentioned by any of them. But *Krazy Kat* is the classic exception in the

history of the comics. Even such marvels of the illustrator's art as Winsor McCay's *Little Nemo*, Harold Foster's *Prince Valiant*, or Jean Giraud's *Lieutenant Blueberry* have generally been relegated to the domain of "kitsch for kids" by their producers as well as critics. Frank Godwin's *Connie,* a marvelously drawn strip that is seriously underrated—not least by feminists who should be celebrating the heroine as an earlier role model for girls that is far superior to *Wonder Woman*—outstripped even Milton Caniff's *Terry and the Pirates* and *Steve Canyon* when it came to spinning long, involved adventure narratives. Caniff, however, was superior even to his master, Noel Sickles, in making use of cinematic effects in comic strip format. Of course, most of these strips are not comical, really; they are more properly referred to as "graphic stories," but the old term sticks and we'll use it here.

Like any specialized field, the comic strip profession has its own jargon. For instance, the blobs containing dialogue are referred to as "balloons" and the tiny dot patterns of varying densities that are used to shade or color areas are called "ben day," after their nineteenth-century inventor, Benjamin Day. Most of the terminology used in the business is like ben day dots, also part of the technical lingo of the publishing business. But a few terms, like "balloons" and "breakdown" are specific to the medium.[49] Breakdown is the reduction of the narrative to separate illustrations. Typically, these small pictures are marked off by boundaries and each is a separate segment of time. (See Figure 7.)

Figure 7: Author's "breakdown" of a sequence from a sword and sorcery strip *Elric #1*, © 1973 by Steven Grant and John Adkins Richardson

Of course, adjacent pictures may show events occuring simultaneously in different places and a few cartoonists have devised alternatives to the boxlike panel, usually by following the ancient technique of employing friezes of figures in a continuous space where the same individual repeated marks off stages of the action, as in *The Column of Trajan* (A.D. 113), showing the Romans conquering Daccia—now known unsurprisingly, as Romania—or the *Bayeau Tapestry* (late 11th century), which relates the story of the Norman Conquest of 1066. Similarly, a cartoonist may show us a page of figures in empty space, the action supported by fragments of an otherwise invisible environment. Or we may see an overview of a landscape or city block with the figures recurring as the action proceeds, in much the way Sassetta shows St. Anthony twice before he embraces Paul before the latter's cave (see Plate 2). Still, all of these techniques depend upon spatializing time. What is seen first, occurs earlier than what is read later, unless the latter is clearly designated as a "flashback."

Most daily newspaper strips are very brief, humorous anecdotes told in three or four panels. No matter how many panels may be involved, the development of the joke follows an inevitable, even inexorable rhythm that moves from opening to close in three stages. First, there is a situation, then the setup, and finally the punch line. For instance in the *Peanuts* strip by Charles Schulz, Linus, the blanket-fondling thumb-sucker is shown with the protaganist, who is sealing an envelope. "I wish I had a pencil-pal like you, Charlie Brown." "Well, it doesn't do much good if you can't read or write." "That's very true," Linus admits, as Charlie Brown walks off to our right, on his way to mail the letter. Now Linus is alone, walking in the opposite direction. He says: "Only five years old and already I'm illiterate!" Like many of Schulz's gags, this is gently touching in its irony, but it is entirely standard fare in terms of establishing a situation, intensifying it with a minor complication, and closing with a punch line.

Although the fundamental character of the breakdown is as ancient as pictographic narrative, its relationship to temporality can be quite involved. Normally, breakdowns propel the graphic story in time, much as motion picture frames do. Indeed, in this respect a comic book resembles the physical structure of motion pictures more than any other art form. In film, normal action proceeds at a pace of twenty-four frames per second; to speed up things—so that automobiles racing through city streets appear to be going sixty miles an hour when they are actually doing about twenty-five—the camera runs slower, so that fewer frames will be needed to capture a vehicle's movement from one end of a block to the other. To achieve slow motion, on the other hand, requires that more than twenty-four frames pass by the lens in a second, thereby prolonging the time it takes to get from one cross street to the next. And, in an analogous fashion, the comic strip artist may intensify an event by showing many fragments of a single event. For example, the typical way of handling fist fights in the comics is to show a punch thrown and its result in a single panel. Speed

lines track the motion of a fist which is at this instant separated from the opponent's chin by an impact burst. In the same panel the victim's head snaps back and his features are contorted by pain. Everything involved in knocking a person down is revealed instantaneously in a way that would never occur in reality or in film. That kind of compression of events into a single picture is a convention of the cartoon form. But, if one wishes to dramatize the importance of a *particular* blow—because, perhaps, the hero is supposedly too meek to defend himself—one might break the action down into a series of pictures. Thus: (1) The hero starts a right cross as he blocks a jab with his left hand. (2) The villain dodges to the right as the hero's fist continues moving. (3) The blow connects. (4) The villain's eyes widen in surprise as the fist plunges deeper into the flesh of the jaw. (5) The fist is now beyond the face but the jaw is out of line, as if drawn by a magnet. (6) Now the man's head is twisting over and back, a tooth spewing out. (7) The whole upper torso bows over backwards. (8) The villain falls to earth in a cloud of dust. This is very like the slow motion effects that became popular following the release of Akira Kurosawa's *Seven Samurai* in 1954 and, by now, have gone beyond cliché to become convention.

As you can see, montage, film, the comic strip, and pictorial narratives from pre-history, Egypt, Antiquity, and the Middle Ages actually form a continuum in which distinctions are less pronounced than similarities. In point of fact, whatever inferences critics may frame about associations of montage with modernism are implicitly arbitrary. Even Kurosawa's manipulation of temporality to disclose the grace concealed in agony and violence has its anticipation in scroll paintings from the twelfth century and later. What is so distinctive about these effects in the modern art of Europe and America is their association with social dysfunction.

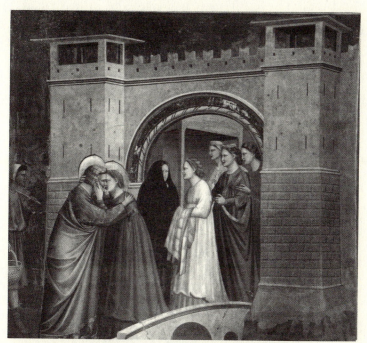

1 GIOTTO, *The Meeting of Joachim and Anna at the Golden Gate.*c.1306. Fresco. Arena Chapel, Padua

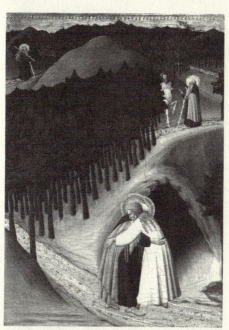

2 SASSETTA,*The Meeting of St. Anthony and St. Paul.*c.1440 Tempera on wood panel.18 3/4 x 13 5/8". National Gallery of Art, Washington, D.C., Samuel H. Kress Collection

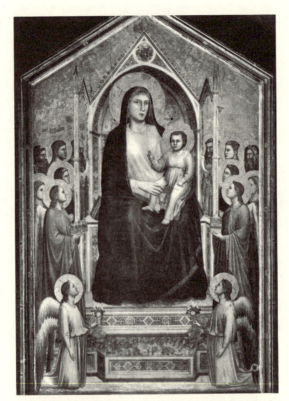

3 GIOTTO, *Maesta*. c.1310. Tempera on wood panel, 10'8 x 6'8". Ufizzi Gallery, Florence

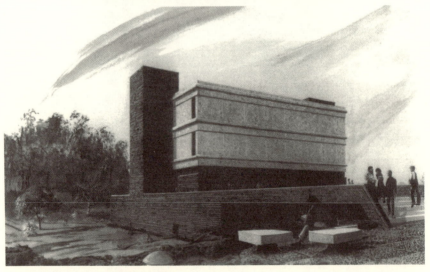

4 The author's delineation of a proposed building

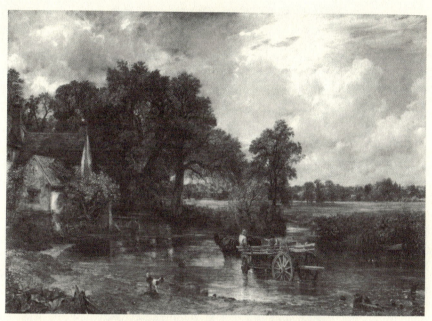

5 JOHN CONSTABLE,*The Haywain.*1821. Oil on canvas, 51 1/4 x 73". The National Gallery, London.

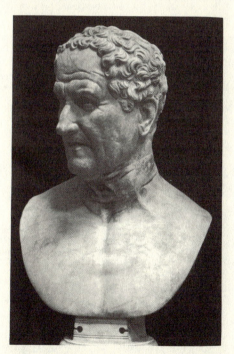

6 *Lucius Cornelias Sulla*. c. 80 B.C. Marble, height 12". Vatican
 Museums, Rome

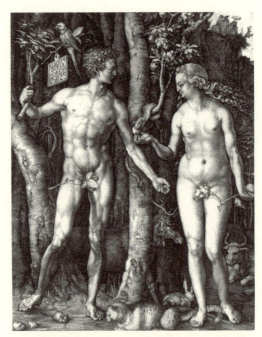

7 ALBRECHT DÜRER, *Adam and Eve*. 1504. Engraving, 9 7/8 x
7 5/8". Museum of Fine Arts, Boston. Centennial gift of Landon T.
Clay

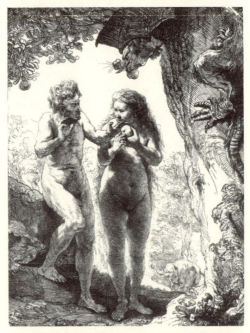

8 REMBRANDT VAN RIJN, *Adam and Eve*. 1638. Etching, 6 3/8 x
4 5/8". Rijksmuseum, Amsterdam

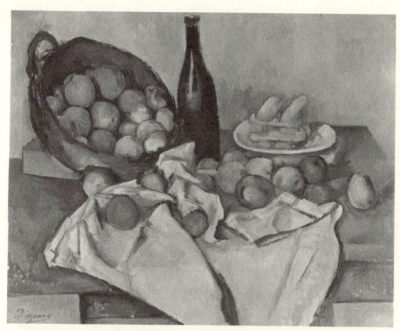

9 PAUL CÉZANNE, *The Basket of Apples.* c.1895. Oil on canvas, 25 3/4 x 32". The Art Institute of Chicago, Helen Birch Bartlett Memorial Collection. Photograph © 1977 by The Art Institute of Chicago

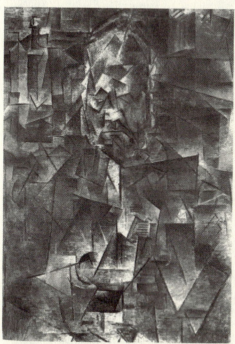

10 PABLO PICASSO, *Portrait of Ambroise Vollard.* 1909-10. Oil on canvas, 36 x 25 1/2". Pushkin Museum, Moscow

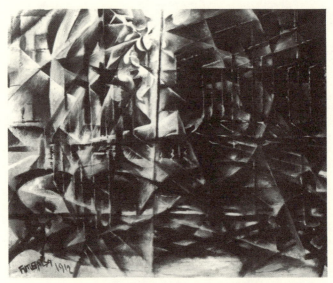

11 GIOCOMO BALLA, *Speeding Automobile*. 1912. Oil on wood, 21 7/8 x 27 1/8". The Museum of Modern Art, New York. Purchase. Photograph © 1998 by the Museum of Modern Art, New York

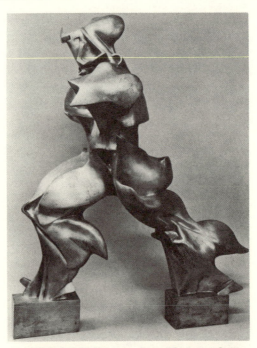

12 UMBERTO BOCCIONI, *Unique Forms of Continuity in Space*. 1913. Bronze (cast 1931), 43 7/8 x 34 7/8 x 15 3/4". The Museum of Modern Art, New York. Acquired through the Lillie P. Bliss Bequest. Photograph © 1998 by the Museum of Modern Art, New York

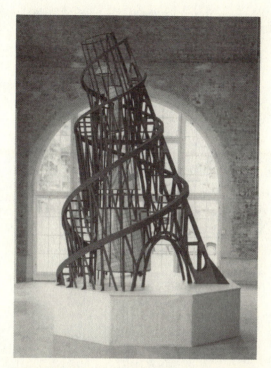

13 VLADIMIR TATLIN, *Monument for the Third International.* 1912-13.
Model in painted wood and plaster.Reconstructed in 1981. Moderna
Museet, Stockholm

14 SIDNEY CHAFETZ, *Academic Landscape.* 1962. Color woodcut, 23 1/4 x 29 1/4", edition of 40

15 WARRINGTON COLESCOTT, *History of Printmaking: Lasansky Reaches Iowa City.*
1976. Color lithograph, 11 3/4 x 15 1/2", Edition of 50. Nause & Graf Print Collection.
The University Museum, Southern Illinois University at Edwardsville

16 ROBERT COLESCOTT, *Grandma and the Frenchman (Identity Crisis).* 1990. Acrylic on
canvas, 7 x 6'. Courtesy of Phyllis Kind Gallery, New York and Chicago. Collection of
James and Maureen Dorment, Rumson, New Jersey

17 Author's DesignCAD-3D Drawing of *Ramjet*

18 RENZO PIANO AND RICHARD ROGERS. *Pompidou Center,* Paris. 1976. Photograph by the author

The Arriere-Garde Character
of the Vanguard

The failure of the attempt to realize a modern marvelous *(almost always scientific in content, almost exclusively urban in ambiance) was also due to the fact that the marvels of technology are now discounted by men of the new times; the poets and artists themselves, in the very great majority of cases, reduced the fabulous to the level of the extravaganza and the apparent, superficial, and fleeting. Bontempelli sensed as much when he recognized that the myth of aviation had already been exhausted, some thousands of years before the airplane was invented, by the myth of Dedalus and Icarus, and when he asked what poet, contemporary with the New Atlantis that is America, or afterward, had ever succeeded in drawing from this event a vision even remotely comparable to the voyage of Ulysses in Dante.*

Renato Poggioli[1]

Realization of a *modern marvelous* to which Poggioli refers was part of Surrealism's program of psychic reform during the 1920s. It was a concept originated in the enthusiasm of the inventor of "art for art's sake" and idol of the Parnassians, Théophile Gautier, for looking at certain aspects of modern life and evoking from them new poetry, myths, and legends. In 1934 Andre Breton still speaks of his resolve "to render powerless that *hatred of the marvelous* which is so rampant among certain people."[2] Sigmund Freud had noted that, typically, patients of his had great difficulty understanding that, in psychoanalysis, psychic fantasy and material reality are to be treated as if they were no different. Breton was trained as a physician and his interest in psychoanalysis was sufficient to inspire a trip to interview Freud in Vienna in 1921, but he did not entirely agree with the master; for one thing, Breton believed in the supreme priority of fantasy and, thus, the fantastic. Indeed, he seems not to have distinguished in any clear fashion between what is fantastical,

amazing, and merely strange, saying, "The admirable thing about the fantastic is that it is no longer fantastic: there is only the real."[3] The thing most distinctive about modernity was, of course, the industrial revolution that radically changed the relationship of humanity to the rest of the natural world.

That Dadaism's fascination with machinery was carried over into its Surrealist future can be seen in the work of Max Ernst, whose 1921 painting, *The Elephant of the Celebes* is a collage-inspired proto-Surrealist work combining fantastical machinery with organic fragments in a style that has clear antecedents in Chirico. The central figure is a bloated iron robot with a constructivist head and a metallic trunk ending in what might be a cast iron cow skull with nickel-plate horns. Such cute grotesques are rare in Ernst's paintings thereafter, but they occur with some frequency in the collage novels of the late 1920s, particularly in *La femme 100 têtes*. Man Ray, René Magritte, and Salvador Dali also include modern devices in their catalogue of incongruities. They recognized that telephones, locomotives, electric lanterns, automobiles, phonographs, and bowler hats were as suited to the dream world of Breton's *Manifeste du surréalisme* of 1924 as the paraphenalia inherited from *art nouveau* and French Symbolist poetry. In fact, the whole attitude of Surrealism was to incorporate into modern life a kind of allegoresis that depended upon confusing dreams and living reality with whatever had the potential to exhilarate and "possess" the imagination. This was, of course, merely an extension of the hallucinatory imaginings of the Romantic movement. It began as a dissension of poets, not painters, and its character owed a very great deal to Breton's enthusiasm for the joining together of arbitrary images which he felt would meld into a new "super reality" the logically disjunctive realities of the originals. For the truths of Surrealism were supposed to lay beyond reason since, in modernity's wonder world, opposites are not perceived as mutually exclusive.

Breton had discovered a startling antecedent of the practices he preached in the writing of an obscure literary eccentric born Isidore Lucien Ducasse. Ducasse, who designated himself Comte de Lautréamont, had died at the age of 24 in 1870,[4] having published a slender book of reflections called *Poésies,* which contains only prose and no poems at all. His most influential work, *Les Chants de Maldoror*, was first printed in Belgium in 1869 but not released until 1874. Previously, the first canto had appeared in France in 1868 and was greeted with a mixed review in *La Jeunesse* which characterized it as being uncommonly original. In 1890 it was reedited for publication in France. Though notorious for its sacrileges, the book went more or less unnoticed until Breton proclaimed its author a genius and a Surrealist before his time. If you read anything at all about Surrealism you are almost certain to see Lautréamont mentioned as an important precursor of the movement and virtually sure to read one phrase, and that phrase only, from *Les Chants de Maldoror*. That will probably be it. One gains the strong impression that these entries in surveys, textbooks, and museum catalogues are written by people who have read other

surveys, textbooks, and museum catalogues but not the book Ducasse/Lautréamont composed.[5] In order, therefore, to clarify what is going on here and also spare you from actually reading *Les Chants de Maldoror*, I shall digress a bit upon it here.

THE WORK OF LAUTRÉAMONT AND THE SURREALIST MANNER

Les Chants de Maldoror concerns a protean super-being named Maldoror who thrives on gratuitous murder, torture, and the disembowelment and rape of little girls, women, and (mostly) adolescent or prepubescent boys. He is also capable of such extraordinary feats of passion as having intercourse with a huge female shark during a tempest at sea. At one point he defeats and humiliates The Creator and his angelic host. The blasphemy that shocked publishers and titillated moderns is as nothing compared to the phantasmagoric world Lautréamont portrays through grotesque, not to say hilarious juxtapositions that made his book required reading for the Surrealists. But most of his similes and metaphors are pretty routine and, before turning up anything strange to a contemporary reader, one has to read a lot of stuff like: "The renegade's arm and the murderous instrument have merged in linear unity, like the atomistic elements of a ray of light penetrating the *camera obscura*."[6] Some of the turns of phrase sound like conscientiously forced updatings of Romantic clichés, to wit: "the implacable snowplough cow-catcher of fatality."[7] The most striking line is the one Breton made famous, about a chance meeting of objects on a dissecting table. Practically the only thing ever quoted from *Les Chants de Maldoror,* it is part of a description of an English youth named Mervyn. Maldoror's last victim, he has just appeared for the first time, walking down the Rue Vivienne.

> I know all about telling age from the physiognomical lines of the forehead: he is sixteen years and four months old! He is fair as the retractility of the claws of birds of prey; or, again, as the uncertainty of the muscular movements in wounds in the soft parts of the lower cervical region; or, rather, that perpetual rattrap always reset by the trapped animal, which by itself can catch rodents indefinitely and work even when hidden under straw; and above all, as the chance meeting on a dissecting table of a sewing-machine and an umbrella![8]

This is the most "surrealistic" language in the book though there are many nightmarish scenes worthy of Salvador Dali or Raoul Hausmann. As a sort of accompaniment to Lautréamont's archness and impiety the prose is full of twisty ambiguities, tricky references to literary form, and outright plagiarisms. For instance, one of the best passages in *Les Chants de Maldoror* opens the fifth canto with a truly wonderful description of the unique flight pattern of flocks of starlings. Their strange way of swirling to the center while the wheeling mass makes headway towards a distant goal is comparable to his own method, says Lautréamont, and his readers should be able to accept the "bizarre way in

which I sing each of these stanzas," in faith that his composition is similarly focused.[9] The remarkable thing about this marvelous tour de force is that it was lifted verbatim from Jean Charles Chenu's *L'encyclopedie d'historie naturelle* of 1850-61—one of the most eloquent reference works of all time. This kind of theft had been rationalized already by Ducasse in his *Poésies:* "Plagiarism is necessary. Progress implies it."[10] And why? Because "Poetry must be made by all. Not by one."[11] It's an attitude to warm Derrida's heart. And, for somewhat similar reasons, Breton's.

Certainly, Lautréamont's epic anticipated the Surrealists in its montage-like juxtaposing of things stolen outright, parodic simulations of the extremes of Romanticism, and the self-conscious intertextual critique of what has been written. With respect to the latter, at the beginning of the second part of the fourth canto he writes: "Two pillars, that it was not difficult, and still less impossible, to take for baobab trees, were to be seen in the valley, taller than two pins. Actually, they were two enormous towers."[12] Now this sort of approach to descriptive prose sounds very like a paradox, but on the following page we discover that "nature caters to all tastes; and at the beginning when I compared pillars to pins with so much accuracy (indeed, I did not think that one day I would be upbraided for it), I based my observation on the laws of optics, which have established that the further the line of sight from the object, the smaller the image reflected on the retina."[13] This playing off of accurate description against misperception and, then, using its very ambiguity to critique the reader's acuity and tolerance, is precisely the kind of thing that would appeal to a Dadaist or Surrealist.

The Surrealists' notion of a *modern marvelous* was not the same as that of the Futurist sympathizer, Bontempelli. Their view of the machinery of the times was only a little less jaundiced than it had been during the nihilistic beginnings of the movement in Dadaism and, in any event, Surrealism is the epitome of art that reduces the fabulous creations of modern sciences to fleeting displays in an extravaganza. No wonder that among its most notable successes were the films *Un Chien Andalou* (1927) and *L'Age d'Or* (1929) made by Dali and Luis Bunuel.

THE FUTURISTIC REALITIES OF ITALIAN FUTURISM AND RUSSIAN MODERNISM

The Futurists were enthusiasts of modern technology, only a little behind Ettore Bugatti, the Italian-born French automobile designer, who had commenced as a painter but soon abandoned the easel for the newest of arts—that of mechanical design. In 1901, still only nineteen years old, he had constructed his first car, and within the decade produced his famous Type 13 racing car which, in 1921, won the Brescia race and was thenceforth known as the "Brescia" Bugatti. His automobiles were masterpieces of engineering—one of the them, the huge 41 "Royale," cost £5,200 when a Rolls Royce Phantom II

was going for a mere £1,900—and some, like the Type 57SC "Atlantic" coupe, were supercharged sculptures made of steel. Every Bugatti was terrifyingly fast; the Royale limousine was powered by an aircraft engine and would do over 100 miles an hour, a remarkable speed for a 1927 luxury car sold with a lifetime warranty.[14] The Futurists must have been frustrated to think Bugatti manufactured cars with an Italian name for their marque in France, for they were altogether enamored of automobiles. In the years before World War I the artist, Giocomo Balla, did a whole series of paintings based on speeding automobiles (Plate 11), and the line that is quoted most often in connection with Futurist theory is Filippo Marinetti's declaration in his "Manifesto of Futurism" (1908) that "a race-automobile adorned with great pipes like serpents with explosive breath . . . a race-automobile which seems to rush over exploding powder is more beautiful than the *Victory of Samothrace*."[15] The entire opening of the Manifesto is concerned with driving fast roadsters into the dawn of a new day. A few lines will give you the flavor:

> We went up to the three snorting beasts to pat lovingly their torrid breasts. I stretched out on my machine like a corpse on a bier; but I revived at once under the steering wheel, a guillotine blade that menaced my stomach. . . . And we like young lions pursued Death with his black pelt spotted with pale crosses, streaking across the violet sky so alive and vibrant. . . . And we sped on, squashing the watchdogs on their doorsteps who curled up under our scorching tires like starched collars under a flat iron.[16]

Almost at once the author skids, nearly hits two cyclists, and flips the car over into a ditch. A group of fishermen help pull the car out of the "maternal ditch" filled with muddy water from a factory. They think his "shark" is dead, "but the stroke of my hand was enough to restore it to life, and there it was living again, speeding along once more on those powerful fins." From this point the declarations of the manifesto proper begin. There are eleven brief, numbered paragraphs, of which the fourth contrasts cars with the *Victory of Samothrace* to the detriment of Pythocrites' winged statue in the Louvre. The aim of Marinetti's consecration of modernity is to "free Italy from her numberless museums which cover her with countless cemeteries." Based in good measure upon the philosophies of Henri Bergson and Nietzsche, Italian Futurism was in revolt against the ills of a very lopsided aristocratic/bourgeois society that was Catholic, conservative, and almost completely irrelevant as a cultural force in the modern world.

For all his bombast Marinetti is rather endearing when it comes to the safe perpetuity of his own views. Radicals are normally quite confident of the eternal verity of their prescriptions for society; not so the founder of Futurism. He says, "The oldest among us are thirty; we have thus at least ten years in which to accomplish our task. When we are forty, let others—younger and more daring men—throw us into the wastepaper basket like useless

122

manuscripts!"[17] The Futurist architect, Antonio Sant'Elia, shared this remarkably nihilistic view of the movement's creations. His building designs expressed themselves in contemporary materials of great elasticity, strength and permanence—reinforced concrete, steel, glass, fiberboards, and every modern substitute for wood, stone, or brick, but his 1914 *Manifesto of Futurist Architecture* proclaimed: "The house will last for less time than we will. Each generation must build its own city."[18] What breathtaking confidence in the vitality of what is yet to come!

The consistency between the viewpoints of a poet and architect may seem expected in a movement dedicated to realization of the new, but Italian Futurism tended to be marked by dissimilarities among its followers. Unfortunately, the profascist ravings of Marinetti in support of Mussolini's invasion of Ethiopia in 1935 have tarred the entire movement with his horrifyingly lyrical assertions about war enriching meadows with the fiery orchids of machine gun blasts and the aerial architecture of formation flights and smoke spirals from burning villages. Like Hitler's SS men wearing skull medallions backed up by lightning bolts, it's too bad to be true, like something from a low brow comic strip or a cheap melodrama. But Futurism itself had a good deal more to be said in its favor. Of course, there was the art work which, though superficially derivative of Cubism, rose to singular heights in the sculpture of Umberto Boccioni that, in the case of Plate 12 at least, is true to his dictum insofar as it is a "sculpture of environment" that models "the atmosphere that surrounds things."[19] And it was dynamic not only in its worldview, but in its ability to reform itself from moment to moment, just as the manifestoes promised the world. Take, for instance the view of woman pressed forward at various times.

In Marinetti's first manifesto, women are treated with great scorn, but this is not precisely what it at first seems inasmuch as the real target is the impossibly romantic conception of femininity and love epitomized by the heroines of D'Annunzio. Rather gradually, this early position, characterized by a declaration of war on moralism and feminism, was "expanded into a social programme that attacked sexual morality, marriage and the structure of the family as the main causes of the repressive castration of the individual, male and female. By 1919 . . . scorn for women had been completely reformulated: 'We want to destroy not only the ownership of land, but also the owner-ship of women.'"[20] Already as early as 1913 the dancer Valentine de Sainte-Point appeared in a Futurist connection with the publication of her *Futurist Manifesto of Lust*. A granddaughter of the grand old man of French Romanticism, Victor Hugo, Sainte-Point argued that the female was equal to the male in lust. She was as vigorous a champion of the sensual intensity felt through artistry and warfare as were the Futurists whose defense was the purpose of her statement. One other woman became an "official" member of the Futurist group—the wealthy collector, Marchesa Casati. Still, Futurism remained very much a masculine club, boastful of its own virility and, so far as feminism was concerned, very typical of modern revolutionary movements in being far more interested in the

abolition of a "double standard" than in securing genuine equality for women. Often enough, the early moderns were men who held liberal views on women's right to behave just like men, but sexual freedom did not necessarily mean equal pay, enfranchisement, or shared domestic labor; rather, it meant greater opportunities to have sex with a class of women who were free—and free not only from moral subjugation but also free in the sense that prostitutes are anything but.

Beyond its capacity for internal reform and nihilistic sacrifice of its own principles for some prospective yet uncertain gain there is yet another feature of Futurism that is not usually recognized as a positive element in the history of modern art. That is the significance of Futurism's cognomen—a term many professors of art history have found bothersome because "futuristic" has been used for years by journalists to signify weird, science-fiction like prognostications. Poggioli, whose field was comparative literature, was untroubled by the popularity of the word among the general public, and what he wrote about the word *futurism* is well worth quoting here:

> As already observed, the futurist movement belongs to all the avant-gardes and not only to the one named for it; to generalize the term is not in the least arbitrary, even in view of Ortega y Gasset's and Arnold Toynbee's use of it as a historic and philosophically generic term to designate eternal psychological tendencies belonging to all periods and all phases of culture.
>
> Therefore, the so-named movement was only a significant symptom of a broader and deeper state of mind. Italian futurism had the great merit of fixing and expressing it, coining that most fortunate term as its own label. Indeed, precisely because the futurist movement is more or less present in all the avant-gardes, the best definitions are not those offered by actual and official futurism, which in any case sensed only its most superficial and external aspects; the best definitions come from witnesses outside the specific movement. One of these is, again, Bontempelli who . . . furnishes, perhaps unwittingly and without wanting to, the definition we seek: "In sum, the avant-gardes had the function of creating the . . . primordial condition out of which is then born the creator found at the beginning of a new series." This means that in the psychology and ideology of avant-garde art, historically considered . . . , the futurist manifestation represents, so to speak, a prophetic and utopian phase, the arena of revolution itself. So evident and natural a political parallel could not escape Leon Trotsky, who . . . defined the historical mission of Russian futurism as follows: "Futurism was the pre-vision of all that (the imminent social and political crises, the explosions and catastrophes of history to come) within the sphere of art."[21]

Trotsky was one of those who believed a revolutionary social system required revolutionary aesthetics, and it is not at all surprising to find him championing things like Futurism, Constructivism, and Suprematism. It may seem that nothing more is here involved than making mere homonyms do duty as historical necessity, but the fact is that early Russian modernism was quite heavily influenced by the Futurist version of simultaneity. For instance, the earlier works of the Suprematist leader, Kasemir Malevich, are abstract studies of the repetitive movements of a scissors grinder, a woodchopper, and the like.

Superficially, at least, Trotsky's liberalism seems sensible. What could be more obvious, after all, than that traditional art forms associated with the aristocracy and wealthy *rentier* classes were inimical to the values of the proletarian masses? Even Realism, often identified with socialist challenges to the status quo, was permeated with bourgeois love of physicality and the natural landscape. Of all attempts to realize the *modern marvelous* that of the Soviet avant-gardists was the most genuine and consistent, for it strove to embrace the whole of modernity; not only did it esteem science and the machine, but also every kind of novelty in art, drama, cinema, graphic design, and architecture. Indeed, some of its more fantastic, "futuristic" emanations are clearly aimed at removing the detritus of nineteenth-century forms and achieving the twenty-first century sooner than possible. The conceits of Vladimir Tatlin encapsulate the whole.

Tatlin was a trained painter who became head of the Moscow Department of Fine Arts and founder with Georgy Yakulov of Constructivism. He had great influence as a philosopher of art and was prolific as an experimenter and designer of proletarian stoves, uniforms, and the like, giving close attention to the relation of materials to practicality. Much has been said in praise of two of this man's projects—neither of which exists in anything other than a cloud of dreams, conceptual writings and blueprints, or models constructed by others— primarily because each project related to the desired destruction of preordained social and pre-Revolutionary aesthetics. Tatlin's devotion to machinery was without limitation and there are many anecdotes such as the one told by Yuriy Annekov in which the master cuts up a reproduction of Rembrandt's *Syndics of the Cloth Guild* and reorganizes the pieces into a new, elongated version, claiming that the work retained its qualities despite this reformulation. Tatlin then removed one screw from his pocket watch, which fell apart on the table. The point: art is relative, mechanics absolute.[22]

Tatlin's proposed Monument for the Third International (Fig. 13) was to be 1300 feet tall. That would have topped the Eiffel Tower (originally about 986 feet) and even the 1938 Empire State Building (originally 1250 feet). Since he considered the spiral the best expression of the modern spirit, as the triangle had been that for the Renaissance, the monument consists of a tilted, more or less cylindrical cage formed by two intersecting spirals of steel. Within the core of the structure were four enormous glass-walled cells, mechanized so they would rotate at specified intervals. The lowest cell (with a rotation period of one year)

was a cube to seat the assembly; the next (rotating once every twenty-eight days, like the moon) a pyramid lying on a side and housing the secretariate, and together a cylinder and offset hemisphere (which were to rotate once a day) containing an information center and broadcasting station. Originally planned to span the river Neva in Petrograd (St. Petersburg), this was certainly a futuristic proposal. Whether it could have been constructed as intended is, however, highly doubtful. Tatlin was an artist, not an engineer, and his grandiose conception of the thing runs headlong against the technological capacities of the early century in Russia or anywhere else. His other project was completely absurd, although the frequency with which the same kind of idea recurred to inventors all through the early century suggests a kind of "common" sense known to swindlers as gullibility.

Apologists for Tatlin frequently list among his accomplishments the design of "aircraft" or "gliders." What he tried to do, in fact, was create a man-powered ornithopter, the *Letatlin* (named by combining his surname with the Russian for "to fly"). Fabricated from bent wood, whalebone, and silk, the *Letatlin* was more a work of art inspired by bird skeletons than a serious attempt to construct a flying machine. And it is perfectly clear that the design could never have succeeded; the spiny, batlike wings were too small to support the weight of a human body even for the kind of passive descent familiar to hang gliding enthusiasts. The first person to prove that human flight in a heavier than air machine was possible and practical was Otto Lilienthal of Germany whose elegant gliders were capable of soaring a quarter mile at heights of seventy-five feet. His craft were made of peeled willow wands covered with waxed cotton fabric but had two or three large plane surfaces to support the pilot who controlled the direction of flight by movements of his body. He might well have been the first to achieve powered flight but died in a crash on 9 August 1896 just before fitting a motor to one of his gliders. By this time it had become obvious to serious investigators that the old idea of men flying like birds by mechanical thrashing of wings was ridiculous. Ornithologists of the day had an infirm notion of how birds flew but understood the extreme intricacy of the structure of the wings of their subject of interest and realized that the power-to-weight ratio of muscle to energy expended was critical. Even Leonardo had recognized that arm muscles alone would never sustain a bird man aloft; he therefore designed some ornithopters that worked by both arm and leg movements and Tatlin seems to have picked up this idea from him. Too, although most of Leonardo's ornithopters were quite impractical, one design showed promise that its inventor could not have appreciated but which it is conceivable might work now, given what we know of the way birds propel themselves plus the kinds of power plants available to us. In this design the wings are divided into fixed inboard protrusions and hinged outer panels that flap.[23] Either inspired by this study in Leonardo's notebooks or, more likely, by coincidence, Tatlin incorporated the segmented structure into his craft. But, so far as powered flight was concerned, the Russian ignored all of the evidence that

had accumulated since 1809 when the real pioneer of aerial navigation, Sir George Clayley, transformed a kite into a glider that was able to carry a boy into the air.

By the time Tatlin began work on his gadget, internal combustion engines and fixed airfoils had already made heavier than air flight a relative commonplace, but it is also quite clear that his was an old-fashioned poetical temperament not really in love with modernity. His forms always arose from the purposes intended and from a kind of anti-scientific approach to the future. In the case of the *Letatlin* he wanted to create a flying "bicycle" that anyone could own and operate cheaply without the need of airdromes, runways, or hangers. It was, as Norbert Lyton said, "a truly functional programme; yet one senses in it also the ancient dream of human flight and all that it implies in the way of mobility, freedom, and spiritual aspirations. Tatlin felt that machine-powered flight, with all that it entails, was more likely to kill the dream than to realize it."[24] When the design was first exhibited in 1932 it excited a great controversy, not over the feasibility of the idea so much as its ideological proprieties. Korneliy Zelinsky stipulated the essentially "reactionary" attitudes embodied in Tatlin's approach, saying that "nature worship, terror of the machine, the adaptation of technology to the feelings of the individual, a naive faith in the 'wisdom' of organic forms, and escape from the industrial world" had been congealed in the concept of the *Letatlin*.[25] Of course, Zelinsky is what is called a "naïve" Marxian critic—that is, strict and doctrinaire—as opposed to a "critical" Marxist like Trotsky. We would expect such a person to reject the experimental organicism of Tatlin whereas the liberal social democrats of the Bauhaus built a whole curriculum on the basis of ideas sponsored in Russia by the designer of the Monument to the Third International and the *Letatlin*.

So far as the *modern marvelous* is concerned, it was the Constructivists and Suprematists who embraced the potential for a new, artistic stimulus in the mechanisms, architecture, and social structures endemic to the urban-industrial civilization emerging during the early part of the century. El Lissitzky, who had worked with Tatlin, created geometric paintings he termed *Proun* (an acronym signifying "for the new art"), did graphic designs for publications, had worked with the van Doesburg of Holland's *De Stijl* and Malevich the Suprematist. Lissitzky was an engineer and architect as well as artist and theorist. In 1922 he published a suite of lithographic prints that amount to a visual liberto for an opera, *Victory over the Sun*, performed by Constructivistic puppets in a large public arena to alogistic poetry by Alexander Kruchenyhk and quarter tone music by Mikhail Matyushin. This opera had been performed in December 1913 in St. Petersburg, featuring costumes and sets by Malevich and had produced a huge scandal. The theme was more suitable for the post revolutionary period than for Czarist Russia since it celebrates the triumph of technology and modernity over nature. Some of the sets featured simple geometric contrasts of black and white and were, Malevich said, his inspiration for the minimalistic Suprematist compositions for which he became famous.

What Malevich believed about the relationship of his work to the emerging Soviet state is intriguing to read. He was convinced that all social goods would flow from industry and the urban environment, going so far as to complain that dwellers in the big city are dismissive of "Futurist" (that is, advanced) art "for they—even they!—have not yet become a part of the big city's metallic culture, the culture of the new humanized nature." Still, he is confident that everyone will eventually be forced to come around.

> The Futurist and the laborer in industry work hand in hand. . . . The form of their works is independent of weather, the seasons, etc. . . . It is the expression of the rhythms of our time. Their work, unlike that of the farmer, is not bound up with any sort of natural laws.

> It is nevertheless to be expected that the culture of the city will sooner or later embrace all the provinces and subject them to its technology. It is only when this has taken place that Futurist art will be able to develop its full power and thrive in the provinces as well as in the city. Futurism is, to be sure, still exposed to relentless persecution by the adherents of the idyllic art of the provinces. The followers of this art, incidentally, are provincial only in their attitude toward art, for otherwise they already lean toward "futuromachinology" for life itself, indeed, is already futurist.[26]

If this sounds a bit silly, attend to a still earlier statement written by Naum Gabo and signed also by his brother, Antoine Pevsner:

> Today we proclaim our words to you people. In the squares and on the streets we are placing our work convinced that art must not remain a sanctuary for the idle, a consolation for the weary, and a justification for the lazy. Art should attend us everywhere that life flows and acts . . . at the bench, at the table, at work, at rest, at play; on working days and holidays . . . at home and on the road . . . in order that the flame to live should not extinguish in mankind.

> The past we are leaving behind as carrion.

> The future we leave to the fortune-tellers.
> We take the present day.[27]

But, of course, the hopes of Malevich for a wholesale acceptance of a metalized, geometric world would come to naught. Now that many of us in the West live in cities that are not far from the idealizations of early modernists, we are in a position to regard their enthusiasms as having been not only misguided but terrifyingly short-sighted, particularly when it comes to ecology. Apart from being obtuse about the environmental consequences (which capitalists also ignored), the avant-garde completely misestimated the attractiveness of their

vision. The masses never understood the appeal of non-representational art and, even without the Bolshevik imposition of Socialist Realism as the official style of the Soviet Union, the average Russian laborer would never have preferred Suprematism to portraiture, bucolic landscapes, or anecdotal pictures.

MODERNISM AS COMPLIANT REBELLION

Obviously, it is not easy for the intelligentsia to make the sort of decision one must come to in order to contribute to social reform through the medium of art. It is the kind the Chinese Communist leader, Mao Zadong, made it in 1942 when he distinguished between the kind of serious art needed to succor the educated cadres of socialism and the kind needed by the masses. Popularization, he concluded, was "the more pressing task."[28]

Virtually everyone connected with contemporary art has thought just the opposite of Mao. Thus, we find Lucy Lippard—an early postmodernist—disappointed in her "hopes that 'conceptual art' would be able to avoid the general commercialization."[29] But why would one think an art of concepts immune to commerce? After all, no more than can one own a concept can one own a piece of music. That is, one cannot possess Arnold Schönberg's Second String Quartet, opus 10, in the same exclusive sense one can own the tenth impression of Kathe Kollwitz's lithograph, *A German Mother*. A musical composition exists as art *only* when it is actually performed. That has not prevented high society from treating ephemera as special pets; symphony orchestras are the favorite beneficiaries of posh social functions in every major city. And appreciation of live performances of serious music is restricted to small groups whose elevated pleasure is achieved, ultimately, at the expense of the oppressed and miserable. Openings of concert seasons and museum shows must consume cereal grains, in the form of alcohol, sufficient to feed whole villages of Third World people. Fortunately, most of us have been ideologically insulated from these realities by liberal parents who grieved for some undernourished Indian when we failed to eat our broccoli, thereby demonstrating the utter futility of making sacrifices.

To be fair, the true avant-garde are rarely profligate. One of their problems is that Americans tend to confuse the avant-garde with modern art in the same way they have so muddled middle class with middle-income that most of the latter, even when working class, actually believe they constitute the former. The distinction between the vanguard and modernity is brought out quite clearly in treatments of architecture, for unlike the history of modern painting and sculpture the story of modern architecture has never been characterized by avant-garde insurrections. Most radically advanced architecture has all along been domestic dwelling or has been designed as a deliberate exercise in institutional aloofness or paternalistic goodwill. It has not been functional so much as it has been superciliously unorthodox. Elitist, intimate, and often determined by leisure time considerations, it reflects precisely the values of

what used to be called "the smart set." The nearest thing to a genuine avant-garde in architecture today is represented by extremes: on the one hand, the benevolent fascism of technocrats who wish to pilot "spaceship Earth" with an eye to the welfare of the passengers; and, on the other hand, the full range of neo-rustic Thoreau idolaters and ecological handyfolk. The modern architecture which textbooks give full scale treatment, though, is *strictly* modern. And nowhere in the world is there more of it than in America. For that matter, nowhere is there more modern art, for in no country is there a larger popular market for its many styles. And that is largely because possession of something abstract became a status symbol for the upwardly mobile during the 1940s and 50s. And most of us learned it all at MOMA's knee.

The role of the Museum of Modern Art in proselytizing for modernity in art is impossible to overestimate. Russell Lynes' *Good Old Modern,* tried to lay out the entire story up through 1972. It is a generally informative, if indescribably boring book which has been superceded by other treatments and even a new version of the museum. I cite it here, however, because it is curious that Lynes did not so much as mention his own contribution to the dissemination of modernism through the upward bound stratum of society.

In 1949 Lynes published in *Harpers Magazine* an essay, "Highbrow, Lowbrow, Middlebrow," which classified each of these types in terms of their habitual preferences. Within a short time the immensely popular picture magazine *Life* ran an article on the essay and, of course, pretentious upper-middlebrows began at once to affect highbrow mannerisms. Suddenly, instead of listening to Rachmaninoff or Tchaikovsky, every other pseudo-intellectual in the U.S. was listening to Bartok and Bach. We were leaving copies of *Partisan Review* in conspicuous places and switching from Brooks Brothers suits to Harris tweeds or something else nubby and "rumpled." Since abstract art was highbrow, according to Lynes, the market for original non-representational oils and watercolors expanded markedly. This game of catch-up—with the real intelligentsia always at least two moves ahead of the rest of us—had been going on for decades in New York, I now realize. But *Life* turned it into a nationwide phenomenon.

I know of no book on modern art that gives serious attention to the roles of *Life* and *Look* magazines in bringing examples of advanced taste to the most provincially remote hamlets in America. And every history of modern art in America ignores the role of another tremendously important force in creating a receptive audience for modem art. That force was art education, a field held in such low esteem by historians, artists, and collectors that not one in ten will know that all of the following are alumni of Teachers College, Columbia University: Georgia O'Keeffe, Agnes Martin, Charles Alston, Jane Freilicher, Ursula Meyer, and Anthony Toney. Lynes does deal with art education, so far as MOMA was concerned with it, by way of MOMA's National Committee on Art Education. Established in 1942, until its demise in 1963 the committee had an enormous missionary effect, particularly through Teachers College graduates

who carried the "word" to art teachers in obscure normal schools all over the nation. Needless to say, the message suffered from its many translations and transmutations. But when the postwar baby boom caused college enrollments to burgeon, teachers' colleges became state colleges and state colleges turned into universities with full-scale art departments whose art faculties were generally committed to the doctrines of modernity as they had learned them at the feet of those who sat at the knees of those who sat in conference with Alfred Barr and the kinds of people who made up *Life's* 1948 "Roundtable on Modern Art." The momentum was irresistible. Modernism had become so much a part of the official establishment that its current modes were publicized abroad as evidences of the freedom and viability of our American way. The domestication of the avant-garde and what passes for avant-garde was virtually complete. The nation loves only successes; real eccentrics came out looking like purveyors of grapes gone sour and old-fashioned conservatives were treated about as cordially as a chiropractor at a convention of M.D.s.

But the avant-garde, in the strictest sense, does not necessarily represent styles that are ahead of their times. Just as the military avant-garde is often sacrificed to the enemy in order to prepare the way for the main force, so an artistic avant-garde frequently gains ground not for its own ideas but for those of some group for which it has an affinity. Poggioli describes the situation well. In America and England, he notes, the absence, or only intermittent appearance, of a rigid classical tradition "has made the sense of exception, novelty, and surprise less acute . . . has made less acute the sense of what would appear formally arbitrary to a cultivated Latin." Further, Anglo-American writers incline "not so much logically to separate, as obscurely to confound, the problem of the avant-garde and the problem of all modern art."[30] One finds support for this viewpoint in the writing of Alfred Barr, the guiding spirit of the Museum of Modern Art through its halcyon phase. Barr was a product of the old Christian literary culture rooted in our colonial past. In a way, it is curious that someone like Bernard Berenson, a Jew, should have taken Matthew Arnold's culture as a defense against anarchy, while Arnold's co-religionist seemed always to be counteracting philistinism with anarchy. In 1958, when Abstract Expressionism had become the mode (complete with a bibliography tracing its progenitors back through Surrealism to various reaches of the past) Barr called for a "revolution" to overthrow the "young academy." His conception of modern art seemed to picture it as a chronicle of perpetually seditious acts against whatever had become sufficiently well understood to be taught. The man's genius and role in inspiring new experiments and in preparing a climate for the general acceptance of styles that had become passé cannot be doubted, and his administrative decisions revealed a far more fluent intelligence than do his speeches, books, and articles. But, regardless of how expressed, the bias of his critical instincts, powered as they were by so refined a sensibility, helped spread the idea that modern art is dependent for its survival upon the perpetual replacement of one style by another.

The conviction that art is in a continual state of revolution is a product of the early part of our century and is otherwise out of step with history. But it is entirely consistent with a *marketing* view of life. That museums, art schools, and universities should have become the foremost participants in a game of required obsolescence may seem odd or even sinister, but it is neither of these things. The only strangeness lies in claiming that art and academe are exempt from the motivations which invest every other nook and cranny of the society. Anyone ought to be able to see that every identification of artistic radicalism with social revolution is completely rhetorical. As it happens, however, it was not just abstractionists and their apologists who were deluded into supposing otherwise. Even the Social Realists of the 1930s and 40s seem to have been terribly muddleheaded about the Marxist doctrine they espoused. Typically, people in the arts resist any characterization of themselves or their ideas as middle class. Committed Marxists would consider this just another of the self-delusions that are part and parcel of the ideological superstructure of capitalism. And they would be right. For the bourgeoisie has contained from the first two different groups: the owners of capital, on the one hand, and on the other, those whose only capital is knowledge. It is true that we of the educated element rarely agree with the propertied group, but our revolts have usually been against philistine cultural attitudes rather than against such fundamental values of capitalist society as individualism or privacy of property and decision. What amazes one about the Social Realists is their casual acceptance of socialist jargon while at the same time they retained, and openly expressed, the passions of middle-class bohemians. Of the many speakers and writers on the artistic left of the thirties only Meyer Schapiro seems to have firmly grasped the situation. What he said to the First American Artists' Congress in 1936 is as true today as it was then. He noted that, since the general purpose of art is aesthetic, even artists of working-class origin are "already predisposed to interests and attitudes imaginatively related to those of the leisure class which values its pleasures as aesthetically refined, individual pursuits." Moreover, an artist's antagonism to the values of organized society will not bring him into conflict with his patrons who "share his contempt for the 'public' and are indifferent to practical social life."[31]

Dore Ashton quoted most of this material in her book *The New York School: A Cultural Reckoning* and then, four pages later, says: "The luxury class to which Schapiro keeps referring was not operative during the Depression, and becomes a strawman for his argument," since artists were in many instances being supported by the W.P.A. "while the rentier class as patron had been all but obliterated in the Crash."[32] Now, this is about as silly as to contend that when slavery was eliminated black servility came to an end. In point of fact, the very success of the Abstract Expressionists—a number of whom were among those on the W.P.A. dole—proves the permanent vitality of Schapiro's so-called "strawman." It is no accident that at least one Abstract Expressionist, Clyford Still, sounds like a replay of Ayn Rand, champion of laissez-faire in economics,

morality, and everything else. Ashton is highly informed, extremely thorough and takes the historic and aesthetic measure of the Abstract Expressionists very well indeed. However, like most of the people she treats, she seems not to have the vaguest understanding of what *ideology* means in the Marxist lexicon. Schapiro's comments touched only one aspect of the general ideological super-structure of capitalism, a system of interlaced truths and delusions which, according to the Marxist exegesis, grows like coral upon the decaying base of our economic system. The mastery of the human soul by money is but a small part of its crystalline architecture. The ideas that the best in life is mental, that the needs and goals of the individual are foremost social considerations, that the discovery of new conditions of feeling and imagination by isolated geniuses is historically progressive—these, too, are part and parcel of the ideological superstructure. As Schapiro said sixty years ago: "An individual art in a society where human beings do not feel themselves to be most individual when they are inert, dreaming, passive, tormented or uncontrolled, would be very different from modern art."[33] We bourgeois apologists may concede that much without experiencing the slightest desire to see such an art come into being. As Trotsky never tired of pointing out, for an art to be bourgeois is not the same as for it to be bad. Too, complacency has signal personal advantages since attempts to reconcile a passionate dedication to modern art with revulsion from the system which breeds it can lead to nowhere but nympholepsy and despair.

Yet, it would not be correct to suppose that every aspect of aesthetic activity and humanistic thought is, perforce, doomed always to do service to the status quo. Only a simpleton would suppose that every new form generated out of a society is absolutely incompatible with other forms of social organization. For clearly this is not the case. Exceptions are infrequent, rarer than masterworks, far more scarce than lofty genius. Still, there is more than empty hope in the belief that pens have power. And censors are right to imagine that images can bring into floodtide desires no government could contravene. What Ernst Fischer wrote is true: "In a decaying society, art, if it is truthful, must also reflect decay. And unless it wants to break faith with its social function, art must show the world as changeable. And help to change it."[34]

Still, if further evidence is needed to demonstrate the essentially bourgeois nature of modernist art, one would think the official role of Abstract Expressionism as an exemplar of Western democratic liberalism would be sufficient. In his *How New York Stole the Idea of Modern Art,* Serge Guilbault shows the way the liberal intelligentsia of the late 1940s and early 50s managed to promote artistic rebellion as democratic freedom of expression in contrast to the doctrinaire repressiveness of the Soviet regime. He is very good on the inherent hypocrisies of this gambit:

> It is ironic but not contradictory that in a society politically stuck in a position to the right of center, in which political repression weighed as heavily as it did in the United States, abstract expressionism was

for many the expression of freedom: the freedom to create controversial works of art, the freedom symbolized by action painting, by the unbridled expressionism of artists completely without fetters. It was this freedom, existential as well as essential, that the moderns (Barr, Soby, and Greenberg) defended against the conservatives (Dondero and Taylor). Abroad, this domestic battle was presented as a token of the freedom inherent in the American system and constrasted with the restrictions placed on the artist by the Soviet system.[35]

Guilbault not only recognizes the pragmatic cynicism of the State Department and the United States Information Agency but also sympathizes with the situation of left leaning intellectuals and artists following World War II. Former radicals like Dwight MacDonald, Sidney Hook, and Meyer Schapiro were forced to moderate their positions, partly because of the the inhumanity of Stalinism and partly because of the increasingly reactionary climate of America during the Cold War. Schapiro, like MacDonald, took lofty refuge in scholarly detachment and adjustment of theory to reality. Guilbault says Schapiro's 1947 article "On the Aesthetic in Romanesque Art," which argued that contemporary art was tied up with modernity and its ideals no less than medieval art had been with its age, indirectly sets modern abstraction in "opposition to its enemies: the right wing, religion, fascism, and communism, all of which despised avant-garde art. His essays were a kind of last refuge for leftist intellectuals who refused to reject Marxism completely; they develop a theory of the artist in opposition, expressing his freedom within the social system."[36] As it happens, however, this particular notion of artistic freedom was associated with the very beginnings of non-objective expressionism in the works Wassily Kandinsky created during 1912 and 13 while he was living in Munich. And it, too, resulted at least in part from a pervasive environment of political constraint.

In an earlier book I compared Kandinsky's paintings of 1913 with the art of the highly developed jazz musician, the very epitome of an impulsive but sensitive and disciplined performer and pointed out, too, a further parallel between jazz and German Expressionism in that both arose in highly authoritarian atmospheres.[37] The music of black Americans, jazz was not subjected to scrutiny or direction by the ruling classes. In Germany just prior to World War I, the realm of the Spirit was the one aspect of being not eclipsed by Prussian rule. In 1844 Heinrich Heine had already, in *Deutschland, ein Wintermarchen* (Germany, a Winter's Tale), expressed this fact of German life when he wrote the famous lines: "The land belongs to the Russians and French; The sea belongs to the British; But we possess in the cloudland of dreams the uncontested dominion." Such an assertion depended upon the viewpoint of German intellectuals from at least that time until the end of World War I. It was widely recognized that autonomous principalities had to be unified, by force if necessary, if Germany was to take its place among modern nations. Therefore the central government needed absolute power over things political and

economic, but the world of pure thought was "uncontested" because the leaders recognized that abstract thought was *in fact* irrelevant to the hard-minded logic of practical affairs. This was a posture generally shared by Czarist Russia, too. The immense difference between the paternalism of the Kaiser or Czar and the totalitarianism of a Hitler or Stalin are clear to see in these vastly different views of intellectual work.

In any event, at the turn of the century one had a curious situation in Germany. Intellectuals and artists were free and active with respect to the sphere of the spiritual or sublime but quite passive and even apologetic about being sullied by the political sphere. When Kandinsky speaks of freedom it is nearly always in terms of artistry which, he said, gives freedom that is nearly unlimited and makes the spirit audible. In his *Reminiscences* he speaks of student uprisings in Moscow during 1885, saying he was lucky that "politics did not completely ensnare me. Different studies gave me practice in 'abstract' thinking, in learning to penetrate into fundamental questions."[38] So much for the radicalism of subjective rebellion. In point of fact, the belief that freedom is a condition of art and culture whereas political liberty is an illusion has become increasingly pervasive in the modern world.

MODERN ART IN THE SERVICE OF EVIL?

The role of modernism in the arts in Germany is instructive because it somehow touched every variety of social commotion during the first half of the twentieth century. Despite all that has been said of the Nazis' hatred of modernism, their taste in graphic design and even architecture ran to clean, regulated, highly legible imagery quite like the preferences of De Stijl modernists. The left adopted deformations of humanity from both the Expressionists and the Cubists to vilify smug burghers and reveal the grotesqueries that lay hidden behind the life of work in the day and play of night. In his painting, *Germany, A Winter's Tale* (1918), Georg Grosz employed a general scheme derived from the Orphic Cubism of Delaunay to contain caricatures of things relevant to the desperate "Winter of Hunger" in Berlin following World War I. What was to become his standard repertoire of whores, pimps, footpads, and beggars forms, against a city in collapse, the background for a middle class fellow having dinner with beer and a cigar. The man looks perturbed, perhaps because of something he has read in his *Lokal-Anzeiger*, Germany's first American-style newspaper, lying on the tabletop. The table itself is supported by the three pillars of German culture: there is a priest, wearing a sly, falsely pious expression, then a flame-florid Prussian officer, and, finally, a fat lout with little beady eyes and a copy of Goethe—clearly a member of the professoriate. In the works of Max Beckman a rather more substantial aesthetic of bitterness drives the painter's distortions. Similarly, Kathe Kollwitz's prints convey a deep compassion for the suffering masses through simplifications and contortions of expression. In looking at these emanations of

pain and fear one cannot help but be moved by the ways momentous events mutilate the finer feelings of which men and women are capable. In his play, *Die Dreigroschenoper (The Three Penny Opera)* of 1928 Bertolt Brecht attempted to show that the essential difference between gangsters and businessmen is merely that thugs aren't hypocritical. But, as Hannah Arendt pointed out,

> The irony was somewhat lost when respectable businessmen in the audience considered this a deep insight into the ways of the world and when the mob welcomed it as an artistic sanction of gangsterism. The theme song in the play, *"Erst kommt das Fressen, dann kommt die Moral"* [effectively, "first comes food, then talk of right and wrong"], was greeted with frantic applause by exactly everybody, though for different reasons. The mob applauded because it took the statement literally; the bourgeoisie applauded because it had been fooled by its own hypocrisy for so long that it had grown tired of the tension and found deep wisdom in the expression of the banality by which it lived; the elite applauded because the unveiling of hypocrisy was such superior and wonderful fun. The effect of the work was exactly the opposite of what Brecht had sought by it.[39]

Arendt notes the larger significance of this: "The avant-garde did not know they were running their heads not against walls but against open doors, that a unanimous success would belie their claim to being a revolutionary minority, and would prove that they were about to express a new mass spirit or spirit of the time."[40] It was a *Zeitgeist* that captivated the right, left, and center. Even the writer Thomas Mann, whose outlook is emphatically bourgeois, used modernistic techniques to reproach art in his novel *Doktor Faustus* (1947).

Arnold Hauser said when Mann, in an essay, *"Kollege Hitler"* (1939), "shows that all problematical, ambiguous and disreputable lives, all the feeble, the diseased, and degenerate, all the adventurers, swindlers and criminals and, finally, even Hitler are spiritual relations of the artist, he formulates the most dreadful charge ever brought against art."[41] Already, in *Der Zauberberg (The Magic Mountain)* of 1924 Mann had focused his powerful attention on the separation between artistry and life by isolating, in an Alpine tuberculosis sanatorium, an international collection of people who are strangely representative of Europe on the threshold of World War I. Arguments between two men, in particular—the humanistic liberal, Ludovico Settembrini, and Leo Naphta (an Austrian Jew who has become a Jesuit)—manage to anticipate virtually all the major intellectual conflicts of the next fifty years, albeit it in a strangely involuted manner, often springing from what today might well be called "deconstruction" of the sickness afflicting them and the social decadence it symbolizes.[42] In *Doktor Faustus* the analogy between extra-human existences of artists and sociopaths is drawn far more decisively, and a collage-like array of

parts is marshaled to drive home the relation of this to modernism in art—in this particular case, the art of musical composition.

As most readers of these remarks will know already, *Doktor Faustus* is a *réchauffage* of Goethe's drama with Mann's protagonist, who sells his soul for twenty years of musical dominance, standing in for Goethe's necromancer. Subtitled "The Life of the German Composer Adrian Leverkühn as Told by a Friend," it is at one and the same time a realistic tragedy of modern life, an exposé of the way the oblivious and self-centered artist is a corollary of ominous tendencies in German life, and a majestic treatment of the music of the culture that brought modernism into being. Written while Mann was in Los Angeles, the story benefits from the existence there of a remarkable group of exiles from Nazi Germany, including Arnold Schönberg, Igor Stravinsky, Artur Schnabel, Ernst Krenek, Otto Klemperer, and Theodor Adorno. Adorno, who was besides being a philosopher and critic of the arts, a sometime composer, became a musical consultant for the technical background of the book. Mann, an admitted amateur in music, was nonetheless a dedicated listener and perceptive observer of human behavior. His protagonist is like Gustave Mahler in some ways, Schönberg in others, and has sprinklings of Anton Berg, Richard Wagner, Schubert, Berlioz, and others in his intellectual makeup. Mann used what he called a "montage technique" in fabricating the technical specifics that describe Leverkühn's progress as a composer; Adorno allowed him to cut and paste his own writings into the text of the novel and Mann clipped and paraphrased from other friends as well. He not only used this somewhat modernistic device to make the novel more realistic, insofar as these contributions give greater range than the authorial voice alone could manage, but he created a richly textured biography of a non-existent composer that was substantial enough in effect to have exerted an influence upon the music of the twentieth century as well as upon the literature of the time. Consider this exchange between Leverkühn and his old school friend, the narrator, Serenus Zeitblom.

> In the schoolyard, between a Greek and a trigonometry class . . . he would talk to me about these magic diversions of his idle time: of the transformation of the horizontal interval into the chord, which occupied him as nothing else did; that is, of the horizontal into the vertical, the successive into the simultaneous. Simultaneity, he asserted was here the primary element; for the note, with its more immediate and more distant harmonics, was a chord in itself, and the scale only the analytical unfolding of the chord into the horizontal row . . .

> "But with the real chord, consisting of several notes, it is after all something different. . . . The chord is no harmonic narcotic but polyphony in itself, and the notes that form it are parts. But I assert they are that the more, and the polyphonic character of the chords is the more pronounced the more dissonant it is. The degree of dissonance is the measure of its polyphonic value. The more

discordant a chord is, the more notes it contains contrasting and conflicting with each other, the more polyphonic it is, and the more markedly every single note bears the stamp of the part already in the simultaneous sound-combination."

I looked at him for some time, nodding my head with half humorous fatalism.

"Pretty good! You're a wonder!" said I, finally.

"You mean that for me?" he said, turning away as he so often did.

"But I am talking about music, not about myself—some little difference."

He insisted upon this distinction, speaking of music always as a strange power, a phenomenon amazing but not touching him personally, talking about it with critical detachment and a certain condescension . . .[43]

This is an early anticipation in the book of the so-called "twelve tone system of composition," described by Schönberg's disciple, Egon Wellesz, as *Tonreihe* or "tone-row," being a melodic structure consisting of twelve notes of the chromatic scale. "All the harmonies are built upon chords consisting of tones of the row. Discordant chords therefore prevail. Consonances are rare, or—as Schönberg once put it—they are not excluded but have to be introduced carefully."[44] The specifics of this system are described in chapter twenty-two of Mann's novel where Leverkühn says of his *O lieb Mädel,*

That song is entirely derived from a fundamental figure, a series of interchangeable intervals, the five notes B, E, A, E, E-flat, and the horizontal melody and the vertical harmony are determined and controlled by it, in so far as that is possible with a basic motif of so few notes. It is like a word, a key word, stamped on everything in the song, which it would like to determine entirely. But it is too short a word and in itself not flexible enough. The tonal space it affords is too limited. One would have to go on from here and make larger words out of the twelve letters, as it were, of the tempered semitone alphabet. Words of twelve letters, certain combinations and interrelations of the twelve semitones, series of notes from which a piece and all movements of a work must strictly derive. Every note of the whole composition, both melody and harmony, would have to show its relation to this fixed fundamental series. Not one might recur until the other notes have sounded. Not one might appear which did not fulfil its function in the whole structure. There would no longer be a free note. That is what I call "strict composition."[45]

References to the system as if it had sprung from the mind of Leverkühn rather than from the actual creator produced great resentment on the part of

Schönberg who, as a Jew and enemy of Nazism, was also infuriated by the argument, taken over by Mann from Adorno's *Philosophy of Modern Music* (1948), that twelve tone music was a sort of dehumanizing analogue for Nazism. In the novel, the Devil himself often speaks directly from and in close paraphrase of the Adorno text as he is bargaining for the soul of Adrian Leverkühn:

> Every composer of the better sort carries within himself a canon of the forbidden, the self-forbidding, which by degrees includes all the possibilities of tonality, in other words all traditional music. What has become false, worn-out cliché, the canon decides. . . . Much rebellion in strict obedience is needed, much independence, much courage. But the danger of being uncreative—what do you think? Is it perhaps still only a danger, or is it already a fixed and settled fact? [The composer answers that the Devil cannot "exclude the theoretic possibility of a natural harmony out of which one might create without a thought or any compulsion." But his opponent is dismissive of this idea.] What I do not deny is a certain general satisfaction which the state of the "work" generally vouchsafes me. I am against "works" by and large. Why should I not find some pleasure in the sickness which has attacked the idea of the musical work? Don't blame it on social conditions The prohibitive difficulties of the work lie deep in the work itself. The historical movement of the musical material has turned against the self-contained work. [During the course of the quarrel between man and Devil, the composer says he could "heighten the play, by playing with forms out of which, as he well knew, life has disappeared." The Devil responds: "Parody. It might be fun, if it were not so melancholy in its aristocratic nihilism." Then he promises that Leverkühn will succeed in a great madness.] Do you understand? Not only will you break through the paralysing difficulties of the time—you will break through time itself, by which I mean the cultural epoch and its cult, and dare to be barbaric, twice barbaric indeed, because of coming after the humane, after all possible root-treatment and bourgeois raffinement.
>
> . . . Since culture fell away from the cult [i.e., **Kult**, or religion] and made a cult of itself, it has become nothing else than a falling away; and all the world after a mere five hundred years is as sick and tired of it as though, salva venia, they had ladled it in with cooking spoons.[46]

The Evil One makes a number of appearances in *Doktor Faustus:* Initially, he appears as the same figure of mystery who haunted the pages of the 1912 novelette, *Death in Venice*, therein seen first as a vagabond in a cemetery near Munich, then as a ridiculously rouged old man on a ship going to Venice, again as an unlicensed gondolier in Venice, finally as an epicene street singer of obscenities.[47] In *Doktor Faustus* he comes to Adrian Leverkühn a second time

in a hallucinatory visitation from which the foregoing quotation was drawn. The last overt appearance of the Devil is in the form of Privat-docent Eberhard Schleppfuss, a sinister theologian whose ideas about the occult had intrigued the narrator and his subject when they were studying at the University of Halle. But, in fact, Adrian is made by Mann to stand in for the Devil, for Germany, and for Thomas Mann himself. One of the things the Devil is not, however, is Schönberg, for Leverkühn is not really a twelve tone composer; rather, he is an eclectic who, I am told by a well-read composer and critic, resembles, more than anyone else, Gustav Mahler as a twentieth-century German avant-gardist.

And, again, although Leverkühn's life and twenty years of demonic success parallel the rise and fall of the Third Reich, from Thomas Mann's point of view it is not modernism in the arts that constitutes a threat to human decency. Rather, it is the extremely rationalistic, secular formalism of modern thought that tends in the direction of the cruel, utterly pragmatic world-view that typifies both modern art and social amorality. Serenus Zeitblom, in his mature life, is briefly associated with an intellectual clique whose members did not for an instant recognize what Germany's defeat in World War I gave them, that is, the Democratic Republic, "as anything to be taken seriously as the legitimized frame of the new situation. With one accord they treated it as ephemeral, as meaningless from the start, yes, as a bad joke to be dismissed with a shrug."[48] These men are absorbed by the thought of Georges Sorel, author of *Réflexions sur la violence* (1908), a social philosopher mention of whom is surprisingly rare today, considering that he is a principal spokesman for "direct action" in the form of terrorism as antidote to government "force."

Zeitblom says that no one can follow his remarks "who has not as I have experienced in his very soul how near aestheticism and barbarism are to each other."[49] His ideas about this association are exactly correct, if looked at from a certain perspective. Consider the ways in which we, ourselves, given only the tiniest push can go from detached analysis of a problem to consideration of "solutions" civilized men of Mann's generation would consider monstrously appalling. I am somewhat reluctant to emphasize that many religious Americans would contend that presently we are in fact engaged in mass infanticide by reason of legalized abortion. As for myself, I am persuaded that there are many times when the extermination of a fetus is the better of alternatives available to society, given the superstitious nitwittedness of those who oppose birth control as interference with the ways of their Lord. Yet, consider the nature of the arguments raised in support of taking the life of the unborn; all of them depend upon the logical reduction of natural processes to molecular biology and relativistic morality. The scientific view is completely logical and unsullied by religious prescriptives. But for moral absolutists it is only a step, if even that, from abortion to infanticide and from there to mass execution. The hypocrisy that surrounds these issues is plainly revealed by the extraordinary inconsistencies encountered on all sides. Thus, the opponents of abortion rights are more often than not in favor of capital punishment, while those who oppose

execution even of serial child murderers are apt to be found also marching in support of abortion on demand. Yes, certainly the issues are complicated for all of us except those who believe in the somewhat incompatible ideas of revealed Truth and freedom of will. Nonetheless, Thomas Mann's argument is by no means far-fetched. The same line of thought that takes the formal intricacy of Schönberg's system for beauty and finds deep emotional meaning in what Piet Mondrian called "the dynamic rhythm" of an abstract painting is one with the scientific detachment that conceives of life as a statistical perturbation of the molecular field.

None of this is to say that the relationship Thomas Mann infers is really anything more than one of the inevitable synchronisms of historical coincidence. Inevitably, all things in an age are part of the same tapestry and the individual threads work together in their pattern. And, yet, the interpretation Mann and Adorno gave to music's avant-garde shows that the liberation of the spirit bourgeois intellectuals have normally claimed for modernist directions in art can easily be assigned a different role in the sociology of the arts. As Mark Roskill notes in *Klee, Kandinsky, and the Thought of Their Time*, it was "a deeper psychological layering of social and historical perception" that gave Mann's final novel "the authority of clear sighted acumen and of a spiritually purifying discrimination."[50]

FORMAL CONTINUITIES AND CONSCIOUS DEPARTURES

Roskill, in the passage above, is concerned with the relationships between German writers and artists who found themselves in exile during the late 1930s and 40s. Though his principals, Kandinsky and Paul Klee, remained in Europe—dying in Neuilly in 1944 and in Locarno in 1940, respectively—he reveals many associations between them and various writers, but particularly with Adorno, Walter Benjamin, Robert Musil, and Hermann Broch. The thought and processes of Musil, author of the famous novel, *The Man Without Qualities*, parallel, for Roskill, those of Paul Klee as Broch's work does that of Kandinsky. While it would be an exaggeration to claim that the reduction of aesthetics to formal relations is predominate in the work of any of these men, Roskill's concluding chapter on "Signs, Metaphors, and Allegory" is an unusually persuasive instance of the way semiotics can be applied to the critical analysis of the way in which "reduction and simplification of constituent detail privileges tenor over vehicle, the adumbrated over the specific," and "imaginative idea over appearance, when it comes to signification."[51] It also shows the degree to which modernism has expressed the values of the leisure class that emerged between the World Wars and the way "the increasingly proclaimed autonomy of the art object as a physical entity, independent of the fixed habits of perception, as it works upon the ordinary and familiar"[52] functions as an affective element in the education of a rather smug liberality that actively denies connection with any other art of the past or even the present. Thereby "the idea of freedom of

invention and the democratic ideal of individualism loom less large . . . than the disinterested play of intelligence and the establishment of a relationship to the preceding history of art that is, almost necessarily, equivocal."[53] I must, however, hasten to stress that Mark Roskill does not place his commentary in the same context as I am, nor does he draw a bead on a specific social group in this way. I have adapted his remarks to my rather limited purposes. His focus is upon the role of criticism in the situation where, he says, it "either adapts to the commercial situation—the marketing and promoting 'system' of the time—or it adopts what Habermas has termed a 'strategy of hibernation,' in which it falls silent for lack of an alternative."[54]

A fair amount of the art practiced today is a kind of criticism in and of itself, sometimes of a curiously literal and satiric kind. For instance, Marc Tansey's 1984 oil, *Triumph of the New York School* is a huge, monochromatic representation of the subject of Serge Guilbaut's book. Before a panoramic "no man's land" the School of Paris, attired in French uniforms from the First World War, surrenders to American victors dressed in khakis and fatigues of World War II. The personnel are explicitly identified: Breton is in the process of signing the surrender agreement while "General" Clement Greenberg looks on. Behind Greenberg, clustered around a U.S. Army half-track, stand Motherwell, Pollock, DeKooning, Mark Rothko, David Smith, Barnett Newman, Ad Reinhardt, Arshile Gorky, David Smith, and critic Harold Rosenberg. The French contingent, assembled somewhat more stiffly on the left side of the work, include Picasso (in a fur coat), Matisse, Duchamp, Gris, Pierre Bonnard, Fernand Léger, Henri Rousseau, and the poet and critic Guillaume Apollinare. The whole painting is done in umbers and siennas that lend this rather comical conception of art history the documentary quality of an old sepia tone photograph.

Usually, critical commentary on *Triumph of the New York School* describes it as being rendered in a dis-tinctly postmodernist style that is as far from Abstract Expressionism as one is likely to get, but that is quite misleading. Not only is the sheer scale of Tansey's work similar to the action paintings of the fifties, but the paint is applied in a rather slippery adumbration of reality that, in detail, resembles earlier abstractions by Gorky, Rothko, Adolph Gottlieb, and Helen Frankenthaler. This is, I think, intentional. Mark Tansey has the perfect background to use the techniques of artists to elucidate art historical relationships. He was, for a time, Frankenthaler's assistant, who held her paintings "while Clement Greenberg critiqued them,"[55] and he had grown up as the son of Richard Tansey (the author, with Horst de la Croix, of the later, more scholarly editions of the most famous of all American surveys of world art, Helen Gardner's, *Art Through the Ages*) and Luraine Tansey, who devised an early example of a computerized slide catalogue and archive. From the outset, his work has had a didactic purpose and been what the New Yorkers portrayed in *Triumph* would have called "illustrative." In 1990 he did a work called *Derrida Queries de Man*, showing an unnerving scene in which the two

deconstructionists struggle, tottering precariously on the edge of a sheer cliff of text. Recently, he showed another vast landscape with figures. It represents a history of the American West from the points of view of four groups, each of which is given its own perspective, literally. In a world of startlingly red granite precipices, rendered in strokes as broad and heavy as those of Clyford Still, the canyon is seen by (1) a tribe of Native Americans, (2) a surveying party, (3) a group of tourists, and (4) a crew removing toxic waste. This isn't the Grand Canyon. This is Hell.

Another artist whose approach to postmodernism is art historical, but far more tongue-in-cheek, is Kathleen Gilje. Trained as a restorer of art, she uses her knowledge of the old masters' techniques to create remarkable replicas of their works which she then modifies in startling ways. For instance, she has copied Domenico Ghirlandaio's popular 1480 panel painting of a grandfatherly old man with a hideously lumpy nose talking with a child before a window through which we observe a conventionalized landscape with mountain, houses, trees, meadows, and a stream. Gilje has replaced the landscape in her version with a copy of Surrealist René Magritte's *Castle of the Pyrenees* in which a 1000-foot-tall rock surmounted by a stone castle hovers over an ocean against an azure sky full of fleecy white clouds. Her modification of Petrus Christus' *Portrait of a Lady* (c.1470) simply adds pierce-rings to the head of the adolescent sitter; she now has nose and lip rings, two eyebrow rings, and nine ear rings of decreasing size going from the lobe of her left ear to the top of the helix or outer rim.

Despite the retention of representational elements in their art works—indeed, regardless of the absolute dependence of the styles upon similitude—both Gilje and Tansey are engaged in consciously reconfiguring the elements of art to create their styles. Surely, as we have noted previously, *all* artistry can be described in the same way, since every creative endeavor entails the manipulation of form. Today this sounds, perhaps, more unorthodox than it is in fact, partly because of a common tendency among humanists to treat content and form in painting as if the distinction were analogous to representation vs. design whereas, in fact, representationalism—even when carried to trompe-l'oeile extremities—is nothing more than a certain conventionalized arrangement of forms. Actually, every competent artist must understand this as a practical matter, and most art historians must also comprehend its truth, but their frequent statements about traditional art being dependent on the imitation of nature make it appear otherwise. (Some Russian avant-garde writers and the Bloomsbury group in Britain showed inclinations in the same direction, but literature is in the distant lurch rather than vangard here, primarily because literary units of operation—namely, words—carry with them explicit meanings.) Every painter since the theory of Pure Visibility gained its foothold on art criticism and instruction is a self-conscious manipulator of color, shape, and space in much the same way as the early moderns. The principal difference between a postmodernist like Tansey and a modernist like Clement Greenberg is that Tansey is not reverential about the supposed sanctity of high art. I do not

mean to suggest by this that Mark Tansey and Kathleen Gilje are not serious in what they do, and still less to imply that they are scornful of the past. Rather, I sense in them a healthy unwillingness to worship as if sacrosanct what are, after all, merely objects created by other highly talented men and women of genius. It is, however, more typical for postmodernists to approach the past in a way that Tansey and Gilje specifically do not—that is, on the assumption artistic greatness is an enormous fraud whose origins lie in the politics of social injustice perpetrated upon the world by white, heterosexual males.

The revelations of an entire subcategory of postmodernism are presented in oddly standardized fashion, as photomontages with lettering appended. Usually the arrangements are unimaginative and the lettering either crude single stroke calligraphy or, commonly now, a sans-serif font like Arial or Helvetica. Anyone who has been teaching art in a university (or even in a professional art school, where naive elders might expect tradition to hold on for the sake of job placement) will know that painting and drawing courses have, for at least two decades, been mired in these dismally documented conceptualist projects that are intended to "address" big issues of an almost irrefragably controversial nature. Ethnic conflict and class or gender disadvantage are sometimes the focus of such self-conscious exercises in social improvement, but those subjects are no longer very fashionable. Recently, the sophomoric explanations of what is wrong with everything are typically impassioned over the oppression of behavior which, with the exercise of a little discretion, would be largely tolerated today and pretty much ignored by everyone except the kinds of idiots who write threatening messages to "drug adicks and preverts."

It is by no means happenstance that advanced movements in art and literature have been pervaded not only by fractioning of formal harmonies but also by what amounts to the celebration of drugs, promiscuity, prostitution, male and female homosexuality, and sado-masochism. The breaking up of visual wholes into fragments in painting corresponded to the rupturing of conventional social demeanor in society at large and the solemnization of deviant behavior as a kind of sacrifice of arbitary boundaries to a higher aesthetic purpose is the very epitome of democratic potential in our times. One may find much of this pathological and quite unpleasant, but it is difficult to see just how it is possible to preserve liberty while avoiding the aberrations that seem always to accompany it. Still, most of us draw the line at *some* point when it comes to social behavior. I, for one, think pederasty or female "circumcision" should be intolerable under any system of justice. Others are more conservative and, incredibly, some still more permissive. No matter. It should be perfectly clear that we are going to have to tolerate overt displays of activities just short of what might have frightened horses in the streets of Mrs. Patrick Campbell's day. I merely find it curious that so much of this tiresome insistence on the normalcy of what is statistically abnormal is given in formats as hackneyed as the designs one might see set up on an easel to illustrate a talk on fund raising at a Rotary Club luncheon. For the most part, the written commentary on the arts pursuant

to these ends is equally dismal. But a few representatives of the libertine fringe can hardly help but catch one's interest because of the sheer extravagance of their critiques. Among these is the unorthodox reactionary, Camille Paglia, author most famously of *Sexual Personae: Art and Decadence from Nefertiti to Emily Dickinson.*

Paglia is enthralled by Nietzsche's *The Birth of Tragedy* and is certain that nature is brutish and art either a Dionysian celebration of its horror or an Apollonian attempt to disguise the facts. She believes in the truth of sexual stereotypes, "the biologic basis of sex differences," and provides at least one startling iconoclasm per page of anything she publishes. For instance, she responds in an unexpected way to the feminist argument that female archetypes are politically motivated falsehoods concocted by males. "The historical repugnance to woman has a rational basis: disgust is reason's proper response to the grossness of procreative nature."[56] From her point of view this kind of statement only *appears* to be antagonistic to womankind because Apollonian rationality holds sway over every member of Western society. Her idol is not Apollo but Dionysus and she follows Freud, Nietzsche, and Sade in her view of the amorality of life. In contrast to the Apollonian pecksniffery of the postmoderns, Paglia's sweeping generalities are like a cosmic force that sweeps before it all that is good, bad, or merely in the way of some choice turn of phrase. Partly nonsense, her text is also invigorating—like being caught in a hurricane full of cutlery and cinder blocks. *Sexual Personae* is seven hundred pages of outrageous notions, dubious old-fashioned theorizing, and blunt language garnished with occasionally brilliant intuitions. When Paglia writes that Henry James is not a social novelist but a "Decadent Late Romantic" whose perverse imagination is routinely censored by academic adulation, she submits in evidence a set of unorthodox, provocative interpretations of his characters that can stand on their own apart from whatever caprice encouraged their existence.[57] Reading her final chapter, "Amherst's Madame de Sade: Emily Dickinson," is like dipping into something written by a "New Critic" from the 1940s who had a curiously literal turn of mind and an alarming heedfulness when it comes to carnal wounds and succulent exudations of the flesh. It is an ingenious and, so far as I know, original approach to the poet.

By contrast with her critiques of literature and popular culture, Paglia's critical commentary on art is merely colorful and, as frequently as not, utterly absurd. For instance, she says of the famous upper-paleolithic figurine, *The Venus of Willendorf*, that "she is the cloud of archaic night," an acceptable metaphor, but also that "her ropes of corn-row hair look forward to the invention of agriculture,"[58] a highly questionable description and a nutty suggestion. *Sexual Personae* is full of easy profundities, such as the assertion that "Beauty is a state of war, a frigid blank zone under siege" or that Christianity turned "Dæmonism into Demonism." The author sees the epicene in every graceful gesture when the subject of a work is masculine, and detects some latent power in all of woman's phases. The *David* of Donatello, "even

more than the ancient *Venus Pudica* was the true model for Botticelli's *Venus.*"[59] Well, hardly, inasmuch as *Venus pudica* is not a work but a classic pose and the Botticelli assumes it whereas Donatello's *David* does not.

To turn up politically incorrect irreverance of Paglia's kind in the visual arts one must look to the spiritual descendents of *Die Neue Sachlichkeit.* Among these are, of course, some youthful artists but, for time-tested impiety tempered by an inflammatory humor, you had best look to elder trouble-makers—to, for example, Sidney Chafetz and Robert Colescott. Chafetz is primarily a graphic artist who does woodcuts, etchings, and lithographs. Personally, he is an empathetic soul of considerable warmth and charm, but he has a relentless disdain for hypocrisy in the political and academic arenas. A good example of the kind of caustic mischief of which he is capable is revealed in the color woodcut, *Academic Landscape* (Fig. 14), in which an enormous basset hound is flanked by two groups of three academics. Those on the left stand on "plinths" of books. The medieval anachronisms of academic regalia are satirized by substituting for the traditional mortar board caps a coach's cap bearing a dollar sign, a "Mousketeer" cap with Mickey Mouse ears, and a ratty velvet *pileus rotundus* (a European doctoral cap dating from the reign of the Tudors). On the right we see a female academic in high heels; she is wearing a grotesque mask that comes to represent, in these academic satires, a figure of particular fatuity, Professor Harley Quinn. One dignitary holds a sheet of paper with the artist's initials and the date of the work inscribed upon it. The masked woman is holding a sign reading "VANITAS," a somewhat more sonorous note than is at first apparent. The term *vanitas* does translate into English as "vanity," but it is also a technical term in the fine arts for a particular kind of still life—one that normally features a skull in association with things of great fragility, such as glass, dry paper, delicately fading blossoms, soap bubbles, smoke, and so on, emphasizing the transcience of human life. The term itself comes from Ecclesiastes 1:2, *vanitas vanitatum* or "vanity of vanities," meaning that vanity is futility, the true theme of the entire book. Of course, Chafetz has given the meaning a special twist in this case, driving home his point with the legend surcharged over the stadium facade, that is, *Ut homunculi, ita valdi magni* (But we are awfully big for midgets). Another of these satires is the woodcut *Un Histoire sans Paroles* (*Story without Words*) from 1963. To quote the artist: "An acid comment on academic leadership and its unexamined acceptance, based on Pieter Bruegel the Elder's *The Blind Leading the Blind* (1568)."[60] Four figures in academic regalia stride across the field before a schematic athletic stadium, led by one whose head is the hind quarters of a horse. He pulls on the gown of a blind jester who is followed by a bespectacled sheep carrying two paintbrushes. Bringing up the rear is a parrot, hobbling along on a crutch. That pretty much sums up university life, especially at Big Ten schools. You will notice that Chafetz doesn't spare faculty, artists, or any other segment of the academic scene. When I first saw these things, as an associate professor of art at an exhibit in 1965, I thought they were rather too caustic, perhaps. Now that I

have attained the honorary level of Professor Emeritus and, thereby, been "authenticated" as a person of mature judgment and balanced sensibility, I can see that Sidney was being far, far too kind to those of my ilk.

When it comes to targeted insult, Sidney Chafetz is to Robert Colescott as a competition target rifle is to a rusty, hair-triggered Kalashnikov. Whereas Chafetz draws a narrow bead on selected specimens of the human comedy, picking off a pretentious academic here, a political monstrosity there, Colescott blasts away at everything in sight, at times it seems with no discrimination whatever. Among the casualties he has inflicted we can, perhaps, include his own foot. The first African-American artist to be included in a Venice Biennale—in 1997—his prominence will probably compel those who write on the role of blacks in art to begin including him alongside Jacob Lawrence and Romare Bearden in surveys of American art where he has been pretty much overlooked up to now. presently, as my close friend and sometime collaborator, Floyd Coleman, Chair of Art at Howard University, said: "He seems anathema to those whose sense of irony does not run deep. When a retrospective of his work opened in Akron in 1988, local black activists attacked it as being defamatory. It *was* defamatory, but in somewhat the same way as Richard Pryor's comedy. Trouble is, of course, that when you go to see Pryor you *know* the stereotypes and exaggerations are supposed to be funny, inside jokes that point up the incomprehension of the applauding whites in the audience as well as the truth about life in a racist society, but when people go to see art work they aren't looking for jokes." There is a sense, however, in which everything Colescott does is a joke. When he took Emanuel Leutze's patriotic icon, *Washington Crossing the Delaware,* and transformed it into a pageant of black caricatures called *George Washington Carver Crosses the Delaware*, he was making a very sophisticated play on stereotyping. The Leutze is a kind of pretentious Neo-Classified revision of reality; the Colescott substitutes white stereotypes of black people in order to poke fun at the pomposity of the original. The only respectable-looking people are the Tuskegee Institute scientist and his aide. Aunt Jemima has her skirt up and her bare buttocks hanging over the gunwale, the Cream of Wheat cook is idling at oar with a stupid grin on his face as a minstrel clown plays the banjo and rustics fish, drink, and row the boat. A blackface version of Vincent van Gogh's *Potato Eaters* ridiculed the racist cliché of rustic darkies happy in their simplicity. Its title, in cartoony script and overlapped block lettering appears in the upper right of the work: *Eat dem TATERS*. But, as Prof. Coleman implies, if you don't know beforehand that van Gogh's Dutch peasants are glum and worn at their simple meal you'll be unaware of the contrast between them and the goofily grinning sharecroppers in the Colescott painting. Improprieties of this sort do not bother the artist a bit. On the contrary, he says: "If everything has to be a political statement and then has to be politically correct, there's no room for inventiveness and self-expression. If people see me as mean and improper, then maybe I have a mean streak. And I usually am improper."[61]

Colescott comes to his twists on the history of art by a perhaps unexpected route. After securing an undergraduate degree in art from the University of California at Berkeley, he made a pilgrimage to Paris during 1949 and 50 to study with Fernand Léger. By that time Léger had moved far from the mechanistic designs of the post-Cubist style that brought him his initial fame and had devised a style based on decorative conflation of flat patterns of bright colors overlaid with cartoonlike figures and fragments. As an active member of the Communist Party, Léger had come to believe only representational painting could really communicate ideas that would contribute to social progress. His late work seeks to "sum up his experiences in the exploration of man and his place in the contemporary industrial world."[62] It constitutes a romantic pæan to the *modern marvelous* in its most obvious and unsophisticated sense; workers construct, the *petite bourgeoisie* go on Sunday outings, factories puff hygenic clouds, and sheep graze through manicured fields. Leger's style had little direct influence on Colescott's designs, but the emphasis on representationalism had a profound effect—an effect intensified by Colescott's later experience of Pharaonic paintings while working in Egypt.

Robert Colescott's brother, Warrington, is also an artist, best known for a series of prints on the history of printmaking. One of the most notable of these is *History of Printmaking: Lasansky Reaches Iowa City* (Fig. 16), portraying one of the most important teachers of printmaking in the U.S. arriving at the University of Iowa's home base. Here, the social circumstance of African Americans is not emphasized, but the overriding importance of sports in the Midwest is; this is Chafetz's impression of college life made hellish and more explicitly barbaric. Probably, it is not mere happenstance that Warrington Colescott and Sidney Chafetz are close friends.

Typically Robert Colescott's social commentaries have to do with interracial sexuality. *Grandma and the Frenchman (Identity Crisis)* (Fig. 17) has reference to the painter's own genetic mix. A black woman's grotesquely prominent breasts are ogled by the white physician who is taking her pulse. Her head, as every critic notes, is possibly derived from the most famous painting in Picasso's "Negro Period," *Les Demoiselles d'Avignon*, but involves the "simultaneous" overlapping of Metzinger's version of Cubism to show the cosmetic mystery and self-regard of the human female. In the lower left a much closer imitation of Picasso's imitation of African masks makes its appearance. Note that the physician holds in his hand, at groin level, a crucifix. Christians are among the numbers of groups Colescott has enraged with his crude satires. One painting included in the Venice Biennale was *Triumph of Christianity*; it features an obsessive Jesus, arms open as if to capture rather than embrace, and a golden hamburger in a glory above the cross. As if to prove he is an equal opportunity gadfly, the artist also sent to Venice *Arabs: The Emir of Iswid (How Wide the Gulf)*, dealing with the enslavement of blacks in the Middle East during the nineteenth century.

It has been said of Colescott that his art generally draws no clear line between life and art: "In each case he sees the issues as the same—exclusion and purity versus integration and high/low impurity. Esthetic discrimination is a metaphor for racial discrimination." The author of this remark, though, believes that the later work shifts the focus from art to life, and very aptly describes it as being "like the work of a black Gully [sic] Jimson."[63]

Robert Colescott and Chafetz stand up as counter-modernists in a way most postmodernist attempts to insinuate low culture and anti-gentility into high art cannot, simply because what they do expresses values that are far deeper than fashion. Postmodernists are, almost by definition, dedicated to giving the age what it demands, or—according to their lights—what it *should* require. But this is already futile, since the age does not know itself and is incapable of defining its demands with clarity. Those who see, or choose to see, only one aspect of the complex truths of modern society are rarely helpful. Thus, professional art critics who testified on behalf of Robert Mappelthorpe's *X Portfolio* in legal proceedings taken against its public exhibition made themselves ridiculous in the eyes of laypeople who had seen the photographs by discussing these homoerotic pictures as if they were in the same category as the photographer's exquisitely formal flower studies. Obviously, the average person was going to find the *X Portfolio* offensive. I myself was a bit taken aback to learn the National Endowment for the Arts had contributed funding in support of the project so I was hardly surprised to see the Christian Right rise up in righteous fury against the irresponsibly artistic elite.

That the spokesmen for homophobic conservatives sound like knuckle-dragging philistines makes it all too easy for defenders of the arts to mislead the educated public. Someone like Senator Jesse Helms is surely an inviting target for anyone who is not a complete nincompoop, but he wasn't *as* agitated over things like nude black men and white men kissing and embracing one another as the art press implied. Like many others, he was shocked by photographs of men doing much creepier things. Mappelthorpe's *Self Portrait* in the portfolio shows him displaying his bared bottom with the handle of a bullwhip disappearing into his rectum. Then there was "Lou" inserting his pinky finger into his urethra, "Jim" urinating into "Tom's" mouth, "Helmut" or perhaps "Brooks" jamming a fist up the anus of the other, and (most disturbing of all) a picture called *Dick*. In this sadomasochistic icon, a penis and testicles have been inserted through holes in a board then bound around and around, tightly, and strung hard back with laces. Subsequently, "Dick's" partner has whipped his privates into a bloody smear. Now, one can say all one likes about the formal structure of the works—and the picture of "Lou" doing his penis trick is at least as well composed as Stieglitz's studies of Georgia O'Keeffe's hands—but, still, who other than a person completely absorbed by form could be persuaded that the angle of the finger relative to the hand and penetrated organ makes the image aesthetic rather than emetic? *Dick* even defies the otherwise plausible and

somewhat persuasive argument that masochism depends, finally, upon the trust the "victim" places in the "master's" unwillingness to go too far.

Though a masochist's trust in the restraint of his or her pet sadist may in fact be a show of love, it strikes me as being a good example of emotional retardation, not unlike the affection a brutalized child has for its abusive parents. Nonetheless, it remains the case that Mappelthorpe's photographs are of *enthusiastically consenting* adults. Therefore, the hysterical reaction of the general public and their political spokespeople seems quite inappropriate. That we of the arts community are not as offended by them as some people think we should be is itself a principal bone of contention, but one that is normally disguised by the Christian Right behind their ostensible commitment to "family values." Fear that children will be exposed to the subject matter of Mappelthorpe and his ilk is always raised by disapproving puritans, but children are not very likely to see such pictures. Moreover, if they *were* to see them, what would be the likely reaction of the vast majority? Why, obviously, that this stuff is "gross." Adult revulsion is not born of real worry over youth being inducted into degeneracy by exposure to photography. What makes the average person furious is that a bunch of insolent immoralists are having what they seem to think is fun and have the nerve to be brazenly flippant about it. But, of course, the *X Portfolio* is consistent with the beginnings of modernism in the nineteenth century. It's just another instance of *épater le bourgeois*. That the arts community takes for granted that taxpayers ought to contribute (even a tiny amount) to a shock attack on their sensibilities by funding exhibitionists and their exhibitors is perhaps inconsistent, but it is really just another revelation of the essentially elitist insularity of a cosseted minority. After all, what can be more vainly overweening than for an artist to contend that failure to support a lifestyle of which you disapprove is no different from censorship?

The fine arts community and academic cloisters have freed themselves of every bourgeois vice except the vested interest and its loving handmaiden, hypocrisy. So far as government support for the arts is concerned they have put themselves in the way of hazard by claiming the National Endowment for the Arts would bring fine art to the have-nots of rural America and the inner cities—after the tradition of the New Deal's Works Progress Administration Federal Art Project—and then using the allocated funding to support what amounts to an artists' version of the good-old-boy network Congressional lobbyists know so well. The grand operas, symphonies, and museums of the great cultural centers of the U.S., that is, New York, San Francisco, Washington. D.C., and so on, get hundreds of thousands while the ghetto and the backwoods get a pittance. Where social progress is concerned, the ostensible avant-garde are among the tardy and next only to advertising executives in their ability to dissemble and delude even themselves.

Substance and Shadow at the Close of the Second Millennium

The old man had listed hundreds of truths in his book. I will not try to tell of all of them. There was the truth of virginity and the truth of passion, the truth of wealth and of poverty, of thrift and of profligacy, of carefulness and abandon. Hundreds and hundreds of truths and they were all beautiful.

And then the people came along. Each as he appeared snatched up one of the truths and some who were quite strong snatched up a dozen of them.

It was the truths that made the people grotesques. The old man had quite an elaborate theory concerning the matter. It was his notion that the moment one of the people took one of the truths to himself, called it his truth, and tried to live his life by it, he became a grotesque and the truth he embraced became a falsehood.

Sherwood Anderson[1]

The first time I encountered Sherwood Anderson's little fable from the preface to *Winesburg, Ohio* my professor of American literature said it was "sophomoric." As a college freshman I readily accepted that what seemed to me a profound insight into human behavior might well be a commonplace among the erudite. Not until later did I come to understand that among the truths my professor had seized upon was Vernon Louis Parrington's *Main Currents in American Thought* and the social theory of Karl Marx.[2] What I find winning about the old man's theory of "grotesques" is the recognition that truth, too, can be delusory. All unitary theories are false, but reality alloyed, too, can draw us into doomed endgames. The weakness the old man's insight may at first appear to lie in its generality, for what is universally applicable is also meaningless. But its strength resides in a more essential factor—that is, the hubris of narrow exclusivity—since any truth taken for the whole is itself a falsehood. Apart from religious zealots few admit to a belief in one thing before all others, but one of the things that makes the cultural scene in the last decade of the

millennium grotesque is the degree to which prominent people behave as if they
were so committed.

The times are filled with the voices of those who have the one principal
answer to the tribulations of the age. Of course, the most vocal are those
absolutely certain that free enterprise and tax relief for the wealthy will lead to
prosperity for all. These zealots are the tiniest of minorities, and are largely
found in the United States for, despite their confident assertions that socialism is
moribund, most of Western Europe is ethically bonded to the version known as
Social Democracy.[3] There are now few who believe in the beneficent
communistic state, but a segment of the left clings to the sentiment still, though
it's often the purity of pre-industrial life styles to which they are most devoted.
These particular fanaticsare very realistic about the problem of humanity versus
nature; after all, only industrialists and their paid oratorical goons even pretend
to believe that "global warming," for instance, is a myth. But the chances of
returning to some kind of technologically smoother Neolithic existence, in
which farmers recoup ten or twenty calories for every calorie expended—as
contrasted with the present, when the energy expended by machinery and
chemicals works out to thirty calories for every one gained—is nil. We are
literally eating up the earth.[4] Despite the doom that awaits us, nothing short of
immediately foreseeable disaster is going to return us to a vegetarian patch, for
blind hope has forever been humanity's vacine against bitter truth.

In the meanwhile, racialists of every stripe claim the past for their particular
ethnic bloc. Just as northern Europeans claimed their heritage was rooted in
Mediterranean Antiquity, Afrocentrists argue that Greece and Rome had their
beginnings still earlier, in a Pharaonic Egypt whose population was principally
black.[5] White European civilization is, indeed, the historic villain in the eyes of
American Indians, Africans, Asians, and even a sizable number of those who are
themselves the descendants of white Europeans, for Europe's heterosexual
patriarchy has been an oppressive monster who haunts the lifestyles of the
homosexual minority and the past, present, and future of womankind. This is a
truth that does not necessarily bring the oppressed into unified outrage,
however. Thus, a good number of African Americans deeply resent the attempts
of gay liberation activists to identify with blacks as victims of prejudice. My
wife, Dr. Glenda M. Lawhorn, whose support for the civil liberties of any and
all minorities was widely recognized during her tenure as a state university
administrator in Illinois and Pennsylvania, nonetheless notes, "In day to day
activity gay white men and women can, with only the slightest adjustments in
their public behavior, avoid being discriminated against. *Nothing* I could do is
going to make a redneck salesperson believe I'm anything other than a dark
complected woman of African descent." And anyone naive enough to believe
that racial discrimination is something educated, middle class blacks no longer
confront, should walk for a few months in shoes adjacent to theirs. Black
conservatives who deny the reality of discrimination either have some special
reason to curry favor with the white majority or they are what popular

psychology now calls "in deep denial." The truth is always more alloyed than slogans make it seem, and whatever is a verity for one person is deceptive to some other. In the same way, today's art scene is marked by a miscellany of visions that are either depressingly similar or radically incompatible.

Of course, art has always been invariant in its variability, even in cultures where conventions were strict and the desire to honor them a supreme goal of the artisans. An individual artist is never wholly absorbed by her society, nor wholly responsive to a stylistic movement of which he is a part. In a sense all remain invincibly insulated. It is possible for an expert Egyptologist to distinguish individual hands in a mural from an Old Kingdom tomb and specialists in Byzantine icons comprehend idiosyncrasies among artifacts that appear identical to the rest of us. With respect to post-Renaissance art the situation is transparently clear; no matter how much a disciple or forger longs for complete and total surrender to the visual language of Vermeer, Raphael, Monet, or Rauschenberg, he can never fully attain it. To some extent vision is autonomous. Surely, that is central to the appeal of something like realistic landscape painting. Consider how different the same scene would appear if painted from precisely the same point of view by John Constable, Jean-Baptiste Corot, Thomas Cole, Frederick Church, Robert Zünd, Luigi Lucioni, and Andrew Wyeth. To some extent we would expect photographers, too, to give us slightly different versions of the same site, depending on their distinctive preferences with respect to brightness, contrast, lenses, and so on. But it is the variations from painters working up an image line by line and stroke by stroke that are peculiarly entrancing in their uniqueness, precisely because they are expressions of attitudes towards nature—subjective even when, as in the case of Zünd or Lucioni the whole attention of the artist seems consumed by detail and a reluctance to disclose the means by which it was attained. This is so readily apparent that it scarcely bears mentioning. The styles of painters Thomas Hart Benton, Grant Wood, Rockwell Kent, and Paul Sample were not merely stylized representations of the North American landscape; they were visions that turned reality into a kind of hopeful dream. Benton may have believed he was honoring El Greco and Wood that his style was homage to fifteenth-century Flemish and German art, but what the popular audience in the thirties and forties sensed in these artists' smooth distortions was the kind of modernism people actually like, namely, streamlining, enamel slick color, and the harmonics of contemporary technology. It's not without reason that Art Deco keeps on undergoing revivals. It expresses the same longing for a marriage of organic form with mechanical perfectibility. (See Figure 8.)

MIDDLE-CLASS TASTES IN THIS CENTURY: 1900 AND HOLDING

Today, in the last decade of the last century of the second millennium of the Christian Era, we are embraced by artistic tastes that are multifarious and riven

Figure 8: Art Deco, the intersection of tradition and modernism

with grotesquely exclusive categories. More than anything I can think of, the art scene resembles the popular music scene in which various kinds of Rock and Roll are dominant overall while specialized pluralities—such as country western music and serious jazz—represent a range of individual preferences. The emergence of Rhythm and Blues in a bleached out form called Rock and Roll is one of the most remarkable cultural phenomena of the century. Raucous, rebellious, explicitly sexual, carried by a strong—indeed, deafening—beat, this stuff virtually wiped the popular music of the forties from the airwaves and, with it, the melodic and thematic variety of the heritage of songs derived from light opera, the music hall, and dance band. Inevitably, the public that was not enamored with what was, at first, a kind of electronic blend of gospel cater-wauling laced with the sappy sentimentality of teenage hicks and angst-ridden dopers, sought alternatives in musical comedy scores, serious jazz, nostalgia stations (playing "The Music of Your Life" for old folks), and country-western music.[6] In a somewhat parallel way the serious art scene today—as it is represented in the art press, museums, contemporary galleries, and academe—consists of the sacred old masters, modern art, and postmodernist deviations from modern art.[7] Everywhere, however, consumers of art find alternatives in (yes) country-western art in the tradition of Charlie Russell and Frederick Remington, and even in paintings originally done in the forties and fifties as "work for hire" for story illustrations and advertising art. A particularly successful category of commercial fine art combines relatively realistic drawing with Impressionistic or Fauvistic color. Galleries whose principal clientele is made up of interior decorators and householders seeking appealing originals, prints, and reproductions are mining an American cultural lode that was first plumbed by people like Childe Hassam and Theodore Robinson.

Impressionism never faced the same kind of struggle in America that it had in Europe. In the first place it had the cachet of something "made in France." Secondly, in the United States Impressionism was recognized immediately as a

form of realism, a fact that made it acceptable to colonials whereas in France, where the classical heritage held sway, realistic art was considered unrefined—the kind of thing a Dutchman or American would like. In the U.S. Impressionism was even *more* acceptable than the "straight" realism of Courbet or Eakins because it enhanced the merely natural by ornamenting it with intense touches of color. Someone—and I am dismayed that I cannot provide a reference—has noted that one reason Impressionism appealed to Americans as a form of realism was that, among the better educated, the idea prevailed that a truthful picture could not also be a beautiful one. This way of looking at art is by no means obtuse; on the contrary, it is consistent with the postulations of Renaissance thinkers—for instance, Alberti and Lodovico Dolce—and even Plato.[8] Finally, although French Impressionism itself contained an implied criticism of the social norms from which it sprang, that side of the matter was invisible to American viewers. French society of the time was extremely formal and hierarchical, whereas the social customs of the U.S. were democratic, informal, and rather crude even at the higher reaches of the social scale, at least when compared with behavior of the French and British. Impressionism's casual randomness and vernacular subjects were unlikely to be seen as negative traits by a people whom Alexis de Tocqueville had described as "fixing their standard of judgment in themselves alone."[9]

In any event, a taste for recognizably pretty things represented in delightfully piquant hues was highly marketable in the late nineteenth century, and has, in today's land of endless choices, become the reigning contemporary style, even though it is celebrated only in magazines like *The American Art Review,* the front covers of upscale mail order catalogues, and the back covers of *The Reader's Digest.* Yesterday, I wandered through a regional art show held on the streets of a small city in east central Maine. It contained a lot of booths featuring watercolors inspired by the work of Maine artist Andrew Wyeth, but in place of the master's slate and gravy tones the more accomplished of these pictures used very bright hues; cobalt shadows and viridian grass hovered over pure white paper while magenta blossoms and lurid yellow dandelions filled out these really quite charming fantasies. Some were like Fauve paintings done by one whose only knowledge of drawing had been distilled from a few lessons in a school of architecture. Too, where Wyeth's work in watercolor is conventionally spontaneous-looking, an adumbrate image of rustic scenery in the tradition of Homer and Sargent, most of these colorful pastiches were "constipated," that is neat, crabbed, overworked, careful drawings colored with transparent watercolor. There were, of course, also some suave manifestations of similar themes done by very able performers with an eye to immediately marketable paintings that would be acceptably representational, somewhat evocative of "Wyeth country" and also colorfully decorative. The exhibit had imitation Hoppers of the same sort and even some modernist works—abominations all—as well as a few exhibits of first rate commercial illustrations, here being presented as fine art for purchase in the form of signed and numbered

"prints," for which read "color reproductions." I have seen, even juried, many larger "come one, come all" exhibitions of this kind in Illinois, Pennsylvania, Washington, and even Alaska. They differ only in the kinds of regional themes and styles that inevitably predominate. Intense color and a certain literalness in representation have been signal in all of these locales. Too, Andrew Wyeth is a popular source of form, but explicit content shifts with the territory, so you get more marinas and lighthouses in Maine and more autumn foliage in Pennsylvania. Nostalgia for the vanishing lifestyle of the rural America most of us can at least dimly recall is marked by the incredible number of weathered gray barns in degressive states of collapse and desolation that show up in every region. These reveries are not, of course, so often brightly colored, but neither are they purchased as frequently as they are admired.

From an art historical angle none of this stuff is important; it is barely a footnote to the mainstream development of a cultural style. The sociological implications, however, are of some interest, inasmuch as they imply a widespread longing for an aesthetic linked to turn of the century tastes of the privileged classes. That the most popular art style today, of all the modes of the past, is Impressionism is not surprising. Study Renoir's *Luncheon of the Boating Party*. Apart from the specifics of costume style, these men and women are very like men and women today in their easy social interaction. Two of the boaters are wearing tank tops and one man is casually clad in a soft sweater. Some of the women may seem overdressed for a summer outing, but theirs is the loose, holiday wear of the time. Still, if we were to dress this cast of characters in L. L. Bean and DKNY, their behavior would seem altogether contemporary to us. And that is true of most of the people who inhabit the paintings of French and American Impressionists at the end of the nineteenth century. It is easy for Americans to relate to them because many of us long for the settled repose of these people lounging in the cool shade of a late summer afternoon, or watching children delighted with simple pleasures, as in John Singer Sargent's wonderful *Carnation, Lily, Lily, Rose* (1886), showing the young daughters of Fred and Alice Barnard lighting Chinese lanterns on the very brink of dusk. These kids behave the way we would all like ours to—if, in most cases, it didn't require whips and hobnailed boots to achieve such solemn good behavior. but, then, placid concentration was never as prolonged as the painting makes it seem, even among the leisure class for whom Sargent painted; Dorothy and Polly Barnard also squirmed, fidgeted, and complained as the artist undertook what amounted to a studio work in a *plein air* setting, through a number of evenings. The paintings of the period are no less imaginary than the illustrations of Norman Rockwell. That is, the appearances are "real" and the sentiments genuinely felt but actuality is buried under false nostalgia.

The intelligentsia of the art world are by no means immune to the ways in which the basic principles of styles are transformed by broad acceptance into largely ceremonial gestures. Harold Rosenberg, a hugely influential critic during the last half of the twentieth century, finally got to the point of being slightly

dismayed by the spectacle of art as a spectator sport. For he shared with other modernists the conviction that an indispensable ingredient of avant-garde art is social dissent. "Cool, or non-rebellious, avant-gardism is an absurdity of the modern art museum and university art department. It assumes that human life rests on a passive faith in the notion of progress; it assumes that human life will be steadily improved without the intervention of imagination and that art will progress by an evolution applying exclusively to art forms."[10]

In an interesting article on contrasting views of Franz Kline expressed in catalogues from two exhibitions of Kline's works in the early 1990s, Daniel A. Siedell commented on the corollary relationship of Rosenberg's art criticism both to American painting of the early fifties and to postmodernism in general. His discussion concerns the essays of David Anfram and Stephen C. Foster, with Siedell coming in on the side of Foster, and it attempts to focus on "epistemological coigns of vantage within which the two exhibitions were intended to function."[11] In this connection the role of Kline, Dekooning, Pollock, and others, was to create a contemporary art outside what had become the aesthetic "tradition" of modernism. These men had come to doubt the relevance of the audience for art to its purposes and, indeed, questioned that their paintings "meant" anything in any context whatsoever. Foster and Siedell, see Rosenberg as "the key to the entire period." For them, the fact that Rosenberg was taken to task by, among others, Clement Greenberg and Robert Goldberg for not paying much attention to the paintings themselves demonstrates that he saw the real problem was an essentially epistemological query, namely, whether "meaning was even possible."

> This is where Kline and Rosenberg "meet," as it were. "Works no longer 'meant,' per se, a fact to which Kline was keenly sensitive. Meaning became dependent on the presence and development of a work in a live situation or setting. Short of this, a work meant nothing." This is precisely what Rosenberg meant in emphasizing the "event" as opposed to the work itself. . . . Foster argues, in effect, that his exhibition is a collection of residual events; objects used as means to transact certain social situations. But he still wants you to look at the paintings. And he wants you to do so by focusing on their internal development. . . . Kline's and the downtown painters' anti-modernism, which doubted the very existence of sender-receiver models, was so radical that it was diluted through over-aestheticization (Rosenberg's fate as well) by mid-century modernism as a means to make them conform to those institutional myths which were believed to be beyond critique.[12]

Siedel recognizes that this line of argument implies that "postmodernism, in all its manifestations in the institution of art is simply another modernist self-critique" with the communicative models the Abstract Expressionists rejected still intact. In a provocative aside he suggests that this might explain the

"unlikely revival of arch-formalists Clement Greenberg and E. H. Gombrich in the semiotic, structuralist, deconstructionist, and psycho-analytical art historical literature."[13] It also tends to confirm Rosenberg's complaint that non-rebellious avant-gardism is in service of a belief in the inevitability of progress.

This fancy that the quality of human life ought to be getting ever better was certainly a fundamental of modernism. The first chapter of this book treated the development of pure visibility and formalism as clearly part of the heritage of the Enlightenment. Since it would probably seem pitiless to question the desirability, if not the feasibility, of improving humanity's lot, we shall not contend against that hope. But supposing that changes in art can or should be aesthetically progressive is open to very serious question. In broad perspective, the fundamental changes that have taken place in art have been transitions from some set of emphases to a subset that eventually evolved into a contrasting type. Most writers on the major historical transformations of style have been forced to dwell on the remnants of the past that were actually perpetuated in art that seemed to have extirpated all that preceded it. Medieval artifacts are replete with Antique elements transfigured by Christian doctrine. Renaissance iconography depends upon the beliefs and habits of portrayal common to the Middle Ages. Rembrandt is partly Caravaggesque, and Manet looks to Hals and Velasquez. Seminal figures like Giotto and Cézanne seem already to embody whomever they inspired. And, yet, it is commonplace to speak of the progressive evolution of art in modern times or, in what amounts to the same thing, to bemoan the degeneration of contemporary art from the pinnacle attained by some previous flowering.

Every once in a while someone sets out to prove that the evolution or devolution of art is a reality and not just a manner of speaking. Always in such undertakings, the proponent must establish some kind of criterion against which the successive variations of style can be measured. Critic Suzi Gablik took up the challenge in her very provocatively titled book, *Art as Progress,* an effort to show that Minimalism is an expression of French psychologist Jean Piaget's highest level of psychic attainment. Gablik is serious-minded and, I think, sincere. It is even possible that her convictions about Piaget and pure non-representationalism have some great merit that has escaped my notice, but she makes ludicrous gaffes along the way to the completion of her argument. Outstanding among them is her contention that Marcel Duchamp's *Three Standard Stoppages* somehow paralleled Bernhard Riemann's non-Euclidean geometry.[14] This is the sort of false profundity critics of art and literature are apt to toss off in the sublime confidence that geometers and topologists do not very frequently read criticism of art or literature and those that do will, in any case, not take it seriously enough to correct. Gablik even received cautious plaudits in a couple of reviews. But no one who has actually struggled through Riemann's *Über die Hypotbesen, welche der Geometrie zugrunde liegen* (1867) could possibly maintain such an idea. It is even less informed than Metzinger's claim that Cubism is a visualization of modern physics. Still, one can easily appreciate

the imaginative appeal of Gablik's formative notion of relating the history of styles to stages of development in Piagetian theory; it is the sort of inspired parallel that moved Riegl, Worringer, and Oswald Spengler to compose important, if flawed, works. Often enough it turns out—as in Gablik's instance—that the great idea overwhelms any author's ability to substantiate it.

One of the curious things about what passes for an avant-garde today is, again, the absence of the *modern marvelous* in any connection whatever. One might suppose that wealthy entrepreneurs of today would seek out expressions of the technology that has made millionaires of computer hacks and their backers, but very little has come to the visual arts from science and contemporary technology. It is odd that as photography becomes an obsolete technology it continues to be practiced by artists who are beginning to look upon darkrooms and hypo solutions in the same way etchers and lithographers view their presses, plates and limestone, that is, as parts of an archaic process that produces prints much richer and more precious than their commercial counterparts can be. Like line engraving in contrast to photogravure, photography makes difficult what digital cameras and computers do with ease. Reluctance of the art world to welcome the new with open arms is an old old story. And hesitation has its merit. As Alexander Pope ordained, "Be not the first by whom the new are tried, Nor yet the last to lay the old aside."[15] Still, the new technology has been around for rather a while now and its influences on art have been minimal and quirky. Perhaps that is in part because the engineers responsible for its emergence are thoroughly conditioned to think of the visible world in the same way traditional painters and delineators have. Physicists haven't been locked into that same realm, so far as their worldview is concerned, for almost a century. So, not wishing to abandon the old altogether, I would like at least to speculate on what would seem the promise lying just over the horizon of the future. The most obvious discovery, and the one most challenging to conventional notions of representation is *virtual reality*.

ON VIRTUAL REALITY AND THE EPISTEMOLOGY OF ILLUSION

The adjective *virtual* is used colloquially as if it were synonymous with "nearly." We can easily imagine, for example, someone saying this very book amounts to "virtual scholarship," meaning that it is nothing but a collection of unsubstantiated opinions disguised with footnotes and the other paraphernalia of a scholarly work. But, although the assessment might possibly be just, the sarcasm depends upon a pun that is more than imprecise. For *virtual* can be rather narrowly defined as something that is functionally or effectively, but not formally, the same as another thing. By this definition virtual scholarship would be every bit as good as "true" scholarliness, even were the author to have come by knowledge through accidental happenstance or simple plagiarism. Popular usage derives, of course, from the adverb *virtually* which does mean "essentially," or "for all practical purposes," as in "virtually impregnable" or

"virtually dead." It is not surprising, then, that most people take *virtual* to mean "approximate" or "almost." *Virtual*, however, connotes a less distant remove from reality. Nonetheless, this imprecise form is commonplace even among those who could be expected to be very careful in applying the term. But what of it? When a woman with a Ph.D. in physics remarks that her ex-husband was a "virtual corpse" so far as sex is concerned, her colleagues don't confuse hyperbole with technical terminology. That we will not either is a virtual certainty—isn't it? And, yet, careless application of the word in connection with computer-generated illusions is apt to muddle one's understanding, so a bit of armchair etymology may be in order.

The earliest use of *virtual* I know of is from 1646 in the term "Virtual Church," signifying a council or similar body acting in the name of the whole Church. Other, more typical early usages are in the fields of optics and physical mechanics, the first of these being "virtual focus" from 1728 in its now standard meaning of a point from which divergent rays seem to emanate but in fact do not, as in the case of light reflected from a mirror, for example. Mirrors produce, then, "virtual imagery." But my associations here make the relationships seem simpler and more straightforward than they are in fact. Like other concepts in the field of physics, even superficial study of the mechanics of something like virtual imagery throws one into a sea of cosines, angles of incidence, spherical versus aspherical surfaces, refraction indices, and all sorts of stuff most of us either did not learn or put out of our minds the moment we passed high school trigonometry. Thus, "virtual displacement" is a by no means common-sensical term; it means the infinitesimal displacement of any of the points in a mechanical system, a displacement that may *or may not* take place but is, in either case, compatible with the constraints of the system. In the arts, however, the use of *virtual* in its more or less conventionally restricted sense is usually quite easy to grasp as a metaphor for various second-level simulacra.

Today the phrase "virtual neighborhood" is often used in connection with communication networking by computer, the neighborhood consisting of the particular network of communicators linked by computers. In the early 1950s, when I was beginning graduate school at Columbia University, I concocted this very term to describe life in New York City where, because of subway travel, one could visit friends and businesses all over Manhattan and the other boroughs without knowing anything at all about what was above ground at express stops untaken. For me, then, my "neighborhood" effectively consisted of Morningside Heights, where I lived and studied, the East Eighties, Greenwich Village, a bar on Fiftieth Street near Broadway, a girl friend's apartment on West 142nd St., and Pratt Institute in Brooklyn. The term *virtual* I drew from Susanne K. Langer's *Feeling and Form* in which the adjective is applied throughout as in the "virtual space" of painting and, most aptly, to the "virtual dream" of cinema.[16] To draw an analogy between a neighborhood made up of urban locations experienced first hand and one constituted of far flung electronic sites is, perhaps, inapt because the Internet's "neighborhoods" and

"chat rooms" are more like telephone conference calls than face-to-face conversations. But as uneasy as the comparison is it is harmless compared to similarly strained legal virtualities, such as those extending the civil status of personhood to corporations. To treat huge business entities as artificial individuals before the bar of justice is a convenient fiction for commerce and a sometime impediment to litigation. Whether one or the other, no one conceives of a fictive individual named Monolith, Inc. as a genuine person. There are, of course, ongoing attempts to create virtual human beings whose digital presence will be indistinguishable from the image of a real person conversing with you over closed circuit television.

Most, if not all, attempts to create a virtual person originate in the so-called "Turing Test" of artificial intelligence. Alan Turing, in an article, "Computing Machinery and Intelligence," set up a hypothetical situation involving a computer and a human being separately hidden from an interrogator who could communicate with them only in some impersonal way, say via a computer terminal. Turing specified conditions to make the test fair—for instance, the human being must try to convince the questioner that he or she is a human being while the computer is programmed to lie and pretend to be a human being (which entails, among other things, not processing arithmetical calculations with the electronic speed neurons can never match). The point is for the interrogator to identify the parties; if she or he cannot, the computer is regarded as having passed the test.[17] Turing's work with this kind of thing is fundamental to much experimentation that has followed. And it is controversial, for there are plenty of skeptics ready to attack the very idea of artificial intelligence (AI) on the grounds that calculators do not "understand" what they are doing. Needless to say, perhaps, the proponents of AI generally dismiss this notion of intellectual comprehension as mystical and, therefore, irrelevant. I, myself, am somewhat inclined to believe them, but I do not think it is as important as some people far more learned than I seem to believe it is.[18] In the first place, the insistence that AI be comparable to human intelligence is a sort of unstated, a priori presumption. Why not primate intellect for a model, or even the mind of some higher quadruped, say a poodle or border collie? Surely, I understand the motivations for creating a thinking machine "in our own image," as it were, but people engaged in robotics research and development often seek to approximate insect and reptile behavior patterns in their metallic creatures.[19]

However that may be, it happens that a friend and former colleague of mine, John A. Barker, professor of Philosophy at Southern Illinois University at Edwardsville, has created the basis for an artificial intellect called *ProtoThinker*.[20] ProtoThinker is a "computer program designed to stimulate thinking about thinking. The user converses with the simulated person, ProtoThinker (PT), and explores PT's abilities to think, reason, understand language, and make decisions. Experiments are conducted with modifications of PT's abilities and with simulations of free will, deception, self-awareness, psychological repression, 'irrational values,' amnesia, multiple-personality,

autism, illogical reasoning, and passage of time."[21] As you can see, PT is an innovative version of a Turing Machine with a pedagogic rather than polemical objective. PT is the primary language and logic program for an artificial person, "Iris," whose official designation is PTX-1/CK-1/M-D1/R-T/V-FT. Ultimately, the design team of faculty and students (from the departments of Philosophy, Applied Computer Science, and Industrial Technology) led by David Anderson, associate professor of Philosophy at Illinois State University, hopes to create an animated image of an android face to serve as the "front end" or visible representation of PT. This being, Iris, is sometimes referred to as a "virtual person" by Dr. Anderson. And why not? If PTX-1/CK-1/MD-1/R-T/V-FT lives up to its promise, Iris will have virtually all of the attributes of an anthropomorphic robot, if not a genuine human being. Actually, the face is intended, ultimately, to serve as the "head" of a robot constituted of a PC, a voice, cameras for eyes, and two mechanical arms. Professor Anderson and his students are also attempting to create a second virtual person, "Cyd," using computer animation rendered by the program 3DStudio Max. In two or three years the team hopes that Cyd will occupy a virtual environment of houses, trees, and so forth on the website.

Still, there is something inherently remote about the virtual reality of anything intended to be perceived as a motion picture on a monitor screen. Even when a living person addresses you from a television screen it is a far remove from a face to face conversation. I hasten to note, however, that Professors Barker and Anderson do not wish PT's personage to be an illusion so complete that the observer is deluded into believing Iris is some sort of human in a gleaming mask. After all, for their purposes, it is necessary that the user understands it is possible to experiment with the computer program that projects PT's thoughts. Cyd, on the other hand, is intended to cause the human users of the virtual environment to mistake "him" for a human intelligence. If the project accomplishes that, it will be a major achievement, but Cyd will remain a moving picture held prisoner on a screen. To create a virtual person that would mislead the viewer into believing she or he was a physical being with independent capacities, the artificial being could not be confined to the surface of a monitor screen; to be altogether convincing it would have to seem to be part of the viewer's normal spatial environment. It would need, in other words, to be an element of a *virtual reality*, the whole of which could be perceived and acted upon by the user.

Digital imagery advertised today as virtual reality (VR) is largely restricted to the world of play, although one kind in particular—that of flight simulation—has very practical applications. And even the relatively inexpensive programs for your home PC are pretty impressive, despite "jaggy" transitions and simplified scenery. Video games in which the players drive racing cars in Indianapolis, NASCAR and Grand Prix simulations (sans crowds) are among the most convincing imitations of reality because, like the flight training programs, they are able to constrain the perceptual field by assuming the user is

locked in a fixed position relative to the view, which is itself limited to the windshield and instrument panel or, alternatively, specified angles to the rear, sides, and overhead. That is consistent with the fact that racing car drivers keep their eyes on the road and rear view mirrors in a structured sweep of the field, so possible views of the track, relative positions of other objects, shadows, and reflections are predictable. With such parameters in place, the realism of the effects depends largely upon the computer's RAM and the speed of its processing chip. Nonetheless, the imagery remains dependent on the principles of orthographic projection dating from the Renaissance.

The typical approach to creating the figurative elements for a game involves breaking contours of the subjects down into what Computer Aided Design (CAD) aficionados refer to as *polygons*. For most of us, polygons are plane figures with several sides, but in the jargon of three-dimensional CAD programs they are convex surfaces—though these may be of zero curvature. Plate 17 will give you a notion of how such shapes can be arranged together in the form of a relatively complex object. The axonometric rendering that is bounded by a heavy black line is the basis of all other views in the illustration; actually, it was done as a multicolored transparent "wireframe," but I have printed it out with an instruction to "fill" the polygons with white so that the drawing will be easier to understand in black and white. This particular orthographic projection is actually a simultaneous combination of three elevations (front, side, and plan) that appear on the computer's monitor screen in small windows alongside the principal "perspective window" where the axonometric projection appears. The absolutely essential trick to master in doing a CAD drawing is how to fix the cursor in exactly the same relative position in every one of the four views; if, for instance, you want to select the tip of that stem protruding from the nose, you must place the cursor on the tip in the front, the side, and the plan views. That will automatically set it at the right point on the axonometric drawing. It is a simple matter, intellectually, to see what must be done but it requires practice and care to manage it. Using a CAD program to draw any three-dimensional object except the most elementary shape is tedious and *very* time consuming, but it is time well spent since a single CAD drawing can be viewed from an indefinite number of viewpoints. In Plate 17 we observe six perspective renderings of my Ramjet, two in the same form as the axonometric model, four with a "skin" shaded by light striking it from different angles. Notice that the airframe is symmetrical but details are not; for instance the gadgets under the wings against the fuselage are unlike and there is a reconnaissance camera on the right edge of the air intake. You are looking at different views of the same aircraft exactly as if it were a genuine three-dimensional object instead of a drawing generated by magnetized data on a computer disk. It should be easy to see that it is only a few, albeit complicated, steps to combining a sequence of views into an animated illusion of flight. Combined with a perspective background the effect can be quite dynamic.

The techniques for drawing figures are no different from those employed in drawing machinery, utensils, or buildings except that the units are generally smaller and more numerous. The construction of a human head, for example, proceeds in classical fashion, building up the skull and features in the same ways academic artists have been taught to do for four centuries, from polygons joined together to make semispheres, rhomboids, columns, and so on. The same goes for torsos, hands, feet, and all the rest. Moreover, one can apply nodes or "handles" to different segments of a figure so that they can be manipulated for the purposes of animation. The amount of work that goes into modeling a game figure, however, is daunting. A really good figure will consist of perhaps 600,000 polygons. While that works well for the spatial setting in which the action occurs and can also provide stunning impressions of rigid objects moving within that space, the imitation of life poses enormous problems. It is hard to make figures move smoothly and naturally without bits and pieces of them "tearing" apart now and then. Of course, if you have the kind of hardware film companies do, you can get around problems of this kind without resorting to the tricks employed by manufacturers of home video games—tricks such as covering the zones most vulnerable to rending with skirts and capes.

It is important to understand clearly that what we're seeing in a highly advanced computer design from Lucasfilms or Pixar is usually no different from the space of Renaissance art; everything is grounded in the same reductive processes, the mathematics of orthography and, specifically, the applied geometry of central projection. The technology is new, the principles centuries old. Whenever I think about this rather comforting constancy I am reminded of the opening pages of Vladimir Nabokov's novel, *Laughter in the Dark* (1938), in which the protagonist thinks that it would be fascinating to employ animation "for having some well-known picture, preferably of the Dutch School, perfectly reproduced on the screen in vivid colors and then brought to life—movement and gesture graphically developed in complete harmony with their static state in the picture."[22] Nabokov was not only sensitive to the difference between the paintings and reality; he was also prescient so far as the future uses of animation in service of imaginative desire instead of reality. One of the things that makes the art of the Netherlands alluring is the very fact that its realism is fantastical. Ironically, some of the most impressive examples of VR in evidence today are, in fact, as far removed from truth as was the gleaming atmosphere that permeated Jan Vermeer's interiors. Reflect for a bit upon those marvelous computer enhancements of scenes sent to Earth from other places in the solar system.

I was enormously impressed with the video flyover of the planet Venus derived from radar data collected by the 1992 space probe called Magellan and released by NASA. The animation is stunningly vivid and the landscape of lofty mountains and deep valleys we seem to be soaring over and zooming through is a science-fiction reader's delight. How disappointing, then, to learn from undoubted experts that the surface of Venus is not full of mountainous

volcanoes but is covered with shield volcanoes the mean slopes of which are 3° or less. What NASA and the Jet Propulsion Laboratory did was exaggerate the vertical scale—by a multiplier of 22.5! This is the sort of thing makers of topographic relief maps do. During my time in the U.S. Army as an illustrator for Joint Staff Intelligence I sometimes worked in close association with Naval cartographers rendering relief maps of Southeast Asia. It was absolutely essential to exaggerate the vertical scale of things to make even such seeming prominences as the Himalayas visible, because something a mere 29,000 feet tall appears pimple-like when viewed as part of a map showing an area that is 100 miles on a side. Think about it. At a scale of, let us say, one eighth inch to a mile, the map would measure a foot and half across and Everest be five eighths of an inch tall. If you were to construct a globe with a three foot diameter and apply to it a topographic relief exactly to scale, the highest points and lowest declivities would be no more than slight wrinkles upon the skin of the Earth. As for huge cities, the Great Wall of China, and the Pyramids, these would be as invisible as they are from the moon.

What you are seeing in the Venus flyover video is data deformed by "dequantification" of the same kind cartographers use but, in this case, used for purposes of dramatizing the space program rather than for purposes of making relationships visible.[23] Deception, though, is inevitable regardless of motives, because the topographic projections, the space flight videos, and the video game environments are all products of the same monocular vision and projective geometry that generate realistic paintings and photographs. Moreover, when binocular modifications *are* applied to these projections, the results are stereoscopic rather than fully three-dimensional; that is, the world depicted seems to be constituted of flat cutouts receding into the space of a world almost without relief.

Presently, the kind of VR offering one the nearest approximation to participating in an alternative reality is the sort afforded through the use of a helmet fitted with monitors wired to a high speed computer that responds to the wearer's movements by adjusting a "realistic" CAD image. The user turns his or her head to the left and the scene shifts accordingly. Sensors can also detect arm and finger motions so that in an arcade game the player can fire guns at a virtual opponent in space or on Main Street of old Dodge City. The imagery is fairly crude as of this writing but the technology constantly improves—led, in this decade, by a film industry which is now at the financial and technological level to have become a source of invention for federal agencies whereas before the film makers were the beneficiaries of government.

Already, the effects of VR are so captivating that they are used for what is called *virtual therapy*.[24] The term is inapt, however, because there's really nothing "virtual" about it. This is actual therapy and not some kind of replica having the same effect; the term *virtual* has been applied to it solely because VR techniques are used to accomplish it. At the University of Washington's Human Interface Technology Lab VR techniques have been used to free a woman of a

spider phobia and to distract burn victims from the excruciating pain associated with the wounds and their cleansings. The therapeutic potential of VR was first demonstrated in 1995 when the Georgia Institute of Technology used it to help victims of acrophobia overcome their irrational fear of heights. That the results of these efforts seem highly promising suggests verisimilitude is not very important so far as the affective reality of the environment is concerned. The settings as well as the extremities of the user reaching into the VR field are very geometric and conventionalized, quite like the simplified elements in animated short subjects from the 1940s, yet patients subjected to these visions react to them emotionally and identify the cartoony hands and feet as extensions of themselves. Of course, it is possible that unrealistic VR is more effective as therapy than indisputably convincing illusions would be precisely because neurotics would be too terrified of trompe-l'oeil scenes to deal with them. That is to say, VR indistinguishable from actuality would be equivalent to firsthand experience and, so, be the same as torturing the patient with his or her affliction. The point is moot, however, because no existing version of VR is vaguely close to normal perception; the very best examples are akin to films of fairly good dioramas and the optics the same as those used by Baroque painters of illusionistic church ceilings and wall murals.

One contemporary invention promises eventually to populate VR with chimera deceptive enough to mislead a normal viewer into believing illusion is reality. That is *holography*, the production of three-dimensional images by the simultaneous intersection of laser beams striking a subject and a piece of film to produce on the film, not a dark and light negative (as in photography) but an interference pattern that can be viewed as a three-dimensional "window" having all of the properties of an actual scene. Initially, two beams of light were split from the same ruby crystal laser source. One beam was aimed at the photographic plate and the other at the subject to be reproduced. These monochrome holograms had to be viewed in coherent light—normally from the same laser—and were always dark red. Later, three beams were used to produce polychrome holograms which could be viewed under natural light and, as the technology progressed, the scale of the images became larger and larger. Also, where at first the illusion seemed to extend beyond a window, it was not long before objects appeared to hover before the window, as if projected into the viewer's space. Shortly after holograms were invented at the end of the 1960s I wrote: "When one couples holography's potential with the vast capacities computers have for storing information in terms of electrical impulses, one can see that our views of imagery, genius, and creativity may be vastly changed."[25] At that time computers were quite primitive compared with the machinery existing today and, in the interim, holography has become capable of doing larger and better imagery.

Today it is possible to project high definition images of reality into space just as though they were behind a windowpane of film. Let us, then, record as a hologram the shapes, color, and atmosphere of a physically extant still life. If

the original were set up in a shadowbox and the holographic copy shown in a similarly framed piece of film it would be extremely difficult to detect which was the original and which the virtual image, especially if the shadowbox and film were set apart in different rooms. To attain truly baffling similitude it would be necessary to use slightly darkened glass to cover the box of real still life objects, because holographic hues are never accurate. As many of you will know, good holograms have all of the attributes of things observed in the real world; for example, you can look around the objects and they shift position as you do, "moving" the way they do in reality. That is, if you focus on a vase in front of a bottle and move your head to the right, the bottle will move to the right with you, the vase remain still, and an apple ahead of the vase move to the left. (Yes, this is what will appear to happen. I am always amazed that most people never take conscious note of this phenomenon. It's why the moon and distant mountains seem to race through the forest along with your car.) Should you want to see what the label on the bottle says when it is blocked out by the vase, you may move to see behind the vase as you do when looking at the real still life. There's no difference. If there is a magnifying glass standing up in the midst of the objects it will behave in the hologram strictly the way it does in actuality even to the extent that the focus will change as you step farther away from it. Obviously, holograms are nothing like paintings or photographs when it comes to imitating real vision. Holograms are virtually the same as vision, a circumstance throwing into question many past assumptions about the nature of representation.[26]

In the first chapter of this book I made quite a considerable point of the ways in which pictorial representations rely upon conventions that correspond to vision in only the most tenuous fashion. That is true, too, of the VR imagery in games and simulators. Holography throws our standard assumptions about the epistemological nature of artificial imagery into question simply because it seems to defy the kinds of assumptions E. H. Gombrich and others (including me) have taken for granted about imagery versus reality. On the other hand holography seems no challenge to psychological theories of vision, given that perception of the real thing is so like seeing the holographic copy. But holography does, in point of fact, raise questions about neurological responses to interference patterns resulting from coherent, highly collimated beams of light and the ways these correspond to first hand perception of the world. Perhaps holography will reveal new semiotic connections between our apprehension of the world and our appreciation of symbolic representations of it. As I noted, with excessive insouciance in 1971:

> One can say with great confidence that as the science of holography
> is perfected and the images become more and more equivalents of the
> real world of vision the effects upon art and upon art criticism will be
> profound. And these effects will not pertain exclusively to its
> potential for mimetic naturalism. Because holography hinges on the
> regularization of the interference patterns of light rays, it will

> someday become possible for any holographer who wishes to, to
> create three-dimensional abstractions, montages, and fantasies quite
> unlike reality. Probably the introduction of motion into the image by
> means of rotation of the film axis is inevitable.[27]

My predictions were far too optimistic. Few artists of genuine talent have been attracted to the medium. Some may have been put off by imperfect color and the difficulty of making holograms measuring more than a few inches, others because holography seems so completely technological and coldly "artificial." Salvador Dali was one of the few major figures who experimented with it, but his efforts produced little of interest. Movement has been introduced as I predicted, by putting the film itself in motion and also by making holograms of cinema clips. The latter are disappointing, though, because they are no more convincing than stereoscopic "3-D," and the color is just as bad. So far as VR is concerned, the capacity probably exists to create virtual people who are visibly identical with real human beings, but motivation to do so is insufficient to warrant the expenditure. Nonetheless, I believe it is only a matter of time before holographic creation of virtual beings is accomplished. That is not to say holography will be capable of creating an entirely plausible kind of VR on its own. A huge problem stands in the way, or so it seems to me.

When it comes to developing settings for holographic beings to inhabit it is hard to imagine any way the space surrounding the laser instruments used to make holograms can itself be captured by beams diffracting to a plate. A camera can't take a picture of itself either, although it can photograph its own reflection. But cameras can capture huge segments of their environment. Holographers can not do that; the landscapes now seen in holograms are artificial settings of the sort model railroaders use for their scenery. Real landscapes and holography appear to be perfect examples of incompatibility, since the theme is not accessible by the medium. This hard fact appears to dash to bits any hope that holography may "replace stage and film sets, tableaux-vivants, zoological gardens and much of Disneyland."[28] But a solution to what seems an inherently insuperable dilemma may lie in the ability of computers to create digital imitations of nature for film production. Already today special effects technicians are able to replace deceased actors with digital replicas doing new screenplays exactly as though the dead star had been resurrected, even from his or her youth. When you can create illusory human beings, things like trees and mansions, mountains and oceans, should be a snap. Before long we will be viewing old favorites like Humphrey Bogart and John Wayne as young men adventuring in landscapes they never knew. Mightn't a twenty some year old Bette Davis' digital twin play Daisy to Alan Ladd's bootlegger in a proper remake of *The Great Gatsby,* or Elvis sing again for the delectation of all his now elderly female fans? Whether or no, the ability to create digital clones of natural forms suggests a way to fabricate VR environments.

It may not in fact be possible to produce effective holograms from digital codes but that it could be seems to me a plausible hypothesis. And, if it should be possible, then television, film, and all the rest would fall to VR at least so far as commercial diversions are concerned. Assuming the medium can eventually approximate "true" color, at least one contribution to the fine arts would be assured—the creation of museums that would not only be without walls but would also be instantaneously available. This is highly appealing to me, at least, for I am interested in being in foreign lands and exotic places, but detest traveling to them. Many things are worth seeing but few are worth *going* to see. Of course, the kind of VR I'm enthusing over here would probably annihilate the travel industry and lead to indolence and early onset arteriosclerosis for everyone. Everything has its trade off. That is surely true of the relationship between digital technology and the fine arts.

APPLIED NEOTERICS AND QUONDOM CONTENT

In the fields of art and art history technophiles are few. And, given that the mediocre of any group always outnumber the gifted, it is foregone that the number of talented people interested in using electronic media is going to be small indeed. That surely goes a long way in accounting for the general dreariness of so many multimedia events. Early performance pieces by pioneer Nam June Paik have the aesthetic appeal of the average high school science fair exhibit. A step or two above his rather clunky combinations of TV sets and human beings are the LED (light-emitting diode) signs devised by Jenny Holzer; her glowing letters race through rooms and down staircases spelling out aphorisms of the kind one might see on bumper stickers at a university campus (MONEY CREATES TASTE and A SENSE OF TIMING IS THE MARK OF GENIUS), witty declarations with enough bite to titillate but not enough to wound the moneyed sponsors of institutions like the Guggenheim Museum. Holzer's spectacles are critiques of the culture from the perspective of a rational, involved, middle-class feminist. They are meant to provoke thought rather than make one's feelings boil. Not so the monstrous pageants of Oleg Kulik.

Kulik is a Russian artist who affects the behavior of a man deranged by the collapse of the Soviet Union and the crumbling away of its successor. *Deep Into Russia* (1997) is a display which looks at first to be a sculpture of three Holsteins with very full udders and open rectums, their heads and forequarters hidden by a black curtain. The anal orifices are viewholes for a video of the nude Oleg Kulik howling, drinking water, eating grass, and taking the female role in a sexual encounter with a huge shaggy dog. Bestiality is a special venue for Kulik, it seems; the Venice Biennale had photographs of him having sex with a number of animals, including a horse and a rabbit. For the most part, however, his performances are impersonations of a dog. At an exhibition in Stockholm he was arrested for actually biting a number of gallery goers, most famously an art critic. In some respects his search for notoriety is reminiscent of

Salvador Dali's paranoiacal manifestations; Dali's craziness also grabbed space in the newspapers and led to celebration by the media and fascination on the part of the public. A bit of correctness—of the political variety at least—entered into Kulik's work when he subjected himself to laboratory experiments whilst pretending to be Pavlov's dog. For him *Deep Into Russia's* use of video is not essential to the message, such as it is, but is merely a way of augmenting and amplifying it.

Japanese artist Mariko Mori has created an intriguing 3-D video installation called *Nirvana* that has been described by critic Marcia Vetrocq as seeming to "bridge the distances between the antiquity of the religious tradition, the naiveté of . . . kitsch imagery and the sophistication of the technology which delivers it all."[29] Certainly, this is what's attempted, and the conception is refreshingly artistic despite the necessity of viewing its result through special Polaroid spectacles. Ms. Vetrocq's review says the artist assumes the role of "Hiten, the kimono-clad flying angel of Buddhism," but this strikes me as an unlikely interpretation, for *Hiten* is one of the Japanese names for the celestial beings called *Apsaras* by Indian Buddhists. Usually represented as dancers or musicians in flight, they are the servants of the Devas (gods called *Tohoki* in Japan). It is true that they are sometimes represented as Bodhisattvas standing on lotus pads—as the principal figure is in *Nirvana*—but they are typically nude above the waist, whereas in the video the principal figure is fully clothed and crowned. She resembles, in fact, the feminine version of the first of the Bodhisattvas of Compassion, Yoryu Kannon. In the video Ms. Mori is surrounded by a transparent aureole and accompanied by five gnomelike beings playing instruments in similarly lucid ovoids, floating around her. Apart from looking like multicolored elves from the same galaxy as the aliens in *Close Encounters of the Third Kind*, the five have the expected attributes of the Hiten. To a Westerner, this cute, cartoonlike treatment seems almost sacrilegious, but Buddhism contains so many sects, all heavily influenced by adaptations to the cultures in which they have found themselves, and such a variety of deities, demons, transmutations, and beliefs that even lifelong devotees of the religion may not be able to interpret the iconography of images from another civilization or unfamiliar branch of Buddhism. Whatever the case, Mariko Mori's brief video is captivating because it uses electronic wizardry to convey something about an ancient belief in attainment of the absolute state of beatification that releases one from all desire for attainment and from the endless cycle of reincarnations. But, of course, it does this in ambitious three-dimensional imagery that is endlessly repeated at the Venice Biennale, attracting crowds whose interest is evoked and held not by the sacrifice of desire but by the sensory titillations of Mori's anything but self-abnegating wit. And, yet, there is another implication to the wavering slipperiness of the three-dimensional illusion that brings the performer and her Hiten from rosy alabaster mist into the viewer's space, particularly if we think of her as a Bodhisattva. Though the term refers, in fact, to anyone on the approach to Awakening it usually refers to lofty

intermediaries between the Buddha as supreme deity (the Vairocana or Adi Buddha) and imperfectly transient beings like you and me. They have renounced being Buddha, through attainment of Nirvana, in order to help humanity attain salvation and, so, create for themselves "emanations" in which they can appear to people—everywhere at once if necessary. Granted, this exegesis may have nothing whatever to do with Mariko Mori's own thematic purposes, but it does make sense.

Women, perhaps because the field of multimedia hasn't the millennial burden of patriarchy that weighs down painting and sculpture, are rather prominent in applying new means to old topics. Sometimes, as in the case of Mori and Buddhist iconography, the result is puzzling at the same time it is amusing and provocative. In a kind of neither-nor realm exist undertakings like those of Marnie Weber in which nude women cavort with woodland denizens in send ups of fairy tales and children's books. Some of the nudes are *Playboy* type pin-ups, some cut from Japanese pornographic magazines specializing in sado-masochism and bondage, but they are placed in bucolic nature as if to rescue them from a sordid past. Quirky but cute.

Moving in an altogether different direction towards the achievement of something with a not completely different resonance is Valerie Jaudon whose abstractions fall into a category rather unimaginatively dubbed "Pattern and Decoration." Jaudon's paintings have a beauty and quality that transcends any merely decorative purpose. The best of them are clearly inspired by the elaborate interlacings of Celtic and Islamic manuscript paintings, but done on a large scale and having a brilliance and formal power all their own. Another innovator of similar authority and even more thrilling talent is postmodern constructionist, Judy Pfaff, who creates blazingly polychrome "environments" from all sorts of materials including woks, beach balls, lattices, and so forth, expertly ornamented with decorator perfect stripes and geometric patterns. Ms. Pfaff's earlier environments were like three-dimensional Jackson Pollocks, full of tangles of barbed wire, neon, and fibers. Gallery visitors could roam through these sites as if wandering through a spatial wonderland. Hers is the very kind of imagination that could bring into existence the kind of non-representational holographic works about which I fantasized in 1971.

POSTMODERNISM VERSUS NEO-MODERNISM IN CONTEMPORARY ARCHITECTURE

Thus far our small survey of cultural perturbations has focused almost exclusively upon the pictorial arts with passing mention given to literature and musical composition. Postmodernism, however, has affected the general public mostly through the most expensive of the arts, architecture. That huge buildings are not constructed without the support of the privileged segments of society who control the purse strings of the economy leads postmodern critics of the left to refer to these structures as examples of "Neo-Conservatism." They

particularly abhor the critical position taken by Charles Jenks in his book, *Post-Modernism*, that is, the notion that postmodernism is a revival of classical form within the kind of open-ended liberality associated with Romanticism.[30] Jenks recognizes that this revival is often associated with the kind of yearning for traditional cultural values and social norms—including older class distinctions—that Classicism itself stood for. He in fact makes reference to a literary avant-gardist who considered himself a classicist, T. S. Eliot, in whose critical essay *Sacred Wood* a claim for the priority of continuity over innovation in the arts was very forcefully argued.[31] My own view, as readers will already have guessed, I suppose, is that pigeonholing styles in this way is a modern phenomenon and there is really nothing that can be very meaningfully designated "Postmodern." If, however, we take Jenks' description as the proper one, James Stirling and Michael Wilford's *Neue Staatsgalerie* in Stuttgart and the works of Ricardo Bofill, Robert Venturi, Kohn Pederson Fox Associates, among many others, fall into a postmodern category. The most interesting buildings of recent decades, though, are more nearly in line with the modernist tradition that stands apart from International Style architecture of the kind practiced by Mies van der Rohe, Walter Gropius, and Marcel Breuer. Since the practitioners of the new approach to architecture seem less didactically pristine than their predecessors and also have inherited the Romantic fervor of Frank Lloyd Wright, I'm referring to them as Neo-Modernists, merely for the purpose of distinguishing them from postmodern designers like Johnson and Burgee, who ornament essentially International Style architecture with traditional motifs, and others who turn the auspices of earlier structures into the fundamental character of their own, technologically advanced buildings—as, for instance, Bofill has done.

The two best examples of what I have in mind when I speak of Neo-Modernism are both European art centers. The earliest of them is the *Centre National d'Art et de Culture Georges Pompidou* located in the Plateau Beaubourg just north of the Seine in Paris. The Italian and English architects, Renzo Piano and Richard Rogers, created a building so aggressively technological as to surpass mere modernism and, as well, go beyond most citizens' tolerance. The exoskeletal trusses supporting the place and the external ducts and pipes (Plate 18), revealed in blazing polychrome, caused locals to refer to the Center as "the refinery." But keeping the structure and functional entrails on the perimeter permitted a tremendous amount of unimpeded space within the seventeen thousand meters enclosed by the windows. Those windows are protected by roll-down metal shutters that drop automatically whenever the interior temperature rises from sunshine or fire. Should a fire occur, the shutters protect not only the exterior supports but also neighboring buildings. This unusual building contains the National Museum of Modern Art, a public library, The Center for Industrial Design, IRCAM (the Institute for Research and Coordination in Acoustics and Music), multipurpose halls (for music, drama, lectures, and film), a children's art studio, a poetry gallery, a reconstruction of

the sculpture studio of Constantine Brancusi, a sculpture maze by Jean Tinguely, and a bar and restaurant. The place is entered by means of a glass-enclosed escalator running up the side of the building; a ride on this device not only affords one a wonderful view of Paris—on a fair day you can see both the Eiffel Tower and Sacré Coeur on Montmartre from there with just a turn of the head—but enables visitors to go into the building on whatever level they wish. Of course, many people would have preferred a design by a postmodernist willing to imitate the facade of the nearby Louvre, something by Bofill, perhaps. As I said five years ago:

> Certainly, the Pompidou Center is presently in the same situation the Eiffel Tower once was; it is anathema to conservative taste. But it has turned out to be unexpectedly popular to visit and shows every likelihood of becoming an object of civic pride. Indeed, the structure has already inspired a more-or-less spontaneous renewal of the area around it. Decaying buildings have been refurbished, restored, and redecorated. There are now pedestrian walks and new shops abound. The street sellers of the city have been attracted to an area that was what Americans call "blighted." Today the atmosphere is festive and the Beaubourg neighborhoods are becoming increasingly prosperous.[32]

While it is the technological kin of modernist forebears like the geodesic domes of Buckminster Fuller and the latticework proposals of the youth group Archigram inspired by Fuller, the *Centre Pompidou* is distinctive in its rather humorous candor and its willingness to have fun with technical innovation.

American architect Frank Gehry is probably one of our century's most important and imaginative designers, but his buildings have impressed many critics as being huge sculptures put together in a haphazard, not to say irrational, manner. They do tend to look that way, it's true. But, as Paul Goldberger notes, Gehry's "genius, in part, has been to create buildings that seem to be arbitrary and irrational but in fact are deeply responsive to their surroundings and to the needs of their users."[33] Gehry himself is thoroughly rational in other, more down to earth respects. For instance, in the middle 1970s his conception of architecture was attacked by architect Leon Krier during a symposium in Florida. Subsequently, he modified his approach to groupings of buildings in light of the criticism and then recommended Krier to be director of the institute of Skidmore, Owings, and Merrill.[34] Such gracious deference to intellectual opposition is rare in the arts, and particularly so in a field where millions in commissions may be at stake. Some of Gehry's work has been characterized as postmodernist, but his new Guggenheim Museum Bilbao (GMB)—under construction as I write—is a fantastically original departure from prototypes. It is a monumental realization of the sort of construction that previously existed only in the domestic dwellings of the great antagonist of conventional form,

Bruce Goff, whose houses are truly unique in their silhouettes and extraordinary textures.

The mere fact that the GMB is located in the north of Spain, not more than twelve miles from Guernica, has caused considerable commentary, most of it focused on the separatist tendencies associated with the Basques whose culture is dominant in the region. But, as Goldberger notes in the article quoted above, this is not a case of political radicalism being translated into aesthetic extremity; on the contrary, the city of Bilbao positively reeks of bourgeois complacency. What is going on here is a marriage of Basque cultural pride with civic "boosterism." The director of the Solomon R. Guggenheim Foundation, Thomas Krens, worked out an amazing deal with the city and the Basque regional government, giving the Guggenheim complete control of the project along with a budget of over a hundred million dollars for construction and related costs. With the selection of the Gehry design (over those of Ararta Isozaki and the Viennese firm Coop Himmelblau) the expenditure was surely justified.

Gehry's design owes something in the broadest sense to Frank Lloyd Wright's Solomon R. Guggenheim Museum in New York, one of the most self-eccentric expressions by any architect of the twentieth century. Here, too, the spiral is a dominant configuration, but Gehry has given his forms a sinuously organic flow in which the glistening skin of titanium plates takes on the character of three slab-sided serpents emerging from underneath the Puente de la Salve suspension bridge before winding into a towering coil along the banks of the river Nervión. Where Wright's museum is wholly dominated by the inverted cone of a circular ramp, the GMB substitutes for the rotunda a glass atrium 165 feet high. One of the problems with the Wright design has always been the confined viewing space; gallery goers must observe a painting within the distance between the work and the parapet or, alternatively, from across the gulf separating one side of the spiral from the other. It's like being forced to look at everything in close-up or through the wrong end of a telescope. Too, the place has always given me apprehensive feelings of vertiginous discomfiture, feelings that are by no means mollified by the shabby detail work typical of every Wright construction I have ever seen. With respect to the latter point, Gehry's building stands somewhere between Wright and the supreme master of the exquisitely fabricated edifice, Mies van der Rohe.

The GMB, which is about twice the size of the Pompidou Center, contains the world's largest art gallery—it is four hundred and fifty feet long and eighty wide, with overarching roof trusses reminiscent of an inverted ship's hull—one of nineteen rooms which will show things from the vast Guggenheim collection for which there is no adequate space in New York. Ten of these rooms are conventional boxes, the other nine billow, curve, and soar like the building itself. Some works were commissioned just for this building; one called *Snake* consists of three rusty steel panels twenty-four feet tall and just over one hundred feet long in the shape of compressed esses set up in parallel about six feet apart. It is a work absolutely concinnuous with the museum and is also the

one sculpture by Richard Serra I can say I actually like. Another huge sculpture now residing here is Claes Oldenburg's *Knife Ship*, a vessel in the form of a Swiss Army knife. This is a building designed by an architect who likes and understands art and artists. Wright's Guggenheim barely tolerates the existence of forms that are not architectonic in the old fashioned sense of *Jugendstil* wall plaques.

Another respect in which Gehry's Bilbao masterpiece both resembles and differs from the work of his famous predecessor is with regard to its setting. Wright's great pieces of domestic architecture—The Kaufmann House ("Falling Water") in Bear Run, Pennsylvania and Taliesen East in Wisconsin, for instance—are so wedded to the site that it is hard to tell where nature leaves off and dwelling begins, or to figure out just where the entrances might be. His institutional buildings, by contrast, defy their surroundings. The Guggenheim has nothing whatever to do with its surroundings; it is so drastically different from the buildings around it that you could not really describe the relationship with a word as conciliatory as "contrasting." The GMB is married to a background of buildings, bridge ramps and highways as completely as "Falling Water" is to the stream site it spans. Although a striking departure from conventional building designs, its forms reflect the curves and architectural masses that surround it in somewhat the way organisms reflect their habitats. Gehry's is truly a new kind of modernism. In fact, it has the effect of lending to its contents a new relevance for the future, which is surely one of the purposes of a museum in today's world.

CONCLUSION

"Bricklayers and architects." That's how a late colleague of mine characterized professional historians, while placing himself in the former category. A medievalist, Harry's specialty had been the Abbey of Cluny and his principal contributions the intellectual reconstruction of buildings that had long since turned to dust. It was Harry's view that he and his fellow scholars were placing factual units into a structure called the history of art under the supervision of a sort of master mason in the person of Harvard scholar Kenneth Conant. But that situation was rather special; normally, art historical studies are undertaken as individual enterprises whose possible relation to some regnant pattern of thought goes completely unrecognized. Which is precisely why my friend's way of looking at it seemed to me to have a good deal of merit. It took into account an obvious fact that more resounding philosophies ignore, namely, the uneasy relation between scholarly discovery and historical comprehension.

Anyone who has thought about this even a little must recognize that a chronicle of events may be entirely true, yet any explanation of those events—their "history" as most of us construe it—is bound to incline towards whatever biases weigh most heavily in the attitudes of those who are measuring out the accounts. When intellectual workers are engaged in seeking out authenticities of authorship and witness or truths of time and place, they are just as unlikely as bricklayers to be concerned with the ultimate character of the design to which their efforts make a contribution. More often than not, they are not even aware of the preordained nature of the designs they are busy fulfilling.

The problem with the metaphor is that it seems to impute to those engaged in customary research activities a standing within the profession that is inferior to those who theorize about historiography, whereas the opposite is much more likely to be the case; practicing iconographers and connoisseurs are usually more highly regarded than are theorists and, in fact, are also more learned. But the matter is ideological, really, and not professional. That is to say, every scholarly undertaking, no matter how apparently impartial and regardless of the

178

austerity of its methodology, is ultimately expressive of a certain ethic and aesthetic. That, of course, is central to deconstructionist analyses of the past. Consider Mark Roskill's readable and thorough little text of 1976, *What Is Art History?* This book defines art history ostensively, by presenting several well-described investigations of specific problems in the areas of attribution, iconography, stylistic analysis, and interpretation of meaning and purposes. Its whole character was, according to the editors of 1988's *The New Art History*, traditional and "untroubled."[1] This is, I think, unfair to Professor Roskill, but it is certainly true that he took for granted certain values that a number of so-called "new" art historians would surely describe as part of the general mystification of art associated with mainstream thought. Among these things would be the idea that the concept of intellectual property is an admirable achievement of Western civilization. Whether these new art historians were right to say Roskill's is as conservative a statement as Sir Kenneth Clark's *Civilization* is doubtful, however. For, where the tone of Lord Clark's book is highly elitist and pontifical, Roskill's is a liberal exposition of various approaches to the discipline of art history. On the other hand, Roskill's book does focus on matters the editors of *The New Art History* seem to consider the tiresome baggage of a materialistic age—with "style, attributions, dating, authenticity, rarity, reconstruction, the detection of forgery, the rediscovery of forgotten artists and the meanings of pictures." Indeed, they end up characterizing *What Is Art History?* in a way both cavalier and quite unjust. "In its serene self confidence, the book stands out like a beacon illuminating the last days of art history's innocence."[2] Roskill, in the Introduction to the second edition of *What Is Art History?* (1989) says that a more descriptive title would have been *Art History as a Discipline: Some Classic Cases* and also effectively contends against the idea that his approach was anything like so complacent as *The New Art History* editors, Rees and Borzello, make it seem.[3]

I have earlier commented at some length on the peculiar biases of poststructuralism. Still, I am cordially disposed to the feeling that conventional art history slights social circumstance, overrates genius, and virtually obliterates the contributions of a whole range of minorities. The new art history, however, tends to exaggerate class and racial interest, underrates knowledge and talent, and has a powerful tendency to inflate the value of mediocrities who happen to have been female or of color. It is also inclined to attribute far more significance to sexual preference than is seemly. To apply Harry Hilberry's metaphor in this situation, all too often one has the impression that architects with limited masonry skills are building faulty walls to suit a whim of iron.

The book you are reading does not lay much brick and is certainly no masterplan. Rather, it is analogous to a cartographer's impression of an ancient watercourse that has been left alone in some places, dredged in others, dammed up here and there, linked by canals and siphoned off into pools at various points along the way. It is a chart that is surely corrigible and may contain distortions like those conventional in topographic relief maps, but it is no more wanting in

these regards than other surveys of its type. From the late Gothic period of Giotto de Bondone we have observed the mainstream of art flow through channels structured according to a fundamentally mathematical conception of order that made optical coherence the equivalent of spiritual propriety. So commanding has been this hierarchy of relationships established during the Renaissance that every image and everything said about images from then until now has felt its influence. Without Giotto's vision, or its equivalent, there could have been no Brunelleschi nor a Vermeer, and neither French Impressionism nor the Theory of Pure Visibility would have arisen.

The conception of fine art as a visual galaxy of various small islands of order has, of course, been consciously resisted by those who abhor things with which this notion of Art has been associated, that is, rationalism, materialism, even patriarchy in disguise.[4] Nonetheless, the image of the world as a given space coordinated by Cartesian axes has held fast, even when confronted by technologies that do not derive from its conventions. Moreover, when great artists have departed from those conventions the effect has been to reinforce the fundamental principles underpinning the superstructure; thus Cézanne and the Cubists disregarded central projection and, in doing so, lent new authority to the constructive role of continuities and discontinuities in painting. Kandinsky's lyrical deviations from convention retained the color harmonics and spatial cohesion of Baroque painting's grand manner. When the nihilistic Dadaists strove to destroy traditions that seemed to them already moribund, it turned out that the weight of modern civilization had so fixed the gaze of educated men and women in its measured regimen that nearly anything could be set aside, distinguished, and treated as an aesthetic expression of creative will—even when it was merely a bottle rack or urinal exhibited as a joke. The Abstract Expressionists, during the 1950s, questioned the very meaning of meaningfulness in art and came up with a "solution" similar to the Existentialists', that is, the sum of the actions gave the works a self-defined purpose. In a sense, this was not really very different in principle from what Cézanne and van Gogh had done. And this approach, too, was unable to overcome the tenacity of a formalist aesthetic that is more firmly yoked to the traditions of rationalism than to any form of modernism. Later, postmodernists who wished to demolish the distinctive category "Art" as such, either failed to gain a hearing from anybody beyond their limited pale or ended up having the detritus of their performances and protests collected as artistic memorabilia. The audience itself thereby imposed upon what were supposed to be anti-aesthetic, non-commercial events the status of mercenary dramas.

Normally, we fear above all the dissolution of order and the collapse of things into chaos. Thus, the appeal of art like Cézanne's, or Cubism, or Abstract Expressionism which risks disorder by overthrowing the reliable while winning some new stability from out of itself. These achievements surpassed the attainment of mere novelty to such a degree that their devotees felt there must be some cosmic significance beyond artistry at work within them. From such convictions arise preposterous theories to account for what the artists were doing—

a few of which I have dealt with here and there throughout this book. One of those was, of course, Metzinger's celebration of Cubism as the assassin of "the prejudice that commanded the painter to remain motionless in front of the object."[5]

Ironically, the "prejudice" Metzinger spoke of—traditional perspective—is making its way back into common currency more strongly than ever because it has become comparatively easy to do. People who know nothing at all about the fundamentals of central projection can produce accurate delineations through application of computer programs, some of which are now so user friendly that little more than patience is required to master them. The situation is very like that of doing arithmetic on a calculator. Who among us still does long division by applying the algorithms taught in the lower grades? Do you put a sharpened pencil to paper when you figure percentages or square roots? Probably not. Most of us just enter the numbers on a keypad and punch the command symbol. With perspective drawing the same thing is true. Full understanding is not required. Results are all that is expected. This means artists tapping commands on a keyboard and clicking mouse buttons are even more a prisoner of an impersonal system than *beaux arts* students were during the nineteenth century.[6] But one is less apt to feel the geometry is despotic when it's as helpful as a genie.

The perseverance of traditional perspective is the most astonishing thing about it, a claim not intended to deny that modernists have successfully challenged the schematic discipline of scientific perspective or other academic conventions. Obviously, the preordained, systematic nature of academic prescription was at odds with the dynamics of an industrial age in which old hierarchies of every kind were being called into question. Who would not come to prefer the unregulated, spontaneous projection of a creative spirit over the diagrammatic renderings of "left-brained" drawing masters? Still, despite the success of modernist and postmodernist styles among the intelligentsia, most pictures produced for consumption in industrialized nations, East or West, are overwhelmingly structured according to the traditional paradigm that has dominated European vision since the Quattrocento. Perhaps that is because every culture touched by capitalism's fruits tends towards individualism, and central projection, which entails the presumption of a given space possessed by the viewer, is inherently individualistic. Photography, cinema, Renaissance and Baroque realism, Impressionism, and so on, all afford onlookers the same self-centered perception of the external world. The viewpoint is egocentric but the contents are not, for distinctly personal styles actually intensify the privileged status of a viewer by enhancing her or his probably unimaginative concept of nature. Expressionism merely exaggerates that effect by delineating the subjective worldview of the artist more explicitly and with greater insistence. Scientific perspective, formalist thought, and the exposure of the unconscious are adjuncts of the social and political individuation of humanity that has accelerated with every major economic convulsion of the last six hundred years.

Contemporary art is individualism personified and attenuated. It is the frail end of what first flowered as robust aplomb during the Italian Renaissance and then rooted itself in the stoical ethic of sixteenth-century Protestantism to bring forth bitterly nourishing fruit during the Enlightenment. It is not surprising that themes of alienation, estrangement and loneliness pervade the art of Western nations and are beginning to hold sway over contemporary Asian art as well. The atomization of populations that have been progressively urbanized during half of our millennium have made what is called "alienation" an irrefragable component of modern civilization. The old ways are doomed and there is nothing to replace them. Reactionaries see more clearly than conservatives or liberals that class distinctions endemic to free market economies can neither serve justice nor ameliorate the breakdown of traditional authority. Thus, the religiously orthodox of all sects attempt to repress individual freedom on the perfectly correct assumption that it is inimical to such traditional bulwarks of social stability as the church and family. And when these medieval-minded demagogues proclaim that democratic individualism encourages social fragmentation they are absolutely right. This does not, however, mean their way will prevail. Most of us would prefer a lonely life in Gomorrah to the "salvation" promised by a host of zealots who are capable of believing a thousand impossible things before lunch.

Despite my dim view of the pious who follow medieval forms of worship, it does seems that people will forever seek to belong to some greater whole. Even when religion is put aside, longing for connection with some higher unity is a prominent feature of human existence and, when such yearnings are entirely secular, they often threaten liberty with reverence for the nationalistic state, putting the security of every person in way of hazard. It seems less and less likely that political solutions to either the longing or the risks will ever be found. There are among us, however, those who believe the arts themselves have the power to move masses in the way religious belief does.

As we have noted, some have conceived of Nazism as a sort of expressionistic art form carried out by other means. Soviet Constructivists and Suprematists identified the clarity of their vision with the collective ideals of urbanization, industrial progress, "futuromachinology," and the "flame of the desire to live." In our recent past the structuralists, poststructuralists, and deconstructionists have been more or less accurate in describing the way art works signify social biases in much the way political slogans might. Postmodernist art, however, has been ineffective in its attempts to repudiate modernism's elitism. Departures from the modernist motifs and methods deferred to by art schools and the press have resulted in a postmodernism reminiscent of the Victorian Age, which doted on syncretic conflations of style. The analyses of the deconstructionists fulfilled already the destinies of their disciples. The art we have is, just as they argue, the art of the culture that contains it. And departures from it serve only to express it more fully. Some years ago, in another connection, I remarked on the way his-

toric dependencies may well be prologue to a future that was not determined by them.

> There is not so much as a whisper of doubt in my mind that the kind of enculturation [E. D. Hirsch, Jr.] and myself would like to achieve in the schools and college education is in service of an essentially hierarchical, capitalist, and elitist social system. Karl Mannheim was right about that during the 1930s, George Counts in the forties, Paul Goodman in the fifties, Ivan Illich in the seventies, and Jacques Derrida had it pegged again more recently. I have news for their supporters; they lost! The system won, and it will continue to win so long as scientific technology and the resulting political economy prevail. It seems evident to me that the system itself is not necessarily racist, sexist, or even inhumane. In fact, it isn't even capitalistic—at least not in the strict sense. But it demands for its dynamic a culturally literate group to operate it in a decently just and responsible way.[7]

I cannot foresee the direction art will take any better than I can foretell the future of government. The new technology does seem less dependent upon class-bound privilege than were media that necessarily produced a few precious hand-made objects. Certainly, easel paintings could become as archaic as hand-lettered manuscripts of the Gospels.

Perhaps all pictorial imagery will be replaced by digital displays, holograms, and virtual scenery full of virtual people. There are those who conceive of the accessibility of alternative realities as positively utopian and others, of course, who are alarmed by the possibilities of dystopian surveillance and the crushing weight of popular taste. The latter can point to the unexpected consequences of previous inventions. Just think of the environmental damage and social dislocations resulting from Henry Ford's affordable mode of personal transportation. And think then, too, of how much the Model T gave back: paved roads and streets that weren't fouled by manure. The odor of carbon monoxide dissipated more swiftly than that of ordure and, seeming more sanitary, seemed safer, too. Who could have foreseen the ultimate effects? Some besides wheelwrights and stablemen did, of course. But hindsight has not made the naysayers look wise to most of us today; despite all that we know and have experienced nearly all of us want our own car and the illusion of freedom it brings.

Illusion is seductive. It can make what's pretty grim seem tolerable; it can comfort us in adversity and distract us from pain; it can, in fact, inspire us to contemplate higher realities and strive for lofty goals. That it may also shackle the spirit and, as Plato knew, lead us to the habit of taking what is patent falsehood for the truth is simply the obverse side of raw fact. Spectatorial detachment from reality was a metaphor for Plato; for us it is one of the defining aspects of existence—an ultimate form of estrangement. Our contemporary ability to send messages to antipodes in moments and observe with near instantaneity events unfolding in places thousands of miles distant is frequently cited as evi-

dence of the growing intimacy of the electronic neighborhood. There is something to the idea. But, conversely, as we watch things on a glowing screen, we assume the role of the uninvolved onlooker. This was most obvious during the Gulf War, when the U.S. military filtered down to television news outlets infrared images of its overwhelmingly powerful air forces smashing Iraq's fortifications. As Michael Ignatieff has written: "Unmanned attack vehicles, self-targeting missile systems, pilotless aircraft—we seem to be in search of a form of warfare which will cost us nothing but money, and which will break, once and all, the link between warfare and human sacrifice."[8] He feels that the aloofness of what Chris Hables Gray calls "postmodern war"[9] is associated with reluctance to go to war for any reason whatsoever and, moreover, that our reluctance is too deep to be fully accounted for by the debacle of Vietnam. He closes his review with a provocative remark: "It may be we are losing our capacity to do good in the world because we are no longer willing to risk the moral danger of doing evil."[10] If this is so—if sheer formalization of thought has made the West effete—then our civilization has gone beyond the sea of alienation to the edge of the abyss. Yet, dismay over such a possibility is probably as misplaced as was confidence in the righteousness of the American Way. Besides, so far as technology is concerned, there is more to be optimistic about than not.

The impress of the machine upon human consciousness and the arts may trouble those whose main industry is pondering the ineffable, but all of us should bear in mind that for one group the effects have been almost entirely benign. Women have benefited hugely from the existence of these devices. Throughout the history of humanity drudgery has been the daily lot of all who had no slaves or serfs, but women were generally consigned to the most tedious labor while being held hostage by their homesteads. From this situation Western women, at least, have been freed by slaves in the form of appliances, slaves that are not only indefatigable but also more docile and efficient than the most loyal helot. Freedom of time and movement afforded womankind by electronic gadgetry and cars has provided them with opportunities no greater than those open to men, but new to their gender. Unsurprisingly, the proportion of artists who are women has blossomed in proportion to the number of working women and that number expanded in relation to technological progress. The transformation in human relations has been so profound, indeed, that were all the machinery to vanish there would be no going back to earlier inequalities. The destinies of Western men and women have been set apart, perhaps, but they now tread parallel paths into the future and are likely to do for the remainder of our history.

Just now, from our tiny ledge on the brink of the millennium, the unknown stretched out before us is made of events sunk into eternity's long night. And, as we go to meet them, we shall be best off to understand that, while we should strive always to accomplish the desirable, we will realize no more than what is feasible. Art, if it is to fulfill its social function must accept the world as changeable and help to change it. In point of fact, much of contemporary art does precisely that, no matter the names we give its various manifestations—modernism,

postmodernism, neo-modernism. The very existence of these "isms" reveals the possibility of change in terms of personal, individual exertion, and adaptation and shows the possibilities of reconciling the common and the divergent, liberty and order, the individual and the society.

NOTES

INTRODUCTION

1. See Jacques Lacan, *Écrits: A Selection*, trans. Alan Sheridan (New York: W. W. Norton & Co., 1977), pp. 5-6. A biography of Lacan has just appeared in an English translation I have skimmed but not yet given my full attention. It does, however, seem to contain a balanced assessment of the psychoanalyst's work, acknowledging, as a review by Perry Meisel, says, "Lacan's personal absurdity and literary extravagance while simultaneously showing why and how he matters" (*New York Times Book Review*, April 13, 1997). See Elizabeth Roudinesco, *Jacques Lacan*, trans. Barbara Bray (New York: Columbia University Press, 1997) 574 pp.

2. In Marxist terminology, for those unfamiliar with this now unfashionable social philosophy, "ideology" does not refer to theory but to the system of interlaced truths and delusions that, according to this exegesis, grows like coral on the decaying base of our economic system. The casual certainty with which people who should know better write off all things related to Marxism as having been swept into the dustbins of history by the collapse of the Soviet Union is mind-boggling. Apart from being rather like assuming the rise of Napoleon proved the emptiness of ideas that underpinned the American Revolution, it also takes for granted the irrelevance of Marxian social theory for the present. Certainly, Marx's ideas about economics appear to have been refuted, but the same cannot be said of his ideas about class structure and personal interaction in general. If anything, they seem particularly pertinent at the end of the millennium.

3. Thomas Wolfe, *Look Homeward Angel* (New York: Charles Scribner's Sons, 1929), unpaged prefatory note.

4. *Newsweek*, CXXIX, 16 (April 21, 1997), p. 16

5. It is not surprising that one of the more prominent jokes to be found on the internet is this riddle:
 Q: "What do you get when you cross a mafioso with a deconstructionist?"
 A: "An offer you can't understand!"

CHAPTER 1
Pure Visibility and the Emergence of Formalism

1. Henri Matisse, *Notes of a Painter* (1908), trans. Jack D. Flam, in Jack D. Flam, *Matisse on Art* (London: Phaidon, 1973), p. 38.

2. Roger Fry's *Transformations*, published nearly two decades after Matisse's essay, is discussed later on in the book in hand, in chapter 2, pp. 39-40.

3. John Adkins Richardson, *Modern Art and Scientific Thought* (Urbana, University of Illinois Press, 1971), pp. 102-3.

4. You will not find this tale in the Gospels as it is given here. In Luke the parents are called Zachary and Elizabeth and their tribulations scarcely noted. Giotto probably based his mural either on the *Prologue* of St. Jerome (c. 340-420) or, more likely, upon the retelling of it in *The Golden Legend* by Jacobus de Voragine (1230-98), a principal literary source for ecclesiastical imagery from the fourteenth through nineteenth centuries.

5. E.H. Gombrich, *Art and Illusion: A Study in the Psychology of Pictorial Representation* (Washington, D.C.: Pantheon Books, 1956). Gombrich includes an interesting anecdote relevant to the relation between anticipation and understanding on page 204 of this book. During World War II he was employed for six years by the BBC to monitor radio transmissions from friend and foe, some of which were barely audible. "It was then we learned to what an extent our knowledge and expectations influence our hearing. You had to know what might be said in order to know what was said." As he notes, this kind of recognition was to become an important component of "information theory," not to mention a fundamental of his own researches in the psychology of pictorial representation.

6. This, again, is drawn from *The Golden Legend*. The St. Paul whose halo merges with that of St. Anthony here is not, of course, the author of the Epistles; he is, like Anthony, an early Coptic hermit. Anthony set out to find one whose sanctity was rumored to be greater than his own. Along the way he meets a pagan centaur, who holds a palm branch and beats his breast in a show of penitence. Anthony blesses him, in what amounts to an act of conversion to Christianity. As Jacobas de Voragine has it, the two old men meet, are fed bread by a crow the Lord sends daily to sustain Paul. Anthony was returning to his cell from the miraculous luncheon with his colleague in piety when "he saw two angels passing overhead, bearing the soul of St. Paul." Anthony returns to the cave where two lions come forth to dig a grave and bury Paul, and Anthony retrieves the dead saint's mantle to wear on high feast days.

7. John Walker, *The National Gallery of Art, Washington* (New York: Harry N. Abrams, 1975), p. 78.

8. Elsewhere, I have dealt with a number of the advances towards Renaissance realism Giotto achieves in this Madonna in contrast to the by no means timid work by his teacher, Cimabue. See John Adkins Richardson, *Art: The Way It Is* (New York: Harry N. Abrams, Inc., 1992), pp. 44-45, 152-53, 198-99.

9. It should be noted, however, that the principle of one-point perspective seems definitely to have been known to the Romans, though extant examples of its application are rare. The most impressive instances are in The House of Masks, from the time of Augustus, where otherwise uninspired wall paintings by journeyman decorators appear to have been devised according to a procedure akin to that described by Alberti (q.v.) fourteen centuries later. But, the viewing angle for these decorations is a generic dead center. Giotto's chosen viewpoint strikes a curiously touching note of human individualism. And, of course, perspective was not reinvented until the 1420s, nearly a century after Giotto's death.

10. Even so, what are we to make of holograms on cylinders of film that project utterly convincing images of three dimensional solids rotating in space? This kind of illusion is so palpably convincing as to surpass mirror imagery—and who wishes, seriously, to contend that the reflection of a face on a still pool is merely conventional?

11. See Jean-Marie Chauvet, Eliette Brunel Deschamps, and Christian Hillaire, *Dawn of Art: The Chauvet Cave, The Oldest Known Paintings in the World* (New York: Harry N. Abrams, 1996) and Jean Clottes and Jean Courtin, *The Cave Beneath the Sea: Paleolithic Images at Cosquer* (New York: Harry N. Abrams, 1996).

12. Leon Battista Alberti, *Ten Books on Architecture*, trans. James Leoni, ed. J. Rykwert (New York: Transatlantic, 1955), p. 113.

13. Jan Bialostocki, "The Renaissance Concept of Nature and Antiquity," *Studies in Western Art: The Renaissance and Mannerism.* Vol. II of Acts of the Twentieth International Congress of the History of Art. (Princeton: Princeton University Press, 1963), pp. 25-26.

14. See, for example, Joseph Kosuth, "Art After Philosophy, I and II," *Idea Art*, ed. Gregory Battcock (New York: E. P. Dutton & Co., 1973), pp. 70-101. Kosuth is a conceptualist with formal training in philosophy. In these essays he attempts to divorce art from aesthetics and, most specifically, from any kind of usefulness, "as entertainment, visual (or other) experience, or decoration—which is something easily replaced by kitsch culture or technology. . . ."

15. Of these people, Etienne Jean Delécluze is perhaps the most interesting in terms of the history of modern art and criticism. A product of David's studio, he wrote a book on the master (*Louis David, son école et son temps*, Paris, 1855) and published critiques of the Salons in 1819 and from 1823 through 1863. He was adamantly opposed to every manifestation of novelty in the fine arts. His was a purely negative force and, yet, he was extraordinarily acute in his defense of classical form and its emotional needs and was really quite farsighted in predicting the consequences for painting and sculpture if the directions taken by Delacroix and Courbet should prevail. Were he to visit the Musee D'Orsay or the Pompidou Center today, I am sure he would proclaim the exhibits housed there proof positive of the soundness of his judgments.

16. Lionello Venturi, *History of Art Criticism*, trans. Charles Marriott (New York: E. P. Dutton & Co., 1936, 1964), p. 191.

17. Ibid., pp. 272-73.

18. I have elsewhere dealt with the possible social origins and characteristics of both formalist and subjectivist trends during the period, most particularly in *Modern Art and Scientific Thought*, pp. 26-117.

19. Morelli's book, containing numerous drawings of "subordinate features" as rendered by various Renaissance artists, was translated into English two years after the author's death. See Giovanni Morelli, *Italian Painters: Critical Studies of Their Works*, trans. C. J. Ffoulkes (London: 1892). The quoted material here is from Edgar Wind, *Art and Anarchy* (New York: Vintage Books, 1963), p. 40. Morelli published under a pseudonym: Ivan Lermolieff-Schwarze.

20. Venturi, p. 274.

21. Ibid., pp.170-75.

22. Heinrich Wölfflin, *Principles of Art History: The Problem of the Development of Style in Later Art*, trans. M. D. Hottinger (New York: Dover Books, 1963).

23. Ibid., p. 90.

24. Meyer Schapiro, "Style," *Anthropology Today*, ed. Sol Tax (Chicago: University of Chicago Press, 1962), p. 290.

25. See Ferdinand de Saussare, *Course in General Linguistics*, trans. William Baskin (New York: Philosophical Library, 1959).

26. What nonsense, to suppose the "exchange" of words is somehow comparable to the proprietary treatment of women. This is an example of the kind of thing French intellectuals seem to "get away with" as the rest of us cannot. I was stunned in 1961 when I read Simone de Beauvoir's celebrated *The Second Sex* where she casually makes judgments of this sort: "If the vital energy is expended in voluntary activities, such as sports, it is not turned into sexual channels: Scandinavian women are healthy, strong, and cold. Ardent women are those who combine langour with fire, like those of Italy and Spain . . ." Though the book, overall, is very impressive, many passages are, like this one, both stereotypical and absurd. Incidentally, Part II of *The Second Sex* is heavily indebted to Lévi-Strauss, as the author acknowledges in a footnote on page xvii of the Bantam paperback edition.

27. The article by Shankman is "*Le Rôti et le Bouilli*: Lévi-Strauss' Theory of Cannibalism," *American Anthropologist*, No. 71 (1969), pp. 54-69. It came to my attention in a sharp analysis of the Lévi-Strauss book by Marvin Harris in his *Cultural Materialism: The Struggle for a Science of Culture* (New York: Random House, 1979), pp. 188-99. Harris has given this section a heading I wish I had thought of: "The Raw, the Cooked, and the Half-Baked."

28. Jacques Derrida, *Positions*, trans. Alan Bass (Chicago: University of Chicago Press, 1981), p. 26. With reference to how this is supposed to work, may I note running across a partial translation of a piece in which Derrida takes on Meyer Schapiro and Martin Heidegger in their little debate about the ownership of a pair of shoes in a painting by Vincent van Gogh. Derrida came in fourth. He treats the shoes as a *gram*, pretending this removes them from the question at hand. Clearly, people as intelligent as Heidegger and Schapiro fully understand that a painting is something apart from the things represented. Derrida, who is struck by the fact that the boots are unlaced goes on and *on* about it, for they have become a metaphor for the complex interrelationship of grams in art work. "Like a lace each 'thing,' each mode of being a thing, passes inside then outside the other." He is insistent on driving home the point that these are not shoes, not even a sign of shoes. It is tiresome but uncontestable. However, he *then* suggests that the two shoes may not be a pair, since they seem to be two lefts. The original argument was about whether the shoes that served as model belonged to van Gogh or to a cleaning woman (as Heidegger thought). I cannot imagine why anyone would bother with the issue in fact. For all I care, Vincent made them up. But whether he did or not *is* a question of fact, is it not? Ah! A deconstructionist would respond that it is not so simple; the very assignment of a signifier indicating what's signified is a pair of shoes that once had a physical existence and a role as private property is fraught with contention. Perhaps. But in that case, why bother raising the issue of lefts and right? Gallic irony? *Sure*. See Derrida, "Restitutions of Truth to Size," tr. John P. Leavey, Jr., *Research in Phenomenology*, Number 8 (1978), p. 32.

29. Jacques Derrida, "The Law of Genre," *Glyph*, No.7 (1980), p. 206.

30. See, for example: Michel Foucault, *Ceci n'est pas une pipe; deux lettres et quatre dessins de Rene Magritte* (Montpellier: Fata Morgana, 1973), passim.

31. It should be noted that Derrida, though identified with the radical left, only recently had anything specific to say about Marxism itself. In *Spectres de Marx* (Paris: Galileé, 1993) he addresses the matter by analyzing four instances in Karl Marx's writings where ghosts are in the forefront of the discourse. See the review essay by George Salemohamed, "Derrida and the Marxian Promise," *Economy and Society*, Vol. 24, No. 3 (August 1995) pp. 471-82. The reviewer characterizes Derrida's attitude as "indebted to the spirit of Marx," since he also calls for the creation of an International. "But this will not be an International based, as the previous one, on parties or unions, but one which repudiates all forms of organization, including nations and states" (p. 479). Pretty spectral, this social program.

32. Hal Foster, "Preface," *The Anti-Aesthetic: Essays on Postmodern Culture*, ed. Hal Foster (Port Townsend, Washington: Bay Press, 1983), p. xii.

33. Ralph A. Smith, *The Sense of Art* (New York, London: Routledge, 1989), pp. 171-72.

34. Ibid., p. 177.

35. Ibid., p. 177.

36. Fritz Stern, "Introduction," *The Varieties of History*, ed. Fritz Stern (Cleveland, New York: World Publishing Co., 1956), p. 26.

37. See John Adkins Richardson, "Dethroning the Dead: Colorless Canons, Darkening Doubts," *The Journal of Aesthetic Education,* Vol. 28, No. 4 (Winter, 1994), pp. 15-30.

38. Mary Levkowitz, *Not Out of Africa: How Afrocentrism Became an Excuse to Teach Myth as History* (New York: Basic Books, 1996), pp. 48-49.

39. Ibid., p.51.

40. Arnold Hauser, *The Social History of Art*, Vol. 1 (New York: Alfred A. Knopf, 1951), p. 462.

41. See, for example, Robert S. Lubar, "Unmasking Pablo's Gertrude: Queer Desire and the Subject of Portraiture," *The Art Bulletin,* Vol. LXXIX, No. 1 (March 1997), pp. 57-84. This article is extremely thorough in its way, delving into many connections between Picasso's self-portraiture and portraits of others as well as sketches revealing his sexual fancies—all rather commonly heterosexual, it seemed to me—to show the artist was intimidated by Gertrude Stein's femininity, which "exceeded definitional boundaries." It is heavily influenced by the psychoanalytic theories of Jacques Lacan and, like much Queer Theory, the overriding presence of Michel Foucault.

42. Smith, 174.

43. I take some pride in having anticipated the direction all this was going to take over thirty years ago. See John Adkins Richardson, "Dada, Camp, and the Mode Called Pop," *The Journal of Aesthetics and Art Criticism,* Vol. 24, No. 4 (Summer, 1966), pp. 549-58.

CHAPTER 2
Estrangement and the Nature of Modernity

1. Marcel Proust, *Rememberance of Things Past,* trans. C. K. Scott Moncrieff and Terence Kilmartin (New York: Random House, 1981) Vol. III, p. 459. This passage is from the seventh book, *Albertine disparue,* which appeared in English originally as *The Sweet Cheat Gone* and is in this collection as *The Fugitive. La Fugitive* was Proust's own preference for a title, but was abandoned when Rabindranath Tagore published a book under that title in 1922.

2. Lucien Febvre, *Le Problème de l'incroyance au XVIIème siècle, la religion de Rabelais* (Paris, 1942), p. 172.

3. See, for example, H.H.Arnason, *History of Modern Art*, 3rd ed. (New York: Harry N. Abrams, 1986), p. 374.

4. One expects that certain of Hegel's terms will take on a comprehensiveness that, in less grandiose thinkers, would be considered outrageous. He did, however, draw a systematic distinction between *Entfremdung* (alienation) and *Entäusserung* (renunciation) which Marx adopted in a slightly different form, adding also the related concept of *Vergegenstandlichung* (reification). *Entfremdung* and *Selbstentfremdung* (self-estrangement) as used in Hegel's *Phänomenologie des Geistes* are close to the most common modern meaning of alienation, that is, an individual's estrangement from social reality or from the self. (I am indebted to philosopher Carol Keene for drawing my attention to the history of the term.)

5. The models have been identified, albeit somewhat insecurely, as (going clockwise from the nearest male): Manet's brother, Gustave, Victorine Meurend, Ferdinand Leenhoff, and the sister of the latter, Suzanne Leenhoff, the artist's wife-to-be.

6. Marcantonio Raimondi's engraving after Raphael's lost *Judgment of Paris* inspired Manet's composition, as a "pastoral concert" (then attributed to Giorgione) inspired the theme, and alert readers may argue that the engraving itself shows individuals separate and apart. But the nymph and her consorts are marginalia; the subject of the work itself is the larger drama of Paris' selection of the most beautiful goddess.

7. George Mauner in *Manet, Peintre-Philosophe: A Study of the Painter's Themes* (University Park: Pennsylvania State University Press, 1975), pp. 161-62, puts the same notion in positive terms, arguing that the mirror device is a way of conveying a philosophical point about the duality of human nature.

8. Lawrence Gowing, *Vermeer* (New York: Harper & Row, 1970), p. 26.

9. The study of the semiology of human spatial relationships has been aptly dubbed *proxemics* by Edward T. Hall. See Hall, *The Hidden Dimension* (Garden City, New York: Doubleday, 1966).

10. Arthur Schopenhauer, *The Art of Literature*, ed. and trans. T. Bailey Sauders (London, 1891), p. 135.

11. The Russell and Toulouse-Lautrec portraits of van Gogh bear a considerable resemblence to Kirk Douglas, the film actor who played the artist in the film version of Irving Stone's novel *Lust for Life*. A rare vindication of Hollywood casting and press releases.

12. Readers should not infer from this remark that the author believes Cézanne's art is dependent upon seeing "cones, spheres, and cylinders" in natural forms. Quite the contrary. See chapter 3, pp. 79-81, 83-85, and notes 9-16, 20.

13. See Richardson, *Modern Art and Scientific Thought*, pp. 57-76.

14. But the dates of Kirchner's pictures are quite insecure. Following a nervous breakdown he redated many, apparently in hope of seeming more advanced in style than he had been in fact.

15. See, for example, Katherine Kuh, *Break-Up: The Core of Modern Art* (New York: New York Graphic Society, 1965), p. 41.

16. José Ortega y Gasset, "On Point of View in the Arts," *The Dehumanization of Art* (Garden City, New York: Doubleday, 1956), pp. 119-20. The "extreme consequences" of the philosophical tendency he finds in Richard Avernarius, Ernst Mach, and Edmud Husserl.

17. Georges Braque, "Thoughts on Painting, 1917," reprinted in Edward Fry, *Cubism* (New York: McGraw Hill, 1966), p. 147.

18. Daniel Bell, *Cultural Contradictions of Capitalism* (New York: Basic Books, 1976), pp. 53 ff.

19. For an enlightening discussion of the identification of Daumier and others with the *saltimbanque* as a political figure, see T. J. Clark, *The Absolute Bourgeois: Artists and Politics in France 1848-1851* (New York and London: New York Graphic Society, 1973), pp. 119-20.

20. Charles Baudelaire, *Le Spleen de Paris* (Paris, 1943), pp. 52-53. ". . . *Voûté, caduc, décrépit, une ruine d'homme, adossé contre un des poteaus de sa cahute; une cahute plus misérable que celle du sauvage les plus abruti.*"

21. Baudelaire, pp. 54-55. "*Et, m'en retournant obsédé par cette vision, je cherchai à analyser ma soudaine douleur, et je me dis: Je viens de voir l'image du vieil homme de lettres qui a servéçu à la génèration dot il fut le brilliant amuseur; du vieux poëte sans amis, sans famille, sans enfants, dégradé par sa misére et par l'ingratitude publique, et dans la baraque de qui le monde oublieux ne veut plus entrer!*"

22. Baudelaire, *Intimate Journals*, trans. Christopher Isherwood (Hollywood, 1947), p. 68.

23. See Edmund Burke Feldman, *Varieties of Visual Experience* (New York: Harry N. Abrams, 1971), pp. 34-36.

24. Venturi, p. 294.

25. Sigmund Freud, *On Creativity and the Unconscious*, ed. Benjamin Nelson (New York: Harper & Row, 1958), p. 44. (From "The Relation of the Poet to Day-Dreaming" first published in *Neue Revue*, Vol. I, 1908, trans. by I.F.Grant Duff.)

26. Meyer Schapiro quoted in R. W. Davenport and Winthrop Sargent, "Life Roundtable on Modern Art" *Life* (Oct. 11, 1948), p. 76.

27. Hannah Arendt, *The Origins of Totalitarianism* (Cleveland, Ohio: World Publishing Co., 1958), p. 246.

28. Francis Bacon quoted in an interview by David Sylvester, "The Exhilarated Despair of Francis Bacon," *Art News*, Vol. 74, No. 5 (May, 1975), p. 31.

29. Jean Dubuffet quoted in an interview by Michael Peppiat, "The Warring Complexities of Jean Dubuffet," *Art News*, Vol. 76, No. 5 (May, 1977), p. 70.

30. Jackson Pollock quoted in B. H. Friedman, *Jackson Pollock:Energy Made Visible* (New York, 1972), reprinted in *Readings in American Art*, ed. Barbara Rose (New York: Praeger, 1975), p. 124.

31. See Andrew Wyeth in *American Realists and Magic Realists*, eds. Dorothy C. Miller and Alfred Barr, Jr. (New York: Museum of Modern Art, 1943), p. 58, where he is quoted as saying he wished "to seek freedom through significant form and design. . . . Not to exhibit craft, but rather to submerge it. . . ." Murch asserted: "I've been working with the disintegration of color itself, the elimination of solid, flat areas of paint." He is quoted in Rosalind Brown, "Short-Range Astronomy," *Art News*, Vol. 64, No. 9 (January 1964), p. 56.

32. See Samuel Adams Green in *The New Art*, ed. Gregory Batcock (New York: Dutton, 1966), p. 231.

33. See Richardson, "Dada, Camp, and the Mode Called Pop," *The Journal of Aesthetics and Art Criticism*, XXIV, No. 4 (Spring, 1966), p. 555

34. See Raymond Williams, *Culture and Society* (New York: Doubleday, 1960), *passim.*

35. Cf. Hauser, Vol. 1, pp. 438 ff.

36. Wind, pp. 62-63.

37. Ibid.

38. Meyer Schapiro, "Matisse and Impressionism," *Androcles*, Vol. 1, No. 1 (February, 1932), p. 23.

39. Vincent van Gogh, *Dear Theo*, ed. Irving Stone (Boston: Houghton Mifflin, 1937), p. 454.

40. Wassily Kandinsky, quoted in Bernard Meyers, *The German Expressionists* (New York: Praeger, 1957), p. 214.

41. Pablo Picasso, "Picasso Speaks," trans. Marius de Zayas, *The Arts* (New York, 1923), p. 316.

42. Clive Bell, *Art* (London, 1914), p. 26.

43. See Gombrich, pp. 291-329.

44. Roger Fry, *Cézanne, A Study of His Development* (London : Hogarth Press, London, 1927), p. 42.

45. See Lionello Venturi, *Four Steps Towards Modern Art* (New York: Columbia University Press, 1955), p. 24.

46. The most obvious connection with middle-classness, apart from a simple interest in the everyday environment, is the necessary commitment of the bourgeois temperament to the positive value of portable possessions. See Meyer Schapiro, "The Apples of Cézanne: An Essay on the Meaning of Still-Life," *The Avant-Garde*, eds. Thomas B. Hess and John Ashberry (New York: Macmillan, 1968), p. 44, and John Berger, *Ways of Seeing* (Harmondsworth: Penguin Books, 1972), p. 109 and elsewhere.

47. For instance in 1964 the American illustrator Norman Rockwell did a painting for *Look* magazine that may have made a greater positive contribution to public support

of humane idealism than all of the "serious" paintings of the century. In that sense *The Problem That We All Live With* (which shows us a chocolate colored little girl all dressed for school in sparkling white, walking between two pairs of U.S. Deputies beneath the word "NIGGER" on an offal-spattered wall) is a significant picture *because* of its anecdotal nature. Knowing that this particular little girl is one Ruby Bridges who was, in fact, one of the children who faced insanely hostile crowds of white racists during the integration of the school system in New Orleans, Louisiana, is not essential to understanding the point Rockwell was making, but knowing about challenges to racial segregation in America *is* necessary to make sense of the painting. Also, the artist's positioning of Ms. Bridges—apprehension presses her to move nearer the anonymous, brawny servants of the law that she can see ahead of her—and the way her school books and ruler are held at a slightly precarious angle intensifies the viewer's sense of urgency. Rockwell was a supreme master of sentimentality in art. It makes for effective propaganda but, of course, obtrudes upon purely artistic interest.

48. Alexis de Tocqueville, *Democracy in America*, trans. Henry Reeve, Vol. 2 (New York: New American Library, 1945), Vol. 2, p.52.

49. Ibid.

50. Cf. Susan Sontag, *Against Interpretation* (New York: Dell, 1966), pp. 293-304.

51. Manifest Destiny is the notion (first given this stirring name by editor John O'Sullivan in 1845) that Euro-Americans had a God-given right to "overspread the continent alloted by Providence for the free development of our yearly multiplying millions." Still today the basic idea seems perfectly natural to nearly anyone who is not a political activist on the side of the aboriginal population. As a cynical friend of mine likes to say: "We stole it fair and square!"

52. See, in this connection, a Neo-Marxist treatment of the topic that is thorough and plausible: Christopher Hill, *Liberty Against the Law: Some Seventeenth-Century Controversies* (London: Allen Lane/Penguin, 1997), passim.

53. The class distinctions implicit in the wholesome ethics of the standard Western have a special interest for me because I grew up in the area where the basic myth was established. Most of the clichés of the form have their origins in Owen Wister's *The Virginian* (1902). This novel contains, for instance, the first literary description of what motion picture directors refer to as "the walkdown," which involves two gunfighters engaging in a fast draw contest on the main street of some cattletown. (A famous horse thief from those days told me, when I was a boy and he very, very old: "When somebody talked 'bout a 'fast gun' they wasn't thinkin' of fancy shootin'. Meant somebody'd shoot you without warning just for nothin' at all. Shit! Who could afford to shoot up .44 cartridges practicin' trick shots from the hip?") It is from Wister's novel that all of those Zane Grey stories, beginning with *Riders of the Purple Sage* (1912) come. Twentieth-century myths built upon sheer make-believe far outdid their predecessors, the dime novels, in creating the image of the Westerner handed down to us by the John Waynes and Clint Eastwoods of the screen. *The Virginian*, itself, is actually about Wyoming's "Johnson County Cattle War," of 1892, which pitted large cattle ranchers against small ranchers and farmers. Most readers do not understand that the eponymous hero is a tool of the land barons and the villain Trampas a hired thug in the pay of the little guys.

In reality, the fighting was brought to an end by the U.S. Cavalry which supported the hired guns of the ranchers against the Johnson County authorities and the people of the state. I am sure the deconstructionists have given this thing the full dress strip down.

I suppose, too, they'll not have missed Jack Schaeffer's novel, *Shane*, which is essentially the same story told from the small rancher's viewpoint with the roles of Virginian (Shane) and Trampas (Wilson) reversed.

54. Herbert Marcuse, *One-Dimensional Man* (Boston: Beacon Press, 1964), p. xv.

CHAPTER 3
Estrangement and the Taste for Fragmentation

1. Kuh, p.11.

2. Ibid., p. 140.

3. It is customary to deny that there is any connection between this picture and the novel by an acquaintance of Manet's, Émile Zola, since the painting was completed three years before the story appeared in print. Probably the title is a coincidence. On the other hand, Zola may have appropriated the name for his heroine. Or, perhaps, Manet used the eponymous title of a work-in-progress, the ninth volume of the twenty in Zola's Rougon-Macquart series..

4. Pierre Schneider, "The Many-Sided M. Nadar," *Art News Annual* (New York, 1956), p. 71.

5. Someone, noting the similarity of mannerisms in the works of Degas and Lautrec, said: "I see Henri is wearing your clothes." "Yes," Degas replied, "but cut much smaller, of course." (This is the gist of the anecdote; I have been unable to turn up the source for it.)

6. Kuh, op. cit., p. 38.

7. Ibid., p. 41.

8. To cite only a very few of hundreds of available essays there are: Ann Marie Bush and Louis D. Mitchell, "Jean Toomer: A Cubist Poet," *Black American Literature Forum* Vol. 17 (1983), pp. 106-8; Eugene Maio, "Onetti's *Los Adioses*: A Cubist Reconstruction of Reality," *Studies in Short Fiction*, Vol. 26 (1989), pp. 173-81 (Maio depends on an interpretation derived from Sypher's *Rococo to Cubism in Art and Literature,* which depends in turn upon Metzinger [q.v.].); Jeoraldean McClain, "Time in the Visual Arts: Lessing and Modern Criticism," *The Journal of Aesthetics and Art Criticism*, Vol. 44 (1985), pp. 41-58 (Based in part on Joseph Frank's *Spatial Form in Modern Art,* this is somewhat Bergsonian in approach and contains a good deal of material on Paul Cézanne's *Bibémus Quarry* as an example of the "synthesis of numerous moments in time"); James Plath, "*La Torero* and 'The Undefeated': Hemingway's Foray into Analytical Cubism," *Studies in Short Fiction*, Vol. 30 (1993), pp. 35-43 (Metzinger again; but Plath quotes Hemingway to show that the writer was consciously relating the story to a work by Gris he owned); Stephen Snyder, "Antonioni as Cubist: The Political and Poetical Aspects of Antonioni's Films from *L'Avventure* to *The Passenger*," *Varieties of Filmic Expression* (Kent, Ohio: Kent State University Press, 1989), pp. 92-98.

9. John Canaday, *Mainstreams of Modern Art,* 2nd ed. (New York: Holt, Rinehart, and Winston, 1981), p. 326.

10. See Theodore Reff, "Cézanne on Solids and Spaces," *Artforum*, Vol, 15 (October 1977), pp. 34-37.

11. See John Rewald, *Cézanne: A Biography* (New York: Harry N. Abrams, 1990), p. 226.

12. See Richardson, *Modern Art and Scientific Thought*, p. 18.

13. Paul Cézanne, *Letters,* ed. John Rewald, trans. Marguerite Kay (New York: Hacker Art Books, 1976), p. 301.

14. Theodore Reff, in the article cited above, concurs with me that the statement is, indeed, conventional but, like everyone else from Bernard on down, he assumes the master's letter describes his method. I assume, instead, that it offers advice on fundamentals to an acquaintance of whose work he held a poor opinion, an opinion clearly expressed in his epistles to Paul fils. Cézanne did not respect Bernard's judgment and felt he needed to learn to draw from nature. That is exactly what he was telling him to do. Professor Reff is a learned and resourceful art historian whereas I am, by comparison, a dilettante hack. But, because he took for granted that Cézanne was referring to his own practice, he had to come up with an ingeniously complex explanation to reconcile the famous statement with the painter's practice. He accounted for apparent discrepancies by drawing a distinction between the perspective of great spaces and small scale solids. Such a contrast is ephemeral. Perspective is a specialized system of drawing objects in a unified space, and what Uccello does with a *mazzachio* or courtyard, and a computer-aided design program does with curves is the same, that is, the application of projective geometry to points in space. This is, as it were, snatching at orthogonals in the wind of rhetoric. Customarily, when we have to judge between an explanation that is highly complicated and involved as opposed to one that is straightforward and unencumbered, we prefer the latter, so long as it accounts for the observed facts. That mine has the greater economy of means does not, of course, mean that truth is declared and all dispute at an end, but it *does* fit the facts—including Cézanne's entirely justified doubts about the work of Émile Bernard. Traditional perspective is a form of projective geometry; it is rigorously propositional and does not permit deviation from its mathematics.

15. Maurice Raynal, "The Lessons of Cézanne and Seurat," *The History of Modern Painting from Picasso to Surrealism* (Geneva: A. Skira, 1950), p. 12.

16. For a modestly thorough but generally accessible discussion of the relationships among orthographic projections, scientific perspective, and related modes of engineering drawing see Richardson, *Art: The Way It Is*, pp. 154-72.

17. Anthony Blunt, *Nicolas Poussin* (New York: Bollingen Foundation, 1967), P. 219. See also pp. 157-76 and elsewhere for consideration of the relationship of Poussin's ideas to Stoicism.

18. I am indebted to a public lecture (May 1993) by Professors Stephen Brown and Edmund Jacobitti which pointed out these parallels among the paintings of David, Haydn's and Beethoven's music, and the prose of Thomas Jefferson. See, too, Stephen Brown, "Coming of Age with the Horatii," *Romance Languages Annual,* eds. Anthony Julian Tamburri and Charles Ganelin (Purdue University Press, 1991), pp. 70-75.

19. See Richardson, *Modern Art and Scientific Thought,* pp. 57-76 and John Gage, "The Technique of Seurat: A Reappraisal," *The Art Bulletin* 69 (1987): 448-54. Gage's is a well researched and closely argued study that disagrees with my position on Seurat's formal intentions but does not, I think, overcome it. Of course, my impartiality in this regard is unequivocal.

20. Quoted by Émile Bernard, "*Une Conversation avec Cézanne,*" *Mercure de France* 148, no. 551 (June 1, 1921): 38.

21. In *Camille Pissarro, Letters to His Son Lucien, ed.* John Rewald (New York: Pantheon Books, 1943), p. 276.

22. Erle Loran, *Cézanne's Composition,* 2nd ed. (Berkeley: University of California Press, 1963), pp. 76-79, 88-95. I should note that, while these portions strike me as highly questionable, the book itself has much to recommend it in other connections.

23. Meyer Schapiro, *Cézanne* (New York: H. N. Abrams,1952), p. 180.

24. When the argument on multiple viewpoints laid out here first appeared in print, Professor Nan Stalnaker of Harvard University raised various objections to it and a few parts of my rejoinder, including this comment on caricature, have been incorporated into these pages. (For her contentions and my full response see *The Journal of Aesthetics and Art Criticism*, Vol. 54, No. 3 [Summer 1996], pp. 287-93) One of the points I dismissed in the course of this debate deserves mention because it is unusual rather than typical. Ms. Stalnaker refers to a book by R. P. Riviére and J. F. Schnerb—*Conversations avec Cézanne*—wherein they argue that the apparent distortions can be explained by his frequent comment that "bodies seen in space are all convex." But her supposition that the absence of cubes in his comment to Bernard is deliberate and, moreover, confirmed by his statements about space being "spherical and cylindrical" is not convincing. If you are going to apply Riviére and Schnerb's "stretch" to planes, you will have to accept a geodesic interpretation of cubes as well. That is, cubes do not cease to exist in Lobachevsky or Riemann—the planes are negatively or positively curved. Of course, Cézanne was not basing the statement on higher mathematics. But, if you are going to argue that all is spherical, you have to accept that every geometric solid has its place. Besides, he included cones and cylinders in his remarks, and these have straight sides. Why, then, *did not* Cézanne mention cubes along with spheres, cones and cylinders? I suspect it is just an oversight in a handwritten letter. Remember, *I* am the one who does not believe the supposed "prescription" was anything more than a casual comment to a tiresome correspondent.

25. See Edward Fry, ed., *Cubism* (New York: McGraw-Hill, 1966), pp. 14-21, 50, 52, 57-60. That the preeminent cubists claimed Cézanne as a forerunner does not, of course, prove that it is so. On the other hand, many attributes of their works do, indeed, seem derived from his. In Picasso's so-called "Rose Period," in particular, one can find numerous paintings that echo devices previously encountered only in Cézanne. It is not at all far-fetched to suppose that Picasso's modifications of the master's *Bather* in his own *Boy and a Horse* (1905) or his imitation of the 1887 *Self-Portrait with Palette* in his own *Self-Portrait* of 1906 reveal a more than incidental interest in the stylistic attributes of Cézanne's art.

26. Loran, pp. 76, 77.

27. Leo Steinberg, *Confrontations with Twentieth-Century Art* (New York: Oxford University Press, 1972), p. 157.

28. Jean Metzinger, "Cubism et Tradition," *Paris Journal* (August 16, 1911) (quoted in Fry, pp. 66-67).

29. Richardson, *Modern Art and Scientific Thought*, pp. 111-12

30. See Linda Dalrymple Henderson's *The Fourth Dimension and Non-Euclidean Geometry in Modern Art* (Princeton: Princeton University Press, 1983).

31. Ibid. p.132.

32. Mark W. Roskill, *The Interpretation of Cubism* (London: The Associated University Presses, 1984), p.34.

33. See Mary Mathews Gedo, *Picasso: Art as Autobiography* (Chicago: University of Chicago Press, 1980), pp. 97-99.

34. Avant-garde poet and critic Guillaume Apollinaire coined the terms "analytic cubism" (to describe the largely monochromatic, fragmentary works done between 1909 and 1912) and "synthetic cubism" (to distinguish the flatpatterned, more brightly colored paintings done between 1912 and 1924).

35. See, for example, Paul C. Vitz and Arnold B. Glimcher, *Modern Art and Modern Science: The Parallel Analysis of Vision* (New York: Praeger, 1984), pp. 167-68.

36. Giorgio Vasari, *Vasari's Lives of the Artists,* ed. Betty Burroughs (New York: Simon and Schuster, 1946), p. 43.

37. Richardson, *Art: The Way It Is,* pp. 51-55.

38. Roger Fry, "The French Post-Impressionists" (Preface to the catalogue of the Second Post-Impressionist Exhibition at Grafton Galleries, London, 1912), *Vision and Design* (New York: Meridian Books, 1956), p. 239.

39. Norbert Lynton, *The Story of Modern Art* (Oxford: Phaidon, 1980), p. 64.

40. Hauser, Ibid., Vol. 2, p. 946.

41. Laszlo Moholy-Nagy, *Vision in Motion* (Chicago: Paul Theobold, 1947), p. 153

42. See John Adkins Richardson, "Art, Technology, and Ideology: the Bauhaus as Technocratic Metaphor" in *Technology as Institutionally Related to Human Values*, ed. Phillip C. Ritterbush assisted by Martin Green (Washington, D.C.: Acropolis Press, 1974), pp. 135.

43. Moholy-Nagy, p. 353.

44. An excellent biography of Cornell uses for its title the somewhat inapt name of the street he lived on with his widowed mother and disabled brother. See Deborah Solomon, *Utopia Parkway: The Life and Work of Joseph Cornell* (New York: Farrar, Straus & Giroux, 1997), 426 pp.

45. *Fountain* was created for exhibition in April 1917 at the Show of the Society of Independent Artists in Manhattan's Grand Central Palace and Duchamp, one of the society's founders, signed his entry form as "Richard Mutt." The surname portion of the pseudonym was in part drawn from the comic strip, *Mutt and Jeff,* and is also a hint of the manufacturer of the porcelain utensil, J. L. Mott. Presumably, the name Richard alludes to American/British slang for penis: "dick." But *Fountain* was never exhibited. The society's board of directors voted against displaying it and the object seems to have vanished, for there is no documentary evidence of Duchamp, Walter Arensberg, or anyone else having possession of it after the opening of the Independents' exhibition on April 10.

46. Roger Shattuck, in an interesting review of two books on Duchamp, touches upon the nihilistic role of *blague* (the studio joke) and *mystification* among European Dadaists in New York, contrasting it with the more light-hearted mischievousness of

Americans Man Ray and Joseph Stella. The difference is related, I think, to the cultural differences discussed herein on pages 66 and 67 of Chapter 2. See Roger Shattuck, "Confidence Man," *The New York Review* (March 27, 1997), pp. 25-27.

47. See Maurice Horn, *75 Years of the Comics* (Boston: Boston Book & Art, 1971), in which passing mention is made of montage in film, and Scott McCloud, *Understanding Comics: The Invisible Art* (New York: HarperCollins, 1993).

48. In, for example, Pierre Couperie and Maurice Horn, *A History of the Comic Strip*, trans. Eileen B. Hennessy (New York: Crown Publishers, 1968), p. 35. This book originally appeared in France as *Bande Dessiné et Figuration Narrative*, the catalogue for an exhibition of comic art under the auspices of *Société Civile d'Etudes et de Recherches des Littératures Dessinées*. The most famous comment on *Krazy Kat* and, indeed, the premier critical essay on a comic strip appeared in 1924 in George Seldes' *The Seven Lively Arts*, a commentary on art and popular culture. In 1946 the poet e. e. cummings wrote a brief introduction to *Krazy Kat*, a reprint of strips published by Henry Holt and Company. This cat walks in elite company and, even today, Herriman's fantasy is worth reading.

49. Reginald Bragonier, Jr. and David Fisher, the editors of *What's What: A Visual Glossary of the Physical World* (Maplewood, N. J.: Hammond, 1981) included, on pages 374 and 375, a lot of inauthentic jargon for which they were taken to task by *Doonesbury* creator Gary Trudeau. Among the things they designate are "briffits," for those clouds of dust left behind speeding characters (even on polished floors). Speed lines are "hites," and the reflection of what appears to be a window with four lights on a shiny object (even out of doors) are "lucaflects." Trudeau is right; this stuff is concoction, not genuine, but he thought it was the result of a hoax. Not exactly. As I noted in *The New York Times Book Review* (Feb. 13, 1994), the creator of this whimsy is a fellow even more familiar to readers of the funnies than Mr. Trudeau. Mort Walker, the creator of *Beetle Baily*, concocted many of these terms for what he described as "a rather pedantic presentation" to the members of the National Cartoonists Society, where he was being satirical with professionals who already know the business and are, like Walker, bemused by those of us who address popular culture from a professor's chair.

CHAPTER 4
The Arriere-Garde Character of the Vanguard

1. Renato Poggioli, *The Theory of the Avant-Garde*, trans. Gerald Fitzgerald (Cambridge: Harvard University Press, 1968), p. 219.

2. Andre Breton, "What Is Surrealism?" trans. David Gascoyne, excerpted in *Theories of Modern Art*, ed. Herschel B. Chipp (Berkeley: University of California Press, 1968), p. 414.

3. Ibid.

4. Ducasse's life history is extremely obscure but, of course, all the more intriguing for that very reason. His death certificate gives no cause of death, and some have suspected that he was assassinated by agents of Napoleon III for political activity. It is by no means clear, however, that a known agitator named Ducasse was the same person who wrote the *Poésies* under his own name and *Les Chants de Maldoror* under the pseudonym, de Lautréamont. (The pen name is derived from the eponymous hero of Eugene Sue's 1837 novel, *Lautréaumont*. Only a *u* has been removed.) For what little

it's worth, my own impression of *Maldoror* is that it is a very well-read young man's send up of the Romantic manner of Byron, Baudelaire, Sade, Mussett, Hugo, Scott, Lamartine, Sue, Sand, and others who are, indeed, parodied throughout. In a letter of 1869 to Auguste Poulet-Malasis, who had published Baudelaire's *Les Fleurs du Mal* in 1857, Ducasse expressly says he has "sung of evil" also but has "somewhat exaggerated the diapason so as to do something new in the way of this sublime literature."

5. I can think of only one exception, though there must be a number. In Moholy-Nagy's previously cited *Vision in Motion* a passage from the third canto is quoted on page 297. It is a nightmarish scene having to do with an ambulatory rod made of cones thrust one into another, imprisoned in a room of stone. It turns out to be a hair as tall as a man! In the translation cited below, this oddity occurs on pages 122 and 123.

6. Comte de Lautréamont, *Maldoror & Complete Works of the Comte de Lautréamont*, trans. Alexis Lykiard (Cambridge: Exact Change, 1994), p. 218.

7. Ibid., p. 68.

8. Ibid., p. 193.

9. Ibid., p. 160.

10. Ibid., p. 240.

11. Ibid., p. 244.

12. Ibid., p. 133.

13. Ibid., p. 134.

14. Only six Type 41 "Royales" were built, the first in 1927 and last in 1933, but Bugatti's sanguine attitude as expressed in the warranties seems to have been well-justified. All of the cars survive still and are in probable running condition.

15. Filippo Tommaso Marinetti, "The Foundation and Manifesto of Futurism" (originally published on page one of *La Figaro*, 20 February 1909), trans. Joshua C. Taylor, reprinted in Chipp, p. 286.

16. Ibid., pp. 284-85.

17. Ibid., p. 288.

18. Quoted in Caroline Tisdale and Angelo Bozzolla, *Futurism* (New York: Oxford University Press, 1978), p. 130.

19. Umberto Boccioni, "Technical Manifesto of Futurist Sculpture." (Originally published 11 April 1912) Trans. Richard Chase. Reprinted in *Theories of Modern Art*, p. 304.

20. Tisdale and Bozzolla, p. 153.

21. Poggioli, p. 69.

22. Cited in K. G. Pontus Hultun, *The Machine as Seen at the End of the Mechanical Age* (New York: The Museum of Modern Art, 1968), p. 109.

23. It may be of interest to scholars of popular culture that an open cockpit ornithopter with this configuration was used during the 1940s in a Hillman Periodicals comic book called *Air Fighters* which threw the lead character, an adolescent "Airboy," into battle against Axis warplanes. His wing-flapping "Birdie" took down Messerschmitt Bf 109Es and Japanese "Zeros" by the score, ostensibly because of her birdlike maneuverability. Birdie could stop, hover, back up, and do all sorts of tricks even

hummingbirds cannot. Once again, however, the technology was fantastical; the wings were too small, the powerplant obscure, and the feats too far-fetched even for a make-believe ornithopter.

24. Lynton, p.104.

25. Korneliy Zelinsky, "Letatlin," *Vechernays Moskva*, Vol. 80 (April 6, 1932), p. 2, trans. Keith Bradfield in Hultun, p. 145.

26. Kasimir Malevich, "Introduction to the Theory of the Additional Element in Painting," trans. Howard Dearstyne from a German translation of the original Russian. Reprinted in Chipp, p. 339.

27. Naum Gabo, "The Realistic Manifesto," in Chipp, pp. 329-30.

28. Mao Tse-Tung [Mao Zadong], "On Literature and Art" (a speech delivered at the Yenan Forum in May, 1942), in *Marxism and Art:Writings in Aesthetics and Criticism*, ed. Berel Lang and Forrest Williams (New York: David McKay Co., 1972), p. 114.

29. Lucy Lippard, *Six Years: The Dematerialization of the Art Object from 1966 to 1972* (New York: Praeger, 1973), p. 263.

30. Poggioli, p. 8.

31. Meyer Schapiro, "The Social Bases of Art," *Social Realism: Art as a Weapon*, ed. David Shapiro (New York: Frederick Ungar Publishing Co., 1973), pp. 124-25.

32. Dore Ashton, *The New York School: A Cultural Reckoning* (New York: The Viking Press, 1973), p. 61.

33. Schapiro, "The Social Bases of Art," p. 127.

34. Ernst Fischer, "Origins of Art," in Lang and Williams, p. 160.

35. Serge Guilbaut, *How New York Stole the Idea of Modern Art: Abstract Expressionism, Freedom, and the Cold War*, trans. Arthur Goldhammer (Chicago and London: University of Chicago Press, 1984), p. 201.

36. Ibid., 199.

37. See Richardson, *Modern Art and Scientific Thought*, pp. 132-33.

38. Wassily Kandinsky, *Reminiscences*, trans. Hilla Rebay and Robert L. Herbert in *Modern Artists on Art*, ed. Robert L. Herbert (Englewood Cliffs, N. J.: Prentice-Hall, 1964), pp. 24-25.

39. Arendt, p. 335.

40. Ibid.

41. Hauser, p. 891.

42. The Settembrini character is generally thought to be modeled on Thomas Mann's older brother, Heinrich, who was anti-German during the First World War. Heinrich Mann was, himself, a noted man of letters; his story *Professor Unrat oder das Ende eines Tyrannen* (1905) was the basis for the famous Sternberg film starring Marlene Deitrich and Emil Jannings, *The Blue Angel* (1930). Somewhat less securely, I think, Naphta is believed to be drawn from the Hungarian Marxist, Georg Lukás, whose greatest work is *History and Class Consciousness* (1923). Lukás' relationship to Communism is, itself, as wild and contradictory as Naphta's personality in *Der Zauberberg*. See my comments on the consequences of Lukás' 1934 article "*Grösse und Verfall des Expressionismus*"

(Grandeur and Decay of Expressionism) in Richardson, *Modern Art and Scientific Thought*, pp. 166-67.

43. Thomas Mann, *Doctor Faustus*, trans. H. T. Lowe-Porter (New York: Alfred A. Knopf, 1948), pp. 73-74.

44. Quoted in *The Concise Oxford Dictionary of Music*, ed. Percy A. Scholes and John Owen Ward (London: Oxford University Press, 1977), p. 400.

45. Mann, p. 191.

46. Ibid., pp. 239-43.

47. The protagonist of the story, a writer named Gustave von Aschenbach, ends up being made up by a barber to resemble the old fop he found so foolish and dies of cholera while in hesitantly troubled, guilt-ridden pursuit of a fourteen year old boy with whom he has become obsessed. *Death in Venice* is a tragic tale of repressed homosexuality and is clearly somewhat autobiographical in nature. In another connection with *Doktor Faustus*, the Aschenbach character is, in physical appearance, a twin to Gustav Mahler.

48. Mann, p. 365. The names of the members of the discussion group, which is said to vary from evening to evening, but to never contain more than eight or ten people at a session, are clearly meant to signify more than merely a novelist's identification of characters. For instance one of them is a Professor Holzschuher, an "art critic and Dürer scholar." Albrecht Dürer had done an oil portrait of one Heironymous Holzschuher, a Nuremberg senator who was a supporter of Luther and a friend of Erasmus of Rotterdam and Philipp Melancthon.

49. Mann, p. 373.

50. Mark Roskill, *Klee, Kandinsky, and the Thought of Their Time: A Critical Perspective* (Urbana and Chicago: University of Illinois Press, 1992), p. 165. In this passage the author characterizes *Magister Ludi: The Glass Bead Game* (1943), the last work of Hermann Hesse, the same way but for different reasons. Roskill is always very thorough and has, in this small book, a treatment of Adorno's championing of Schönberg's twelve tone system in 1932 in the journal of the Institute for Social Research in Frankfort. Adorno finds the composer's "solutions to technical problems . . . socially relevant in spite of their isolation." See pages 137-138.

51. Ibid., p. 186.

52. Ibid.

53. Ibid., p. 193.

54. Ibid., p. 194.

55. Quoted in an interview with Phoebe Hoban, "The Wheel Turns: Painting Paintings about Paintings," *The New York Times* (Sunday, April 27, 1997), p. H-35.

56. Camille Paglia, *Sexual Personae: Art and Decadence from Nefertiti to Emily Dickinson* (New Haven: Yale University Press, 1990), p. 12.

57. See ibid., pp. 607-22.

58. Ibid., p. 55.

59. Ibid., p. 148

60. Sidney Chafetz, *Chafetz Graphics: Satire and Homage* (Columbus: The Ohio State University Gallery of Fine Art and the Ohio State University Press, 1988), p. 63.

61. Quoted by Holland Cotter in "Unrepentant Offender of Almost Everybody," *The New York Times* (Sunday, June 8, 1997), p. H35.

62. H. H. Arnason, *History of Modern Art*, 3rd ed. (New York: Harry N. Abrams, 1986), p. 177.

63. Ken Johnson, "Colescott on Black & White," *Art in America* (June 1989), p. 152. For those who have not read Joyce Cary's *The Horse's Mouth* (New York: Harper & Brothers, 1944), Gulley Jimson is the artist protagonist, a talented reprobate later portrayed in the 1958 motion picture version by Alec Guinness. It is widely believed that Jimson was based on the painter Gerald Wilde who was also obsessed with art and booze to the exclusion of anything else, but this is probably not true since Cary and Wilde did not meet until years after *The Horse's Mouth* was published. Whatever the case, the novel is arguably the best representation in all of literature of the way an artist, drunk or sober, sees the world.

CHAPTER 5
Substance and Shadow at the Close of the Second Millennium

1. Sherwood Anderson, *Winesburg, Ohio*, (New York: W.W. Norton & Co., 1996), pp. 6-7. This volume is A Norton Critical Edition, edited by Charles E. Modlin and Ray Lewis White, of the novel originally published by B. W. Huebsch in 1919.

2. Parrington's major work, a three-volume "Interpretation of American Literature from the Beginnings to 1920" was deeply influenced by (1) Hippolyte Taine's *Histoire de la littérature anglaise* (1864) which conceived of a people's literature as the inevitable outgrowth of their racial makeup, environment, and temporal setting, and (2) by the application of economic theory to social analysis by J. Allen Smith in his *The Spirit of American Government* (1907) and Charles A. Beard in *An Economic Interpretation of the Constitution* (1913). *Main Currents in American Thought* has, like these works, been attacked for its heavy emphasis on socio-economic influences in literature, but it is a powerful treatment of its subject, particularly with regard to Colonial and Federal periods. Although Parrington died in 1929, before the work was completed, his thoughts on the twentieth century were edited as the final volume by E. H. Eby, relying on Parrington's notes and the syllabus for his lectures at the University of Washington. Parrington considered Sherwood Anderson a "psychological naturalist" whose *Winesburg, Ohio* was like a prose version of Edgar Lee Masters' *Spoon River Anthology* (1915). See Vernon Louis Parrington, *Main Currents in American Thought* Vol. 3 (New York: Harcourt Brace and Company, 1930), p. 370.

3. An interesting and informative book on the success of socialist thinking in practical terms is Donald Sassoon's *One Hundred Years of Socialism* (New York: The New Press, 1997, 965 pp.), which points out that everything favored by the conventions of European socialists in Paris during 1889 and Erfurt in 1891 have become the measure of decency to everyone except a very few capitalist ideologues. The list includes: democratic government and equal rights for all (including women), free education and medical care, graduated taxation, separation of church and state, eight-hour days, and the right to unionize. When America's extreme conservatives start spouting their standard

Jingoistic slogans about the good old U. S. of A. being the "greatest country ever on earth," listeners should consider how positively most Europeans view *their* social democracies. The French, for instance, are as arrogantly sure of the divine superiority of their State as Americans are of the supreme rightness of our nation.

4. See Ernest L. Schusky, *Culture and Agriculture: An Ecological Introduction to Traditional and Modern Farming Systems* (Westport, Ct.: Greenwood Press, 1989), passim.

5. See Richardson, "Dethroning the Dead: Colorless Canons, Darkening Doubts," pp. 15-30.

6. The country-western form had an astonishing renaissance, particularly in the mode someone finally got around to calling the "Somebody Done Somebody Wrong Song." But the best satire on this kind of junk was written by Mason Williams, best known for the composition *Classical Gas*. His facetious attempt to write a hillbilly hit, *You Done Stomped on My Heart*, contains lines worthy of Cole Porter: "Sweetheart, you just sorta stomped on my aorta." And "I only hope that someday, when you have got the blues/In some lonely room, you look down at your shoes/And think about this tender heart you crushed beneath their soles/When your young body craved good times and fancy clothes."

7. As for serious music, the situation is too bizarre to be compared with that in the visual arts. Rather curiously (in view of the interpretation Mann and Adorno placed on the theories of Schönberg), the twelve-tone system was taken up by many American composers and a few in Europe as antidote to a past that had led to Hitler and the holocaust. Milton Babbitt, for instance, conceived of Schönberg's system as merely an intitial step on the way to a completely systematic formalization of music which he called "Serialism." Serial music severed most links with the past; thus, where Schönberg's atonality had concerned itself with pitch, Babbitt's theories undertook to rethink everything, including pitch, rhythm, and duration. Others, for example, Pierre Boulez and Karlheinz Stockhausen, developed "Total Serialization" which required the strictly organized predictability even of silences and gradations of volume and timbre. The only places serial compositions were likely to be performed were in recitals at universities and music schools and, even in academic settings, the only audiences appreciative of it that small percentage of neoterics with a technical grasp of the principles of composition. Mainstream supporters of symphony orchestras and schools of music hated serial music, turning instead to contemporary composers like Copeland, Britten, Prokofiev, and Shostakovich to insinuate a little something modern into the programs of Baroque and Romantic music that could be counted on to draw to performances reverent audiences with open purses. This schism between academic Serialists and practically everyone else persists to this day, except that since the late 1970s a backlash has produced what is somewhat comparable to postmodernism in art. It has taken two main forms, so far as I— an interested ignoramus—can tell: Neo-Romanticism and Minimalism. One element of the latter branch of modernism is aleotory music, that is, the employment of chance as a deciding component in the construction of a musical work or performance. The most famous of all people associated with aleotory music is a marginal and atypical member, John Cage.

8. Q.v. pp. 17-18.

9. de Tocqueville, p. 114.

10. Harold Rosenberg, *Artworks and Packages* (New York: Horizon Press, 1969), pp. 223-224.

11. Daniel A. Siedell, "Kline Contra Kline," *Art Criticism*, Vol. 12, No. 1 (Spring, 1997), p.84.

12. Ibid., pp. 85-86.

13. Ibid., p. 86.

14. Suzi Gablik, *Art as Progress* (London: Thames and Hudson, 1977), p. 72.

15. Alexander Pope, "An Essay on Criticism" (1711) lines 335, 336 in *The Great Critics*, eds. James Harry Smith and Edd Winfield Parks (New York: W. W. Norton, 1939) p. 394.

16. See Susanne K. Langer, *Feeling and Form: A Theory of Art* (New York: Scribner, 1953), 431 pp. Langer credits the artist and stained glass craftsman, Robert Sowers—then a student at Columbia University—with the cinema/dream comparison.

17. Alan Turing, "Computing Machinery and Intelligence," *Mind*, Vol. 59, No. 236 (1950), pp. 433-60.

18. For what it's worth, the requirement that intelligence must be introspective in the way we believe ourselves to be seems to me comparable to the notion that personal responsibility is dependent upon freedom of will, a supposition that has always seemed to me (as I discover it did to A.J. Ayer) to assume that liability for one's acts depends upon the utter inscrutability of one's motives.
There are two quite interesting books dealing with the question of whether mechanical computations can be considered "thought." A very celebrated one is by Roger Penrose, Rouse Ball Professor of Mathematics at Oxford University. It is *The Emperor's New Mind: Concerning Computers, Minds, and the Laws of Physics* (Oxford: Oxford University Press, 1989), 466 pp. A second book, expressing a somewhat eccentric view of the history of technology and communication in very broad philosophic terms is George B. Dyson's, *Darwin Among the Machines: The Evolution of Global Intelligence* (Reading, Mass.: Addison-Wesley, 1997), 286 pp.

19. An author who seems to have thought a lot of this stuff through at least a decade ahead of others is Joseph Deken. See his *The Electronic Cottage* (New York: Morrow, 1982), 341 pp. and *Computer Images: State of the Art* (New York: Stewart, Tabori & Chang, 1983), 200 pp.

20. John A. Barker, *ProtoThinker: A Model of the Mind* (Belmont, Calif.: Wadsworth Publishing Co., 1997).

21. David Anderson, *ProtoThinker and the PT-Project*, PT website. The PT-Project website (www.ptproject.ilstu.edu) contains quite a lot of information on the history, participants, and procedures involved in the emergence of PT and is continually updated. For readers who have some knowledge of the issues revolving around AI—including, for instance, the Turing Machine and John Searle's "Chinese room" counter argument—this site is definitely worth visiting.

22. Vladimir Nabokov, *Laughter in the Dark* (New York: New Directions, 1939), pp. 5-6.

23. The distortions of the Magellan data were revealed to me in a marvelous book by Edward R. Tufte, *Visual Explanations* (Cheshire, Ct.: Graphics Press, 1997), pp. 23-25. Tufte cites an article by David Morrison, "Forum: Flat Venus Society Organizes," *EOS*

73 (March 3, 1992), and also mentions the necessity of making relief maps exaggerated in vertical scale. Tufte's books are unusually informative and thoughtful about ways of presenting information graphically. The author is annoyingly immodest but, then, he is also nearly always right.

24. See Sharon Salyer, "The Dawn of 'Virtual Therapy,'" *USA Weekend* (July 18-20, 1997), p. 10.

25. Richardson, *Modern Art and Scientific Thought*, p. 175.

26. There are many other remarkable things about holography apart from its illusionism. For instance, a hologram can be cut into tiny pieces and each of the pieces will contain the entire image that was recorded on film—albeit with a considerable reduction in resolution and clarity. This has enormous implications for fields like information theory.

27. Richardson, *Modern Art and Scientific Thought*, p. 175.

28. Jasia Reichart, "Images in Waiting," excerpted on *Search the Light—Holography*, http://www.holo. peper/search.html. April 27, 1997.

29. Marcia E. Vetrocq, "The 1997 Venice Biennale: A Space Odyssey," *Art in America*, Vol. 85, No. 9 (September 1997), p. 75. This article contains small color reproductions of a number of works from the Biennale, including a still from *Nirvana* and Kulik's *Deep Into Russia* installation.

30. See Charles Jenks, *Post-Modernism: The New Classicism in Art and Architecture* (New York: Rizzoli, 1987), pp. 37-40.

31. Ibid., 319.

32. Richardson, *Art: The Way It Is*. 4th ed. (New York: Harry N. Abrams, 1992), pp. 395-96.

33. Paul Goldberger, "The Politics of Building," *The New Yorker* (October 13, 1997), p. 49.

34. See Jenks, p. 354, n. 17.

CONCLUSION

1. A. L. Rees and Frances Borzello, eds., *The New Art History* (Atlantic Highlands, N.J.: Humanities Press International, 1988), p. 2.

2. Ibid.

3. See Roskill, *What Is Art History?* 2nd ed. (Amherst: University of Massachusetts Press, 1989), pp. 3-6.

4. See, for example, Craig Owens, "The Discourse of Others: Feminists and Postmodernism," in Foster's *The Anti-Aesthetic: Essays on Postmodern Culture*, pp. 57-82.

5. Metzinger, ibid., (note 28, chapter 3).

6. The cult-like enthusiasm of Macintosh users is, perhaps, the supreme example of the way a technological convenience like graphical interfacing can entrance the naive—even when they are postmodern skeptics with a grim view of capitalist ideologies. Engineers are not so easily led. I was very amused to see the following posted in the window of a Professor of Electrical Engineering: "DEATH TO RODENT HANDLERS!

ALL POWER TO ALMIGHTY DOS!" Now there is a man who not only enjoys membership in an esoteric "priesthood" but also knows what lies behind the friendly interface now accessible to any semi-literate boob on the planet.

7. John Adkins Richardson, "The Visual Arts and Cultural Literacy," *Cultural Literacy & Arts Education*, ed. Ralph A. Smith (Urbana and Chicago: The University of Illinois Press, 1991), p. 66-67.

8. Michael Ignatieff, "The Gods of War," *The New York Review of Books*. Vol XLIV, No. 15 (October 9, 1997), p. 13.

9. In *Postmodern War: The New Politics of Conflict*, a book reviewed in the above cited article.

10. Ignatieff, ibid.

BIBLIOGRAPHY

Alberti, Leon Battista. *Ten Books on Architecture*. Tr. James Leoni. Ed. J. Rykwert. New York: Transatlantic, 1955.

Anderson, Sherwood. *Winesburg, Ohio*. New York: W.W. Norton & Co., 1996.

Arendt. Hannah. *The Origins of Totalitarianism*. Cleveland, OH: World Publishing Co., 1958.

Arnason, H. H. *History of Modern Art*. 3rd ed. New York: Harry N. Abrams, 1986.

Ashton, Dore. *The New York School: A Cultural Reckoning*. New York: The Viking Press, 1973.

Barker, John A. *ProtoThinker: A Model of the Mind*. Belmont, CA: Wadsworth Publishing Co., 1997.

Battcock, Gregory. *The New Art*. New York: Dutton, 1966.

Baudelaire, Charles. *Intimate Journals*. Tr. Christopher Isherwood. Hollywood: Privately printed, 1947.

_____. *Le Spleen de Paris*. Paris, 1943.

de Beauvoir, Simone. *The Second Sex*. Tr. H.M.Parshley. New York: Alfred A. Knopf, 1952.

Bell, Clive. *Art*. London, 1914.

Bell, Daniel. *Cultural Contradictions of Capitalism*. New York: Basic Books, 1976.

Berger, John. *Ways of Seeing*. Harmondsworth: Penguin Books, 1972.

Bernard, Émile. "Une Conversation avec *Cézanne*," *Mercure de France*, Vol. 148, No. 551 (1921).

Bialostocki, Jan. "The Renaissance Concept of Nature and Antiquity," *Studies in Western Art: The Renaissance and Mannerism*. Vol. II of Acts of the Twentieth International Congress of the History of Art. Princeton: Princeton University Press, 1963.

Blunt, Anthony. *Nicolas Poussin*. New York: Bollingen Foundation, 1967.

Bragonier, Jr., Reginald, and David Fisher, eds. *What's What: A Visual Glossary of the Physical World*. Maplewood, NJ: Hammond, 1981.

Brown, Rosalind. "Short-Range Astronomy," *Art News*, Vol. 64, No. 9 (1964).

Brown, Stephen. "Coming of Age with the Horatii," *Romance Languages Annual*. Eds. Anthony Julian Tamburri and Charles Ganelin. Lafayette, IN: Purdue University Press, 1991.

Bush, Ann Marie, and Louis D. Mitchell. "Jean Toomer: A Cubist Poet," *Black American Literature Forum*, Vol. 17 (1983).

Canaday, John. *Mainstreams of Modern Art,* 2nd ed. New York: Holt, Rinehart, and Winston, 1981.

Cary, Joyce. *The Horse's Mouth.* New York: Harper & Brothers, 1944.

Cézanne, Paul. *Letters.* Ed. John Rewald. Trans. Marguerite Kay. New York: Hacker Art Books, 1976.

Chafetz, Sidney. *Chafetz Graphics: Satire and Homage.* Columbus: The Ohio State University Gallery of Fine Art and the Ohio State University Press, 1988.

Chauvet, Jean-Marie, Eliette Brunel Deschamps, and Christian Hillaire. *Dawn of Art:The Chauvet Cave, The Oldest Known Paintings in the World.* New York: Harry N. Abrams, 1996.

Chipp, Herschel B., ed. *Theories of Modern Art.* Berkeley: University of California Press, 1968.

Clark, T. J. *The Absolute Bourgeois: Artists and Politics in France 1848-1851.* New York and London: New York Graphic Society, 1973.

Clottes, Jean, and Jean Courtin. *The Cave Beneath the Sea:Paleolithic Images at Cosquer.* New York: Harry N. Abrams, 1996.

Cotter, Holland. "Unrepentant Offender of Almost Everybody," *The New York Times* (Sunday, June 8, 1997), p. H35.

Couperie, Pierre, and Maurice Horn. *A History of the Comic Strip.* Tr. Eileen B. Hennessy. New York: Crown Publishers, 1968.

Davenport, R.W., and Winthrop Sargent. "Life Roundtable on Modern Art," *Life* (11 Oct. 1948).

Deken, Joseph. *Computer Images: State of the Art.* New York: Stewart, Tabori & Chang, 1983.

_____. *The Electronic Cottage.* New York: Morrow, 1982.

Derrida, Jacques. "The Law of Genre," *Glyph*, No. 7. (1980).

_____. *Positions.* Tr. Alan Bass. Chicago: University of Chicago Press, 1981.

_____. "Restitutions of Truth to Size." Tr. John P. Leavey, Jr. *Research in Phenomenology* 8 (1978).

_____. *Spectres de Marx.* Paris: Galileé, 1993.

Dyson, George B. *Darwin Among the Machines: The Evolution of Global Intelligence.* Reading, MA: Addison-Wesley, 1997.

Febvre, Lucien. *Le Problème de l'incroyance au XVIème siècle, la religion de Rabelais.* Paris, 1942.

Feldman, Edmund Burke. *Varieties of Visual Experience.* New York: Harry N. Abrams, 1971.

Flam, Jack D. *Matisse on Art.* London: Phaidon, 1973.

Foster, Hal, ed. *The Anti-Aesthetic: Essays on Postmodern Culture.* Port Townsend, WA: Bay Press, 1983.

Foucault, Michel. *Ceci n'est pas une pipe; deux lettres et quatre dessins de Rene Magritte.* Montpellier: Fata Morgana, 1973.

Freud, Sigmund. *On Creativity and the Unconscious.* Ed. Benjamin Nelson. New York: Harper & Row, 1958.

Fry, Edward. *Cubism.* New York: McGraw Hill, 1966.

Fry, Roger. *Cézanne, A Study of His Development*. London: Hogarth Press, 1927.

_____. *Vision and Design*. New York: Meridian Books, 1956.

Gablik, Suzi. *Art as Progress*. London: Thames and Hudson, 1977.

Gage, John. "The Technique of Seurat: A Reappraisal," *The Art Bulletin*. Vol. 69 (1987).

Gedo, Mary Mathews. *Picasso: Art as Autobiography*. Chicago: University of Chicago Press, 1980.

van Gogh, Vincent. *Dear Theo*. Ed. Irving Stone. Boston: Houghton Mifflin, 1937.

Goldberger, Paul. "The Politics of Building," *The New Yorker* (October 13), 1997.

Gombrich, E. H. *Art and Illusion: A Study in the Psychology of Pictorial Representation*. Washington, DC: Pantheon Books, 1956.

Gowing, Lawrence. *Vermeer*. New York: Harper & Row, 1970.

Guilbaut, Serge. *How New York Stole the Idea of Modern Art: Abstract Expressionism, Freedom, and the Cold War*. Tr. Arthur Goldhammer. Chicago and London: University of Chicago Press, 1984.

Hall, Edward T. *The Hidden Dimension*. Garden City, NY: Doubleday, 1966.

Harris, Marvin. *Cultural Materialism: The Struggle for a Science of Culture*. New York: Random House, 1979.

Hauser, Arnold. *The Social History of Art*. New York: Alfred A. Knopf, 1951.

Henderson, Linda Dalrymple. *The Fourth Dimension and Non-Euclidean Geometry in Modern Art*. Princeton: Princeton University Press, 1983.

Herbert, Robert L., ed. *Modern Artists on Art*. Englewood Cliffs, NJ: Prentice-Hall, Inc., 1964.

Hess, Thomas B., and John Ashberry, eds. *The Avant-Garde*. New York: Macmillan, 1968.

Hill, Christopher. *Liberty Against the Law: Some Seventeenth-Century Controversies*. London: Allen Lane/Penguin, 1997.

Hoban, Phoebe. "The Wheel Turns: Painting Paintings about Paintings," *The New York Times* (Sunday, April 27, 1997), p. H35.

Horn, Maurice. *75 Years of the Comics*. Boston: Boston Book & Art, 1971.

Hultun, K. G. Pontus. *The Machine as Seen at the End of the Mechanical Age*. New York: The Museum of Modern Art, 1968.

Ignatieff, Michael. "The Gods of War," *The New York Review of Books*, Vol. XLIV, No. 15 (1997).

Jenks, Charles. *Post-Modernism: The New Classicism in Art and Architecture*. New York: Rizzoli, 1987.

Johnson, Ken. "Colescott on Black & White," *Art in America* (June, 1989).

Kosuth, Joseph. "Art After Philosophy, I and II," *Idea Art*. Ed. Gregory Battcock. New York: E. P. Dutton & Co., 1973.

Kuh, Katherine. *Break-Up: The Core of Modern Art*. New York: New York Graphic Society, 1965.

Lacan, Jacques. *Écrits: A Selection*. Tr. Alan Sheridan. New York: W. W. Norton & Co., 1977.

Lang, Berel, and Forrest Williams, eds. *Marxism and Art: Writings in Aesthetics and Criticism*. New York: David McKay Co., 1972.

Langer, Susanne K. *Feeling and Form: A Theory of Art.* New York: Scribners, 1953.

de Lautréamont, Comte. *Maldoror & Complete Works of the Comte de Lautréamont.* Tr. Alexis Lykiard. Cambridge: Exact Change, 1994.

Levkowitz, Mary. *Not Out of Africa: How Afrocentrism Became an Excuse to Teach Myth as History.* New York: Basic Books, 1996.

Lippard, Lucy. *Six Years:The Dematerializtion of the Art Object from 1966 to 1972.* New York: Praeger, 1973.

Loran, Erle. *Cézanne's Composition.* 2nd ed. Berkeley: University of California Press, 1963.

Lubar, Robert S. "Unmasking Pablo's Gertrude: Queer Desire and the Subject of Portraiture," *The Art Bulletin,* Vol. LXXIX, No. 1 (March 1997).

Lynton, Norbert. *The Story of Modern Art.* Oxford: Phaidon, 1980.

Maio, Eugene. "Onetti's *Los Adioses:* A Cubist Reconstruction of Reality," *Studies in Short Fiction*, Vol. 26 (1989).

Mann, Thomas. *Doctor Faustus.* Tr. H. T. Lowe-Porter. New York: Alfred A. Knopf, 1948.

Marcuse, Herbert. *One-Dimensional Man.* Boston: Beacon Press, 1964.

Mauner, George. *Manet, Peintre-Philosophe: A Study of the Painter's Themes.* University Park: Pennsylvania State University Press, 1975.

McClain, Jeoraldean. "Time in the Visual Arts: Lessing and Modern Criticism," *The Journal of Aesthetics and Art Criticism.* Vol. 44 (1985).

McCloud, Scott. *Understanding Comics: The Invisible Art.* New York: Harper Collins, 1993.

Meyers, Bernard. *The German Expressionists.* New York: Praeger, 1957.

Miller, Dorothy C., and Alfred Barr, Jr., eds. *American Realists and Magic Realists.* New York: Museum of Modern Art, 1943.

Moholy-Nagy, Laszlo. *Vision in Motion.* Chicago: Paul Theobold, 1947.

Morelli, Giovanni. *Italian Painters: Critical Studies of Their Works.* Tr. C. J. Ffoulkes. London: 1892.

Nabokov, Vladimir. *Laughter in the Dark.* New York: New Directions, 1939.

Ortega y Gasset, José. *The Dehumanization of Art.* Garden City, New York: Doubleday, 1956.

Paglia, Camille. *Sexual Personae: Art and Decadence from Nefertiti to Emily Dickinson.* New Haven: Yale University Press, 1990.

Parrington, Vernon Louis. *Main Currents in American Thought.* New York: Harcourt Brace and Company, 1930.

Penrose, Roger. *The Emperor's New Mind: Concerning Computers, Minds, and the Laws of Physics.* Oxford: Oxford University Press, 1989.

Peppiat, Michael. "The Warring Complexities of Jean Dubuffet," *Art News.* Vol. 76, No. 5 (1977).

Picasso, Pablo. "Picasso Speaks," Tr. Marius de Zayas. *The Arts.* New York: 1923.

Pissarro, Camille. *Camille Pissarro, Letters to His Son Lucien.* Ed. John Rewald. New York: Pantheon Books, 1943.

Plath, James. "*La Torero* and 'The Undefeated': Hemingway's Foray into Analytical Cubism," *Studies in Short Fiction*, Vol. 30 (1993).

Poggioli, Renato. *The Theory of the Avant-Garde*. Tr. Gerald Fitzgerald. Cambridge: Harvard University Press, 1968.

Proust, Marcel. *Rememberance of Things Past*. Tr. C. K. Scott Moncrieff and Terence Kilmartin. New York: Random House, 1981.

Raynal, Maurice, et al. *The History of Modern Painting from Picasso to Surrealism*.Geneva: Albert Skira, 1951.

Rees, A. L., and Frances Borzello, eds. *The New Art History*. Atlantic Highlands, NJ: Humanities Press International, 1988.

Reff, Theodore. "Cézanne on Solids and Spaces," *Artforum*, Vol. 15. (1977).

Rewald, John. *Cézanne: A Biography*. New York: Harry N. Abrams, 1990.

Richardson, John Adkins. "Art, Technology, and Ideology: the Bauhaus as Technocratic Metaphor," *Technology as Institutionally Related to Human Values*, eds. Phillip C. Ritterbush and Martin Green. Washington, DC: Acropolis Press, 1974.

_____. *Art: The Way It Is*. 4th ed. New York: Harry N. Abrams, 1992.

_____. "Dada, Camp, and the Mode Called Pop," *The Journal of Aesthetics and Art Criticism*, Vol. 24, No. 4 (1966).

_____. "Dethroning the Dead: Colorless Canons, Darkening Doubts," *The Journal of Aesthetic Education*, Vol. 28, No. 4 (1994).

_____. *Modern Art and Scientific Thought*. Urbana: University of Illinois Press, 1971.

_____. "The Visual Arts and Cultural Literacy," *Cultural Literacy & Arts Education*. Ed. Ralph A. Smith. Urbana and Chicago: The University of Illinois Press, 1991.

Rose, Barbara, ed. *Readings in American Art*. New York: Praeger, 1975.

Rosenberg, Harold. *Artworks and Packages*. New York: Horizon Press, 1969.

Roskill, Mark. *The Interpretation of Cubism*. London: The Associated University Presses, 1984.

_____. *Klee, Kandinsky, and the Thought of Their Time: A Critical Perspective*. Urbana and Chicago: University of Illinois Press, 1992.

_____. *What is Art History?* 2nd ed. Amherst: University of Massachusetts Press, 1989.

Roudinesco, Elizabeth. *Jacques Lacan*. Tr. Barbara Bray. New York: Columbia University Press, 1997.

Salemohamed, George. "Derrida and the Marxian Promise," *Economy and Society*, Vol. 24, No. 3 (1995).

Salyer, Sharon. "The Dawn of 'Virtual Therapy,'" *USA Weekend* (July 18-20, 1997).

Sassoon, Donald. *One Hundred Years of Socialism*. New York: The New Press, 1997.

de Saussare, Ferdinand. *Course in General Linguistics*. Tr. William Baskin. New York: Philosophical Library, 1959.

Schapiro, Meyer. *Cézanne*. New York: Harry. N. Abrams, 1952.

_____. "Matisse and Impressionism," *Androcles*, Vol. 1, No. 1 (1932).

_____. "Style," *Anthropology Today*. Ed. Sol Tax (Chicago: University of Chicago Press, 1962).

Schneider, Pierre."The Many-Sided M. Nadar," *Art News Annual*. New York: *Art News*, 1956.

Scholes, Percy A., and John Owen Ward, eds. *The Concise Oxford Dictionary of Music*. London: Oxford University Press, 1977.

Schopenhauer, Arthur. *The Art of Literature*. Ed. and tr. T. Bailey Sauders. London: 1891.

Schusky, Ernest L. *Culture and Agriculture: An Ecological Introduction to Traditional and Modern Farming Systems*. Westport, CT: Greenwood Press, 1989.

Shankman, Paul. "Le Rôti et le Bouilli: Lévi-Strauss' Theory of Cannibalism," *American Anthropologist*, No. 71 (1969).

Shapiro, David, ed. *Social Realism: Art as a Weapon*. New York: Fredereick Ungar Publishing Co, 1973.

Shattuck, Roger. "Confidence Man," *The New York Review* (March 27, 1997).

Siedell, Daniel A. "Kline Contra Kline," *Art Criticism*, Vol. 12, No. 1 (1997).

Smith, James Harry, and Edd Winfield Parks, eds. *The Great Critics*. New York: W. W. Norton, 1939.

Smith, Ralph A. *The Sense of Art*. New York, London: Routledge, 1989.

Snyder, Stephen. "Antonioni as Cubist: The Political and Poetical Aspects of Antonioni's Films from *L'Avventure* to *The Passenger*," *Varieties of Filmic Expression*. Kent, Ohio: Kent State University Press, 1989.

Solomon, Deborah. *Utopia Parkway: The Life and Work of Joseph Cornell*. New York: Farrar, Straus & Giroux, 1997.

Sontag, Susan. *Against Interpretation*. New York: Dell, 1966.

Steinberg, Leo. *Confrontations with Twentieth-Century Art*. New York: Oxford University Press, 1972.

Stern, Fritz, ed. *The Varieties of History*. Cleveland, New York: World Publishing Co., 1956

Sylvester, David. "The Exhilarated Despair of Francis Bacon," *Art News*, Vol. 74, No. 5 (1975).

Tisdale, Caroline and Angelo Bozzolla. *Futurism*. New York: Oxford University Press, 1978.

de Tocqueville, Alexis. *Democracy in America*. Tr. Henry Reeve. New York: New American Library, 1945.

Tufte, Edward R. *Visual Explanations*. Cheshire, CT.: Graphics Press, 1997.

Turing, Alan. "Computing Machinery and Intelligence," *Mind*, Vol. 59, no. 236 (1950).

Vasari, Giorgio. *Vasari's Lives of the Artists*. Ed. Betty Burroughs. New York: Simon and Schuster, 1946.

Venturi, Lionello. *Four Steps Towards Modern Art*. New York: Columbia University Press, 1955.

_____. *History of Art Criticism*. Tr. Charles Marriott. New York: E. P. Dutton & Co., 1936, 1964.

Vetrocq, Marcia E. "The 1997 Venice Biennale: A Space Odyssey," *Art in America*, Vol. 85, No. 9 (1997).

Vitz, Paul C., and Arnold B. Glimcher. *Modern Art and Modern Science: The Parallel Analysis of Vision.* New York: Praeger, 1983.

Walker, John. *The National Gallery of Art, Washington.* New York: Harry N. Abrams, 1975.

Williams, Raymond. *Culture and Society.* New York: Doubleday, 1960.

Wind, Edgar. *Art and Anarchy.* New York: Vintage Books, 1963.

Wolfe, Thomas. *Look Homeward Angel.* New York: Charles Scribner's Sons, 1929.

Wölfflin, Heinrich. *Principles of Art History: The Problem of the Development of Style in Later Art.* Tr. M. D. Hottinger. New York: Dover Books, 1963.

INDEX

Numerals in **boldface** indicate Plate locations, those in *italics* are Figures

About the Author

JOHN ADKINS RICHARDSON is Professor Emeritus of Art and Design at Southern Illinois University at Edwardsville. Previously published books include *Modern Art and Scientific Thought* (1971) and *Art: The Way It Is* (1974).

ISBN 0-275-96088-9

90000>

EAN

9 780275 960889

HARDCOVER BAR CODE